ERIC FISCHL

1970–2000

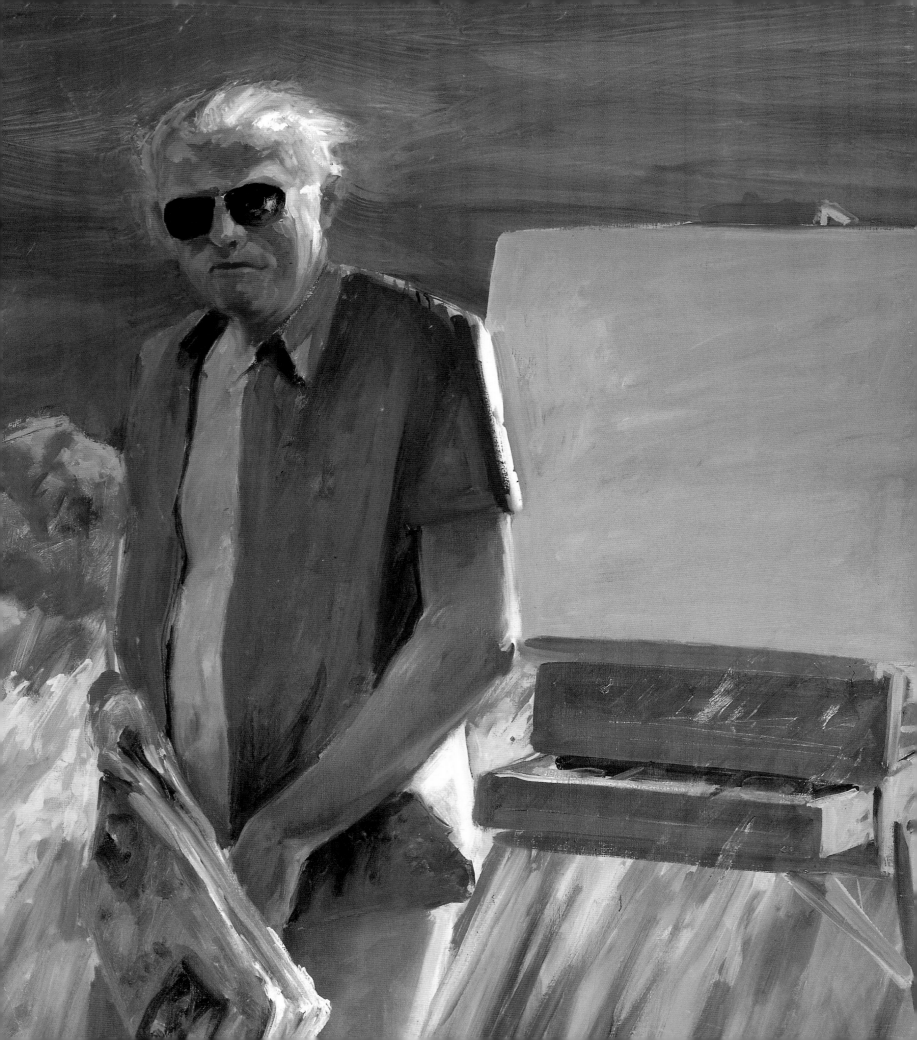

ERIC FISCHL

1970–2000

THE MONACELLI PRESS

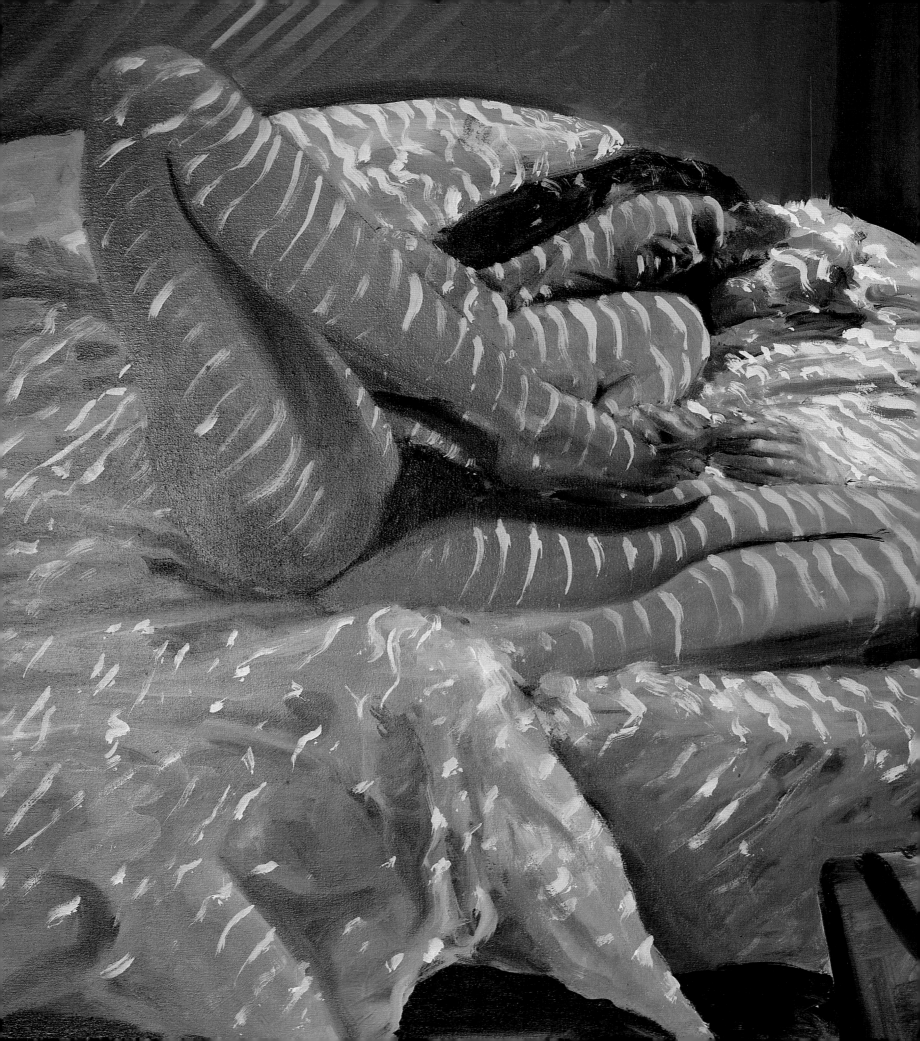

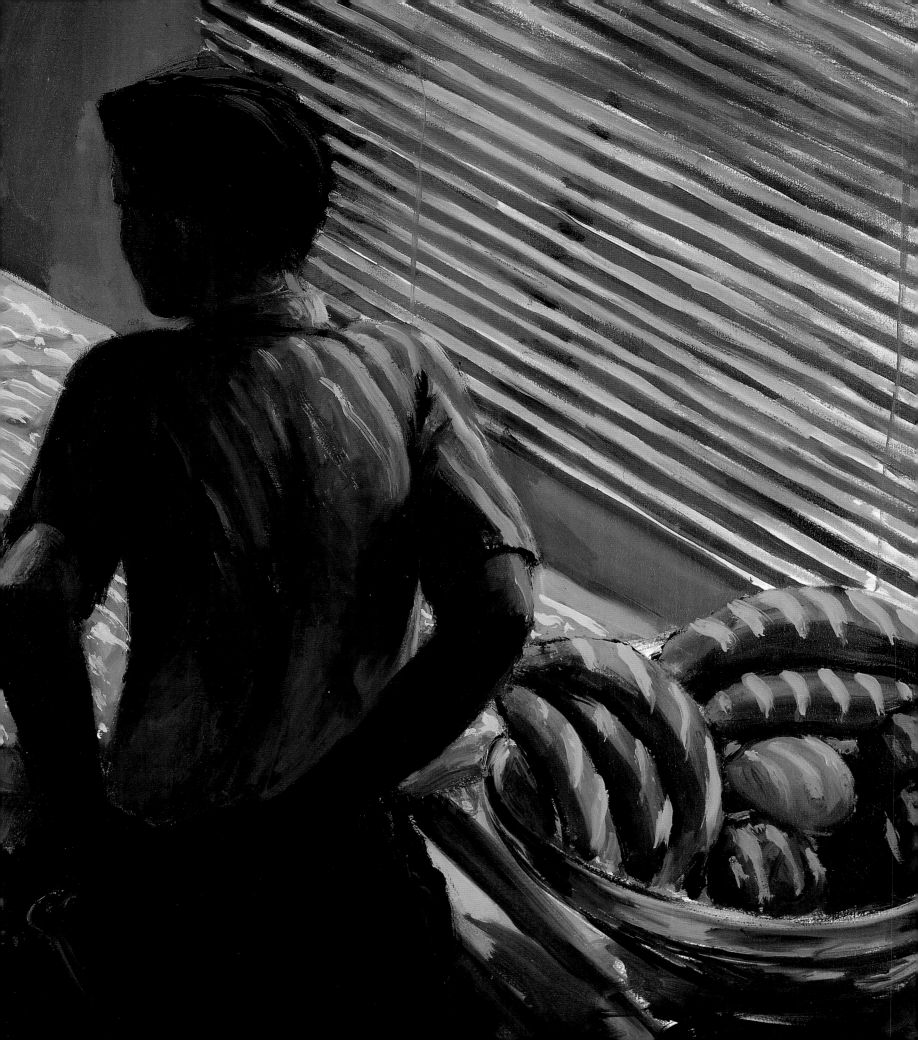

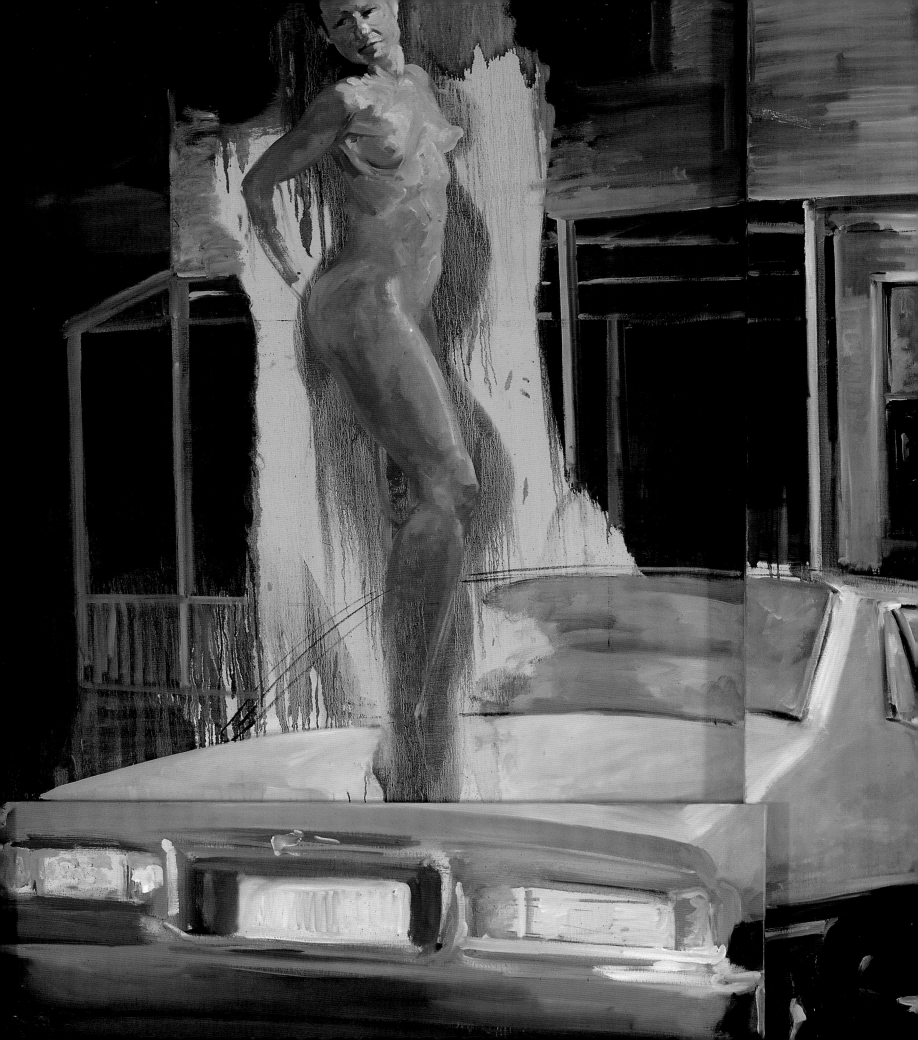

CONTENTS

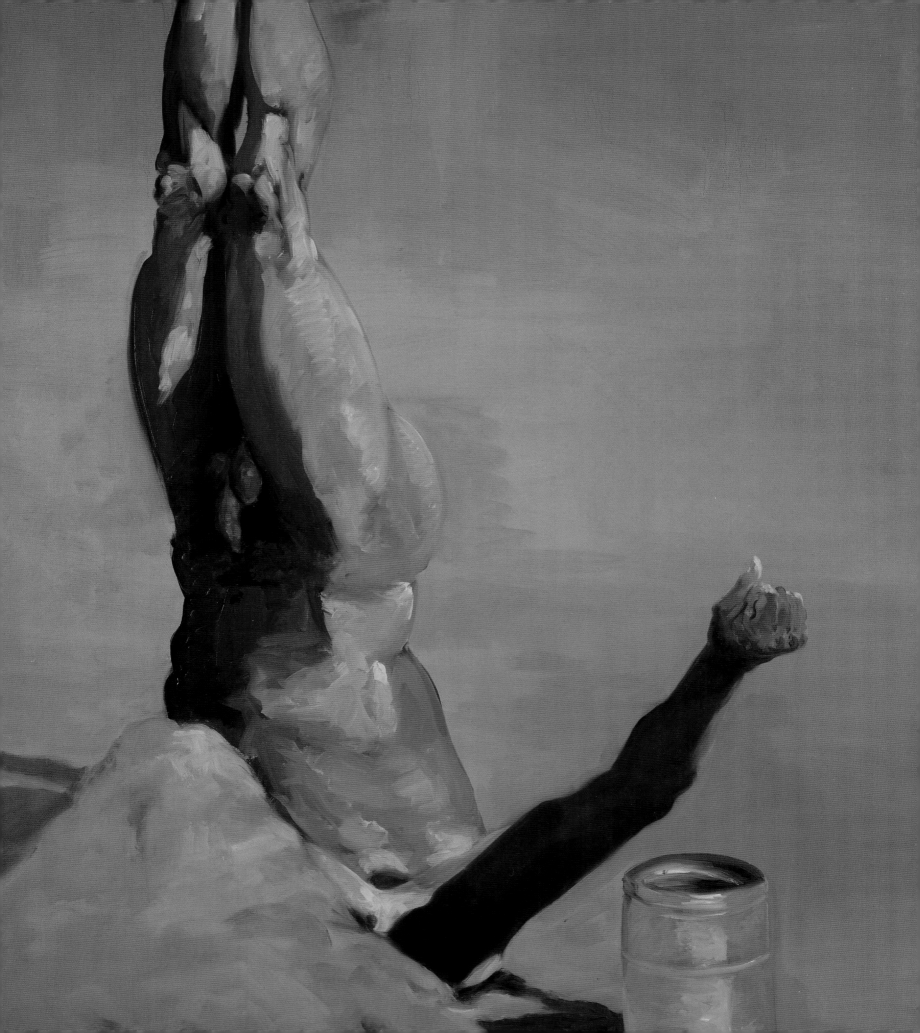

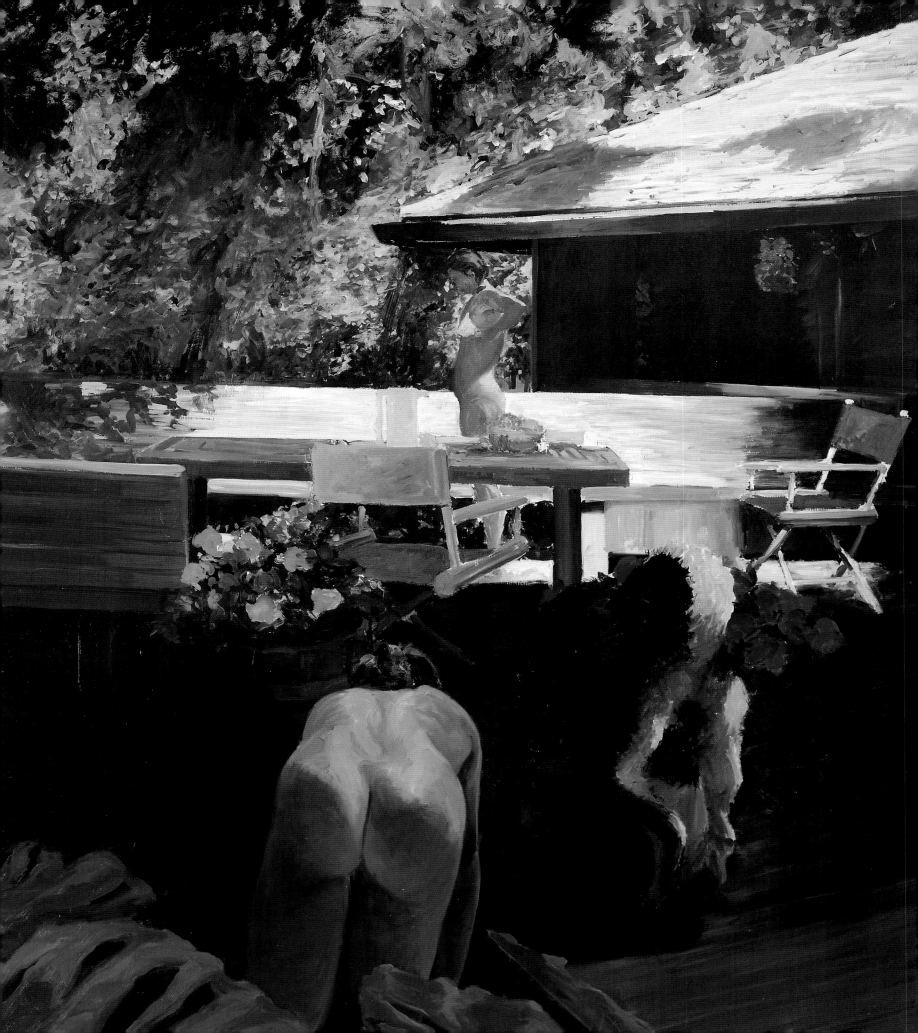

I paint to tell myself about myself.

— Eric Fischl

FORMATION, SUCCESS, AND MASTERY

Eric Fischl Through Three Decades

Arthur C. Danto

I. The 1970s

Eric Fischl's one-person exhibition at the Edward Thorpe Gallery in 1980 aroused considerable critical interest in the artist, not simply because of the arresting images which became the focus of most of the writing devoted to him, but because of the fact that what he showed were paintings. Fischl was part of an international cohort of artists—American, German, Italian—who burst into art-world consciousness in the early 1980s, after a period in which painting was largely absent from the scene. From the outside, it seemed as though painting had made a spectacular comeback after a blank and barren interval—and, since painting had been widely accepted as the vehicle of art history, it was as if art itself had once again found the path from which it had strayed. From the perspective of the early 1980s, the preceding decade was accordingly perceived as having been a caesura in the history of art. There had been, it must be said, relatively little new painting in the 1970s. But at least part of this was because the very idea of painting had come under severe theoretical and even political pressure from what was accepted as the most

advanced thinking about art at that time. The less radical attitude was that making art was no longer narrowly identified with making paintings. The more radical attitude was that painting was dead or ought to be dead. And then, in the early 1980s, there was so remarkable a renaissance of painting, so tremendous an explosion of painterly energy, that it seemed as if the medium had burst the bonds of a tethered giant and reaffirmed its inherent artistic dominance. It was an intoxicating moment, evidenced by the crowds who thronged the important openings, filling the streets of SoHo with excitement. A whole new scene had emerged.

The 1970s was the crucible from which Fischl emerged as a painter, and it is important that he be understood against the background of that extraordinary decade, the art history of which is still little understood. In part this was because the art school emerged as the defining institution of the art world. It was, however, a very different kind of art school than the traditional *academie des beaux arts.* It was not a training institution, but a kind of institute of advanced philosophical thinking about art, where teachers and students were

treated as collaborators and equals. Or perhaps the students were advantaged through the fact that, unlike the teachers, they had no past from which to cast themselves free. They were in any case considered artists already, in that they participated in the discourse that was a chief artistic contribution of the era, and virtually every piece of art was an application of that discourse, through which it had to be understood. The geography of the American art world before and after the 1970s consisted of a center—New York—surrounded by provinces. But in the 1970s it was a dispersed constellation of art schools across the entire country. These were not workshops in which one acquired the basic skills of painting, drawing, or design. They were running seminars in the meaning of art. There was, so to speak, no artistic *a priori*: art could be anything. But because a radical political consciousness was carried over from the 1960s, the *mentalité* of the art-school artist—student or teacher—was far less tolerant than the openness of artistic practice would lead one to believe. So it was a period of intense experimentation, in which artists could try anything, so long as it was not politically disapproved.

Fischl recalls an extraordinary drawing class at The California Institute of the Arts. Drawing had always been the foundational discipline in traditional art training. Whether or not someone could draw had been the test of artistic authenticity, when possession of that skill meant, to the skeptical or the dubious, that he or she was not incompetent, whatever the evidence of the art itself. When Giotto drew, freehand, a perfect circle, it was implied that he could draw anything. But "drawing was frowned upon at Cal Arts," Fischl said. So what was put in its place?

It was about 1970, the peak of crazed liberal ideas about education and self development. Do your own thing. No rules. No history. We had this drawing class that Allan Hacklin had put together. I arrived late. It started around nine or ten in the morning, but I couldn't get there until eleven. I walked into the studio and everybody was naked. Right! *Everybody* was naked. Half the people were covered with paint. They rolled around on the ground, on pieces of paper that they had torn off a roll. The two models were sitting in the corner absolutely still, bored to tears. Everybody else was throwing stuff around and had climbed up onto the roof and jumped into buckets of paint. It was an absolute zoo.[1]

It is always problematic to envisage the future, but the students we see behind easels in engravings of Jacques-Louis David's classes, or those who were endeavoring to master anatomy with Thomas Eakins at the Pennsylvania Academy of Art, would have been blankly uncomprehending were they given a glimpse of the scene Fischl describes and told that these students were learning what drawing really was.

Well, there was, after all, paper, on which marks were made. There were, after all, models. But it would have struck participants in eighteenth or nineteenth-century art instruction that these naked, paint-smeared young people had reverted to some primitive human condition, as if civilization had somehow been erased. But that was the point of the exercise. The students were engaged in regressive conduct in an effort to draw in the most primordial manner—far more primordial than what the legendary Corinthian girl achieved when she allegedly invented drawing by tracing the shadow of her lover's profile on the wall. Drawing may be basic—but how basic can we get? Hacklin's class was intended to reconnect the students with something ordinarily repressed—using the body as the surface on which marks transform it, like war paint, into something magical, and then transferring this to another surface. But I cite this extraordinary memory only to illustrate the kind of thing that belongs to the discourse of art, circa 1970. It is a discourse which of course draws on the ideas of its time—Norman O. Brown's polymorphic sexuality, the Living Theater's *Paradise Now,* primal scream therapy, the theories of R. D. Laing, Woodstock as utopia. There is a distant connection between these ideas and those of the Cultural Revolution in China—a program of radical erasures, of leveling out the differences due to culture. That was precisely what must be dismantled if we are to begin anew in the making of an art we have not as yet

begun to visualize. "Tear it all down and begin again" was something one often heard in the 1960s. It can't be worse than what we have. It was a scary and an exhilarating time.

What was true of "drawing" was no less true of painting. Easel painting is a form of art peculiar to the West, unparalleled in the art forms of any artistic tradition other than those which had become cultural colonies of the West. But the West itself was demonized in the wake of the Vietnam War, and painting—which had once been regarded as proof of the West's superiority—was collaterally demonized. Painting and sculpture were so identified with the political establishment that it seemed politically imperative to dissociate oneself from them as a way of expressing an opposition to a despised government. Beyond that, there was a vexed question in speculative feminism whether painting was not somehow so connected with a kind of masculinist psychology that its appropriateness to feminine artistic consciousness was uncertain. There was a massive critique of a number of what were felt to be disabling concepts—the genius, the Great Artist, the masterpiece, the museum of fine arts, the idea of artistic quality. Since art criticism was deeply inflected with cultural criticism, painting faced objections to its existence unparalleled since the iconoclastic controversies of earlier ages. There had always been a morality of painting, first in terms of a morality of subject matter, later in terms of a morality of aesthetic purity, which reigned in the modernist period for which Clement Greenberg was a main spokesman. But never had the morality of painting as painting been an issue as it came to be in the 1970s. It was widely presupposed that in any case painting was internally exhausted, having used up all its possibilities.

The atmosphere in the advanced art school of Fischl's student years was like that of a theological seminary in which students accepted that God is dead but want still to lead a religious form of life. Seminaries in the 1970s actually saw themselves as producing prophets rather than pastors and conceived the ministry in terms of social activism. The young American painters who made such a splash in the early 1980s were so thoroughly the products of their art school's formative

atmosphere, so different from anything that had prevailed in earlier times, that they were obliged to reinvent—and rejustify—the idea of painting if they were to persist in its practice.

For one thing, if they were to become painters, they would have to paint in an unprecedentedly pluralistic artworld, where painting was far from *primus inter pares.* In his interview with Donald Kuspit in 1987, Fischl explained:

> The artists of my generation feel that you can borrow freely from any time and place to construct your own image. So-called pluralism means that you can locate yourself in different periods of time. My work seems to come out of the nineteenth century, but it also uses twentieth-century primitivism. Other artists go back to the fifties or surrealism or the thirties. All these different styles and philosophies based on different stylistic advances are available for use. It's like the universe has curled back on itself and become full of possibilities that were half realized but still have a long way to go. In that sense I think I am a postmodernist.[2]

Consider the work of David Salle, like Fischl a graduate of Cal Arts, perhaps the furthest out of the art schools of the time. Salle's paintings internalized the disjunctiveness which was accepted as the reality of artistic production in the 1970s. He juxtaposed unrelated images in different styles within a single canvas, often attaching to it extraneous objects such as chairs or feminine garments. And he used a certain bland, notational drawing style that almost expressed contempt for the idea of draftsmanly virtuosity. It was easy to believe that Salle had found a way of representing a world of fractured meanings. Fischl has more than once said that he regards Salle as the contemporary painter he most admires. And he sees his work and Salle's as answering to parallel impulses, whatever the outward differences. By contrast with Salle's disjunctiveness and the diversity of styles he appropriated, Fischl's paintings typically showed a single narrative moment executed in a single

distinctive representational style. His pictures for some years were to be representations of suburban life, toward which they seem to express a certain moral anger. Nevertheless, he feels that someone who does not appreciate Salle's work can hardly understand his own. It would have been, for example, entirely comprehensible that one might use pictorial strategies from the nineteenth century to convey the reality he had selected as his. One could paint like a nineteenth-century artist and still be of one's own time.

Whatever the case, Eric Fischl graduated from Cal Arts fluent in the prevailing theoretical discourse of that institution, but almost entirely self-taught as a painter (as he was as a sculptor when he took up that medium). He came out an abstractionist, which in terms of the art culture of the moment was something of a hedge. Ironically he was hired to teach painting at another remarkable art school, The Nova Scotia College of Art and Design in Halifax. (It is significant that the school turned to Fischl's teacher, Allan Hacklin—a lyrical abstractionist—to recommend someone for the position, since its own agenda was in many ways like that of Cal Arts.) Practically, NSCAD had to cater to a population of students eager to study painting. But painting was not where its heart lay. It was a mecca of advanced conceptual art. There were memorable visits by Vito Acconci and Carl Andre. Josef Beuys was the commencement speaker in 1978. And for the enlightened, painting, as at Cal Arts, was of marginal interest. When I visited NSCAD in the early 1990s, I was struck by its unexpected look of the traditional art school. There were paintings on easels, drawings pinned to the wall. The sculpture studio had partially shaped stone blocks, with chisels and mallets at hand. I wondered how this was consistent with an institution which had invited Beuys to address it, or which still celebrated a legendary moment when Vito Acconci bit someone on the ankle, who then had the tooth-marks tattooed. If that was what the school believed in, why all this evidence of old-fashioned painting and sculpture? My guide, who had graduated from NSCAD, told me that in those days they were all conceptual artists. There was no reason to teach or study painting unless you needed to realize

some concept. If you actually needed painting for your work, you would learn how to do it on your own. It would be the same if the work required you to master glass-blowing or electronics. You would not expect an art school to teach everything an artist might be required to know. "At Cal Arts," Fischl said, "we were taught to believe that we were all professionals. We could do anything we wanted to." He had never learned to paint the figure—but when he needed to, he thought, "What the hell, I can do that."[3]

Why did he need to? It was while teaching at NSCAD that Fischl made the transition from abstraction into something like a kind of realism. He told me that it once occurred to him to change the shape of a canvas by cutting off the corners. This immediately suggested the form of a house or of a boat. "I reduced the image to that of a house, an object," he told Robert Pincus-Witten in 1985.

The house I saw as a shield, as a protection. From here I could go inside the house and abstract the table and chair. But such objects were insufficiently ambiguous. So from here I began to deal with the figure.[4]

It would be the figure that would vest the household furnishing—the chair, the bed, the table, the lamp, but also the yard and the porch with the ambiguities which marked his New York debut at the Thorpe Gallery. So he needed to master the figure.

Fischl resigned his position at NSCAD in 1978, the year his companion (and now his wife), April Gornick, graduated from the school. His works from the late 1970s are mainly paintings on glassine, which have the appearance of monotypes, a medium that was to prove particularly congenial to him later in his career. At first his figures bear some resemblance to drawings by late Degas, especially one of a woman in a bathtub which looks as though the figure has been scrubbed onto the surface. The difference between it and anything one can imagine Degas as having done lies in the fact that Fischl has overlaid one sheet of glassine with another, which acts like a cataract, dimming the contours of the tub and

graying the shadows. *Saturday Night* (1980) has four superimposed glassine panels and three characters—a woman, probably the mother, sits on the edge of a bathtub in her slip, smoking and preoccupied; a man, probably the father, his penis hanging down, shaves himself, gazing into the mirror; a child is in the bathtub, apparently touching his genitals. Each of the three figures dominates, but does not completely occupy, one of the glassine planes, and one supposes that this serves, or could serve, as a metaphor for the typical family we imagine represented here. There certainly does not appear to be anything by way of communication between the family members, and the implication is that they live in different if overlapping but not necessarily interpenetrating spaces. Each is occupied with her or his interior life, the child most especially. How otherwise explain that mother and father seem unaware of or indifferent to what the child is up to? Either they do not see or they no longer care whether the child touches himself. It is, one might say, a (very) modern family.

The glassine works are, Fischl says, "narrative and psychological." Both psychology and storytelling were anathema to orthodox modernism, which in its insistence on each medium purging itself of everything extrinsic to its essence, would have assigned them to literature. It was important to Fischl to maintain his modernist credentials, however, and he makes a point of observing that the glassine paintings "revealed their structure and material." These are certainly modernist attributes, so it must have seemed to him that his overlapping planes could serve both functions. One translated form, so to speak, into content, by supposing each plane to define a particular psychological space within the total composition. The graying or blurring effect of overlapping sheets of glassine perhaps implied different meanings for the individuals who "owned" the space.

We can discern both tendencies—that of modernism and of psychological narrative—in what Fischl says about *Rowboat*, an important if transitional painting of 1978. Fischl describes it as a boy's boat, a kind of toy. "I decided that I'd paint the boy's boat to suggest a story in which the boy's father was a fisherman and the boy imitated the father with the toy boat."[5] That, more

or less, was what play has classically been expected to be: the child imitating the adult, the toy imitating the appurtenances of adult life, the child an imitation of the grown man or woman. But neither the psychology nor the narrative are visually implied by the painting, which, as Fischl told Kuspit, "turned out to be beautiful . . . It had an extraordinary light in it. It was very moving."[6] He almost reflexively draws attention to the painting's modernism: "The painting turned out to be red, yellow, and blue—absolutely reductive," as if the reductive use of primary hues connected the painting with Mondrian. But the reduction has little to do with the beauty or the light in the painting. I always resisted Fischl's "modernism" because I felt it did not always have much to do with the intense, often shattering content of his paintings, which raised moral questions and indeed leveled moral judgments. They seemed to reveal the smallnesses of human beings, which we all know about and all share, just because we are human ourselves. What contribution does the fact that the large oil paintings he was to do in the 1980s, which were made of adjoined or overlapping panels, make to the depicted narrative? They echoed the overlapping glassine panels, but did not contribute to what the latter did. I always thought the paintings were divided against themselves somehow, irrelevantly modernist in most cases. I said as much in the review I wrote of his show of 1986 at the Whitney Museum of American Art, and the paintings he concurrently exhibited at Mary Boone. There is something overwhelmingly evocative about an empty boat, even perhaps an empty toy boat, whether or not the story is the one Fischl hoped the painting would suggest. And that evocativeness would be lost or dissipated in any pictorial space save the conventional one.

"I knew that if I went directly into representational painting, I would have to give up even the little bit of modernism I had cleverly used in the glassines,"[7] Fischl said. He confessed to Gerald Marzorati that he "was definitely afraid when I began to paint realistically." He added, "There's all this weight."[8] The weight, in my view, is not the weight of the great pictorial tradition of the West, to which he was bound, but was, rather, the weight of modernist discourse he had to shrug off when

he attempted to join the tradition of narrative realism. I tend to think that using different panels in constructing a painting was an effort to reaffirm the felt pertinence of modernism—it was like the overlapping sheets of glassine. But the painting to which Fischl next turned, *Sleepwalker,* is in no sense modernist in format, though it is, one might say, super-modernist in content. With it Fischl entered onto a plane of meaning which the 1980s, come at last, was made for.

II. Sleepwalker, 1980

Sleepwalker shows a boy masturbating in a plastic pool on a suburban lawn. I imagine that it must have occurred to Fischl, when he undertook to do a figurative painting based on his toy boat, that he might put a boy in the boat. The boat then suggested the bathtub, which figured so prominently in the glassine painting and carried a different psychology than a boat would. And the bathtub suggested the plastic outdoor pool. Retroactively we can say that the boy in the bathtub in *Saturday Night* was masturbating, though the drawing is ambiguous enough that he might merely be exploring his body. But there can be no mistaking the action in *Sleepwalker,* for the boy's whole body is bent to the task. It is a shocking image.

But to understand the decision to produce a shocking image, we have to situate it in the extended Cal Arts discourse, which found images problematic in a new way. In the late 1970s, when Fischl and Gornick moved to New York, they had a number of friends, many of whom had moved there from Cal Arts, bringing the Cal Arts language east with them. When Sherrie Levine encountered some of these artists, she felt as if she "had been let in on a conversation."[9] It was a way of talking and thinking never encountered by her before. It in particular helps explain *Sleepwalker.* As evidence for the proposition that painting was dead was the corollary that images have lost power to provoke. This was a problem one faced if one intended to be a realist painter and to control the viewer's responses. It is somewhat difficult to reconstruct the terms of the discussion, inasmuch as there was a great deal of evidence that images in fact retained a great deal of power. People found it very easy to be offended by

certain pictures, and scarcely a season passed without some group or other insisting that a certain image be removed from an exhibition. The black aldermen of Chicago physically removed a painting of Mayor Washington, shown dressed in lacy underpants and brassiere. An instructor of English found it harassing that a print of Goya's so-called *Naked Maya* hung in her classroom, and petitioned to have it removed. Feminists found Fischl's paintings deeply insulting to women. Political correctness ruled the day, most particularly in the art world, where a fair amount of blame continued to be laid at the feet of white males. It is difficult to see how the Cal Arts contingent should have been oblivious to all this, but in fact it became a project for its members to find images that could be counted on to shock or offend, and hence to make plain that images had retained a certain power after all. As Fischl put it "You'd do a painting of Hitler, or something like that, because everyone knew what Hitler meant . . . You needed to call up big, big things to give the work power."[10] So painters would make paintings, for example, with an undeniable Nazi content, not for political reasons but as part of an artistic experiment. David Salle was exceedingly inventive in finding images which women found deeply humiliating. Pornography entered the mainstream from having belonged in the near criminal fringes of artistic production. Fischl's masturbating boy was intended to shock in this way. So *Sleepwalker* belongs at the intersection of two sets of causes. The first was the discovery of beauty, and with this the felt need to paint a realistic image. The second was the question of what images, if any, retained the capacity to provoke. The decision to paint a boy in solitary *jouissance* presented itself as a perfect solution. It was to make Fischl instantaneously famous.

It is interesting to compare *Sleepwalker* with a glassine sketch from the same year. Both show the boy in the plastic pool, set in a yard and viewed from above. Both show a pair of woven plastic folding chairs, next to the pool and empty. In the painting, the chairs are placed next to one another and to our right, making the yard seem somehow emptier than in the sketch, where they are placed on either side of the pool. The boy seems more alone in the painting. But in the sketch,

there are three sheets of glassine—one for the chairs, one for the pool, and one for the boy. It is almost as if the surrounding world is receding for the boy, graying out. The decision to make a realistic painting meant that the devices of modernism were withdrawn, so that viewers would look at the boy and not the art object. It meant that we were to respond to the scene shown, rather than to the material object which showed it.

The yard in which the pool is placed seems pretty clearly suburban, though to judge by the lawn furniture and pool, it is a lower-middle-class suburb. The chairs, for example, are cut rate, on sale everywhere, by contrast with the chaise longue in *Daddy's Girl* (1984), where father and daughter lie together on a piece of upscale furniture, just outside an adventurously contemporary home. The plastic pool suggests that there is not a swimming pool. The clipped lawn implies a concern for propriety. There are many decisions that are difficult to explain. One is that the scene takes place at night. The devices of perspective and shadow dramatize the incident. The empty chairs do not imply abandonment, but the simple fact that mother and father have gone to bed. The title implies that the boy had gone to bed as well, but has in consequence of somnambulism found his way to the site of a soon-to-be-outgrown childhood. He has no consciousness that he is not merely visible but brilliantly visible under what we suppose is an outdoor light. We are left with the question of whether someone can masturbate in their sleep. But sleepwalking is not something most of us know very much about. It may even be possible that *Sleepwalker* is the content of a guilty dream, as when we dream of ourselves exposed and naked. The point, however, is that though Fischl's intention was to "paint a dirty picture,"[11] the imperatives of realism, which required him to deal with light, with shadow, with the texture of grass and the feel of plastic, transformed it into a meditation on memory, pleasure, dream, the discovery of the body, and innocence. "The painting started out as a sensational idea," Fischl said. "I wanted to shock an audience. I wanted to make something pornographic . . . It was powerful in itself." But in the end "the image turned out to be a lot more loaded than I thought it would be. My relationship

to it was a lot more complex than I had initially imagined it would be. When I finished the painting, I found that I had painted a sympathetic image of a profound moment in a child's psychological and social life."[12]

It is a profound moment wherever it takes place. That masturbation takes place on a suburban lawn is not an indictment of suburbia, but almost a declaration that the suburbs are like everywhere else. Once committed to an exploration of psychology, on the other hand, the suburb became an ideal site for Fischl—not because it itself was ideal so much as because one could show people at their leisure, without outside distractions, disclosing their inner thoughts and impulses. It was a twentieth-century decision which paralleled the nineteenth-century decision by Henry James to write his novels only about the rich, who were liberated to deal with their feelings, which became James's true subject, as it became Fischl's. He may have done some paintings in which people do constructive things, or engage in business or in public life. But I can think of no examples. I believe that everyone who saw *Sleepwalker* knew what it was about. There may have been some shock, not so much because people were shocked by masturbation, after all pretty universal, as by the fact that masturbation was shown. At that historical moment, masturbation was losing its taboos. New attitudes toward sexuality even made it seem healthy—a form, just a few years later when AIDS became generally known about, of safe sex. In any case, no one in the critical establishment expressed shock on behalf of their readers.

III: The 1980s

What is important about Fischl's works of the 1980s is how little you have to know about the history of art in

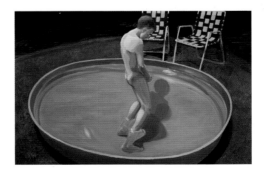

Sleepwalker, 1979
oil on canvas
69" x 105"

order to understand what they are about. There may be ambiguities, but they are not arcane. We may not know what is going on inside the heads of the people he paints, but we can give pretty fair guesses. Formally speaking, Fischl put before us just what he wants us to respond to. He does not, as it were, work the whole picture up the way, to use his example, a Géricault would. In this too, the images are like dream images, occurring in dream space. Dreams contain nothing extraneous. If we dream of ourselves naked, the dream work only adds what is needed to the content to make plain to the dreamer that he or she is outdoors, or in a place where nakedness is proscribed. The literature on Fischl is for the most part quite psychological, and the psychology can of course be fairly recondite and technical. But in Fischl's paintings, the psychology is of everyday life. In his suburbs, people act out the fantasies that people used mainly to dream about, which in fact was the way Plato characterized the tyrant. It is our own dreams that we see enacted on Fischl's canvases. It is ourselves we see. We are all small tyrants by Plato's criterion.

There is a great deal of commonplace sexuality as well, which means, since most of our sexual ideas are formed when we are about the age of the masturbating boy, that there is a lot of preadolescent sexuality—looking or sneaking looks, and touching. In *Imitating the Dog* (1984), a child is on all fours, looking at an adult woman fastening or unfastening her brassiere, unaware of or indifferent to being watched. In *Birth of Love* (1981) a naked woman smokes while an adolescent boy touches her thigh, not as a pass but as a fulfillment, as when the male character in *Claire's Knee*, a film by Eric Roehmer, touches a girl's knee. It is meant as a caress

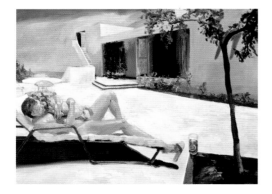

Daddy's Girl, 1984
oil on canvas
78" x 108"

but not received as a caress. In a way the children no more form part of the adult's consciousness than the dogs do—no one, Aristotle says, is ashamed to make love in the presence of an animal. In *Time for Bed* (1980)—an ambiguous title, meaning something different depending upon whether it is bedtime or time for lovemaking—a boozy woman spills her drink down a man's front while clutching his wrist with her other hand to keep her precarious balance. She is being exceedingly aggressive, and the man, not certain he is up to her, looks away. A boy nearby, in a Superman costume, looks down and holds his crotch. He is not aroused by the adults. Adult sexuality is beyond his understanding. Small wonder a boy aims his water pistol at two women lounging in their bathing suits in *Squirt* (1982). The title is three ways ambiguous. The boy holds a squirt gun. He *is* a squirt. And squirting the gun may be a surrogate ejaculation—a kind of gestural "Fuck you!" The woman in the green bathing suit smiles indulgently. The woman in the pink bathing suit pays no attention whatever.

The exclusionary character of the two worlds—the world of the child and of the adult—helps perhaps explain the other signature painting, *Bad Boy* (1981). There is a woman on the bed, her legs wide apart, who seems to be trimming her toenails. Commentators have inferred that she is showing her sex to the boy, but in fact she is probably indifferent to his presence. There is no way of knowing whether she is his mother, his older sister, an aunt, or just a houseguest. She is completely inside herself, basking in the slatted light of a summer afternoon. The boy has his hand in her purse. Commentators drew an immediate inference that there was some deep analogy between the woman's purse and her sex, whereas the boy may simply be intent on watching her to be sure he is not discovered pilfering. In *Birthday Boy* (1983) a woman is lying on a king-size bed with a boy. She is lost in reverie, though the boy, as in *Birth of Love,* touches her leg. The boy is not worth getting dressed for. There is no ambiguity in paintings by Fragonard, in which a woman lifts the skirt of her nightgown to allow a spaniel to lick her sex. But the relationship in *Master Bedroom,* between a girl in rollers and the big

black dog she hugs is not ambiguous either. She is on the cusp of adulthood, as evidenced by the rollers, but still a child through her need for predictable, accepting warmth. She is not *Bad Girl,* though if that had indeed been the title of the painting, we would be licensed to entertain a number of naughty hypotheses. In *Daddy's Girl,* a father hugs his little girl. It is interesting that Fischl talks is if this were something he came to *realize*: "I realized that nothing is wrong with what's happening. There's nothing wrong with the way the man holds the child. He is not sexually aroused. He's not fondling her in an erotic way, not touching her private parts. He's just hugging her."[13]

I have often felt that the paintings Fischl exhibited in his mid-career show at the Whitney in 1986 had a unity and a certain set of internal references, the way a suite of Hogarth engravings does. There used to be a literary genre which consisted in readings of Hogarth prints—Charles Lamb wrote that "they are indeed books; they have the teeming, fruitful, suggestive meaning of words. Other pictures we look at—his we read."[14] Something like this is true of Fischl's paintings in the early 1980s and perhaps explains his effort to keep connected with the imperatives of modernism, which in fact became more and more pronounced in large multipaneled paintings like *Saigon Minnesota* (1985). The effort was to deflect attention momentarily away from content and to insist that these were, after all, paintings. Little matter. The critical literature on Fischl, as on Hogarth, was comprised of exercises in moral psychology, in which one or another interpretation was tested against whatever clues the picture gave, as is the reading I have offered here. Hogarth of course filled his engravings with crafty details, each in its own way commenting of the central action, like asides to the audience. Fischl has very little of that. Does the foreground dish of bananas in *Bad Boy* contribute the its interpretation? There is a giggling lexicon in street-corner psychoanalysis in which bananas are phallic analogues—but do they really play that role in the painting when it is not clear that the relationship between the boy and the woman is really sexual to begin with? In any case, the paintings in the 1986 show could be thought of as part of a single cor-

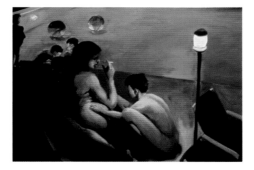

Birth of Love, 1981
oil on canvas
72" x 96"

pus. Together they implied something about the suburbs, something about the discontents of the flesh, and something in the moral psychology of sexual awareness. The pleasure of the show in part lay in the way its pictures demanded readings, and in the assurance that, as with Hogarth, one needed little save literacy in the book of ordinary life to participate in the interpretation. There were few art historical references, there was hardly any art theoretical apparatus. Everything we needed—including the ambiguities—was in the pictures themselves. Responding to them was more like what takes place when we *gossip*: "I saw her in her underwear, hugging that huge dog": "I saw him hugging his little girl—they thought they were alone." More than any of the other art stars of the 1980s, Fischl seemed to be one with his viewers—not like Salle, in some kind of sullen conflict with them; not like Schnabel, who presented himself as a virtuoso of some sort.

The Whitney show marked an ending. For one thing, from that point on, Fischl was on his own. The fingers of modernism no longer clutched at his shirtsleeves. He told me how a major European critic had seen *Sleepwalker* in the studio, when it was being painted. The critic had a very high opinion of the glassine paintings and was appalled by what, from the perspective of 1980, looked like nineteenth-century painting. He scolded Fischl. That is what studio visits can be like. And it devastated the artist. He thought maybe he should make it more modern. But in the end there was an irresistible drive to make that particular painting. Two years later, the critic admitted he had been wrong. He was wrong because in 1980 Fischl had demonstrated that realistic painting was *possible*. It was "back," as so many enthusiasts claimed, but in a

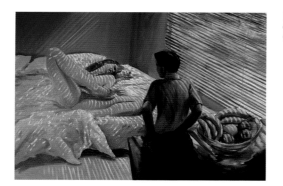

Bad Boy, 1981
oil on canvas
66" x 96"

new way. It was back not as the historically next thing but as an option in an indefinitely large array of options, among which the artist could choose. The critic had gone in with the sense that there were certain things that could not be done. Two years later he would have had to concede that anything, really, could be done. Hence the pluralism Fischl referred to in his 1987 interview with Donald Kuspit.

IV. The 1990s

Nancy Grimes visited Fischl in his studio some months after the Whitney show. Fischl had not been painting since it closed. He had gone to St. Tropez, where he photographed people who wore their nudity the way the rest of us wear clothes. "What I was most attracted to was people interacting in a social way, and they were naked."[15] The people were inadvertent models for him: "I could take those people and put them in a bedroom or kitchen or some other situation that's not about being at the beach. Their gestures are such that I can take a magazine that someone's rolled up in their hand and put a telephone in." But at the same time Fischl felt he was in a "transitional stage": "Its very hard to be quite as angry or hysterical as I was in some of the earlier work. I've made my point. It feels repetitious. The urgency is gone."[16]

In late 1990, Fischl exhibited a small number of paintings markedly different from anything he had shown before. These were of India, where he had been invited to work. He was amazed by India—it was, he says, more vividly *other* than anything he had imagined, let alone encountered; and he photographed what he

saw, though with no particular intention of transforming these pictures into paintings. The experience was certainly different from photographing naked bathers in St. Tropez, and putting them in the kitchen using the telephone, or the bath, the yard, the pool, the seaside balcony, the barbecue grill, the bed, or playing ping pong or throwing sticks for the dog. There would be no way in which one could transfer the Indian figures into American domestic surroundings. Every American, whether or not suburbanite, knows instantly what is happening or could be happening in the Whitney paintings. Perhaps painting Indian motifs occurred to Fischl as a way of breaking free from the style and subject he felt was exhausted. It was a way of making a fresh beginning.

The Indian subjects are other in the way a language foreign to us is other. Viewers were struck by how little they understood what was driving their subjects. In *Holy Man* (1990), there is a nude male with stringy muscles, his genitals displayed. But he is standing on his head, the head is buried in the sand, and next to him on the ground is a jar in which passersby can toss rupees as an investment in good karma. Whatever nudity may mean in St. Tropez or Malibu, it clearly means something entirely different in India. The paintings of the suburbs connected with a set of conventional moral attitudes which could get little purchase on the conduct of Indians, from whose look or body language we can infer very little. As a painter, Fischl was becoming more masterful. In compensation for the uncertainty of their psychological or narrative content, the pictures of India exploit a confident bravura style. The dramatic treatment of light and shadow in *On the Stairs of the Temple* (1989) is assured. There are two maimed beggar boys on the stairs, a number of the green monkeys one finds at sites like the Tomb of Akbar, a woman in a pink sari who ascends the steps, a man with a turban and shifty eyes. One supposes him a sort of Fagin figure, exploiting the boys, whom he perhaps maimed or had maimed. Begging is a profession in India, after all, and the boys are his livelihood.

One feels about the Indian paintings that they could have been done in the nineteenth century. They show no special mark of being modern, and indeed from this

point onward, it was as if Fischl had at last transcended the need to present his modernist credentials. He is now on his own. He can, under the pluralist auspices of a new art world, paint for the pleasure of painting, for viewers who take pleasure in the kind of painting he is doing. In a remarkable canvas of 1990, *Kowdoolie,* what looks like a company of saltimbanques is posed next to an idol, against a golden sky. With qualifications, it looks like a painting by the le Nains. The work in general has taken on the appearance of an old master. The paintings evoke Delacroix or Sargent.

In 1994, Fischl finished a suite of five rather mysterious paintings, which in some ways synthesize the exoticism of an Other World with a search for meaning that his suburban women would understand. The suite is titled *The Travel of Romance* (1994), and the implication is that the Woman—or the Women, since each one seems different from the rest—have made a passage to India in quest of something not easily formulated, and for which fleshly love may at best be a metaphor, as it so often was in the literature of mysticism. She has come seeking romance. The Woman is always naked, and, with qualifications, alone in a room. The qualifications are prompted by the first panel, in which the Woman is shown in what appears to be deep concentration. Her brow is furrowed, the chin is in her hand, her look is pensive and inward. Between her and the bed is a negro male, in a very athletic pose, as if it were an invitation to a dance. He looks like a dancer in any case, and his eyes are closed. The Woman seems so entirely unresponsive to this male that one must assume it a vision or a fantasy. In that case, she is alone in the room. Something has not worked out for her. In an introduction, John Guare says she looks like a Manet. He cannot have meant the nude woman in *Dejeuner sur l'herbe,* with her bright provocative eyes. This woman is squatting. She looks, in truth, like someone we might encounter in the corridor of an insane asylum. Squatting is not a Western posture. In the next frame, the woman is on hands and knees: she appears to have her eyes on something which, from her angle of vision, is on the floor. We are given no hint of what it can be. In the third frame, she ponders her reflection in an oval mirror. She is standing, with her

hand again placed to her chin, in search of her identity, and disturbed by what she sees. Perhaps it was her own reflection she saw across the floor. There is a large painting of a black person on a wall of the room, sexually indeterminate from the garment it wears. We shall see it again, much more clearly, in the fifth and final panel, in which it seems to be of a black child. It is hard to figure out the light source in the room—the woman's shadow goes one way, the shadow cast by a vase of flowers goes the other. In the fourth panel, the woman is bent over, intensely inspecting what may be a garment. The vase is to her right. Behind her is a sculpted primitive head on a stand. We now know three of the room's walls (the room is the actual room in which Fischl and Gornick were housed in India). In the final panel, the Woman, gathered into a kind of fetal position, appears transfigured by light. The transfiguration notwithstanding, we feel, again, that something has not worked out for her. The five panels make an extremely mysterious work, and one for which our commonplace psychology seems even more inadequate than it was for India. Guare, this time I think rightly, refers us to Forster's *Passage to India,* where, in the episode of the Malabar Caves, Adele Quested, the heroine, is convinced that she has been raped. A story has been enacted, but we cannot say with certainty what happened, or whether, whatever happened, it took place in her head or in her room. The woman is a traveler and a romantic—but what she found or felt in the room at the end of her trip is hidden from us and perhaps from her.

It is striking that the narrative is distributed among five panels, rather than composed in five panels fastened together to form a single eccentric shape, as in

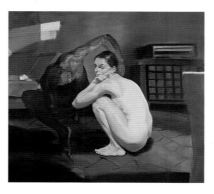

The Travel of Romance: Scene I, 1994
oil on linen
58" x 65"

the paintings Fischl had exhibited in 1986 at Mary Boone. It is clear that he has moved closer to a tradition and the traditional mainstream of Western painting. Psychological narrative remains central to his undertaking, but the stories conveyed are idiosyncratic and somehow private. They have immense meaning to his characters, but are puzzling to us. We can no longer rely on what everyone can be expected to know—cannot rely, that is to say, on the kind of body language found on the nude beaches of St. Tropez, or the lawns of Long Island suburbs. So painting has to be more exact, somehow, if only to hold easy interpretations at bay. The meanings conveyed by his figures' gestures have universal relevance to our lives, but are not for that reason universal in actual human experience. Working out the meanings is more like eking out the meaning of a poem than perceiving that one person is touching another in what may or may not be a sexual signal. Paintings were now something viewers had to work on.

In 1997, after his father's death, Fischl went to stay at the American Academy in Rome. There he underwent, as pilgrims to Rome so often do, a powerful reorientation. He began to paint the light-slashed, dark, contemplative interiors of baroque churches, using the baroque gestures which came so naturally to him as a painter. In *Dog in God House* (1997), a dog wearing a party hat is sleeping in a patch of light at the base of a fluted column. In a sense, the narrative is obvious enough. The dog had run off from the party and had entered the church, a cool place. But the meaning of his being there, and being there alone with the figures on the altarpiece, is less easy to furnish. Dogs on the beach, in the sailboat, at the foot of the bed don't obviously call for special explanation. But a dog in a paper

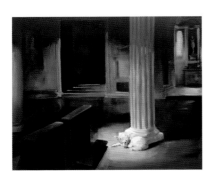

Dog in God House, 1997
oil on linen
55" x 65"

hat in a marble church has entered a symbolic space, and we must make of it what we can. If Fischl were an overtly religious painter, the painting could have a religious meaning.

In Rome, Fischl sketched a certain amount of statuary—an interesting term in view of the fact that modernist artists use the term "sculpture." We cannot easily imagine David Smith referring to his pieces as statues. But statuary is often conceived of with reference to the architecture it is to ornament, and Rome, like Vienna or Paris, has a vast population of statues among which their citizens live their lives. In an interview with Ealan Wingate in 1998, Fischl said:

> In Rome, where so much sculpture is placed on columns and domes and roofs, you can see in that beautiful light of their gorgeous sunsets these warriors, heroes, seers, and saviors, come to life like celestial beings flitting across the sky. It is such unabashed fantasy, such spectacle, that you cannot help but be charmed and amused and inspired by it.[17]

He was inspired enough to want to make sculpture himself, in part, he said, "to reenergize my paintings." The "paintings had become all too familiar to me." Fischl had said this sort of thing before, which is evidence that he was responding more and more to problems arising from his own work, and less and less with art-world questions and attitudes. The beauty of our pluralism is that it is entirely acceptable to work with baroque spaces or baroque figures, and to allow oneself to be influenced by such figures as Rodin, who is generally thought of as bearing little relevance to art today. The clay figures Fischl made had a clear reference to the solution of pictorial problems, but they look like the figures one sees in Rodin's studio in Meudon, meant to be fitted somewhere in the great *Porte d'Enfer*. One feels, in Rodin as in Fischl, the presence of the artist's hand, which so many modern artists, beginning with Duchamp, wished to eliminate from their work. "My hand became my enemy in 1912," Duchamp said. "I had to get rid of my hand," Sherrie Levine told an

interviewer in 1986. So much of artistic production today is conceptual; so much conceptual sculpture is fabricated. Fischl's sculpture is about the hand in the making, the feel of it, and "the stored information that's in the hand, in relationship to the body."[18] The problem with the painted figures, for Fischl, is that he felt he did not know what they were like in three-dimensional terms. He knew them only from one side, so to speak, and sculpting taught him how to think of them as rounded and weighted beings, and not, as Courbet said about Manet's *Olympia,* like the Queen of Hearts on a playing card. In the moral notation of the 1980s paintings, all that was needed was enough physical information to read an action, and a state of mind through that. The figures were moral hieroglyphs.

The exhibition of portraits at Mary Boone in 1999 shows the result of sculpture. The paintings are of individuals personally close to the artist, who have become part of the fabric of his life. They are fully formed, and fully themselves. At the same time, there is an uncertainty about what the artist means to say about them in addition to what they look like. This comes from their postures. Fred—a heavy man—sits on what seems like an inadequate piece of office furniture, his mouth half open, delivering some pronouncement, accompanied by a gesture. Steve is standing on the beach, smiling for the camera, wearing a leisure cap. His legs have the look of legs by Munch, or the incredible legs Bacon put on the figure of Van Gogh. Mike, wearing spectacularly polished shoes, leans forward in his chair, his fingers interlaced, all attention, as if listening to Fred. April is like the transfigured woman in the fifth panel, in a Hopperesque interior, where the light that strikes her is so much more intense than the light that appears to be coming through the room that it seems to imply a source the painting does not disclose. Mary stands outside in an unforgiving light, (just) resisting what feels like an immense downward pressure from above, smiling but desperate. I think the greatest of these paintings is the one of Bruce Ferguson, wearing black, his hands raised before him like a conductor's—or like a wizard, raising spirits from the vasty deep, or Christ raising the dead, or a priest summoning a supplicant to rise. It has the

gravity, in every sense of the term, of one of Velázquez's portraits, the figure facing the light, surrounded by darkness.

One of the portraits is of Fischl himself. It is hardly very flattering. He looks like a vaudeville clown, wearing baggy pants and a fez, which may have some symbolic affinity with the paper hat on the dog. His hands are thrust in his pockets, he is leaning backward, going through some routine. It is certainly a very different image from the 1984 *Portrait of the Artist as an Old Man.* The old artist is standing in front of a portable easel, with a blank canvas. The sun is setting to the figure's left, brightening the rushes, casting sharp shadows. The artist's shadows are very like the shadows of the easel, his *Doppelgänger.* His hair is white, he wears sunglasses, and he is touching his penis, though a newspaper hides the precise action from us. Probably he is masturbating, the boy in the pool grown up, not having found a more intense release than what he stumbled upon in his first explorations of his body. Or the gesture perhaps goes with the blank canvas. He has not managed to paint whatever motif brought him to the beach, and the sun is going down. Or painting has come to be like masturbation, in whatever way we can work out the structure of that equation.

In the 1998 *Portrait of the Artist,* the figure is shuffling off the stage, perhaps singing as he leaves the spotlight. The proper title might have been *The Artist as Vaudevillian.* That was how Hopper painted himself and his wife, Jo, as comedians, bowing to the audience, the act finished, near the end of his life. It feels like a parable. There is no pathos to speak of in Fischl's latest self-portrait, except whatever pathos arises from the idea of the entertainer, alone on the stage but not altogether alone, since there is the audience for whose benefit he has performed. Perhaps he is in effect saying; "Don't think you really know much about me from the paintings I have done."

I am insufficiently in command of the psychology needed to explain Eric Fischl's art from the circumstances of his life before he became an artist. I am, however, sufficiently enough a critic to believe that his work concerns humanity, and not merely his personal

history. For this reason I have divided his life into three decades: the 1970s formed him; the 1980s gave him success; in the 1990s he sought to go beyond that success in increasing departures from what formed him in the 1970s. Whatever came before was just growing up in the 1960s—a decade difficult for everyone, especially the young, who felt constrained to find lives for themselves very different from what they were leaving behind. Just that order of problem defined the life of art after the 1960s closed, and I have treated Fischl entirely from within the context of his art.

1. Donald Kuspit, interview with Eric Fischl, in *Fischl* (New York: Vintage, 1987), 33.
2. Ibid., 46.
3. Ibid., 33.
4. Robert Pincus-Witten, "Entries: Snatch and Snatching," *Art Magazine*, September,1981, 91.
5. Kuspit, *Fischl*, 32
6. Ibid.
7. Ibid.
8. Gerald Marzorati, "I Will Not Think Bad Thoughts—An Interview with Eric Fischl" *Parkett* 5 (1985): 25.
9. Gerald Marzorati, "Art in the (Re)Making," *Art News*, May, 1986, 90.
10. Nancy Grimes, "Eric Fischl's Naked Truths," *Art News*, September, 1986, 72.
11. Kuspit, *Fischl*, 34.
12. Ibid.
13. Ibid., 41.
14. Charles Lamb, "Essay on the Genius and Characters of Hogarth," *The Reflector*, no. 3 (1811). Quoted in Jenny Uglow, *Hogarth: A Life and a World* (New York: Farrar, Straus and Giroux, 1997), 702.
15. Grimes, "Eric Fischl's Naked Truths," 72.
16. Ibid.
17. *Eric Fischl, Sculpture*, "A Conversation about Sculpture with Eric Fischl and Ealan Wingate" (New York: Gagosian Gallery, 1998), 11.
18. Ibid., 3.

DESIRING AMBIGUITY

The Art of Eric Fischl

Robert Enright

In 1986 Eric Fischl painted a large oil on linen called *Couple In and Out of the Sun.* The painting shows what is described in the title: a naked man and woman, supine under an umbrella and in front of a dark screen that reduces their faces to shadow while their bodies, mostly thighs and buttocks, radiate in the brilliant sun. It is a painting that has it both ways, in more ways than one. From a technical standpoint, it is almost aggressively casual, the pigment applied in a way that is less reverie than slapdashery. Thematically, it is promiscuous: the couple gets to be in two spaces simultaneously while they are permitted to reveal their flesh and hide it too. Their situation is classic Fischl, an embodiment of his declared aesthetic wish: "I want ambiguity all the time."

What Eric wants, he creates. No American painter has so consistently and so intelligently manufactured a visual world of such promising bewilderment. In one sense, Fischl is engaged in the process of manufacturing dissent. His visual narratives—and he is unparalleled in contemporary painting as a storyteller—invite multiple interpretations. We rarely know where we are in a Fischl painting because the characters we are observing are themselves in the middle of the perplexing drama of their own lives. We are all of us together—painter and viewer and subject—at the heart of a compelling predicament. The predicament is as layered as the scene we are looking at; it is a question of comprehension, of the ethics of looking and the role of the witness. At the simplest level, we want to know what is going on, who these people are, what they are doing, and why they are doing it. Why is the young girl in *The Pizza Eater* (1982), prepubescent and unaware, wandering naked on a beach littered with young men who appear more likely to devour her than her food? Why is someone being carried away in the confusion of a beach scene in a painting called *What There Is Between You and Me*, 1992, a work whose alternative title, *What's between you and me*, is posed as a question. It's hard to tell if the figure is a participant, a victim, or somewhere in between. It's not even clear whether the figure is male or female (my guess is the latter), but the inability to assign gender is only one among a myriad of unanswered questions raised by the painting. Fischl is especially attracted to rendering figures from behind because they remain more

mysterious. And mystery is a condition that he seeks out. It is telling that his favorite novel, the only book he has read twice, is John Fowles's *The Magus*, a story about a character caught in a bewildering game of love and lust and deception. The point of Fowles's book, and the lesson of Conchis, the Magus himself whose name is pronounced with a soft "c-h," is to bring Nicholas Urfe to a workable kind of self-knowledge. In Fischl's world of images, we are also being urged toward consciousness.

It is a state of awareness not easily won and no more easily understood. But Fischl is convinced that the only way you can get close to it is through a radical interrogation of the work itself. There are times in looking at his work when you feel you are less a viewer than a private investigator, wondering about the motivations and the actions of the characters in the paintings. What you end up activating is something like a forensic gaze. While the paintings aren't exactly crime scenes, they do seem to be places where damage has either been done or is about to be done. This is a painted world where an observant and critical questioning is a necessary attitude.

Fischl is an uncompromising questioner of his own work, endlessly restless, in that his imagination is almost disturbingly active and migratory. It is a habit of mind that not only causes him to produce a lot of work, but to feel compelled to reconfigure it after its initial making. He is constantly reinterpreting his visual world, but his intention in this endeavor is not to come up with answers. What Fischl wants is a way of making art that encourages him to come up with questions; what he edges toward is a wished-for and a willed confusion. His way of knowing when a painting is finished speaks to this desire. "It's done," he says, "when I become the audience, when I'm looking at something and not fixing it."

In every sense of the term he has no interest in "fixing" his work, either in time or space. Nor has he any interest in realism, which he dismisses as "the world, simply recorded. But the minute you try to make the physical world be a place in which you are present, then it's about being alive. It's about always

being aware of yourself being in the moment." The emphasis he places on "being" in that observation is critical. Spoken language, as the comments that fill this book make apparent, are revelatory. Eric Fischl is the great American painter of being in the moment. This has led him to also be the great American painter of looking both ways, a kind of pragmatic Janus figure with his eyes set omnivorously in two directions. He is enamored of the in-between, and the figures in his paintings are often caught in actions that can be legitimately perceived as having opposite intent. Are the women dressing or undressing; have the couples just made love or are they about to make love? The double take extends even to simple gestures. The nude woman standing so imperiously on top of the car in *Birth of Love: 2nd Version* (1987) offers her body in a way that is both natural and calculated; the maid of honor in *Untitled* (1987) is both giddy with excitement and a good actor. In an earlier casting of the work the scene pulls us back (as if the painter were a photographer with a zoom lens) and reveals the paraphernalia of a fashion shoot. What appeared as girlish enthusiasm turns out to be performance; what might have been a moment of surreptitious voyeurism for us as viewers is actually a sales pitch for the perfect bride. Fischl's stereoscopic gaze implicates the viewer as thoroughly as it directs the characters in the painting. It is possible to think of him as a combination of casting director, set and costume designer, and producer in the ongoing film of his psychic life. It goes without saying that he is also the director. What is no less obvious is that all his skills are focused on realizing moments of transition. It explains his early fascination—in works like *Bad Boy*, *Birthday Boy*, *Dog Days*, and *First Sex*—with those events in which we pass, sometimes consciously and sometimes unaware, from one state of knowledge to another. These shifts often involve the body, the territory that Fischl describes as containing "the edges and boundaries of the flesh." It is a landscape where he has located himself throughout his career. He likes those interstitial spaces where one reality meets another, where one part comes up against another. It can be a measure of

the intimate body—which he expresses in his admiration for the close-up eroticism of his friend Ralph Gibson—or it can be the expanse of a beach—that fecund place where land meets sea, where our civilized selves often come face to face with our primitive selves.

Fischl likes to bring the viewer to the edge and then demonstrate how precarious that position really is. He makes the argument less with drama than through the subtlety of what has become an object metonymy. From the beginning of his painting career he indicated a desire to return to a time before feelings were words, "when they were just the thing itself." The phrase is an inescapable reminder of William Carlos Williams's aesthetic pronouncement that there were "no ideas but in things." While there may be no literal red wheelbarrows in Fischl's work, there is a deep understanding of the aesthetic potential in a thing or a person simply being seen, in that moment of narrative ignition when perception begins to form into story, when one thing literally starts to connect to another. "If the thing itself holds value and meaning and experience," Fischl says, "then you can continually go back to it for reexperiencing and reexamination and reinterpretation." But the painter goes beyond the poet; for Fischl, ever on the move, the aesthetic dictum becomes "no ideas but in transformative things." It is interesting that when Fischl first made the transition from abstraction to representation, he relied on words rather than on images because he could trust them more. "At first I kept it general," he told A. M. Homes in 1994. "I made everything a noun." It didn't take long before he was activating his nouns. Fischl was attracted to the visual equivalent of the gerund; in a drawing like *Transform* (1977) he registered his interest in moving across forms, and in the glassine sheets that he began using in the late 1970s he was able to manually organize the narrative shifts and variations that he had in his head. The portable medium of glassine allowed him to constantly change his story.

I mentioned metonymy, a term that addresses how one thing can stand in for another, a part for a whole.

Fischl's use of this device is brilliant. In *Daddy's Girl* (1984), a painting that continues to be troubling fifteen years after it first appeared, a father, who lays naked on a *chaise longue,* holds his young daughter in an embrace of ambiguous intent. The metonymic container for all our anxiety about this situation is the glass of iced tea that sits precipitously on the edge of a planter. We are obliged to ask who put it there and why: a wife, a servant, the little girl as a joke, the man as a temptation? What lends weight to a darker reading of this sun-riddled painting is the phallic shadow of the father's foot that extends beyond the end of the *chaise longue.* It points in the direction of the glass, a suggestive and menacing black metonymy on its own. In *Birthday Boy* (1983) the tension that develops because of the nakedness of the older woman and the young boy is contained in the creased newspaper, pitcher, and penetrating spoon, what the artist calls "the still life which re-creates the whole symbolic dynamic." There are even paintings like *Time for Bed* (1980) and *The Day the Shah Ran By* (1982), where creases on the palm of a man's hand, or at a woman's waist, are rendered in such a way that they are metonymic bodies, parts that stand in for a different hole in the delirious and perversely sexual worlds these painting insinuate. There is nothing in a Fischl painting that is not worth serious attention, because there is nothing in them that is not considered. To hear him talk about his close looking at other painters, to overhear his readings of the mysterious visual narratives of Matisse or Bonnard, is a rare privilege. What becomes apparent when you read what Eric Fischl has to say about his own work is how much of that close looking is invested in its making. When asked why he is compelled to make paintings, his response seems to look toward simplicity and hits on the profound. "It's the way I am in the world."

FISCHL ON FISCHL

Selected and arranged by Robert Enright

The following comments by Eric Fischl are extracted
from interviews with Robert Enright conducted in the
artist's studio in January 2000.

Being an Abstract Artist

When I was an abstract artist every painting I did was basically the last painting I could do. It was always such an existential drama to make a picture. It was so draining; there was nothing natural about it so one painting didn't flow to the next. Every now and then I could string three or four paintings together where it seemed like I was onto something. Then it would die and I'd have to start all over again. Looking at artists I knew who were abstract painters, I could see that for them the language was totally natural. There was no hesitation; they knew when they should change the size of their brush. I never changed the size of my brush: Why change, what's the rationale? Painting became very boring because I was working with a limited color range, limited brush size, and limited shapes. It seemed arbitrary to change or mix up any of those things. That's where realism becomes interesting because I can actually say, I can't paint a flower with this big fat brush, I have to use a smaller brush.

What made me persist was my relationship to myself, actually, which was something of a revelation. I wasn't someone who made art as a child. Later I was more of an athlete, and then a drug user, so after I'd failed my first attempt at college, I took a year or so off. Then in a desperate moment I decided I would go back, but I went to a junior college because of my grades. I decided to take art because if you're really bad they still give you a C. You don't fail art, right? I just used it as a way of socially connecting to people. I was living in Phoenix and I didn't know anybody. Anyway, when I went home at the end of the day, I found myself able to sit in my room working on something—a collage or a drawing—for hours at a time and for the first time in my life being able to concentrate. I wasn't afraid of being alone and I realized this was what I wanted to do. Whether I was bad or good at it didn't matter at that point because it made me feel more integrated.

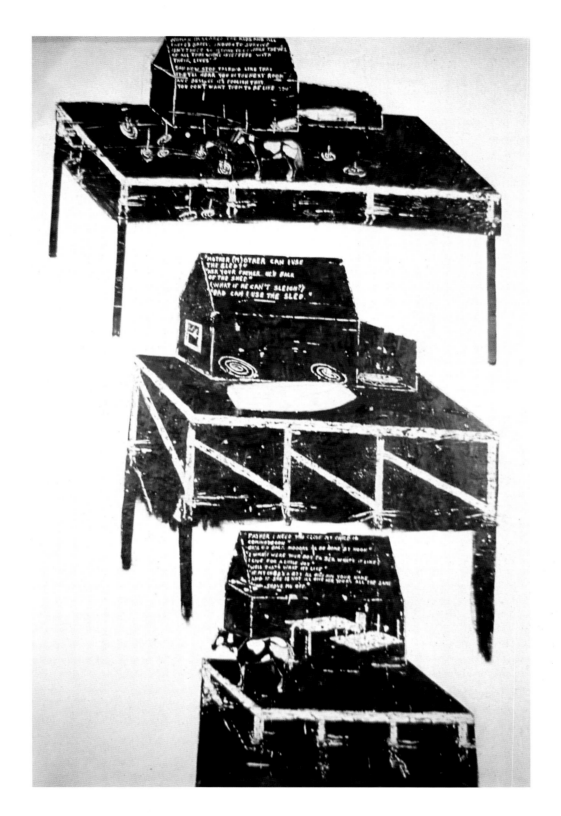

Mural, 1976
enamel and beeswax on wall
120" x 96"

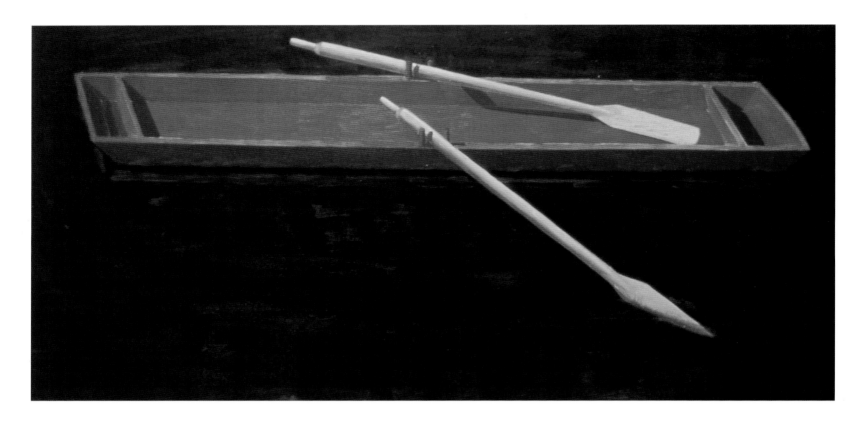

Rowboat, 1978
oil on plywood
48" x 96"

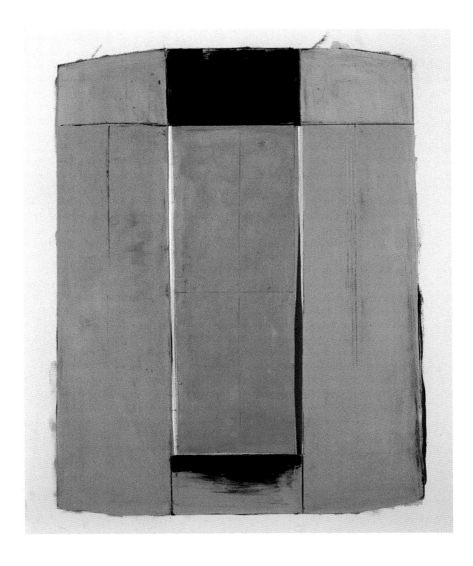

Shield, 1975
oil and wax on
paper
22" x 30"

From Abstraction to Representation

When I was a student at Arizona State I was learning to paint
abstract paintings á la Kandinsky. You know, arabesque forms
and one edge of color bumping up against another and starting
a different shape. I was having a horrible time with one paint-
ing. I didn't know what to do and I worked on it for weeks and
weeks, painting and overpainting and getting really frustrated.
I remember this one day, at the absolute limit of my tolerance,
getting up and just drawing this form across the middle of the
painting, then filling it in with white. When I stepped back I
saw that I'd painted a shape that looked like a white bed. And
I had finished the painting as well. It was this weird painting
in which there are flat abstract shapes and then this isometric
"bed" sitting in the middle. I never understood it, but I knew
it was done. It's always been a vivid memory for me. Then
years later that bed started to appear and reappear until its
presence became clarified to me.

Electric Chair, 1979
oil on canvas
72" x 96"

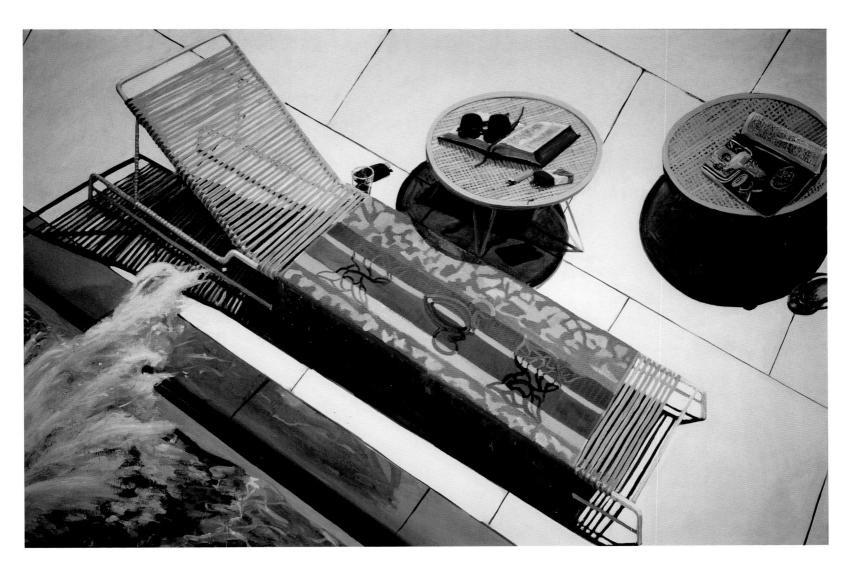

Christian Retreat, 1980
oil on canvas
64" x 78"

Formalism

Formal paintings are never just about formality. Think of Barnett Newman's *Stations of the Cross.* Here's somebody who is dovetailing this deep symbolic, mystical, and historical event in the Christian narrative into a set of relationships about edges and proportions and in the process creating a believable environment equivalent to the passions and pains and humiliations of the Stations of the Cross. It's an incredible feat. Look at a lot of Malevich paintings that are wholly abstract and at the same time come out of an Orthodox Christian iconography. In other words you can read them symbolically. It's not necessarily a narrative, but it's a symbolic structure. I guess even in Agnes Martin you look to the landscape and to light and color as a way of understanding things that are reduced to the purely abstract.

I tend to look for human connection in abstract art, although I think a lot of the artists who work abstractly don't want you to connect in that way. They want you to connect as though there was a truth that existed outside all of us, a purity that is greater than all of our weaknesses.

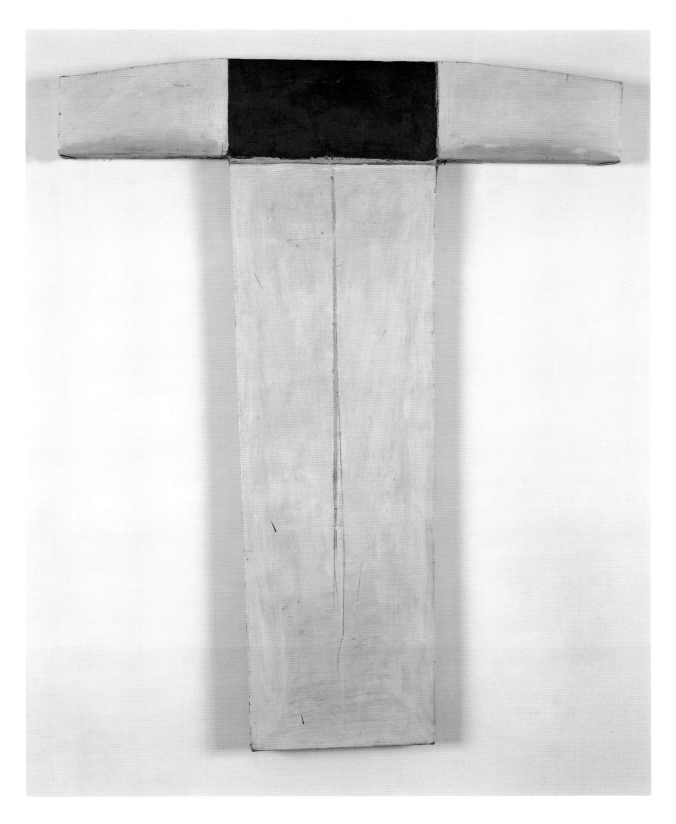

Steer, 1975
oil and wax on canvas
32 ¼" x 25 ½"

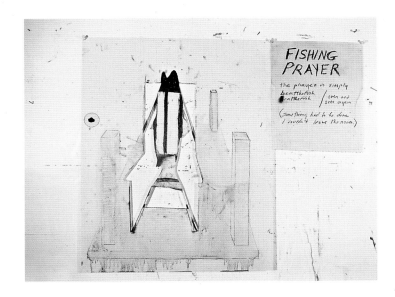

Untitled #1, 1976
mixed media on paper
22¼" x 28¼"

The Death of Painting

I definitely had no drawing skills. I figured that if I could create an image that looked somewhat like what I was trying to draw, then I could contextualize it with words. It would give it more of a three-dimensional spin. That's when I started doing these scratchy, static drawings of people, and then I'd write stuff on the bottom. In fact, the narrative element was there in my abstract paintings as well. I was thinking that I was painting tigers and princesses and actually I was painting an orange rectangle and a pink rectangle. I wanted people to say, "Boy that reminds me of a princess and a tiger," but they'd say, "I like the weight shift" or "I like the way the two edges meet." Anyway, when I got into the images the narrative was already a part of the thing. I was talking to myself and I trusted words more than I trusted imagery. I relied more on their resonance than on the actual image. They were more the subject than the image. Eventually that reversed itself and the words disappeared.

There was a strong belief in the late 1960s and early 1970s that painting was dead or dying. Certainly imagery in painting was totally dead. When I started to make the change to images I did it through drawings because I too believed that paintings were dead. I'm a painter, so I obviously believed that the activity had value, but I always believed that your job was to prove it. I never took it for granted, so every abstract painting was an attempt to prove that it was still alive, and every image painting was an even greater effort to bring back integrity to something that had been degraded. There were legitimate reasons why some things in painting would be declared dead or dying. When painting became so dominated by abstraction, photography became the dominant language for realism and for the figure itself.

Untitled #1, 1976
mixed media on paper
22 ¼" x 28 ¼"

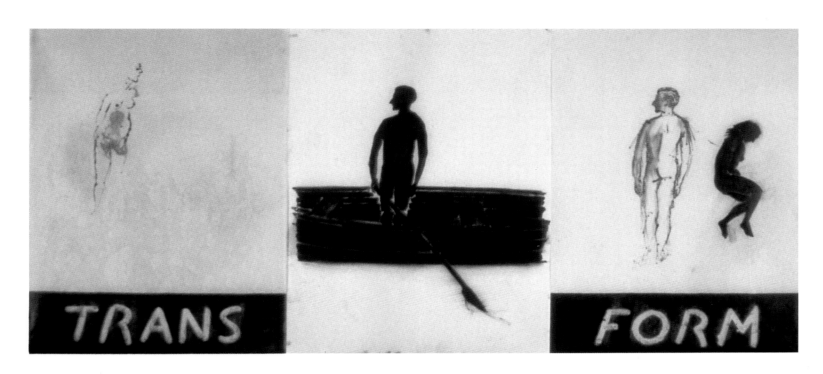

Transform, 1977
ink, oil, oiled paper
32" x 66"

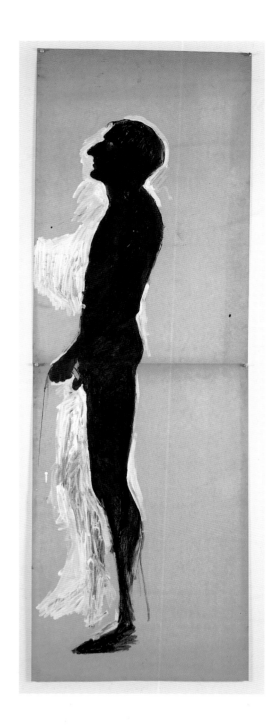

Blind Man Standing, 1979
india ink on oiled paper, two pieces
70" x 23"

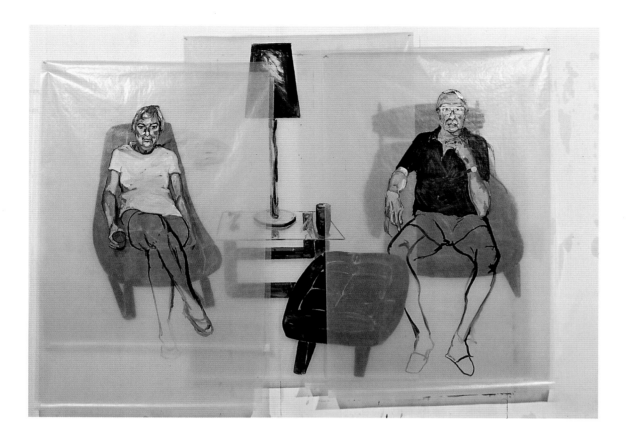

Marion and Karl, 1978
oil on glassine, six sheets

Family

I came out of a white, upper-middle-class, Protestant suburban background. We had to go to church, but our parents didn't. I've been thinking lately that they probably used that time to have sex. They'd take us to church and then they'd go have sex. Some of my early paintings were reconstructed memory. They weren't strictly autobiographical but I was drawing on and conflating past events. I lived in essentially a secretive environment. My mother was a ferocious alcoholic, and alcoholism was something that was totally taboo and secret. It was a family shame, something you kept out of public. I grew up in a household where there was a dual reality: outside and inside. Inside was frightening and tumultuous and violent and dirty and disgusting. It was also heroic. My father, my sisters and brother and myself, we were all trying to cope with a devastating situation. So that was on the inside. The outside was nicely kept yards, clean pressed clothes, and going to school on time. My father was carrying a tremendous burden having to be the caretaker of the family because my

mother was absent a lot. She was present but absent. So he had to be the breadwinner and then come home and be a nurturer. It took its toll. They had an intense, volatile, and very physical relationship. If you can imagine it we were a desperately loving family.

Using my family experiences as subject matter was a decision by default. I had explored other ways of making art that I just wasn't very good at. I came to a point in the mid-1970s where I'd used up everything I'd been taught and none of it was really working. I began to make this transition to working from a content point of view. I thought maybe I'd just start from something more familiar, something that I knew.

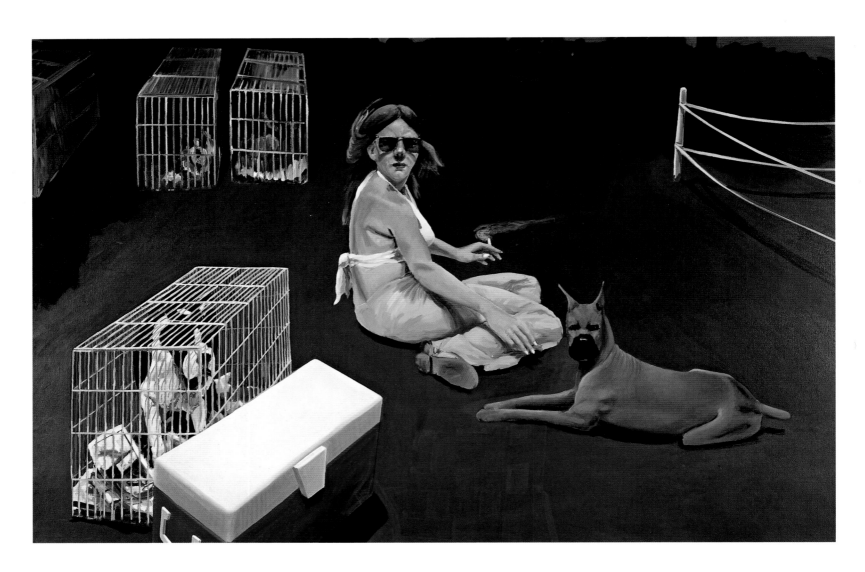

Woman Surrounded by Dogs, 1979–80
oil on canvas
68" x 106"

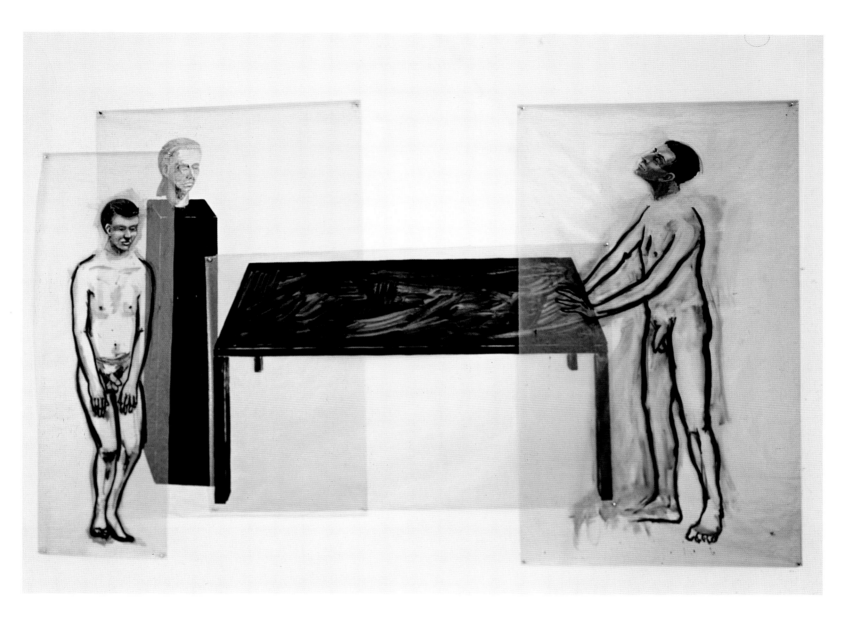

Head of the Family, 1980
oil on glassine, four pieces
72" x 108"

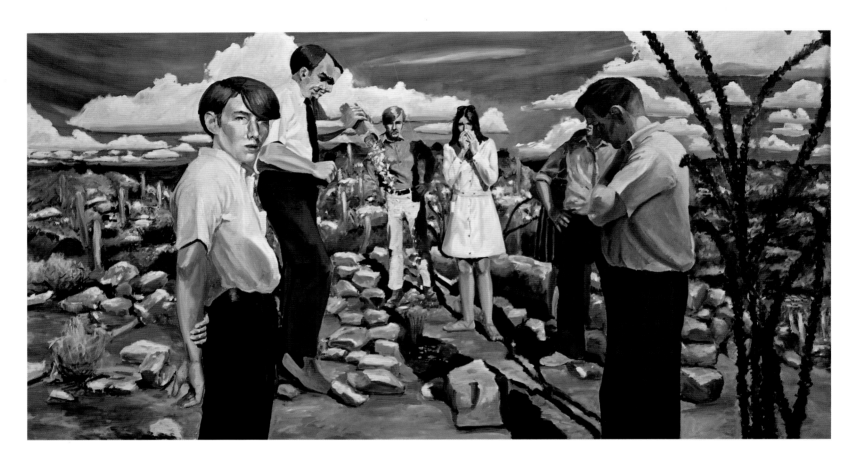

A Funeral, 1980
oil on canvas
60" x 96"

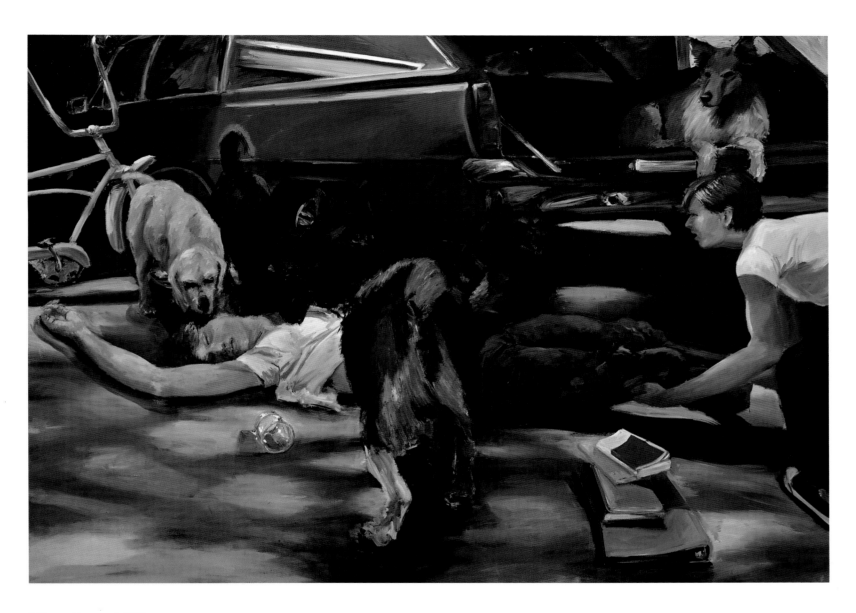

A Woman Possessed, 1981
oil on canvas
68" x 96"

On the Glassine Drawings

I can almost say that glassine unlocked my creative process. It was something about the translucency of the material. Also the size was right. I was working with these three-foot-by-ten-yard rolls: three feet is enough to get a life-size figure on and so I could make large scenes. First of all, the way the paper accepted oil paint was really sexy; it had this Vaseline jelly feel to it, slick and viscous at the same time, and you could erase what you didn't like. So you could really work with it and that made it fun. Then I found that I was better at drawing if I could use my whole arm from my shoulder down than if I just used my knuckles.

That was part of it, and also the translucency of the paper and the fact that I could overlay one thing on another and get this feeling of space. The color of the paper itself— while I can't call it beautiful—was a compelling green that separated itself from the wall and created the light in which the action took place. All those things came together. I found that I could literally project a scene: I could say who's sitting at that table, are they sitting, are they standing, are they walking, are they underneath, what if they were underneath? I could put something on and if it didn't work I could take it off and use it in another scene. I connected to the process right away. I envisioned that I would make a life's work out of it. It didn't seem like there was any reason why it would end. I was

actually surprised when I realized it wasn't enough. I also thought that it would be an ongoing, evolving soap opera. Soap operas don't ever end; they just introduce new characters. It turned out, though, that I wasn't looking for something that was ongoing; I was actually looking for frozen moments, for something where somebody's gesture, the interaction between that gesture and its environment and what had caused it—all those things created a poignancy that filled the room with meaning. Although I could rearrange the glassines endlessly, I noticed that every time I put one back up I did so in the same way. It was the particular configuration of the scene that gave it meaning.

I didn't literally translate glassine to painting; I just continued the process on the canvas instead. I was looking for the frozen moment and it was something I realized painting in its greatness can do better than anything else. It seemed heroic to make a big, narrative painting work.

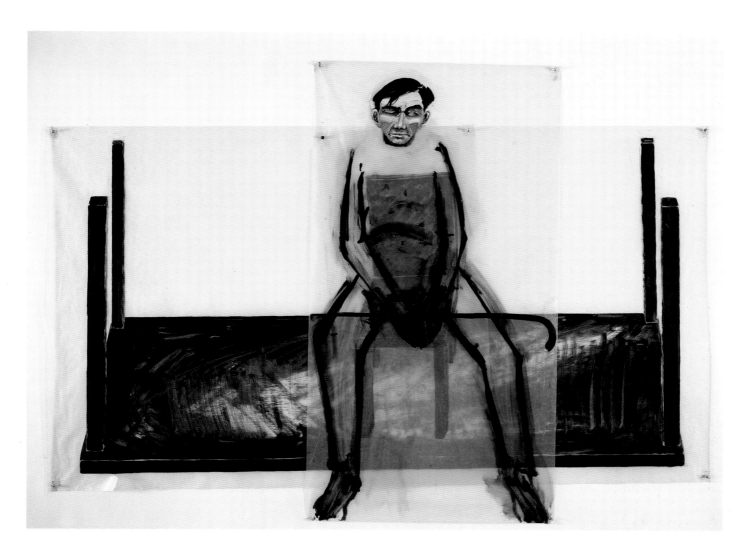

Blind Mans Boat, 1977
oil on glassine, two pieces
53 ½" x 74 ½"

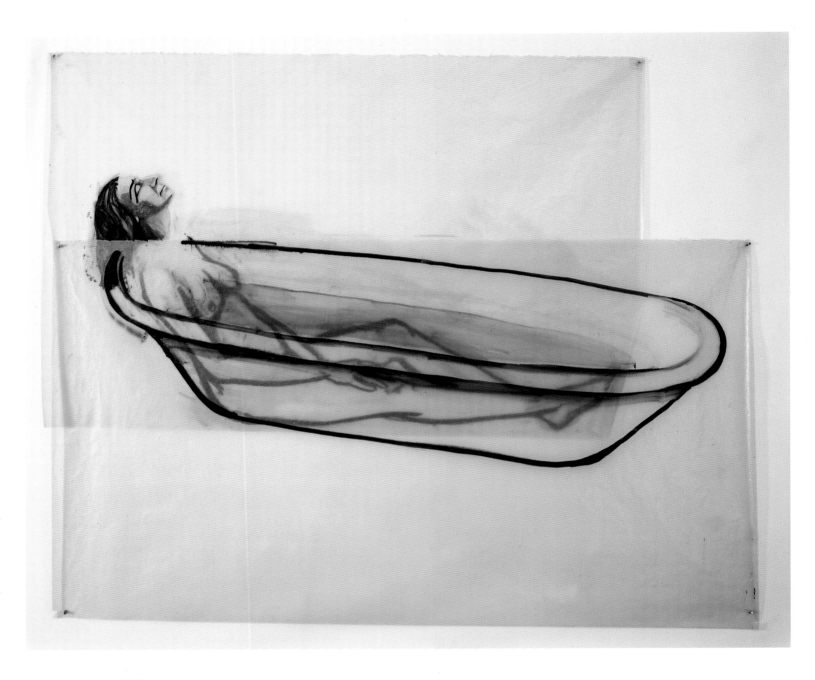

1st Woman in Water, 1977
oil on glassine, two pieces
62" x 75 ½"

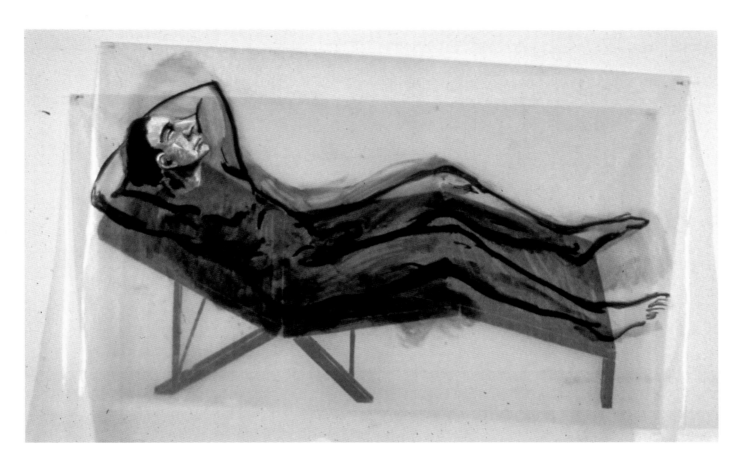

Family Scene, 1977
oil on glassine, two sheets

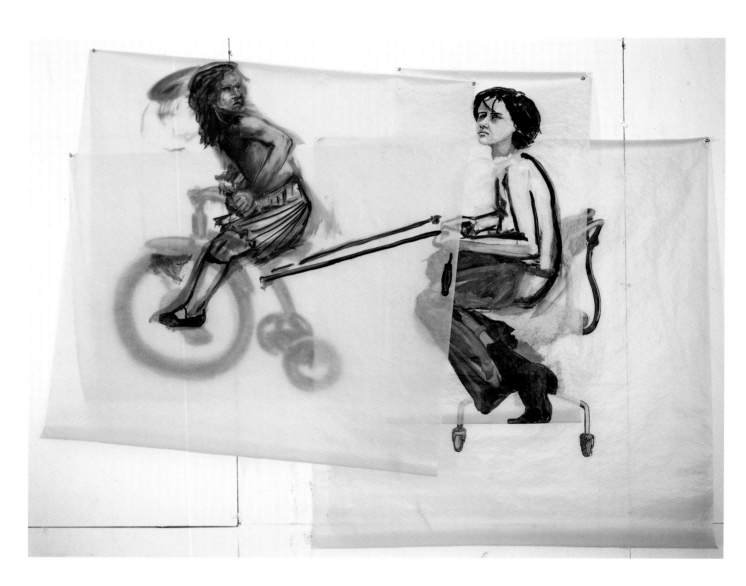

Horse and Rider, 1979
oil on glassine, four pieces
60" x 79"

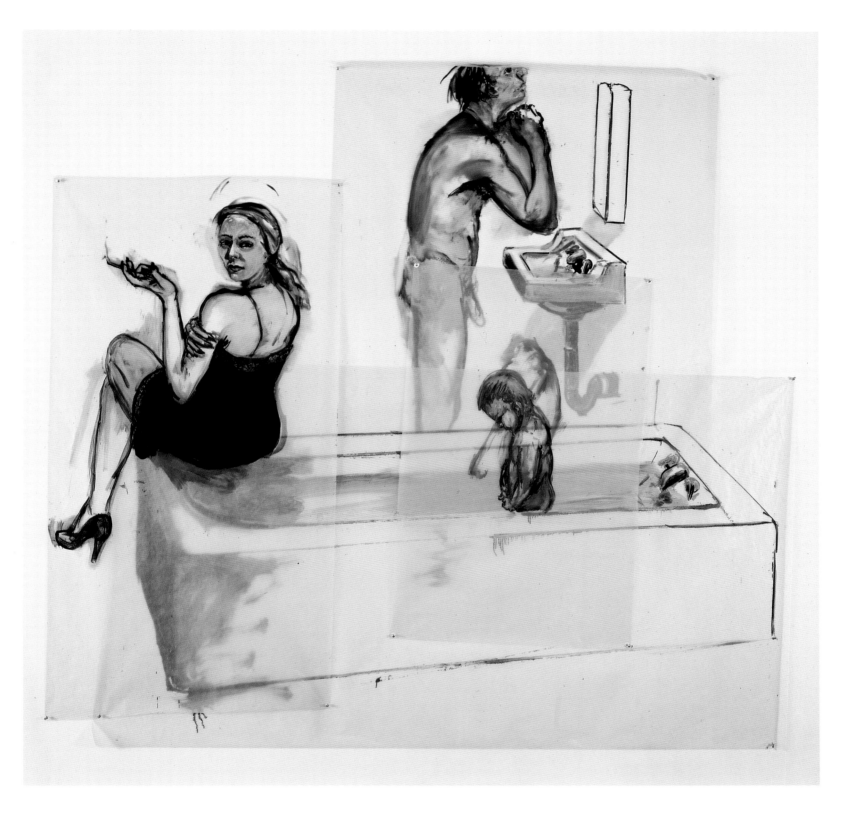

Saturday Night (the Aftermath Bath), 1980
oil on glassine, four pieces
72" x 84"

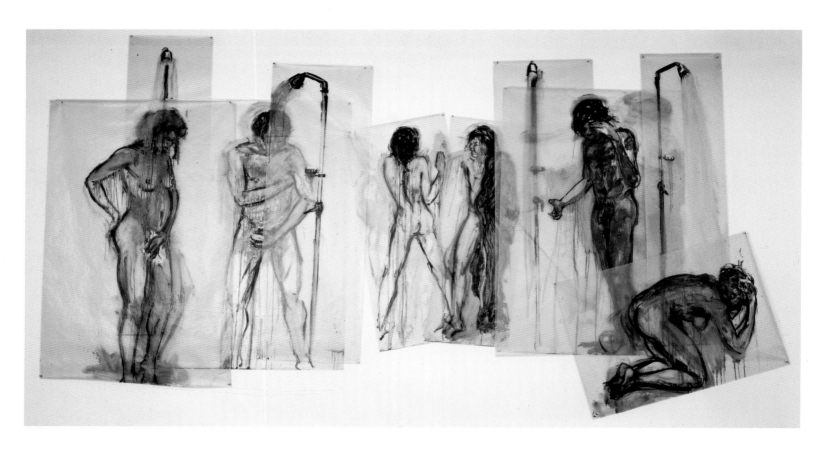

Bathers, 1982
oil on glassine, eleven pieces
96" x 164"

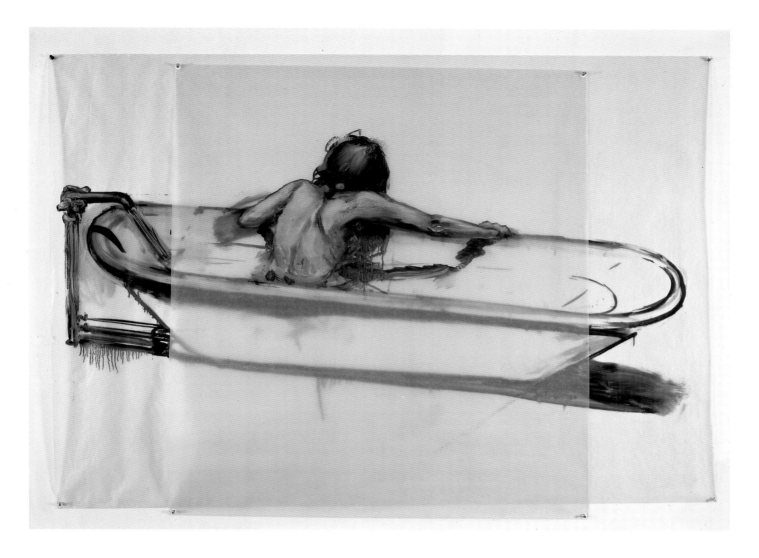

Woman in Bath, 1980
oil on glassine, two pieces
49" x 67"

Woman in Bath

I was thinking that the husband is a fisherman and he's responsible for their ability to stay alive, because if he fails they don't eat. Then I started thinking, "If I were her would I trust him to do that?" I'd want to offer some help; I'd want to be part of it in some way. What would I do? I couldn't be there because I have to be home with the kids, so I'd project through sympathetic magic. I ritualize it, I participate in this other, symbolic way. There is something tragic and pathetic about it. The bathtub becomes this vessel, a vessel of transformation, where it becomes a boat but it is also a container for her fantasy about participation and an expression of her limitations.

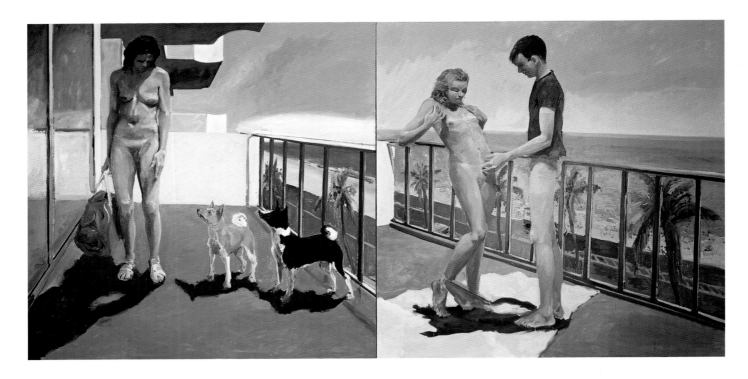

Dog Days, 1983
oil on canvas, two panels
84" x 168"

Transgression

I had totally underestimated the audience. I really had
thought in stereotypical terms about who the audience was
and what they'd react to. I was surprised, time and time
again, by their ability to accept challenges or acknowledge
painful things. I thought my first show would be roundly
attacked by feminists and by blacks for what could have
been perceived as stereotyping, or the fact that I so blatantly
painted such a male point of view. It turned out that I wasn't
being as stereotypical as I thought. And the fact that it was
dealing with these subjects on such an emotional and psy-
chological level made people actually appreciate the com-
plexity of the problem.

Sometimes I thought I was being incredibly transgres-
sive in a deliberate bad-boy way, only to find out that I was
doing something that was touching instead of nasty. I used
to work from a place in which I gave myself permission to
discover meaning as it was being made. I often made paint-
ings thinking I was doing one thing, and when the painting
was finished it was another thing entirely. Creatively, it's a
great place to work from.

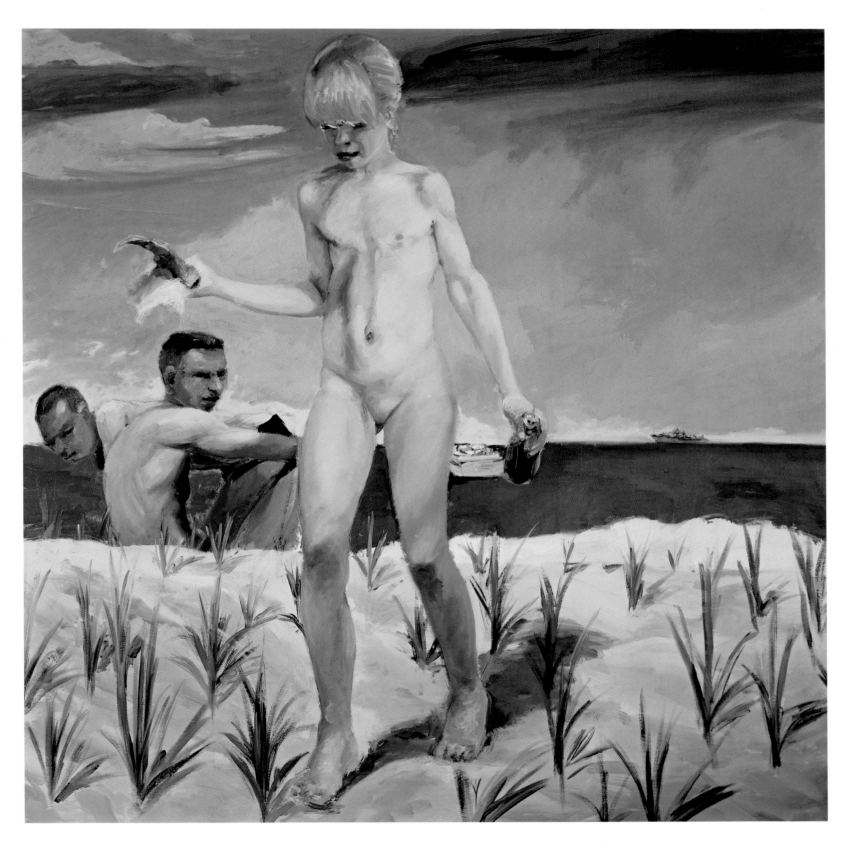

The Pizza Eater, 1982
oil on canvas
60" x 60"

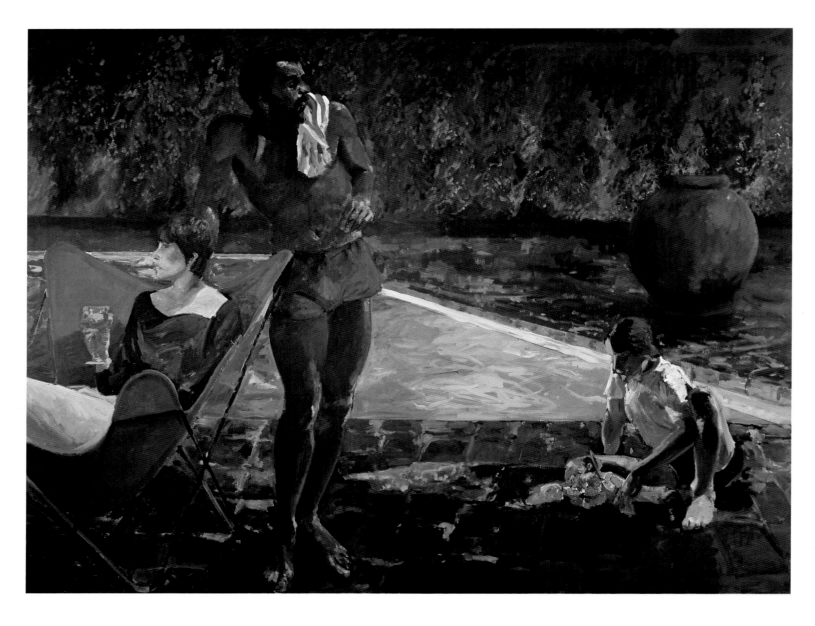

The Brat II, 1984
oil on canvas
84" x 108"

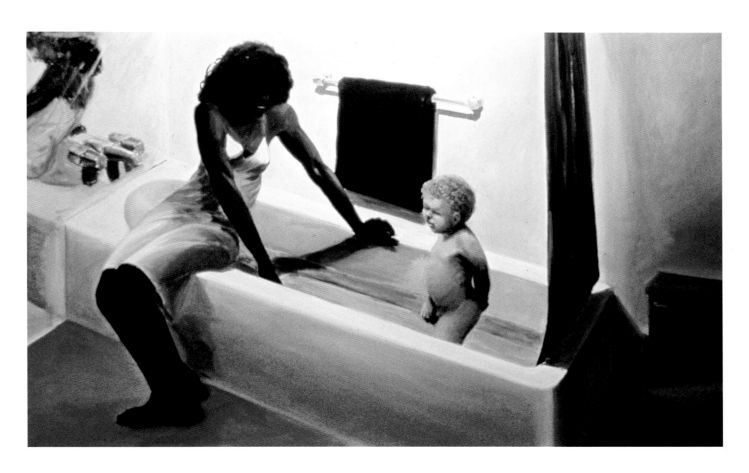

Help, 1980
oil on canvas
60" x 96"

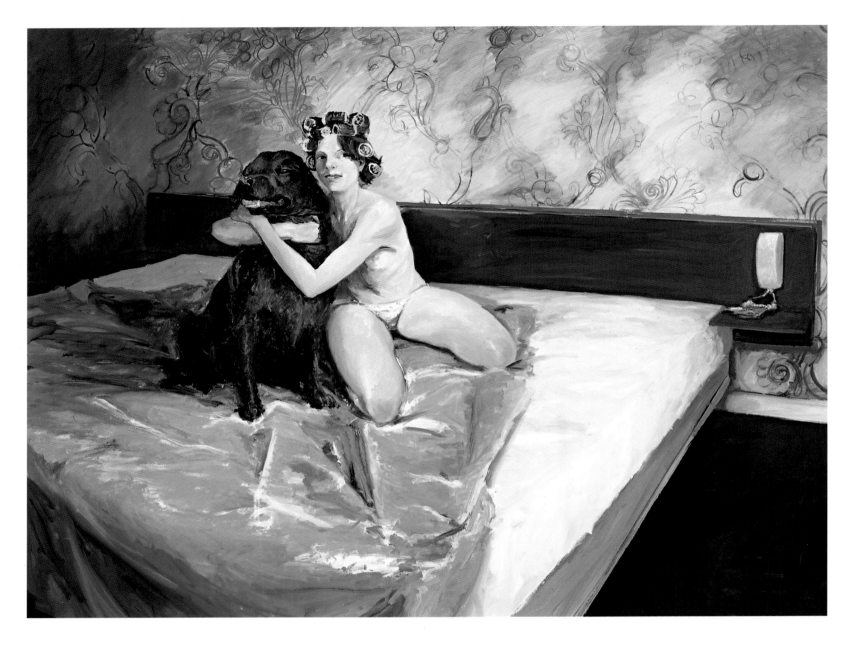

Master Bedroom, 1983
oil on canvas
84" x 108"

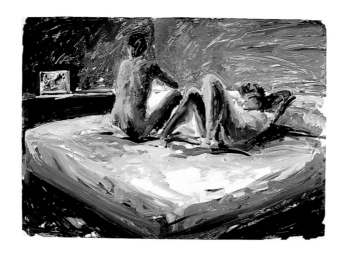

Study for Master Bedroom, 1983
oil on paper
35" x 46"

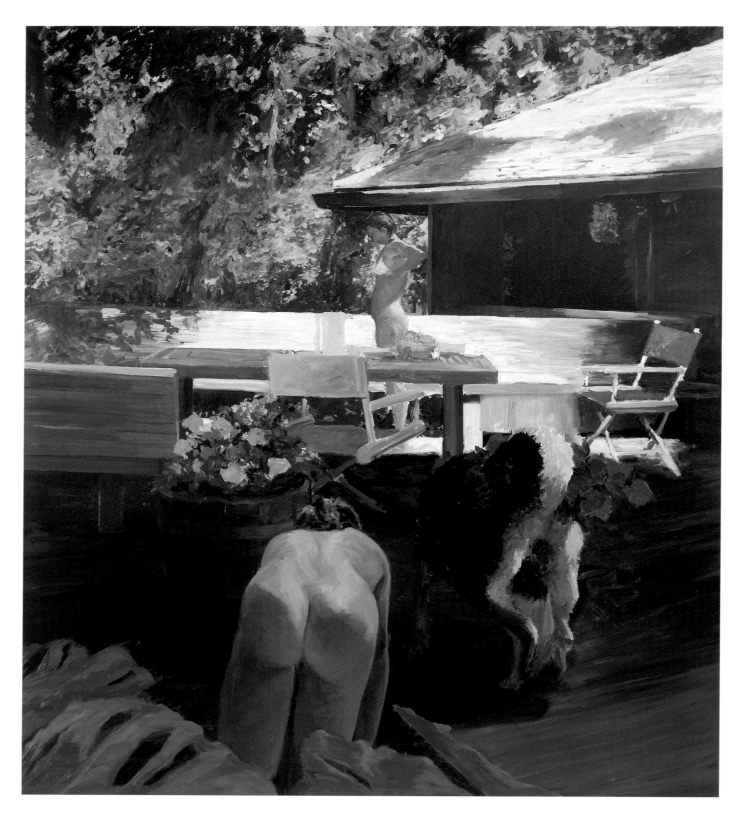

Imitating the Dog (Mother and Daughter II), 1984
oil on canvas
96" x 84"

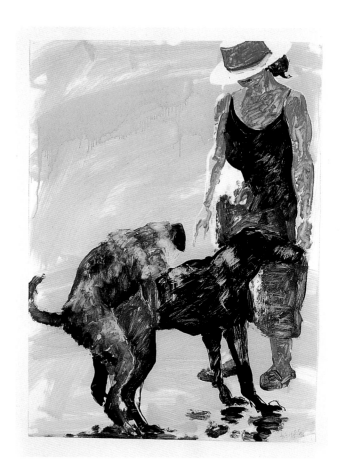

Untitled, 1993
oil on paper
39 ½" x 27 ½"

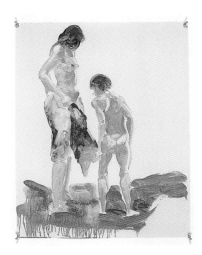

Untitled, 1996
oil on chromecoat
26" x 20"

On *Bad Boy*

I don't actually know how to think about *Bad Boy*. It was an extremely meaningful painting for me to paint, not only because of what it ultimately came to mean to my career, but also because of how I got to it. It taught me a lot about my own processing and creativity. The point was hard won. I was so lost in that picture that I actually had no idea what I was looking for or where I was going. As a creative expedition it was actually pretty funny. I started out just wanting to paint a bowl of fruit. I went from painting that bowl of fruit to constructing the room that the fruit could be in, to finding who might be in that room and what time of day it was. Who I first thought was in the room wasn't there. People came and went. The twelve-year-old boy stealing money from the purse started out as an infant lying next to the woman; then became a five-year-old sitting on the edge of the bed looking out the window.

He literally grew up in that room. I had no way of predicting what would happen. I just kept following it, working by intuition. I tried things that didn't work, things that seemed too forced. I just painted things in, and painted things out. You want process to be a part of your creative output all the time, but the reality is that the more familiar you get with your themes, the harder it is to be lost. I was working on a deeply intuitive level and it was incredibly satisfying to me that it came to a point of clarity.

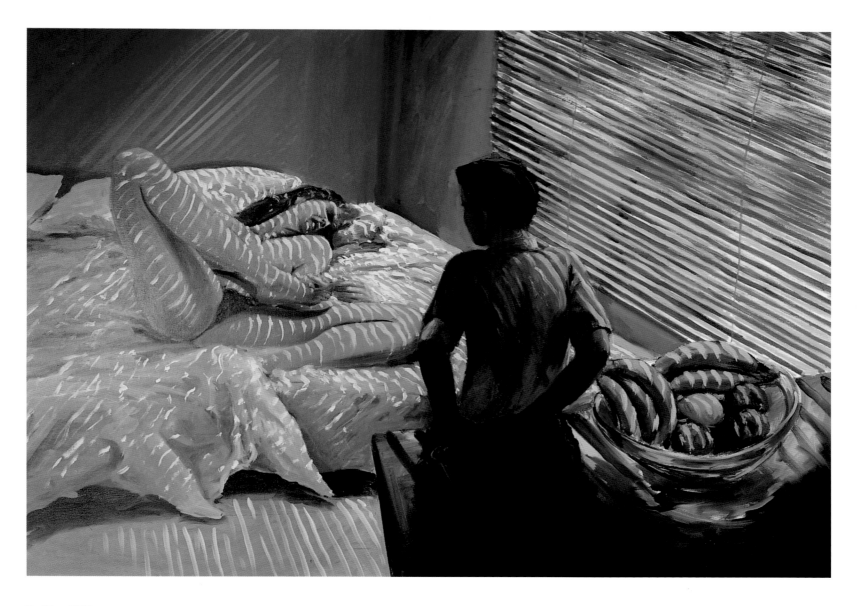

Bad Boy, 1981
oil on canvas
66" x 96"

On *Birthday Boy*

The problem I had with *Birthday Boy* was the voyeuristic position I was in while watching the scene. The woman and the boy on the bed remained fixed throughout, but what I couldn't figure out was where I was watching it from. What was I trying to put in front of me in order to mollify the situation or to heighten or to spin it? I remember at one point you were going to see the whole thing through a fish tank. It was just silly, but I guess I was thinking about the aqueous nature of sex and the underwater unconsciousness of the sexual dynamic between these two. I was also trying to create a barrier between me looking and the viewer witnessing. I think the thing that finally worked for me was the still life that exists on the side, which re-creates the whole symbolic dynamic. It's all about folds and penetration: there's a penetrating spoon in a glass of water that changes its shape because of the water. There are folded newspapers and vessels and things representing this sexualized moment.

The woman embodies a totally narcissistic self-absorption that doesn't take into account any ramifications of the effects she's having on the boy. It's similar to *Bad Boy*. *Bad Boy* and *Birthday Boy* are sister paintings. Even though they were done apart, they're really the same event. I don't usually work in series, but I've established themes that I keep revisiting. I just finished a painting that revisits that situation one more time, only now it's from an old man's point of view. But it presents a similar kind of dynamic.

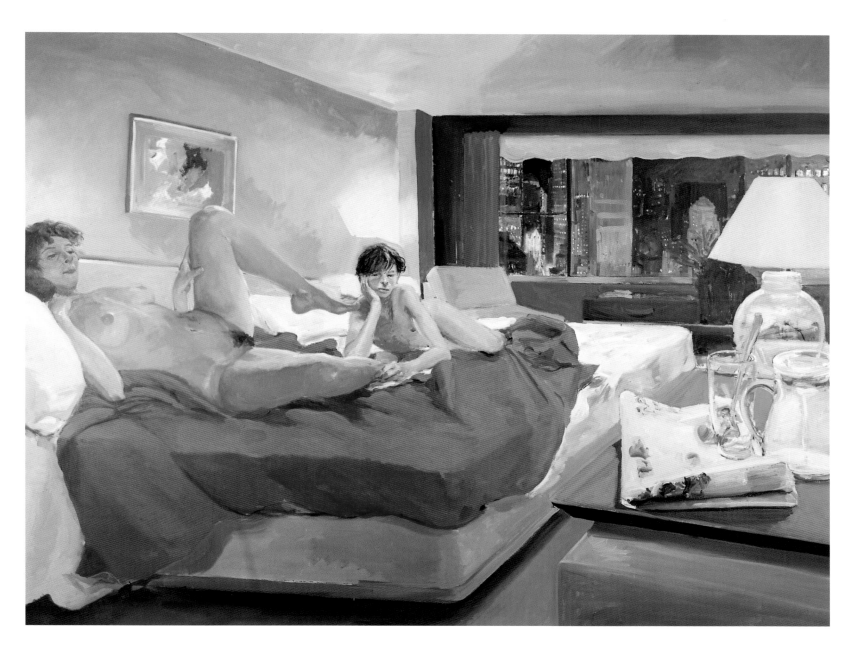

Birthday Boy, 1983
oil on canvas
84" x 108"

Untitled (study for Daddy's Girl), 1984
oil on paper
12" x 16"

On Daddy's Girl

When I was working on *Daddy's Girl* I couldn't find where I was in it. I just wasn't sure. What I was trying to do was set up a situation that brings into question one's preconceptions about the scene. The viewer's first instinct would be that the scene suggests a dangerous situation, but there would be nothing to indicate that it really was, other than that a child and a man were naked. But it was their nakedness and aloneness that seemed potentially transgressive. So I kept putting in and taking out things that I thought would determine that nothing was happening. I put in the mother lying on a chaise longue next to them; I put in a gardener who was watering plants. At one point I even put myself in, sitting at the table. Then I finally found the glass of iced tea, which sits between the viewer and the people in the scene. We're equidistant to that glass, which somehow mediates the scene. It's placed in a precarious position and it implies a delicate balance.

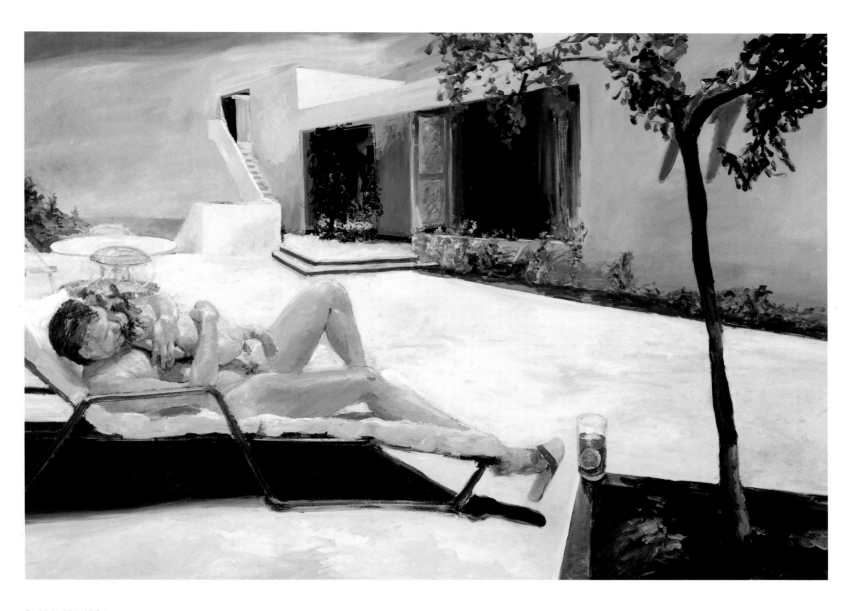

Daddy's Girl, 1984
oil on canvas
78" x 108"

Slumber Party, 1983
oil on canvas
84" x 108"

On Otherness and *Slumber Party*

I grew up in an environment where every house I went into had some object that was foreign. Something bought at the airport, a Japanese scroll, a little Chinese carved ivory knickknack, or a Caribbean doll. In some way it was meant to represent worldliness, but what it really highlighted was the smallness of their own reality set against this object they didn't really know anything about. Years later, when I was searching for a way to represent this, I remembered that everybody had these objects and nobody knew what the hell they meant. What I tried to do was to animate a moment in which the objects that people surrounded themselves with seemed to exert pressure on their lives and in some cases seem to be controlling it. I used a shamanistic object from Africa, like in *Slumber Party*. It's a situation where a boy is about to sleep in this black woman's room—you can assume she's the maid or the housekeeper. His sleeping bag is laid out on the floor, implying that they're not going to sleep together. Yet she's undressing, so the tension of sex is in the air. I imagine him seeking some kind of solace in her room rather than being where he's supposed to be, which

is either in his room or his parents' room. And though he's losing himself inside the TV, turning stations, above the television is this object that casts a shadow over the whole room and creates a magic that is more connected to her heritage than to his. Of course, the object itself is totally decontextualized, so in a way it's impotent. Maybe it requires the artificial light of a television to reanimate it. So the painting has a powerful sense of dislocation. That theme runs through several of my paintings, where something that may have had power in one context becomes silly or ineffectual when taken out of that context. In *Slumber Party* a spiderlike shadow emanates from this strange object. Because it's multiarmed, it also stands for the sexual body, which grows another limb. Is its power real or just theatrical? Those are legitimate questions raised by the picture.

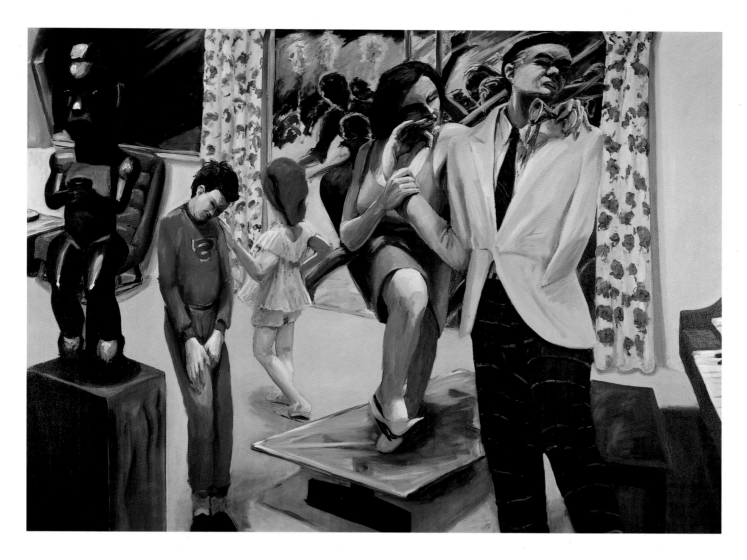

Time for Bed, 1980
oil on canvas
72" x 96"

Time for Bed

Time for Bed is a scene of pure chaos. It's set against the backdrop of some kind of suburban bacchanalian festival outside, and in the interior all hell's breaking loose. For me, the outside was ritualized but celebratory in some way, and the interior was this nightmarish scene of runaway destruction. The fact that the man has only one arm renders him wounded and castrated; the woman stands on a glass table, which makes her whole being precarious. Not only is she blasted but she's wearing high heels. And then there's the blood-red wine and this big tiki doll that seems to be overseeing the event. The daughter's hand touches her brother in a reassuring gesture. The son is dressed in his Superman pj's put on inside out so that the S is backwards. He winces and holds his crotch. He seems to be the only one who feels the full impact of this humiliating drama.

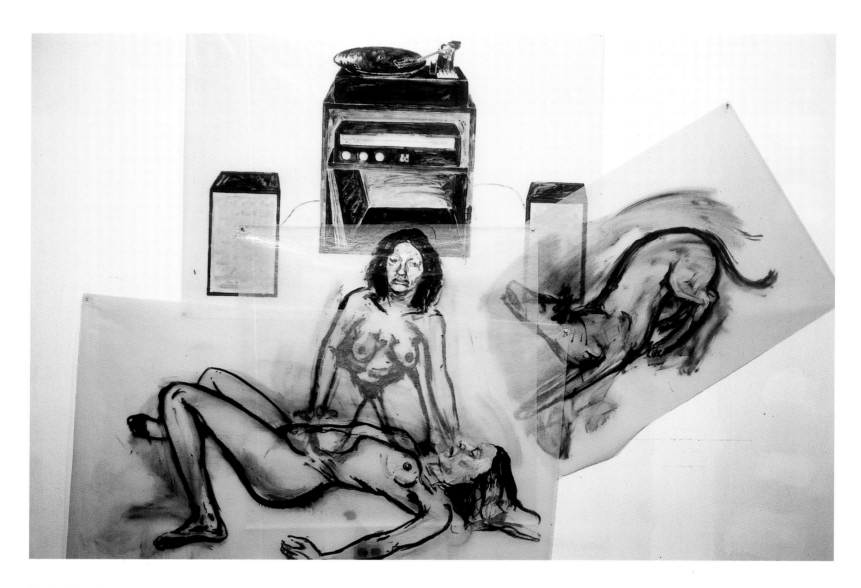

Dead Girl, 1979
oil on glassine
72" x 96"

Psychology

I don't think my work is so much about opening up wounds; I think it's about understanding the nature of the wound. I'm not bleeding on the canvas. I, like most people, have suffered traumatic events. The character of a person's life is determined by the way they deal with those events. I am a creative person and I deal with it creatively.

Grief, 1981
oil on canvas
60" x 65"

I paint to tell myself about myself. The image in *Father and Son* was very compelling to me, and I think the drawing I originally did wasn't monumental enough for the feeling I had about it, so I did this painting. Generally it's seen as a homoerotic image, but that's not my only reading. It's as much about progeny and sequencing—boy to man and father to son. It was inspired by a short story by Paul Bowles in which a homosexual son confronts his father when the father finds out that his son is gay. The father doesn't really know how to deal with him and goes for a long walk alone, after which he comes home to find his son lying in his bed, naked. The story ends that way. It's about them becoming physical realities to each other.

With the pillows I was trying to create a safe zone, something that would work both as a potential barrier between the two and also as a distraction from the intensity of the physical moment. I created it for myself as well as for the viewer.

Father and Son, 1980
oil on canvas
72" x 72"

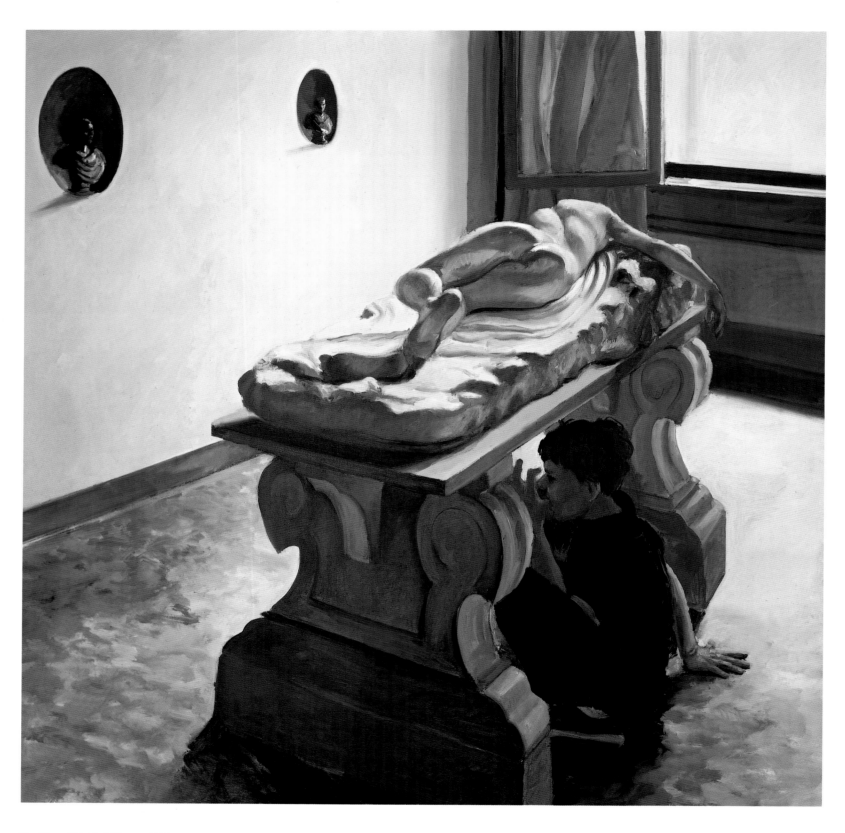

The Sheer Weight of History, 1982
oil on canvas
60" x 60"

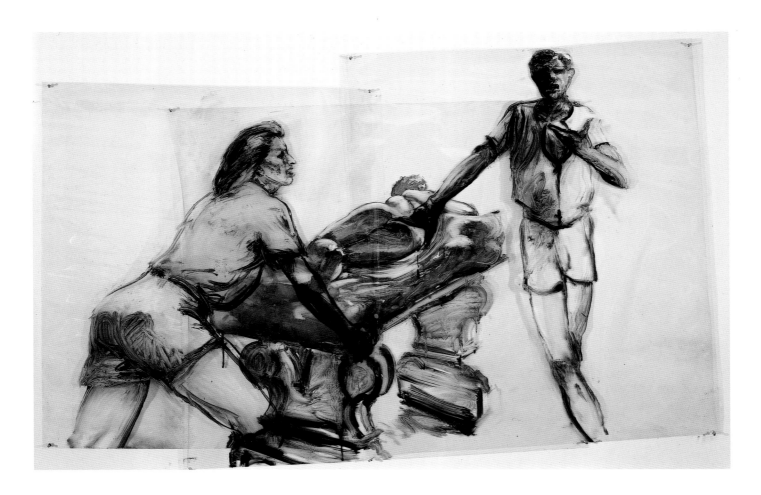

Study for Sheer Weight of History, 1982
oil on mylar, three pieces
48" x 75"

On the Sheer Weight of History

When I took the photograph of the Hermaphrodite in the Uffizi I had never seen the sculpture before and the room was closed off. I saw it from behind and thought it was a woman; it wasn't until a while later that somebody said that's the Hermaphrodite. That becomes rather interesting as well. Anyway, in the beginning it was about the tension of the body in a relationship between a man and a woman. That didn't work, so at one point I introduced a busload of school kids—I just filled the place up with kids and stuff. By the time everything was done there was one kid left and he was under the table. I think the whole painting is about exhaustion and this unending relationship. On the wall are these two scooped-out alcoves with busts of Roman senators in an eternal gaze onto the body of this hermaphrodite in repose. Then there's this boy underneath sucking his thumb, looking for a place to hide and also being a witness to this eternal relationship.

To me art isn't simply the weight of all the objects that have ever been made; it's also the weight of the content of art, which was always about the relationship of man to woman, man to God. It's about an eternal dialogue that manifests itself as art.

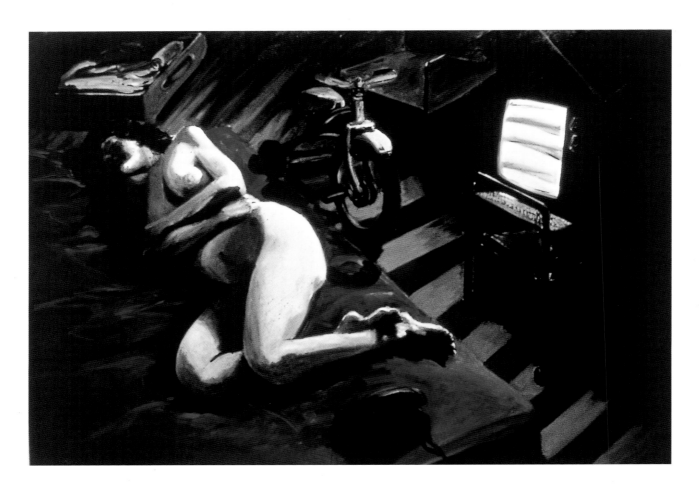

The Visitor, 1981
oil on canvas
68" x 96"

On Television

Television had been my main influence because that's what I looked at when I was growing up, and then less frequently film and, of course, magazines and photography. I prefer film to television. Film has a richness of light that television doesn't. It has a real, sensuous quality. And it's enveloping: you really disappear into the blackened theater. With television you're always aware of the books above the shelf. It's a more schizy kind of absorption.

I feel competitive with film and photography. They're such incredible visual inventions. In my paintings, I've used images of televisions, Walkmans, telephones, binoculars, et cetera, because they're all sense-extenders. And that's a quality of life that is unlike anything in the past. It's a conflict between the inner and the outer body, between the limitations of the physical world and the desire for the all-seeing, all-hearing, all-knowing that is part of our ego. Velázquez's *Las Meninas* con-

tains a revelation about painting being a reflection of a reflection carried by way of the self-reflective language of art and painting. What a mirror does in a painting is inform the viewer that there are other things in the room they can't see. What a television in a painting does is inform the viewer of realities that exist in that room but have nothing to do with what's in that room. It's more schizophrenic: you have something that has absolutely no bearing, other than distraction, on what is taking place. It heightens the complexity of our lives.

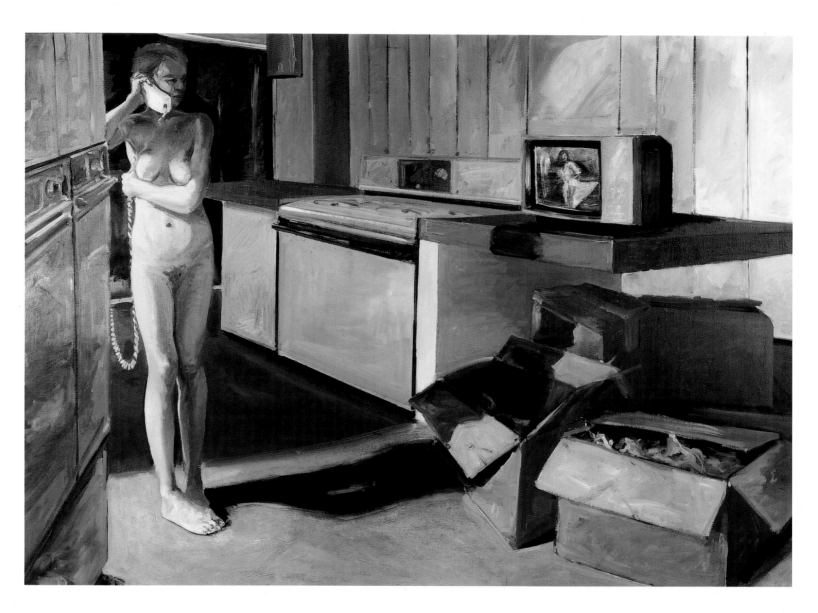

New House, 1982
oil on canvas
68" x 96"

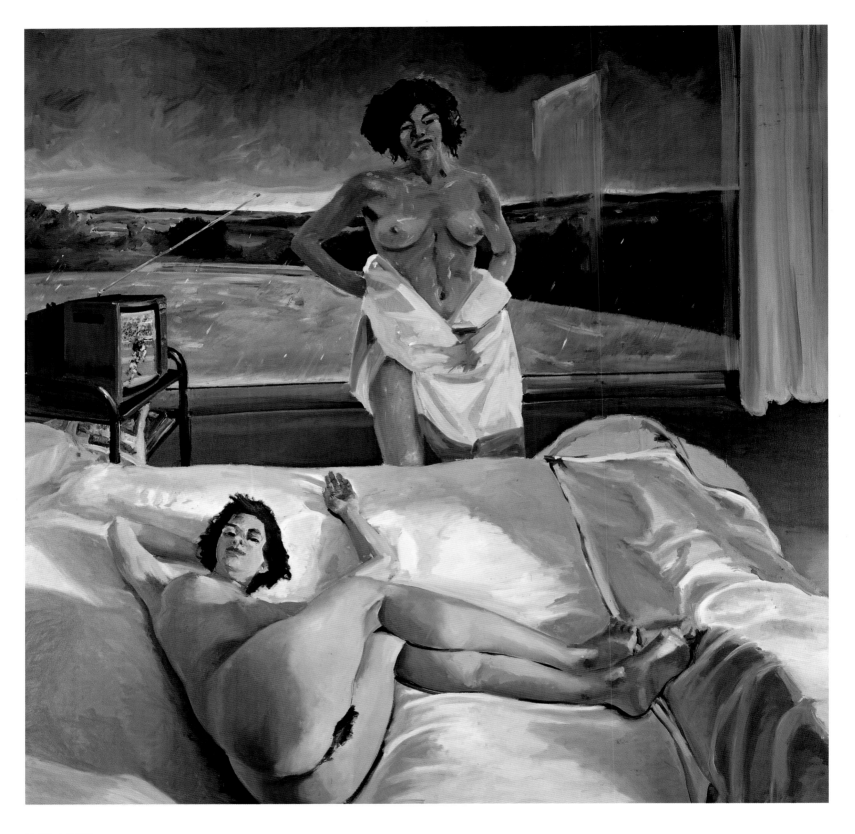

Untitled, 1982
oil on canvas
84" x 84"

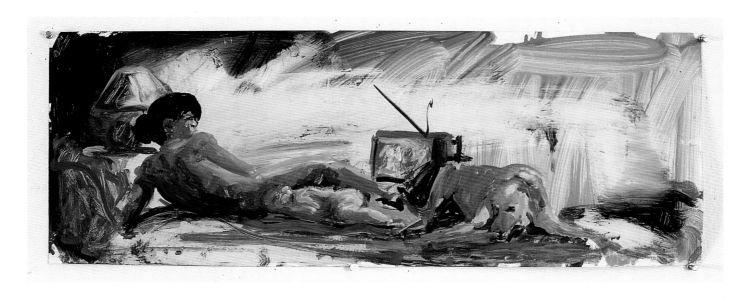

Floating Islands, 1985
oil on chromecoat paper
12" x 32"

On *Squirt*

The ambition of a painter is to name the world, to shape the worlds into images that become references and ways of understanding. *Squirt* is a painting of an eleven-year-old boy by a swimming pool. He's in flippers and goggles and mask and he's standing on the edge of the pool with a squirt gun, the contents of which he's unloading into the crotch of this woman who's lying on a chaise longue with her back to him and her legs spread apart. It's a very funny, Freudian moment. The thing is, it actually happened and I was just recording what took place. My nephew did precisely that to his mother while I was watching. I found myself thinking, "My god, I could paint this." What actually happened was that my nephew turned to me and said, "Uncle Eric, you could paint

this." In the midst of doing it he knew it was something worth acknowledging and remembering. That's when I realized how art works. Here's a kid who had seen my work, and in his young and innocent way had understood certain permissions that the work gave. Not for him to do that, but for him to acknowledge having the experience while he was having it. The social aspect of this is really profound. That's what art does: it gives you permission to have an experience and frame it in a way that makes it socially acceptable.

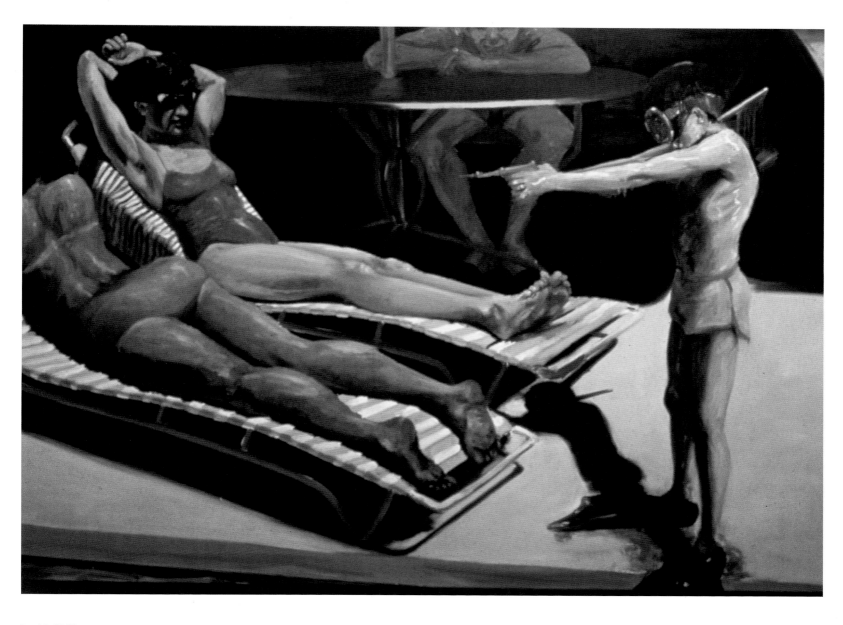

Squirt, 1982
oil on canvas
68" x 96"

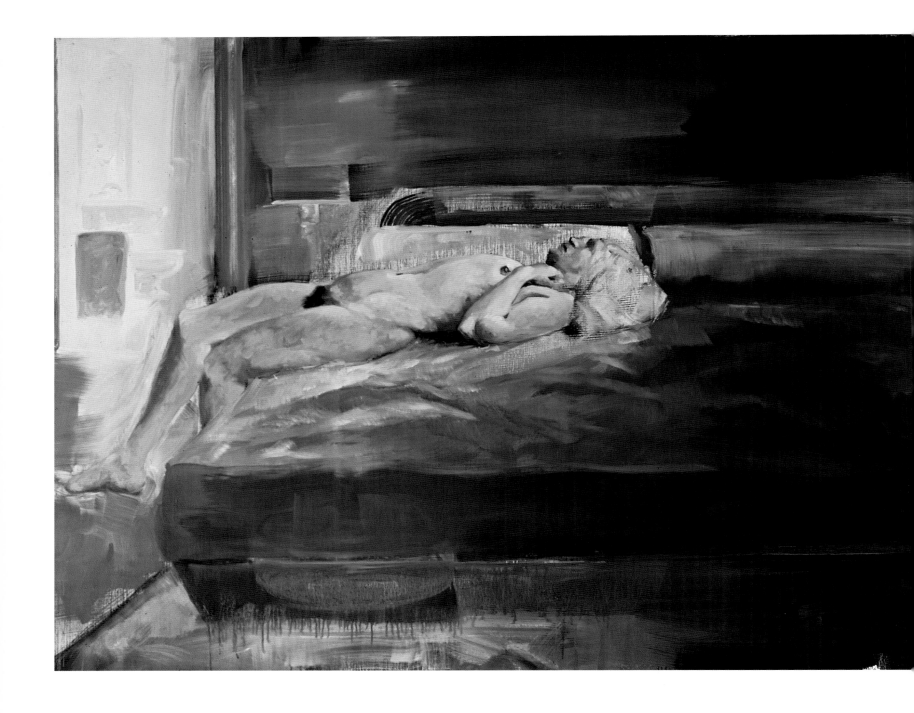

On Realism

Realism itself has no interest for me at all. I mean the physical world, simply recorded, has no interest for me. But the minute you try to make the physical world be a place in which you are present, then it's about being alive. It's about always being aware of yourself being there in the moment. It seems natural to want that.

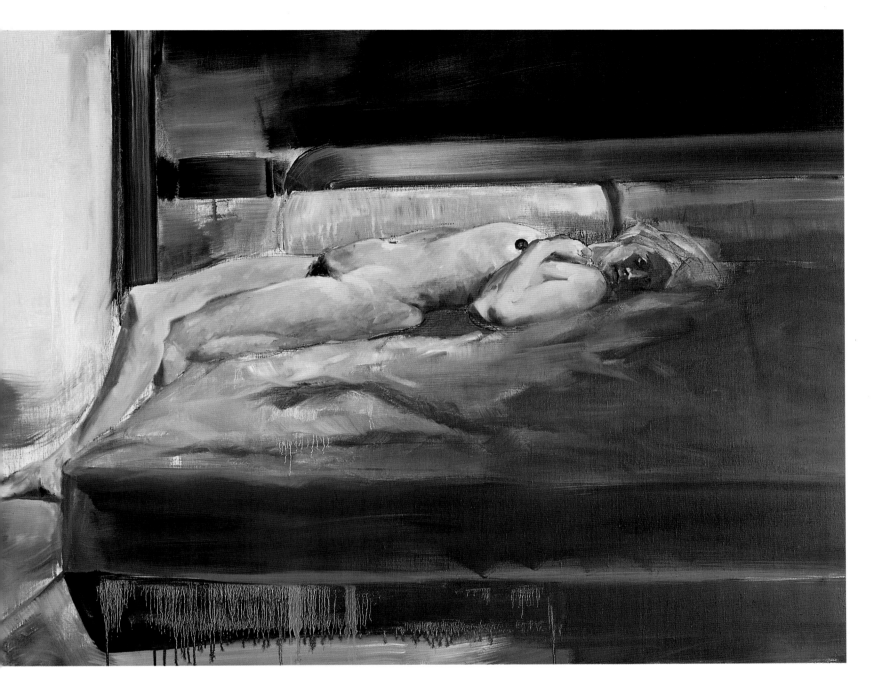

Untitled, 1987
oil on linen, two panels
45" x 120"

The Visit II, 1981
oil on canvas
68" x 84"

On the History of Modernism

Modernism has always allowed painters from the realist tradition to be part of each movement. I just happened to be that painter who was attached to neo-expressionism. Balthus was included with the surrealists, David Hockney with the pop artists, Philip Pearlstein with the minimalist painters, or Fairfield Porter with the abstract expressionists. There's always one realist because they address the issues in their work, but they're still connected to this other tradition. They justify the avant-gardists' program because they become the dialectic. Although I hadn't named myself early on, it was very important to be shown and associated with David Salle and Julian Schnabel, Barbara Kruger and Cindy Sherman, the artists who were my peers. The way the history of modernism writes itself is always with two main guys; it's Picasso and Matisse, it's Max Ernst and Marcel Duchamp, it's Pollock and De Kooning, Rauschenberg and Johns. It's always two guys and then this other element that animates the whole moment. It makes the dialectic more interesting to have a third voice.

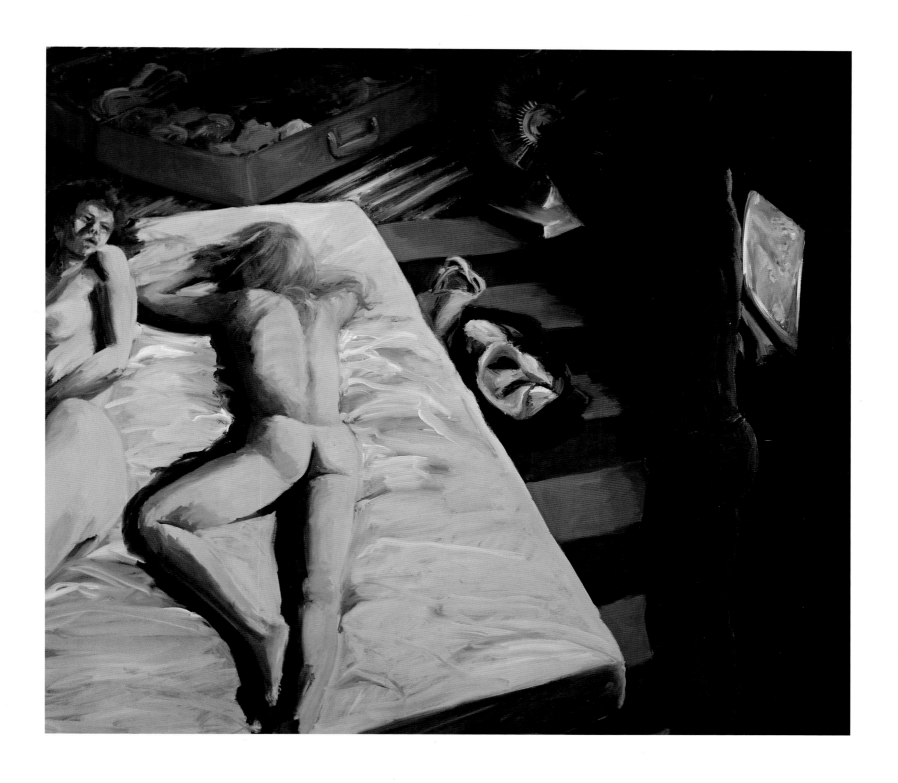

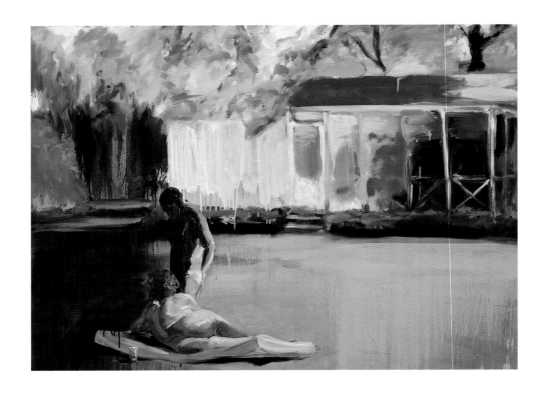

Growing Up in the Company of Women #3, 1987
oil on linen
35" x 48"

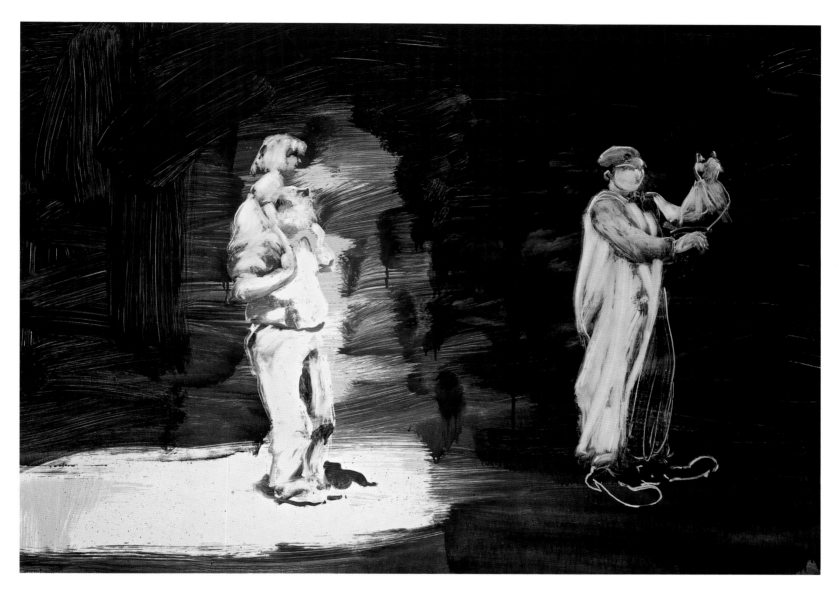

Untitled, 1997
oil on chromecoat
27 ½" x 39 ¼"

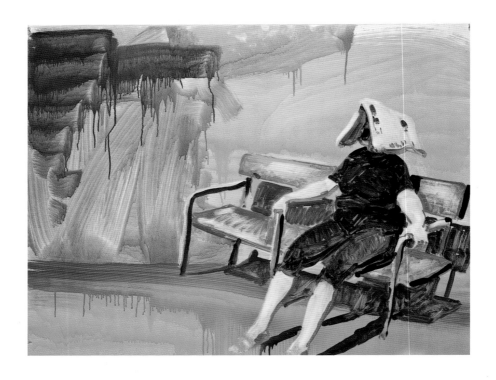

Untitled, 1997
oil on chromecoat
27 ½" x 39 ¼"

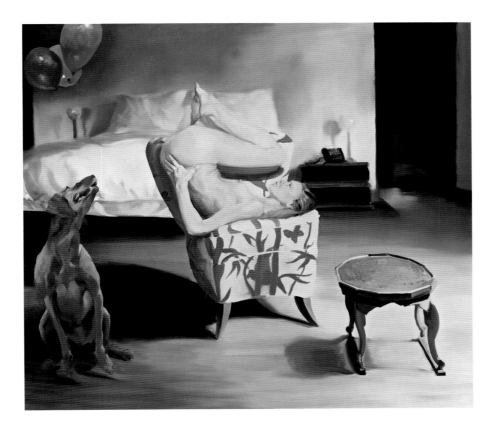

The Bed, The Chair, Waiting, 2000
oil on linen
72" x 80"

Bonnard

Bonnard's photographs were a revelation for me. It was seeing his figures in black and white, stripped of his impressionist color, that made me understand the emotional and psychological character of his work. I had always thought of him as a postimpressionist painter, working with the comfortable aspects of bourgeois daily life. The photographs showed me how his eye actually picked up the awkward moments expressed through the body, which I strongly related to. And made me reassess his work in terms of my own.

A photograph is a witnessed moment, and great photographers have incredible skill in recognizing that moment. A painting arrives at that frozen moment through accumulation. It's not something that is taken out of the world; it's something that is actually put into the world. The viewer not only experiences the poignancy of that frozen moment, but also participates in its reenactment. We're given all the decisions that go into it: what was included, what was excluded, what was distorted, what was refined—building a different bond between the artist and the viewer. We feel the reality of a photograph because it slices a moment. It leaves us apart from the reality, and we become witnesses rather than participants.

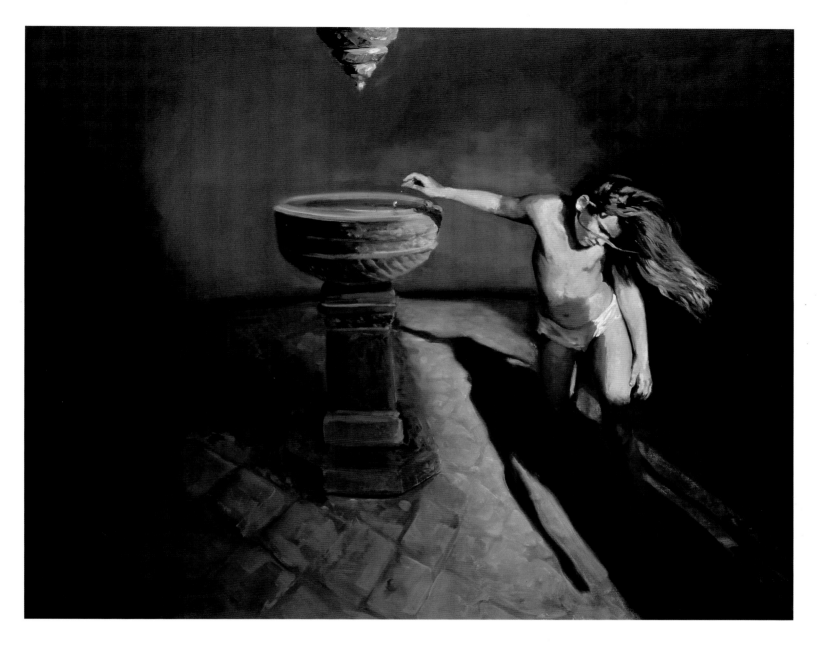

Communion, 1997
oil on linen
55" x 68"

On Painting Figures

Winslow Homer is a great painter in the lexicon of American realism, but I've never been especially compelled by him. Although I did borrow water from him in *The Old Man's Boat and the Old Man's Dog*. Eakins is much more psychologically complicated. Eakins's photography has been a real source for me. I feel I share something with the way that his figures feel natural rather than posed. If he does pose them, they're posed in an unexpected, nonclassical way, so they become psychologically charged, so much so that I can take them out of his photographs, put them in my work, and their potency remains intact. The emotional distance in his work seems very American to me. I like the way he absents himself. His portraits are of people who are important but they're not heroically portrayed. There's something real about them; they're beautifully painted but they're not beautiful people. He doesn't involve himself in that kind of thing.

I've found there's a difference between a painting of one person, two people, or a painting of three or more people. Each one puts the viewer in a very different relationship to the scene, to meaning, and to self. A painting of just one person really is a one-to-one relationship. You have to ask how that person is establishing a relationship with you: Is he confronting you or turning away, is he luring you? When you have two people the viewer can be involved as a third participant, but oftentimes it's an interaction between the two, in which the viewer becomes a voyeur. You're witnessing their intimacy. Three or more people becomes a social dynamic. It can be social within a family framework or literally social in which the viewer takes a more removed position, like watching people on the street; you're just one of the many.

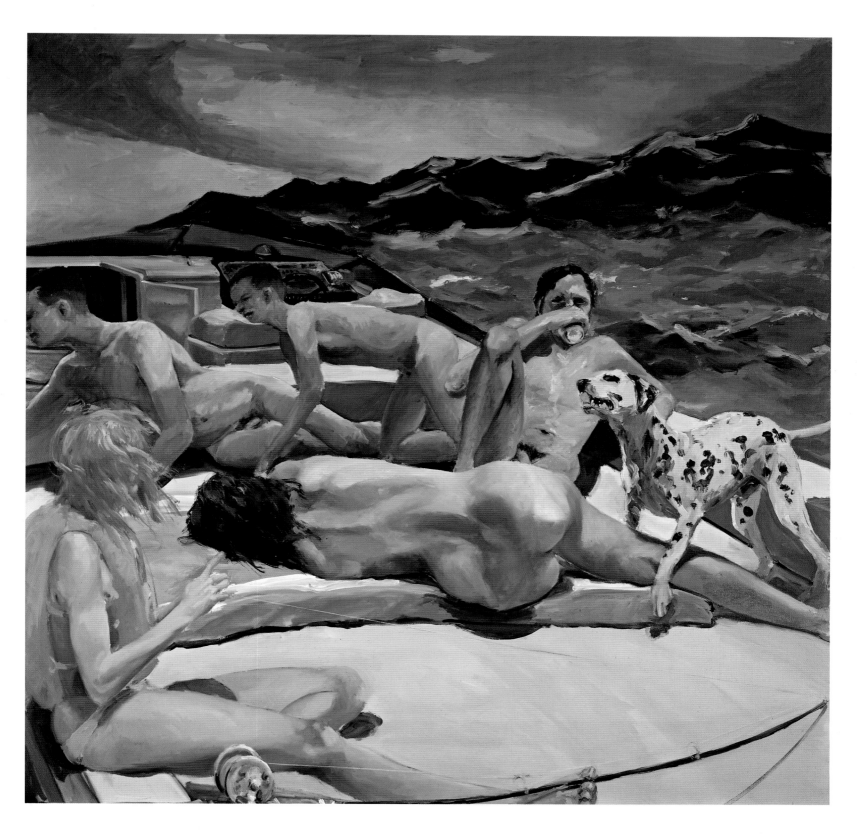

The Old Man's Boat and the Old Man's Dog, 1982
oil on canvas
84" x 84"

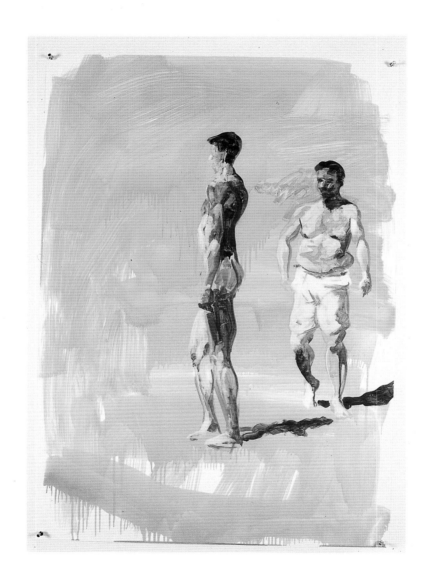

Untitled, 1988
oil on chromecoat paper
39 ¼" x 27 ½"

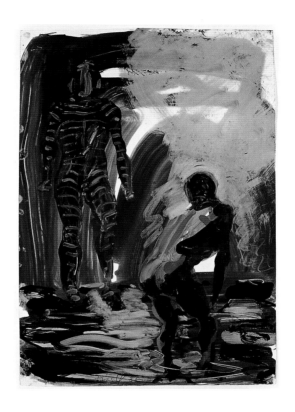

Untitled, 1984
oil on paper
20 ¼" x 15 ¼"

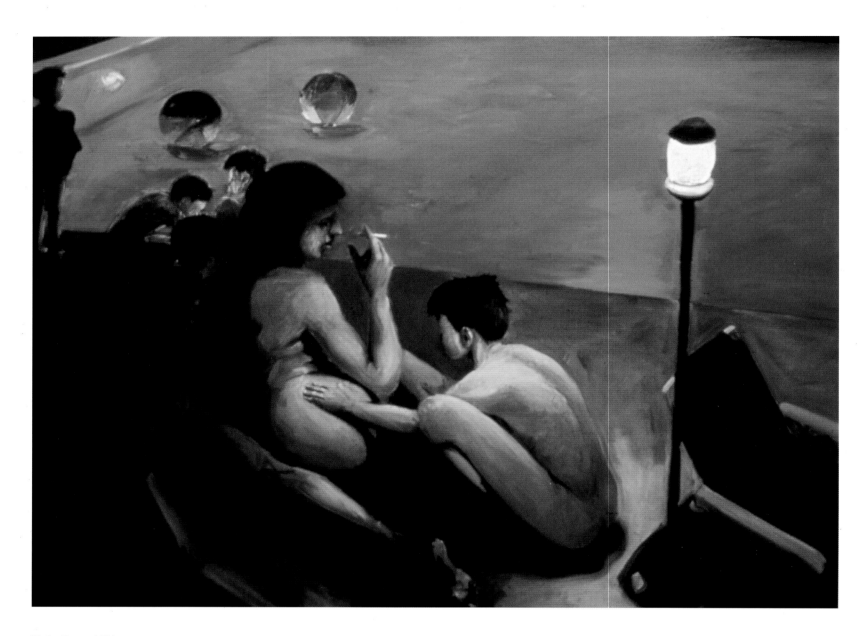

Birth of Love, 1981
oil on canvas
72" x 96"

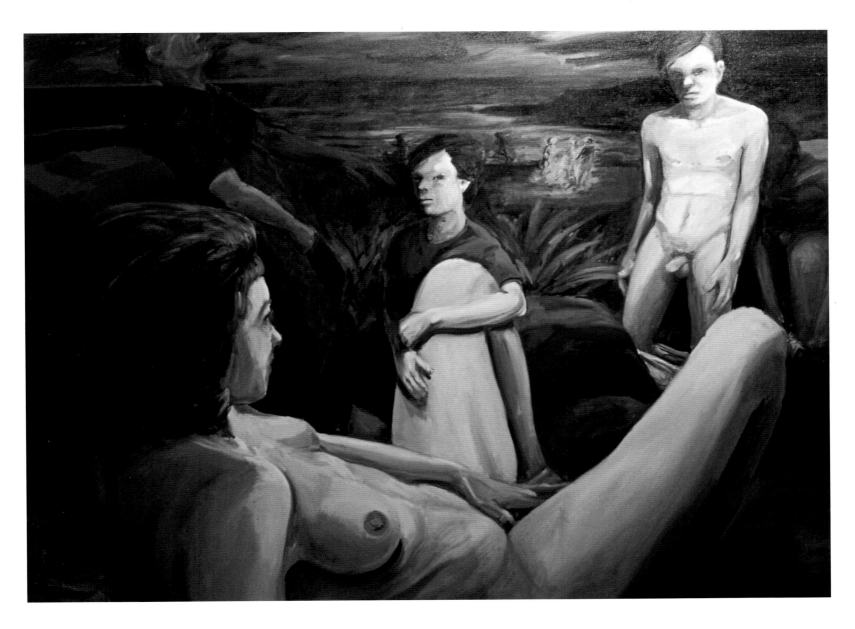

First Sex, 1981
oil on canvas
68" x 96"

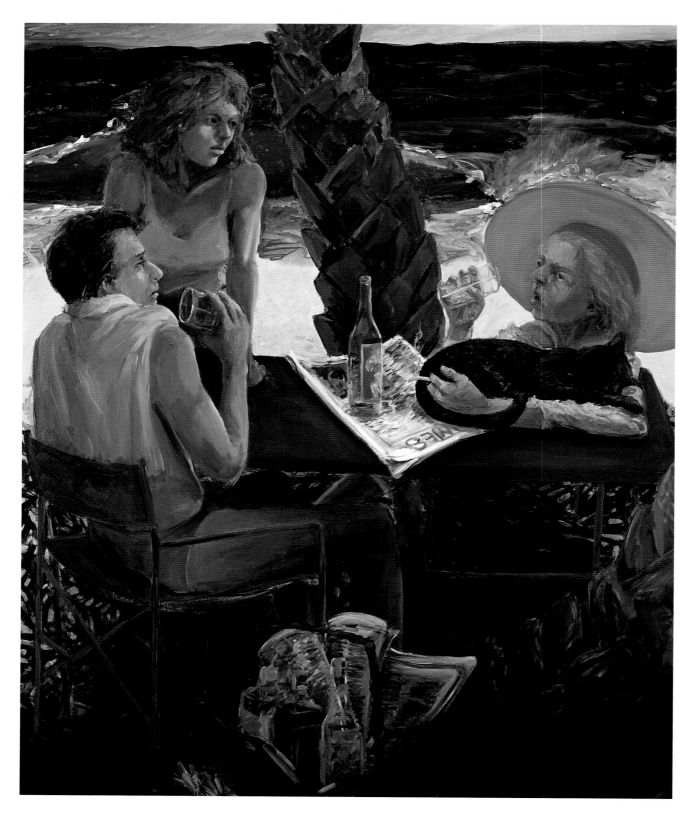

The Visit I, 1981
oil on canvas
84" x 60"

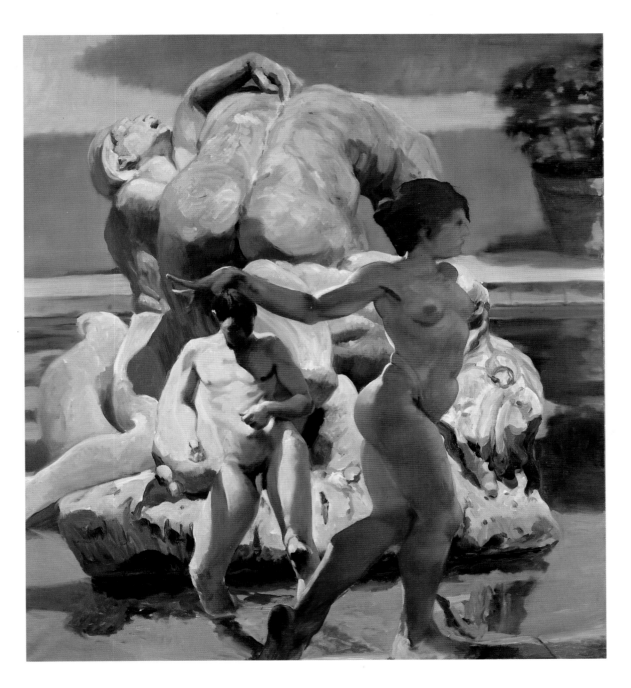

Scene from Around a Reflecting Pool, 1993
oil on linen
58" x 64 ½"

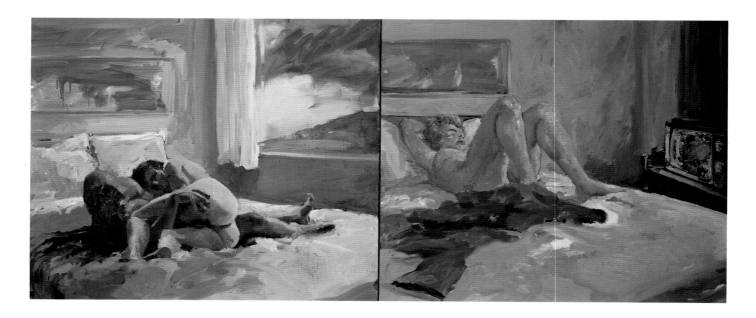

Motel, 1984
oil on canvas, two panels
46" x 84"

On Hopper

A couple of years ago my Boston dealer, Mario Diacono, came to me with the idea of entering into a dialogue with Edward Hopper, specifically using two paintings; one is called *Summer in the City* (1949) and the other is *Excursion into Philosophy* (1959). They're companion pieces. The first one shows a woman in a red dress sitting on the edge of a bed with a naked man sleeping behind her. Broad daylight is streaming into the room. The second reverses the situation: it shows a clothed man sitting on the edge of the bed with a book open next to him and behind him a sleeping woman naked from the waist down. Mario thought it would be interesting if I made a painting that commented on them. Out of a two-year-long gestation period came my painting called *The Philosopher's Chair*, which shows a bedroom in which a woman on the left side is partially obscured by light and shadow. She is either taking off or putting on her clothes—fastening or unfastening her bra. On the right side of the painting is an older man, ostensibly the philosopher, who looks like an academic of some kind. He is fully clothed except that his zipper is open. He's not so much staring at her as at an empty chair that occupies the middle of the painting, a sort of French 1940s slipper chair. The painting speaks to an inability to connect, to find satisfaction in relationships, or to realize sexual desire.

My first reaction to Hopper is that he's like an imperfect father. He's somebody whom I've both always admired and found tremendous fault with; he's also somebody who has cut out a territory that I can't get around. I have to move through it. He expresses something about the American sensibility so profoundly. It has to do with his reductive painting technique, the directness of it, and certainly with his ability to make a profound narrative seem like just a snapshot from daily life, to make ordinary things seem extraordinary while appearing ordinary.

The thing is he's an awkward painter. He's a great and compelling artist, but he's terrible at rendering the figure. His figures are overworked and turgid. They so reveal his puritanical anxiety about flesh that it's as if he's not in control of his medium. His hang-ups spill out in a way that I don't even think he's aware of or can't finesse. For example, *A Woman in the Sun*, that wonderful painting of a woman standing naked looking out a window—she's parallel to us in this plank of yellow light and Hopper just can't resist his need to see both her nipples. So he actually extends her left breast, even though that's not the way the body would be.

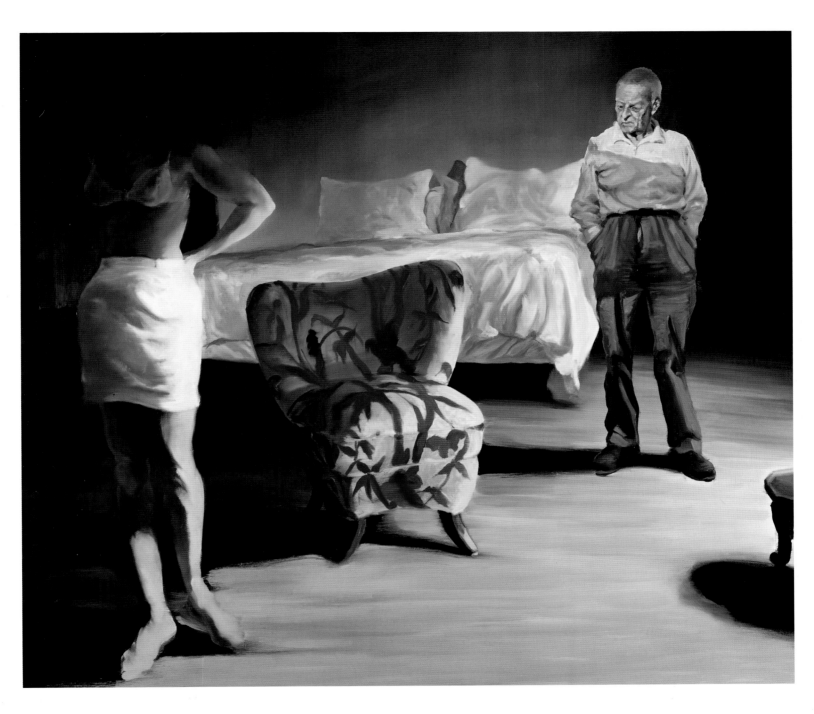

The Philosopher's Chair, 1999
oil on linen
75" x 86"

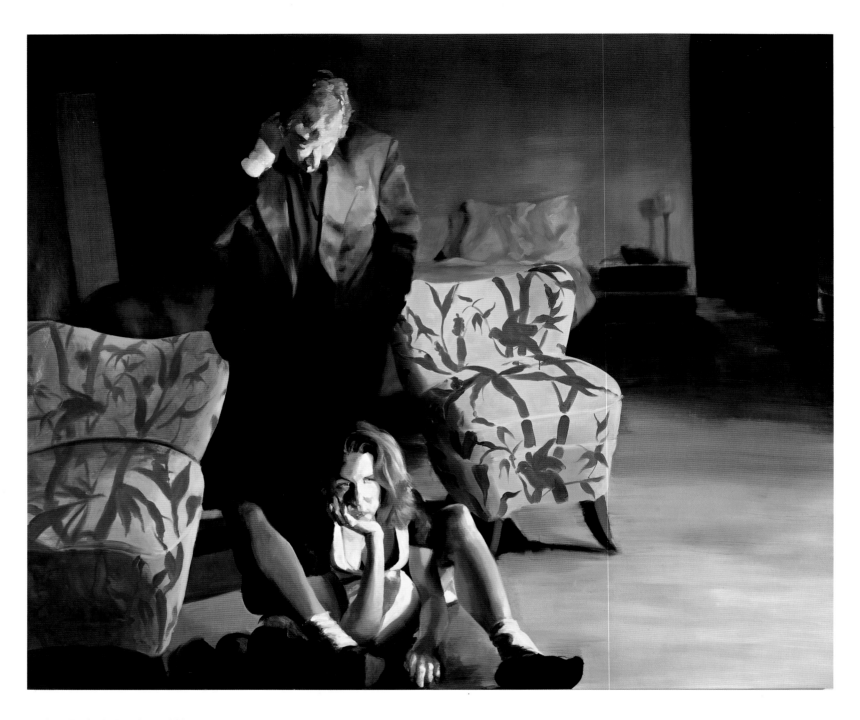

The Bed, The Chair, The Sitter, 1999
oil on linen
78" x 93"

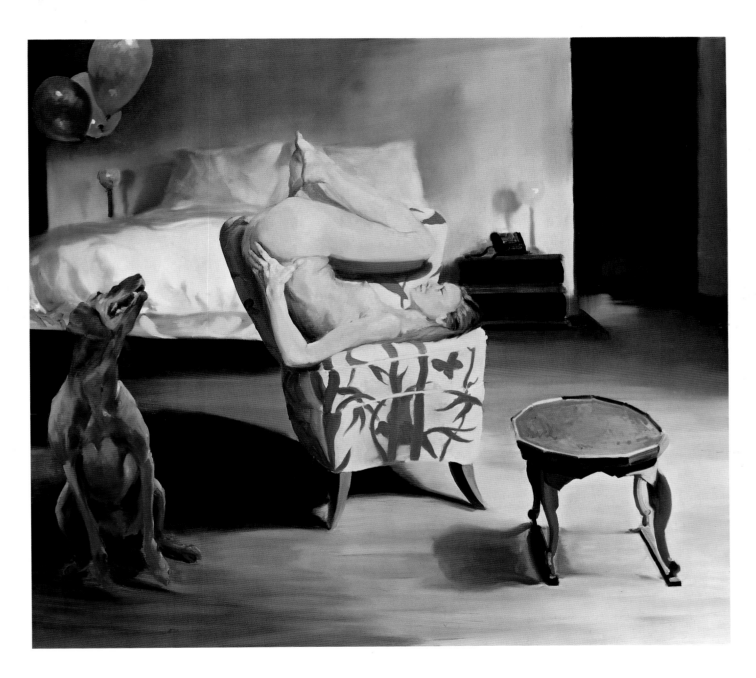

The Bed, The Chair, Waiting, 2000
oil on linen
72" x 80"

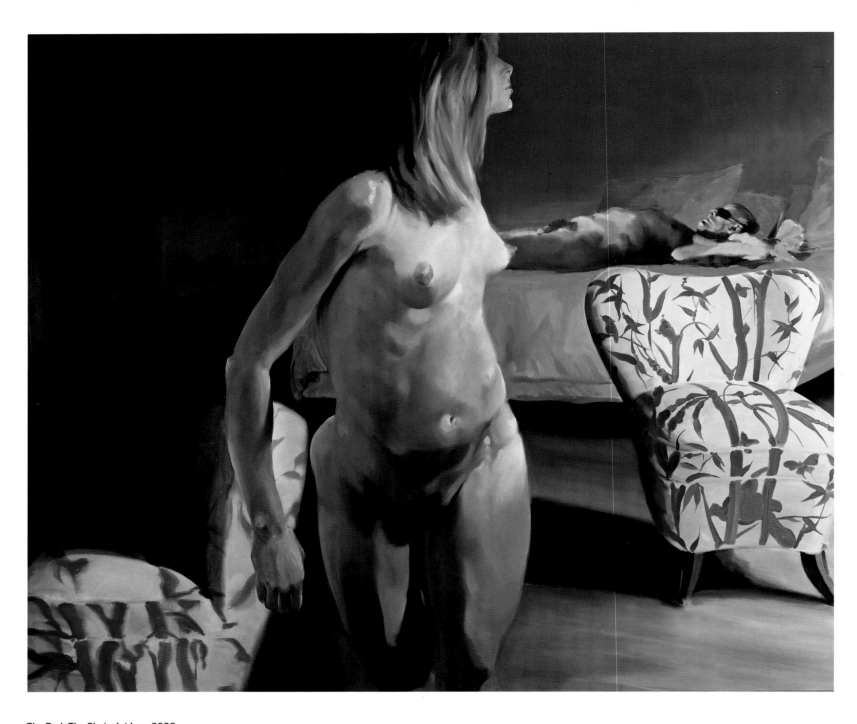

The Bed, The Chair, Jet Lag, 2000
oil on linen
85" x 105 ⅝"

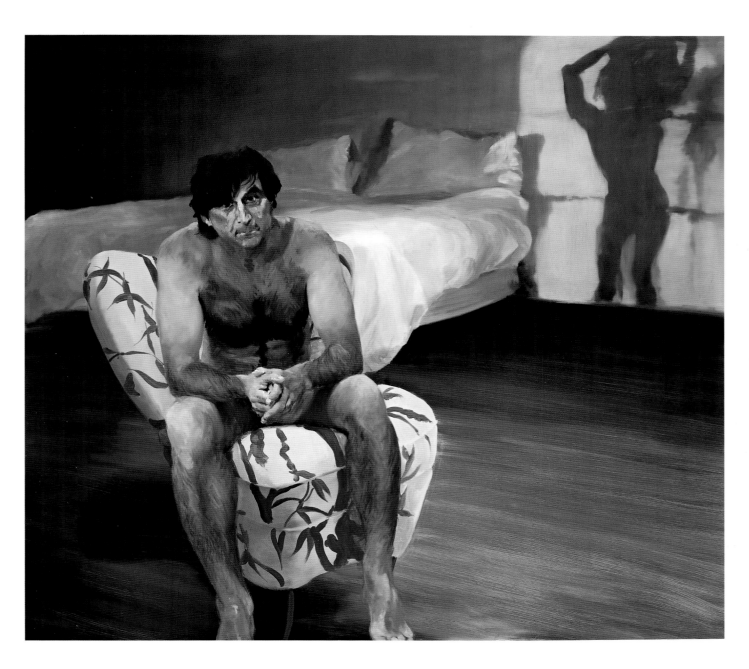

The Bed, The Chair, Dancing, Watching, 2000
oil on linen
69" x 78"

On the Erotic and Sexual

The erotic is an unencumbered expression of desire, and the sexual is connected to identity. It's a manifestation of a more complicated character. I was watching a program on the sex channel called "Sex Bites" and they were interviewing people who were into S&M—bondage and burning and blood and lust—and they all talked about intimacy and trust. They talked about it in a very moving, philosophical way. The expression of sex is used as a way of understanding self. I thought their insight was absolutely legitimate. It's interesting too, because it's taking place in an arena that is seen as culturally perverse, as some kind of aberration. At the same time, in its extreme way it highlights the basis of healthy relationships.

David Salle jokes with me about how he's always accused of being pornographic and he thinks I'm far more pornographic than he is. What's always impressed me about David's use of the female is that he never seemed afraid to piss women off. It seemed like a very honest approach. He wasn't afraid of the anger directed at him for the way he expressed himself in relation to women. Partly it was because he was angry enough to handle their anger. I've been persuaded by the feminist argument and have tried to see things from that point of view. I was also afraid of their anger and thought it justified.

In a large amount of my work there has been a sense of vulnerability. In some cases there's a hyperawareness of that vulnerability in the woman and that changes the nature of the relationship with the male viewer because he becomes self-conscious. There is a sensitivity there even though the poses are not ingratiating or flattering. The aspect of privacy has always been a big question in my work. It goes back to the atmosphere that existed in my family between public and private realities. When you're dealing with an alcoholic, particu-larly a narcissistic one, you're dealing with someone for whom boundaries are totally eradicated. It gets pretty complicated, especially as you move into puberty. I know I was using anger as a justification and as a shield for going back into a lot of that stuff. At the same time, I was fictionalizing it in a historical tradition. I tried to put myself into the roles of all the characters. I would sometimes make the protagonist female instead of male. I was trying to imagine my way into situations, trying to reframe them, and I was also coming up with understandings of things where I had started out angry and ended up by being sympathetic or loving. Sometimes I wish I could have been as good a painter back then as I am now. Earlier on I was a clumsy painter who was really hot on content. Had I been able to bring the facility that I have to painting now, would I have made greater paintings? I can't answer that. As to what the difference is: there's just no way you can pretend that you know as little as you did then, when you've been exploring the same material for twenty years. I think the work grows ever more subtle. There are times now when I make situations in which there doesn't seem to be anything going on, but I'm completely riveted. I just can't quite figure out why I'm held there. I think it's that the subtle tendrils of life are more intriguing in a less obvious way.

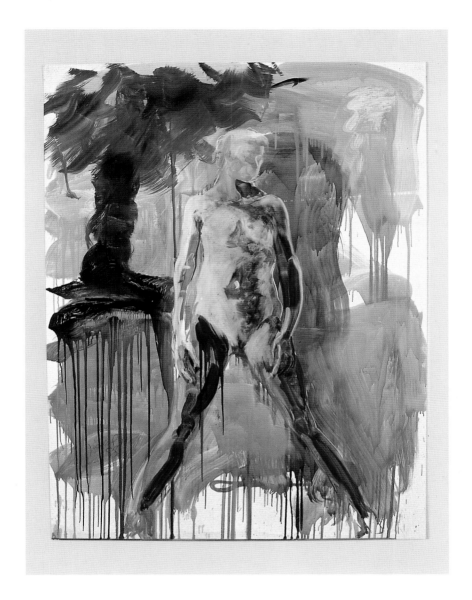

Untitled, 1987
oil on chromecoat
46" x 35 ⅛"

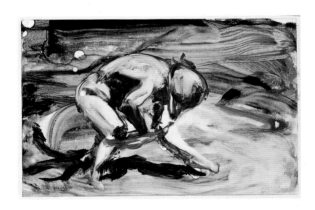

Untitled, 1985
monotype
10" x 15"

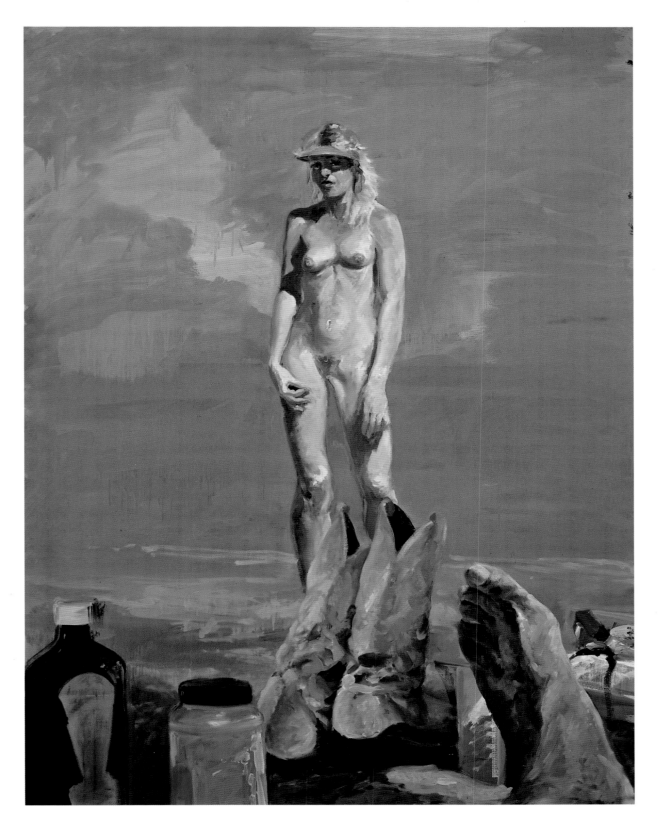

Untitled, 1987
oil on linen
60" x 45"

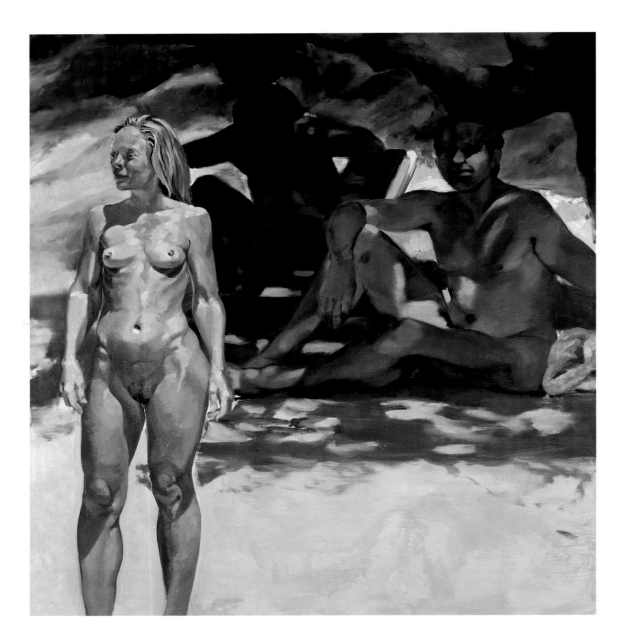

Untitled, 1992
oil on linen
58 ¼" x 54 ¼"

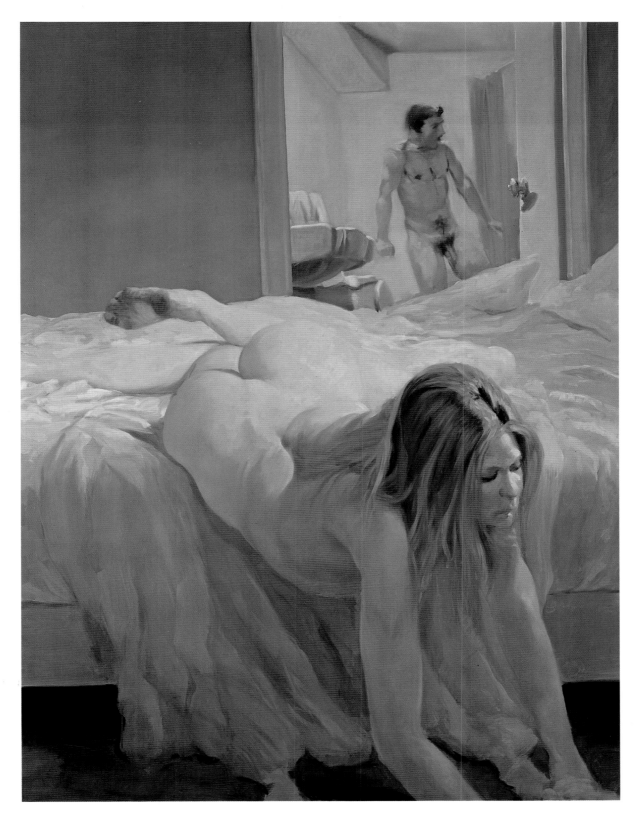

Untitled, 1995
oil on linen
72" x 54"

Untitled, 1992
oil on chromecoat
27 ¼" x 35 ⅛"

On Beauty and David Salle

I used to think that the ability to make a beautiful painting would carry a fair distance, but I actually don't think it does. Let me put it this way: early on I always put content before the beauty of painting, but I wanted the paintings to have a seductive quality that kept you there. The balance was always a question, and I invariably erred on the side of content. I thought the pleasure aspect of painting was overwhelmingly seductive and that ultimately it weakened the work. At the same time, the ability to paint a difficult moment in a beautiful way is probably a painter's highest accomplishment.

The thing about modernism was that it separated form and content. And certainly late modernism has degraded that even more, so that our struggle as artists had been to figure out exactly the relationship between them. It's interesting that the question is coming back at a time when people are more aware of their bodies. Culturally there's been a shift toward a reclamation of the body itself, because the body is where form and content started and where the shifts are—like the split between the mind and the body. But within painting they became these two very separate things, and my generation was always aware that the dialogue focused on a search for content. The argument among ourselves was whether there was a content that could be expressed by a medium as dead as painting. Or whether the content was just expressing the deadness of the painting itself. Could you make a sincere gesture expressed through painting, or did it have to be ironic or cynical? David Salle was so poignant in the way that he fractured the world and didn't make any attempt to make it holistic. Stylistically he took something from here and something from there and put it all together in a heterogeneous way without trying to make it look like it should sit in the same plane or be in the same moment. Nor should it have specific content; that is to say, you could create out of it any meaning that he would acknowledge, because he denied all specific meaning for it. I took a different position; I tried to take all those disparate things and put them into a homogenous, unified, and holistic reality. Old things said in a new way versus new things said in an old way.

The Empress of Sorrow, 1992
oil on linen
98" x 90"

Northern Girl, 1987
oil on linen
60" x 80"

Painting the Body

When I look at Lucien Freud's painting I have profoundly mixed feelings. They're scatological, so morbid, and so rivetingly detailed that I am seduced by them. I have this perverse feeling of being both drawn in and totally pushed back, but in such a grounded way that I can't deny my fascination, or their inherent rightness. It's tough stuff. He equates the material of paint with fecal matter, which just reinforces the yuckiness.

I look at Alice Neel's paintings and wonder how she talked people into sitting for her. But then you're so happy they did because they're such fabulous, interesting paintings. And the world isn't just about being vain. I think it's that people perceive the artist as capable of truth. I think we all want to participate in truth and we want to be seen as an example of truth. Maybe it's just that they want to be seen. I think that's the other thing: people really want to be seen.

Ralph Gibson is one of those artists who celebrates the erotic side of life in a way that is awe-inspiring. His gaze is incredibly intimate and yet formal, the way he works with the small negative spaces of the body in his close-ups to create incredible abstract shapes. It's really so sexy, a loving eye looking at the form of a woman and finding her every crevice, corner, crack, shadow, and volume to be a source of great delight. I am profoundly inspired by him and by his celebration of sexuality.

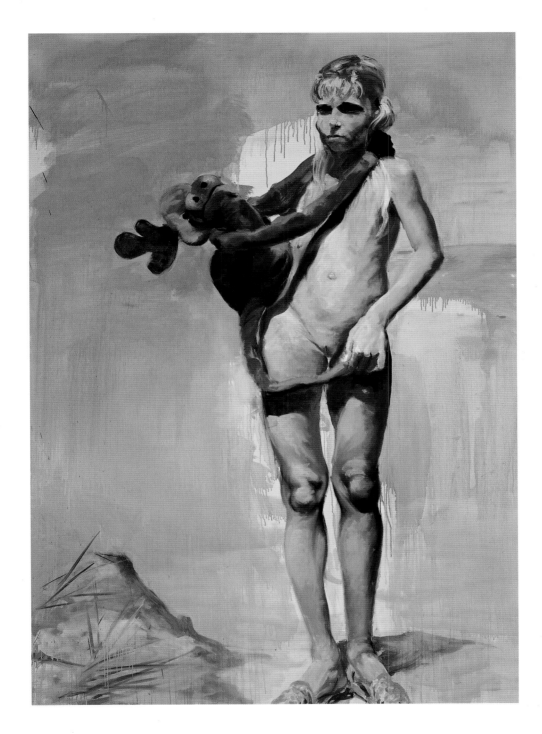

Girl with Doll, 1987
oil on linen
70" x 50"

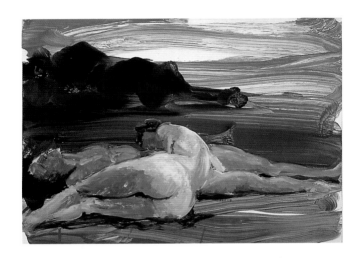

Untitled, 1984
oil on paper
20" x 23 ½"

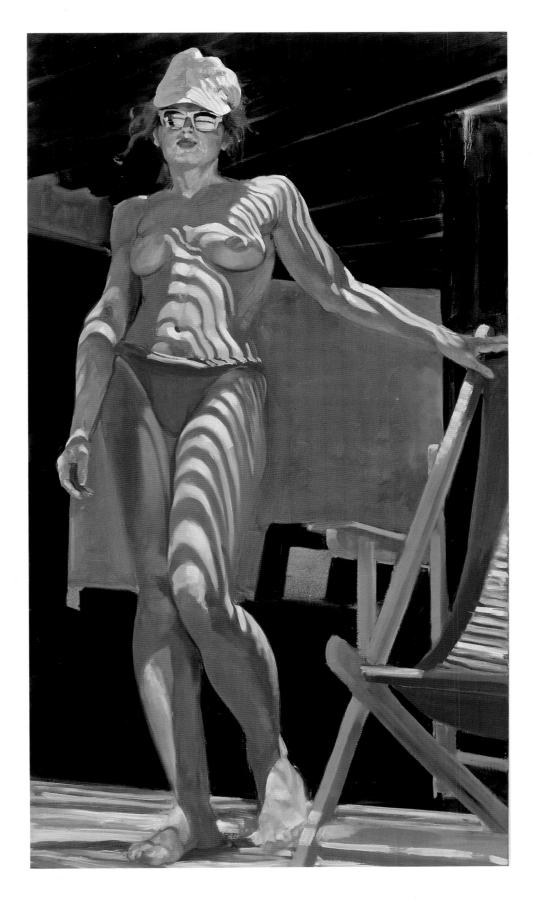

April in Mojacar, 1993
oil on linen
70" x 38"

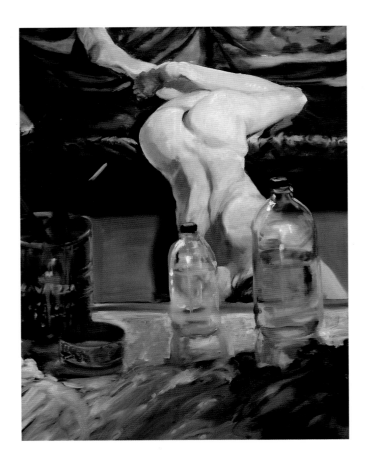

(What is there) Between the Artist and His Model, 1994
oil on linen
40" x 30"

Balthus

I'm selective with Balthus. He's an artist whose work I can often resist liking and then find myself coming back to years later. I remember when I first saw these paintings he did of a Japanese woman on the floor looking at a mirror. There were two of them and they were painted in a dry fresco style that sucked all the moisture out of my mouth when I was looking at it. In one way I was resisting the painting because I didn't like its manner. He was clearly addressing himself to Japanese prints, which explained the simplification of form and flattening of perspectival space. The formal problems he was working on declared themselves very quickly and they didn't seem that interesting to me. But I found over the years that I couldn't get the shapes of the bodies out of my mind. They were the most awkward poses for the beautiful line he was working on. It was a simplification of space that was a deeply erotic thing. Not the voluptuous and coquettish eroticism that you get in Boucher or Fragonard but something in which desire contorts the object in extraordinary ways.

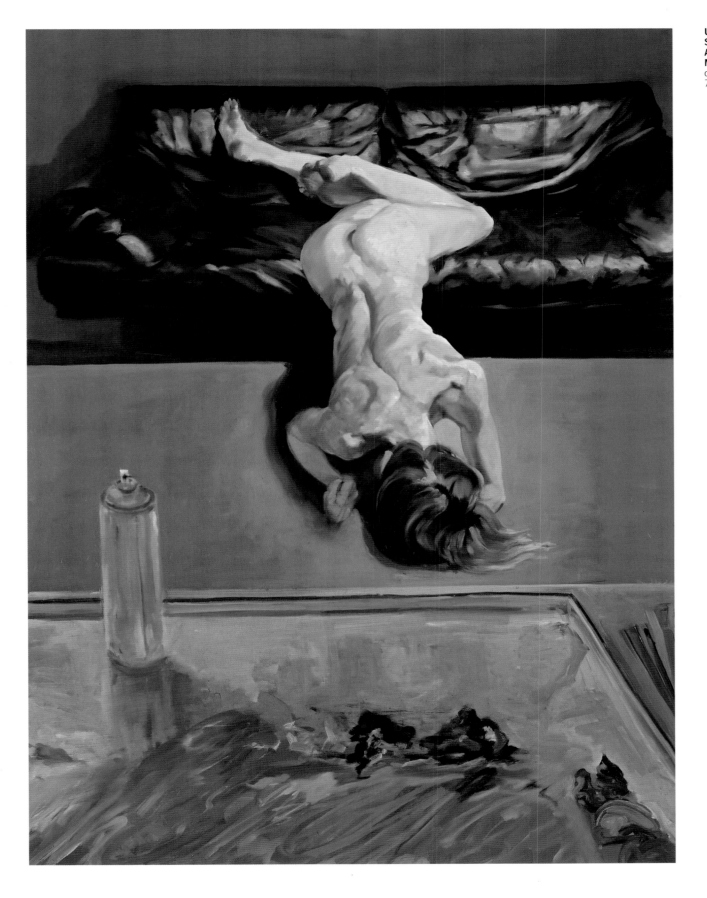

It's mostly Klimt's drawings that interest me. He has a way of using the figure in a very expressive, very dramatic way. The way he negotiates the balance between the observed and the felt is incredibly sensuous. He would often do drawings where he wouldn't look at the paper at all. Of course, you come out with this interesting distortion, and yet they're felt in the way one would caress a body. When you're touching something it changes the scale; you can see an arm as a certain portion of the body, but there's a way of touching it and touching it and touching it where that arm becomes thirty or forty feet long.

This reminds me of a student I had when I was teaching in Nova Scotia. He did this piece using a small branch—it might have been three feet long—which he brought in to critique one day. He had taken a string and wrapped it very tightly around the whole branch. I was looking at it and I didn't know what to make of it. He started talking about how he was fascinated because he could see the branch was only three feet long and to perceive it took a very short time. But when he started wrapping it, it took days. So this very small distance became a very large distance. It was really poignant.

Untitled, 1994
watercolor on paper
13 ⅛" x 14"

Untitled, 1997
watercolor on paper
60" x 40"

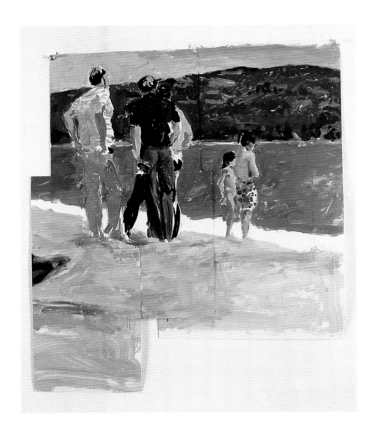

Untitled: study for year of the drowned dog, 1983
oil on chromecoat paper
28" x 24"

On Cargo Cults

I lament the loss of the magical object. I did a beach painting called *Cargo Cults*. Guys in sailor suits are on a beach and they look like they're out of the *Love Boat* or some Caribbean cruise. The guy standing in the foreground is naked, his back is to the viewer, and it looks like he's saying something to two naked girls, a black girl and a white girl, who are walking along the edge of the water. In the background is an African shaman who seems to be making a gesture of warning or aggression that is being ignored by the guys on the beach. This painting sits exactly between two cultures. I could do another painting on either side, in which I return the white guys to their boat and their banal reality, and I can return the shaman to his village where he accrues great power. But taken out of his village and put on the beach he looks like a bag person or a street madman. In a way the painting is a meditation on the nature of spiritual power when the context for its belief and magic have been withdrawn.

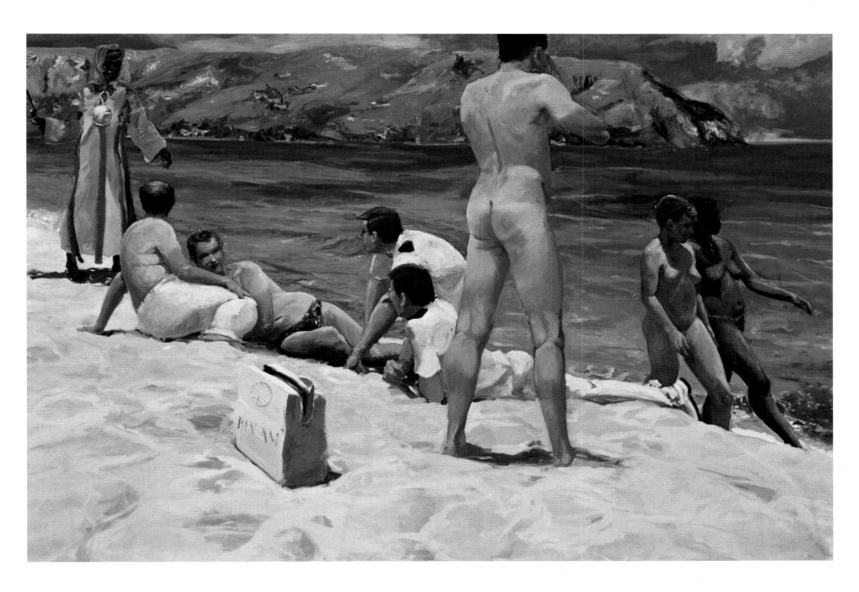

Cargo Cults, 1984
oil on canvas
92" x 132"

Manhattoes

I've put the decapitated head of a man into the hands of a woman. It's in *Manhattoes*, in this incredible human parade, like a strange carnival of costumes, all being led by a bride who holds in her hand the head of a man. On the other side of the painting is a boy dressed in a matador costume with a pig face who's being offered a ceremonial knife by an exotic Thai dancer. Behind them is a witchlike masked woman and between them are furies, these whirling Peruvian dancers and masked Haitian guys on stilts with colorful ballooning pants. I call them furies because there's a feeling of a tempestuous, eddying wind operating in the work. So this boy is being offered this object both castrating and phallic and he's thinking about it while he looks across to the bride and the decapitated head. I set it against the backdrop of the Statue of Liberty, whose back is to us. So it's something taking place behind the symbol of liberty.

In America we don't have cohesive cultural narratives, so little is agreed upon. You just can't be sure images mean what they are supposed to mean. When Gustav Moreau used a symbol people knew what he was referring to. Now the narratives have been so diluted you have to invent the meaning. My paintings move back and forth between narrative and allegory. While most of my work takes place in the narrative, every now and then an allegory emerges. Allegory is a story told in symbolic form, rather than in a situational narrative. I never know when an allegorical painting is going to happen, but some feelings can only express themselves in an allegorical or a symbolic way. It used to trouble me, but I've come to see that it's just this pendulum swing taking place between the two. The allegorical work is more related to dreaming. It functions in the same nonlinear way, where the images have strong resonance in and of themselves. They don't even adhere to time and scale but they're clearly meaningful.

Manhattoes, 1986
oil on linen, three panels
115" x 221"

A Brief History of North Africa, 1985
oil on canvas
88" x 120"

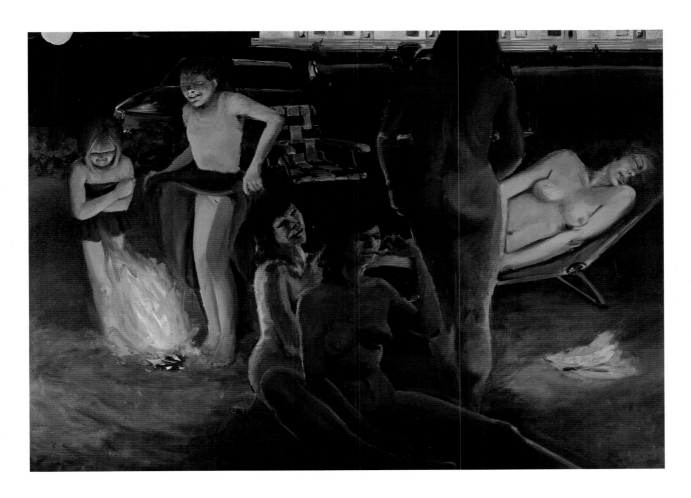

The Women, 1982
oil on canvas
66" x 96"

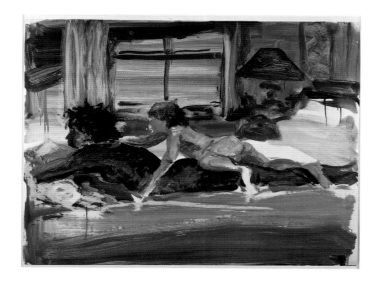

Study for Pretty Ladies, 1986
oil on paper
35" x 46"

Bayonne and the Multiple Canvas

From time to time I have changed the way I would approach a scene by how I would construct it. These are the ways that I keep painting interesting to me. They are also the ways I change the emphasis on my subject matter so I can explore other relationships within it.

The multipaneled paintings of the mid-1980s were a dramatic break from the way I used to make paintings. Time is very much a part of the experience of the works: the time it takes to construct the scene and the time it takes to break it down. Each painting has its own specific shapes. For me each panel was like a separate but intact artifact of my memory. I wanted the viewer to experience the constructing of the scene simultaneous with the discovery of the scene.

In *Bayonne,* for example, you're looking at an older woman and a young girl: the girl is dressed in a ballerina costume; the woman is naked on a chair—I took her from a Bill Brandt photograph. I put them in a bedroom, split the painting in half, and separated one panel from the wall. The panel of the young girl is cantilevered out. There is a point, if you're standing right in front of it, that the two blend together and make one room. But when you move to either side the painting fractures into two different events. Two figures have become isolated from one another. This separation highlights an aspect of time as a quality of their relationship. It also brings into the scene the possibility that these two characters are really the same person, older and younger. The woman sits staring in the direction of the child, who is not particularly aware of her. It is as if she were remembering herself as a young ballerina. The gesture of the child is stiff and clumsy, nonballetic. Her hands, raised before her, feel more like a barrier. She is putting up resistance. It's about the sadness you feel when you can no longer gain a certain access to the past, not because you don't want to, but because the past won't allow it.

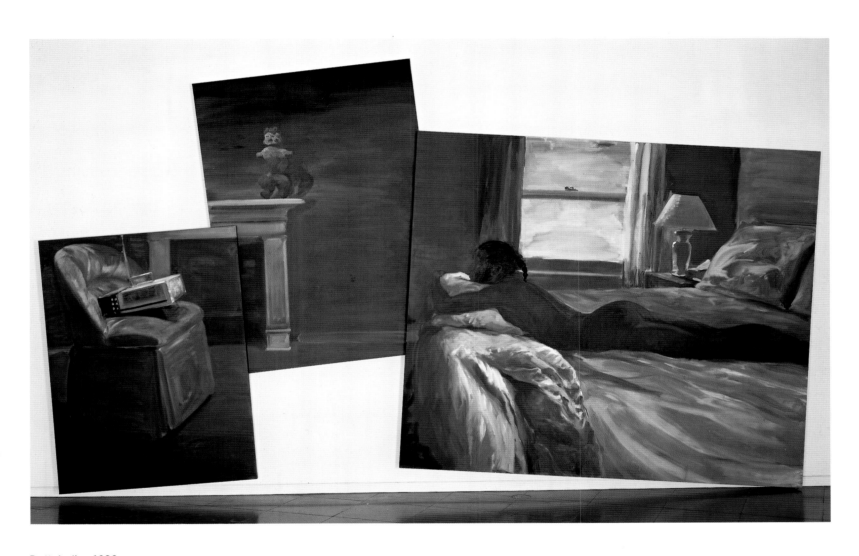

Pretty Ladies, 1986
oil on linen, three panels
103" x 177"

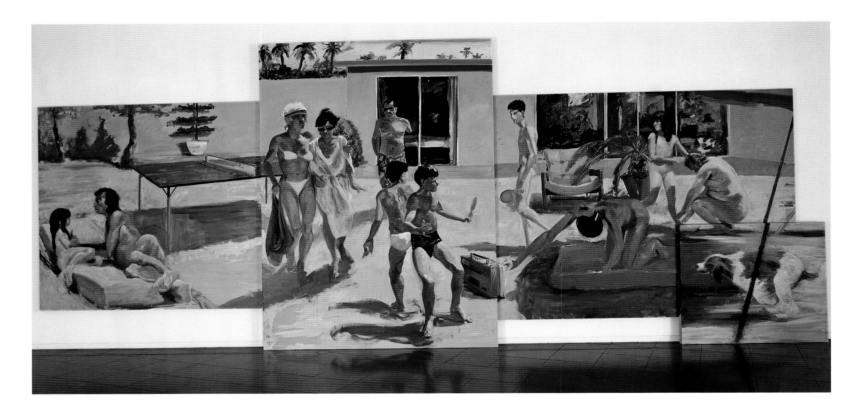

Saigon Minnesota, 1985
oil on canvas, four panels
120" x 288"

Growing up in the Company of Women #2, 1987
oil on linen
108" x 105 ¾"

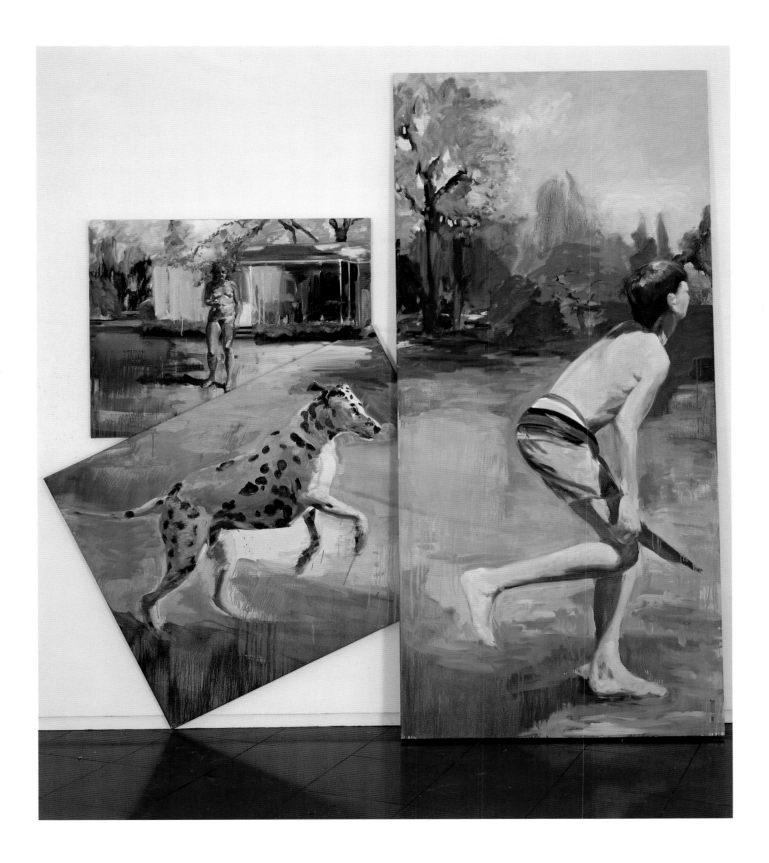

Bayonne, 1985
oil on linen, two panels
102" x 129"

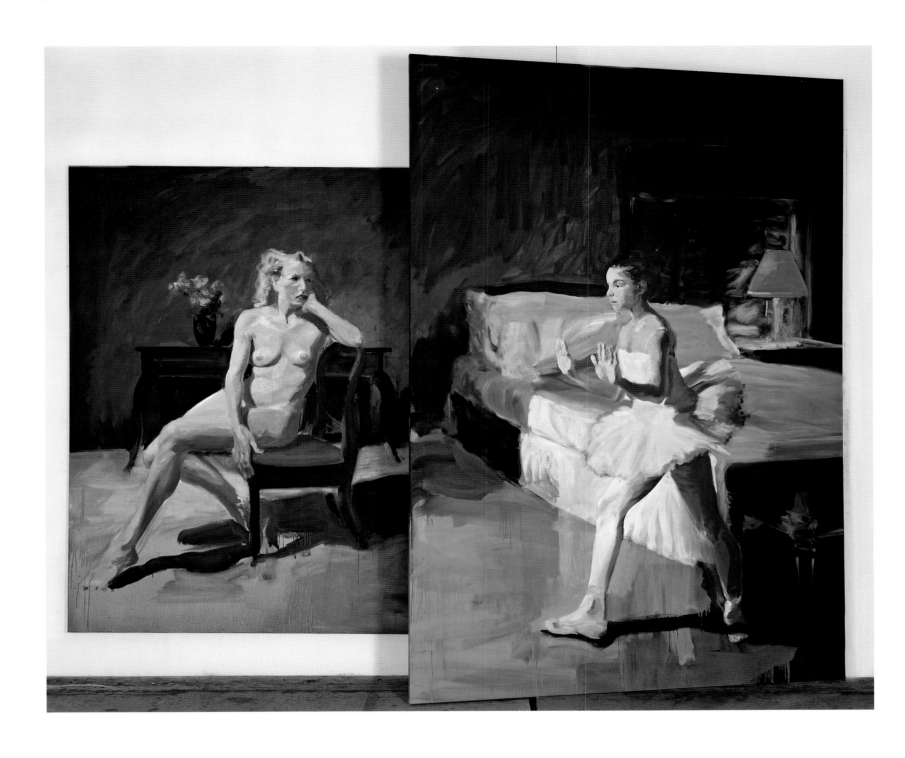

On George Platt Lynes

The young girl from the George Platt Lynes photograph appeared in an earlier version of *Bayonne* but was edited out. The panel that the woman and the chair are on was a larger canvas in which the Platt Lynes girl appeared in a washy, gestural way, and was covered by the panel with the young girl in the ballet costume. Only by moving off to the side would you have seen her. She was like an animus; she represented a more sexualized and maybe a more sexually vulnerable figure. The thing about Platt Lynes's photography is that it's oddly cold. You're looking at a young, prepubescent girl who's standing exposed, her legs spread apart, and its charge comes from the coldness in which she's presented. Because you really don't know how to respond, you don't know why the picture was taken. It's not clinical and it's not explicitly sexual, and its neutrality causes a tremendous ambivalence. That's what animates it: you rush in to contextualize it—is it good, bad, desirable, not desirable—is it taboo?

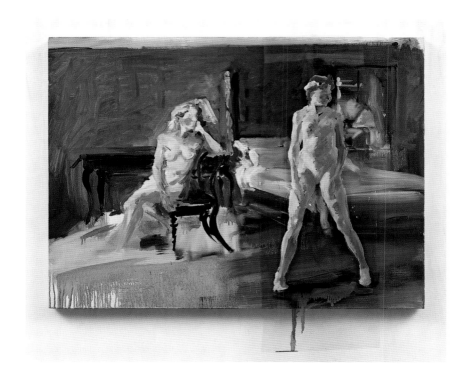

Study for Bayonne, 1985
oil on canvas
30" x 40"

Untitled, 1985
oil on chromecoat
12" x 16 ½"

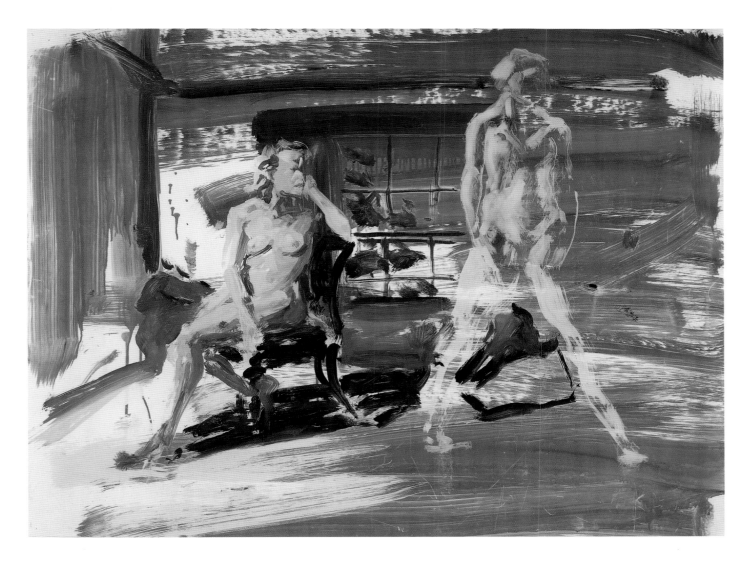

Study for Bayonne, 1985
oil on chromecoat
26 9/16" x 35 1/8"

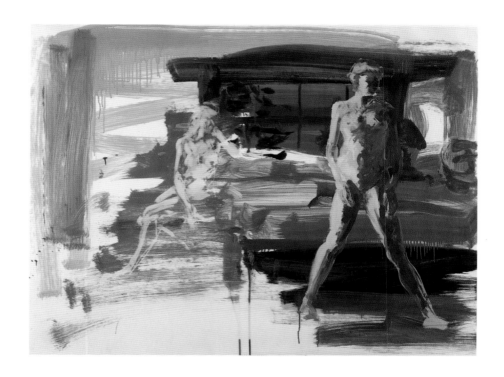

Study for Bayonne, 1985
oil on chromecoat
35 ⅛" x 46 1/16"

Untitled study for Floating Islands, 1985
oil on chromecoat
23 ½" x 17"

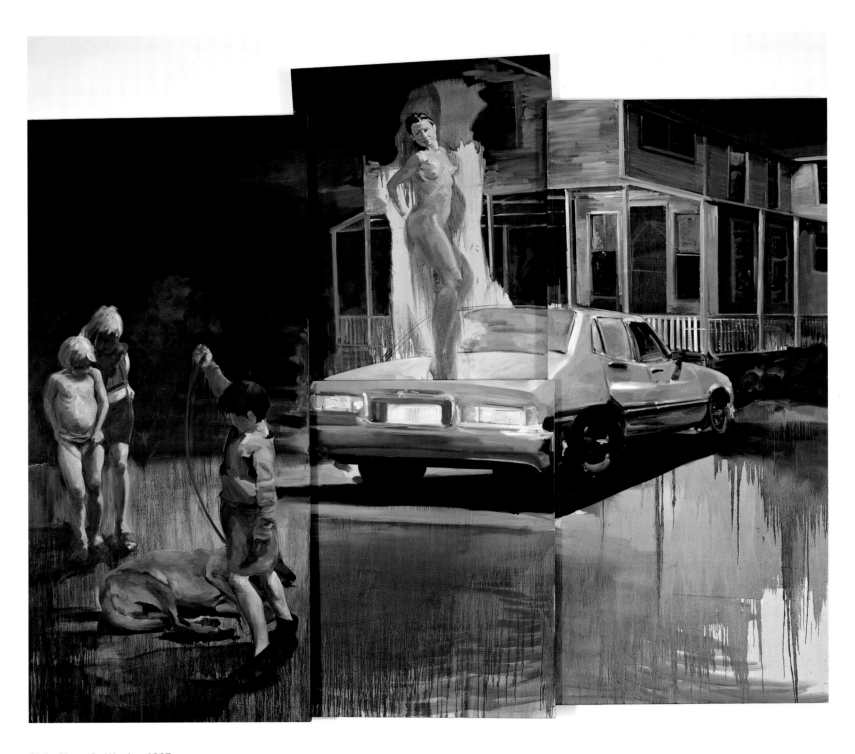

Birth of Love, 2nd Version, 1987
oil on linen, four panels
119" x 142 ½"

A beautiful woman is rising out of the trunk of a car like Aphrodite rose out of the sea. In her nakedness she is a vision of sexuality. In our own mythology the back seat of the car is associated with the loss of innocence.

In the foreground are two kids and their dog. The dog is lying in the driveway; I think he is dead. One child tries to get the dog to move by tugging on its leash. It is a comically tragic image. These children are too young for sex, but they are not too young for love. The death of their pet, and the need for comfort and reassurance, are set against the miraculous appearance of sex, which seems wholly inappropriate to their needs.

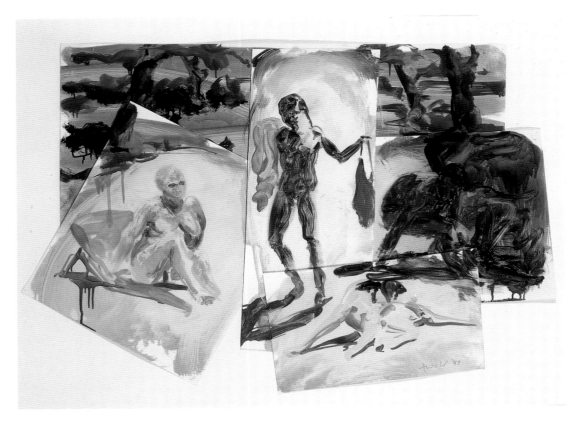

Study for The Life of Pigeons, 1987
oil on chromecoat, five sheets
23" x 28 ¼"

If you compare the painting of the two dogs in *The Life of Pigeons* and *Scarsdale* you'll see that the dog coming out of the water is arrived at with less brushwork. Three very simple things—three brush strokes, three kinds of colors—created movement and splash and light on wet hair. That's why it's better. The woman floating on the air mattress I got from a photograph taken on the beach in St. Tropez. She just seemed this delectable, desirous thing. I like the guy getting up slowly with his mirror sunglasses, buglike and predatory. Then all the way on the opposite side of the scene in another part of the park is an older woman who is not desirable. She's large and uncomfortable in her body and surrounded by birds that exist somewhere between oil slicks and rats. It's sad and isolated and it's also a kind of *Le Déjeuner sur l'herbe* in one sense, although everybody's naked in my version.

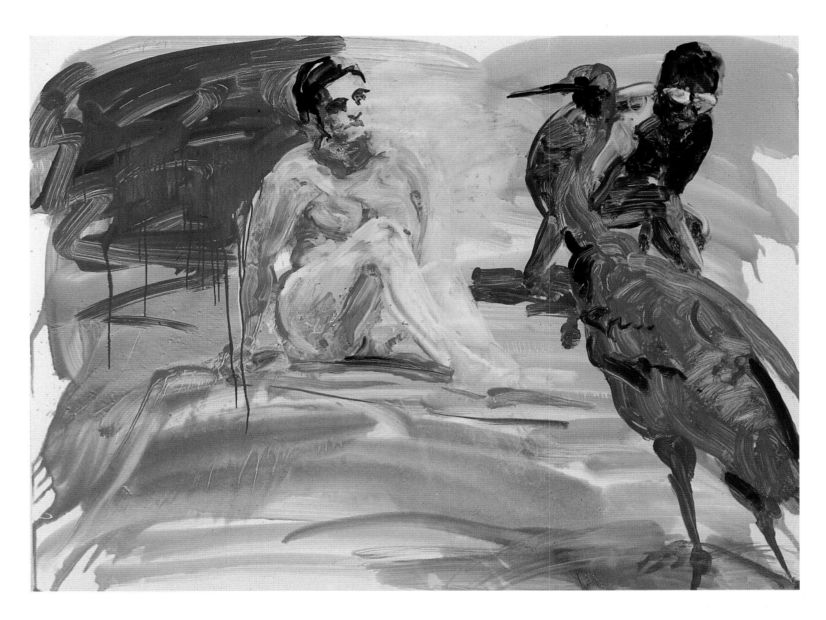

Study for The Life of Pigeons, 1987
oil on paper
35" x 46"

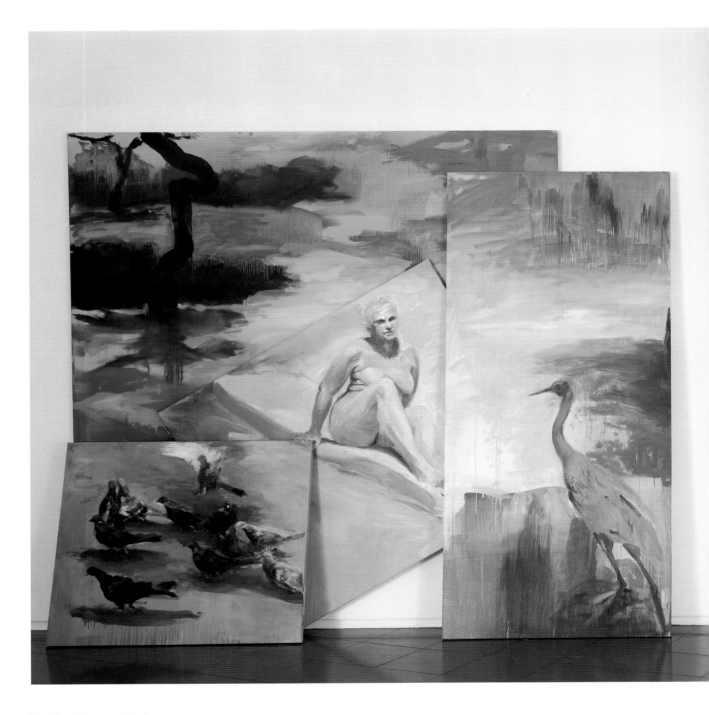

The Life of Pigeons, 1987
oil on linen, seven panels
117 ½" x 292"

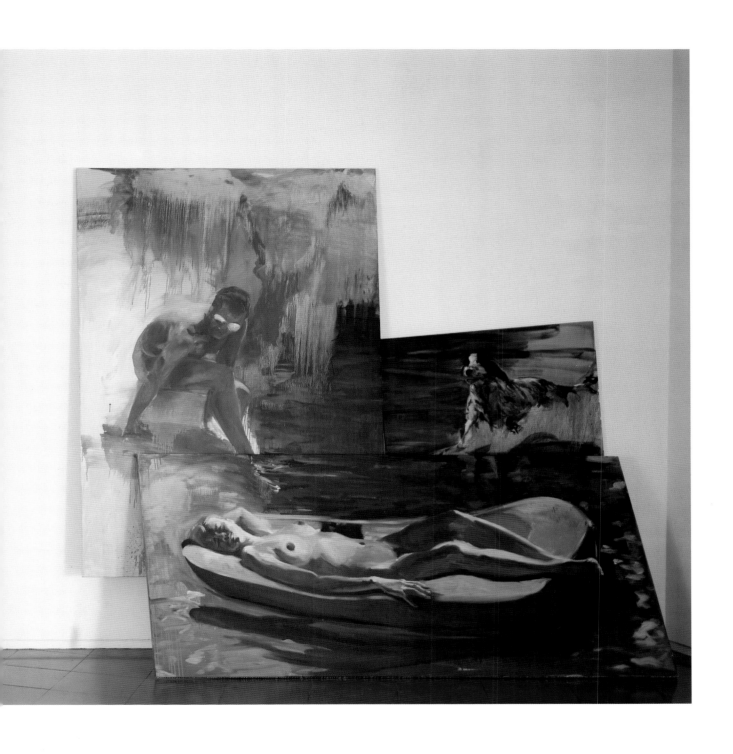

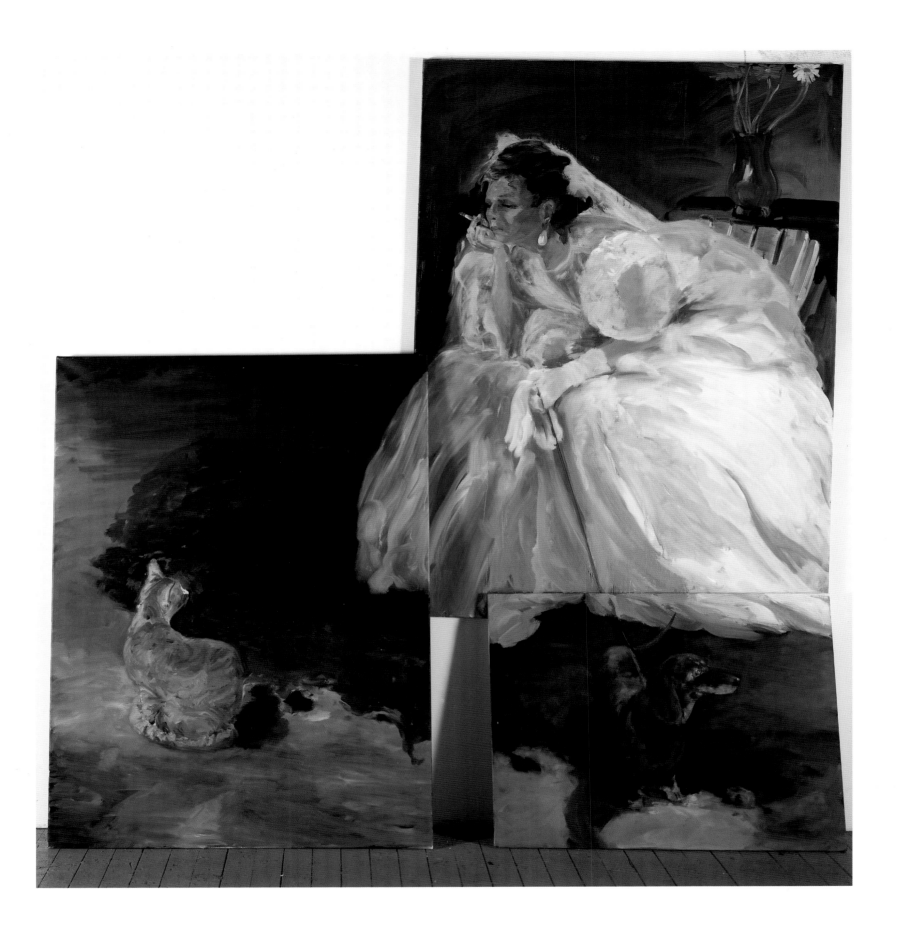

Scarsdale, 1986
oil on linen, three panels
96" x 93 ¼"

On the Figure from Behind

Any figure seen from the back immediately creates a sense of mystery. You're being excluded from something so you want to know what's on the other side. One of the ways painting can let you in is to throw a barrier in front to see if it clarifies what you're seeing from the back.

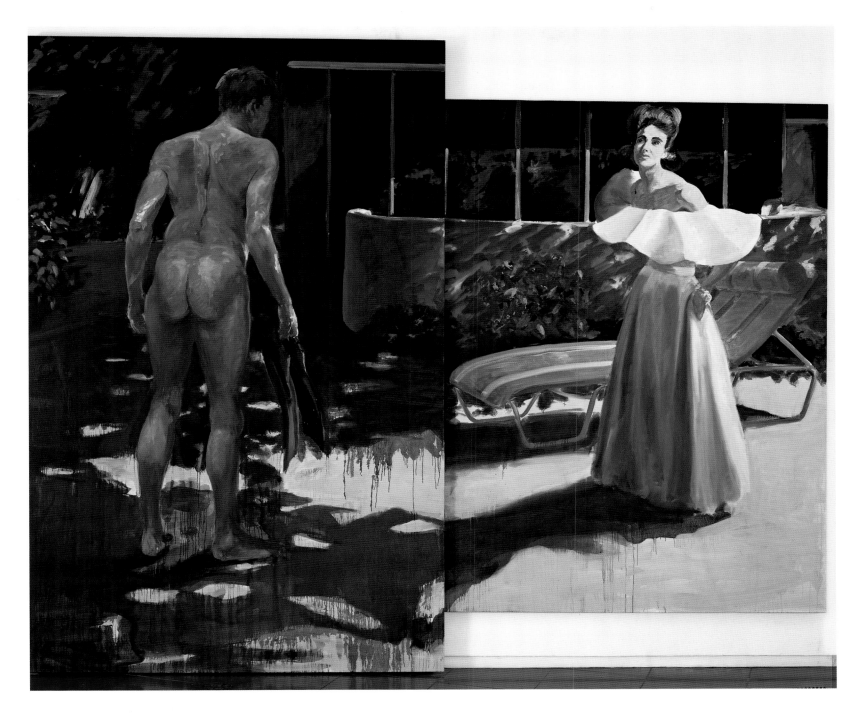

Far Rockaway, 1986
oil on linen
110" x 135 ½"

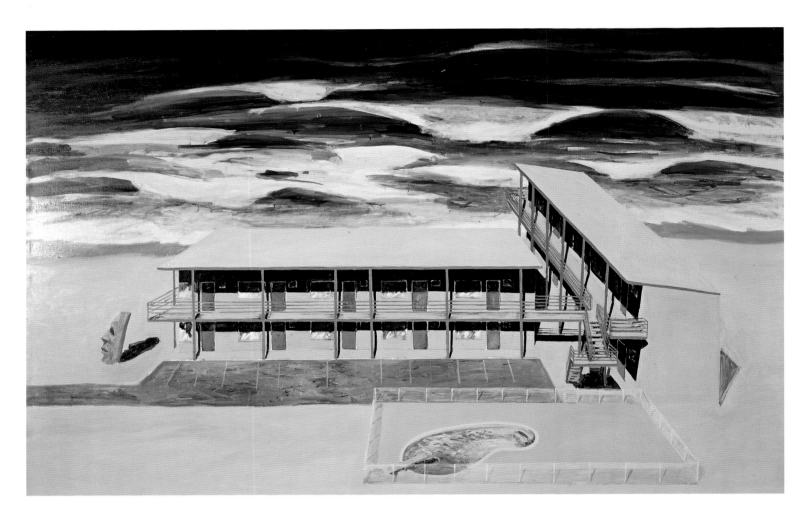

The Last Resort, 1980
oil on canvas
72" x 96"

On Water

For me the water represents the place we've come from, whether by way of biology or immigration. I've always been fascinated by our obsession with hanging out at the beach. In a metaphorical way it's like hanging out really close to where we came from, which is analogous to sex. It's like wanting to play with and meditate on the mysteries of this thing that we've come from and can never go back to. You can go ten feet into the water but you can't live in it, so you have to return to shore.

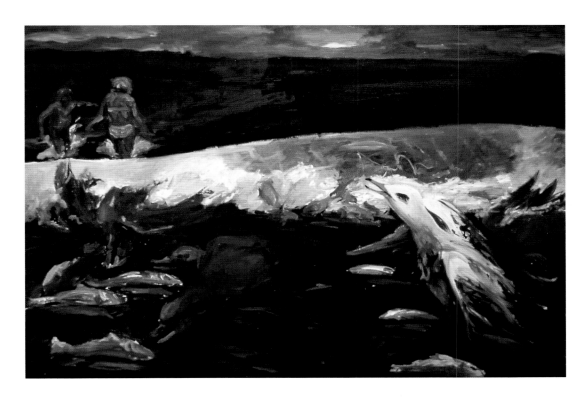

After the Kill, 1980
oil on canvas
42" x 64"

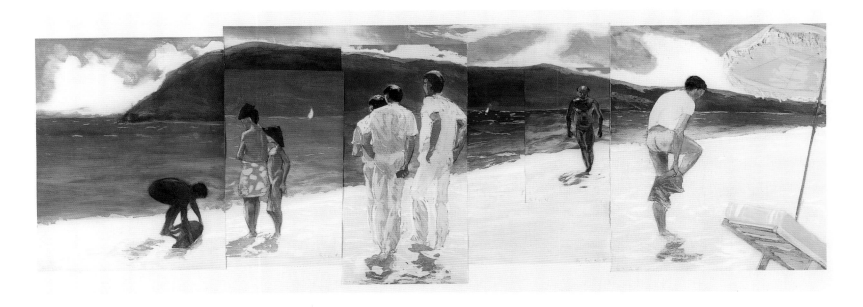

Year of the Drowned Dog, 1983
etching, aquatint, six panels
16" x 37"

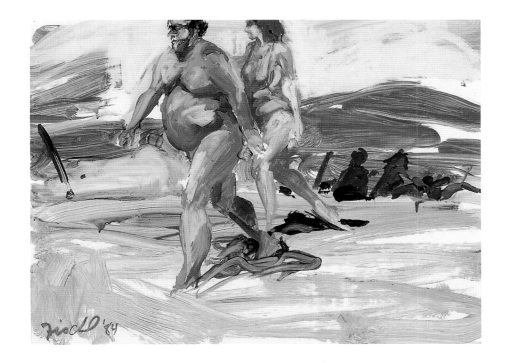

Untitled, 1984
oil on paper
30" x 35"

Untitled #6, 1984
oil on paper
13" x 16"

Swimming Lovers, 1984
oil on chromecoat
11" x 16"

Untitled study for Floating Islands, 1985
monotype
11 ½" x 31 ½"

Untitled, 1997
oil on chromecoat
27 ½" x 39 ¼"

The Beginning and the End

I did a painting titled *The Beginning and the End*, in which the female is standing, her back to us. Between her legs is a standing man. In the foreground you see the head of a sleeping man and opposite him, a pair of feet. This image I find very funny. It implies that the sleeping man wraps himself entirely around the world, comes back on himself and encompasses this eternal relationship between man and woman.

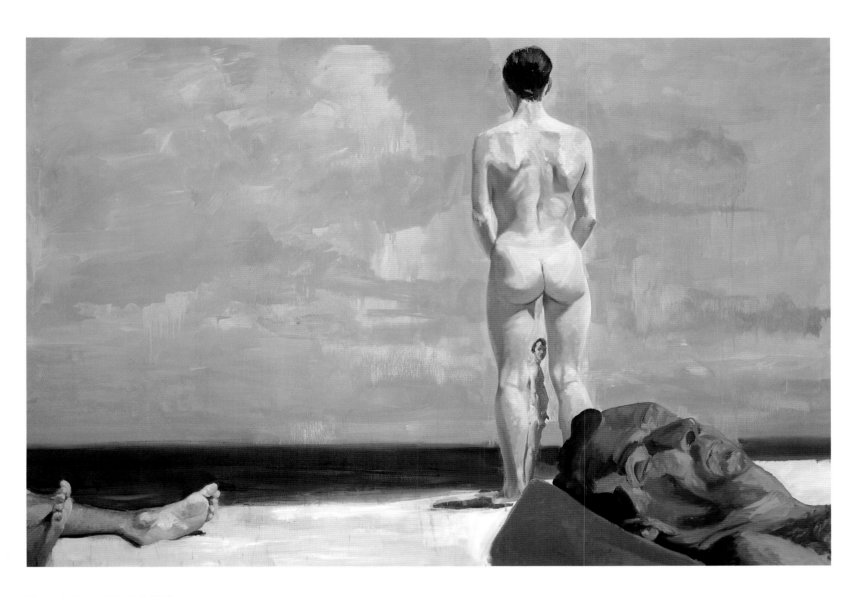

The Beginning and the End, 1988
oil on linen
75" x 110"

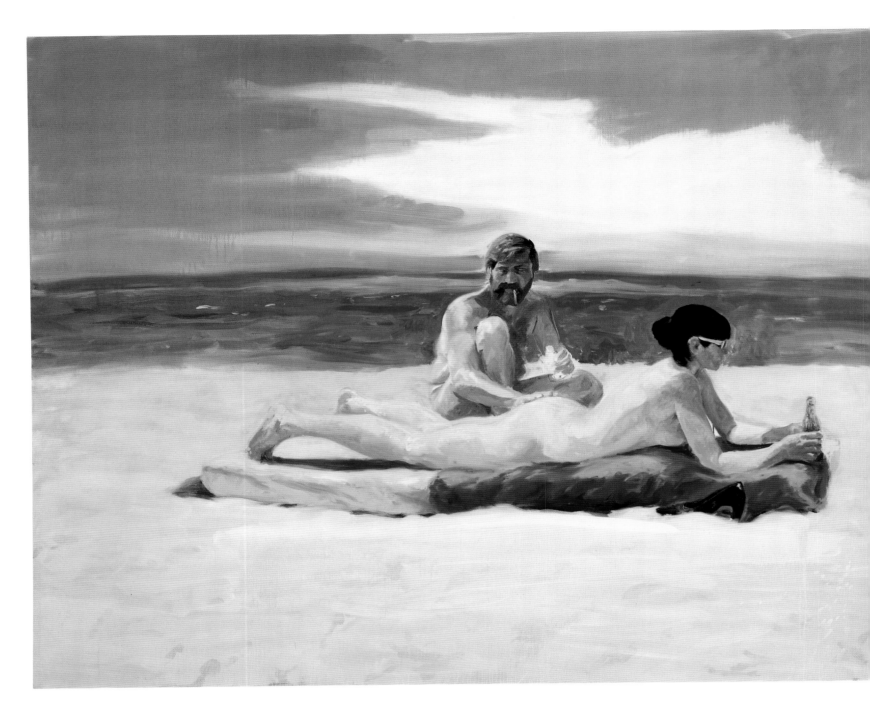

The Black Sea, 1986
oil on linen, two panels
85" x 175 ½"

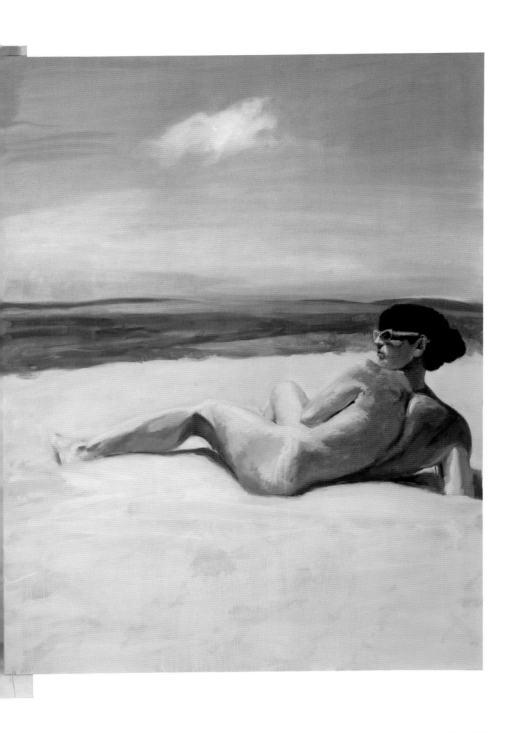

The Woman in *The Black Sea*

The woman on the beach in *The Black Sea* appears a lot. She also appears in *Costa del Sol,* in *The Brief History of North Africa,* and a number of drawings and small paintings. To me she is like the Sphinx, a symbol of mystery and power. There was something inscrutable about her. It's her back turned toward you, and a certain attenuation that's almost androgynous. Things seemed to evolve and revolve around her, although she remains an inscrutable presence.

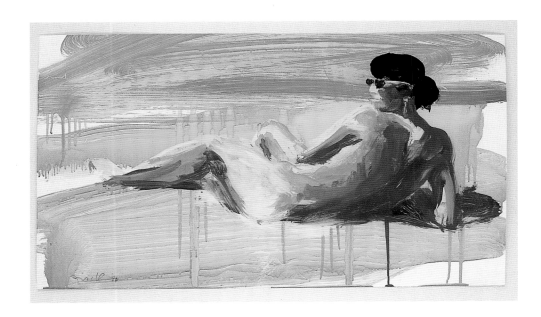

Untitled, 1985
oil on paper
12" x 22"

Untitled, 1985
oil on paper
25" x 18"

Untitled, 1985
oil on linen, two panels
36" x 93"

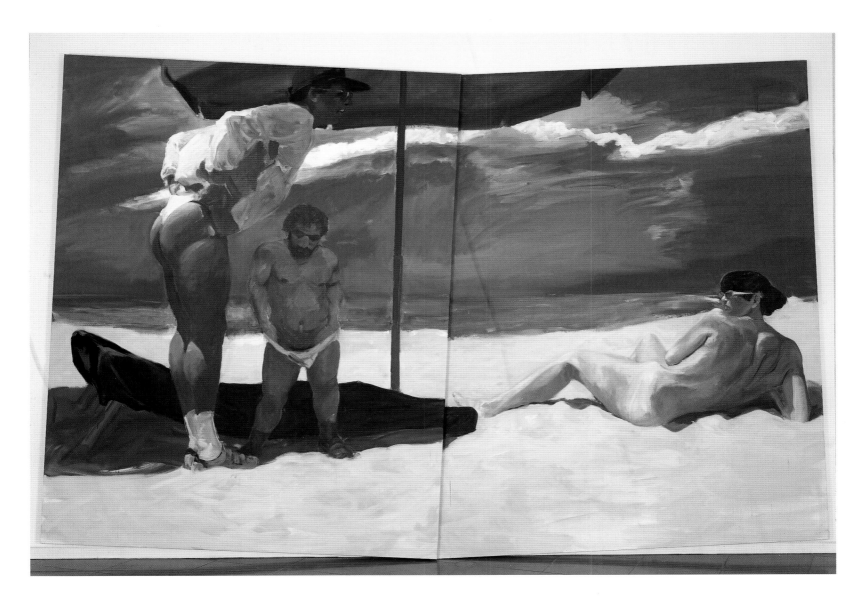

Costa del Sol, 1986
oil on linen, two panels
103 ¼" x 156 ½"

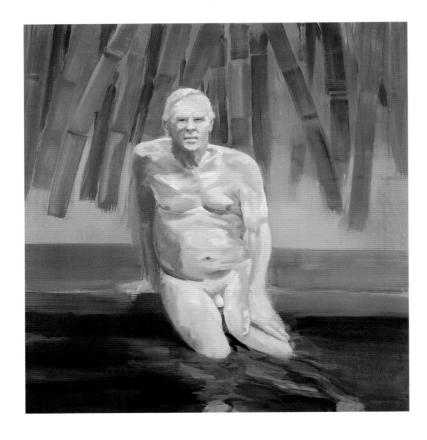

First Time in Japan, 1988
oil on linen
58 ½" x 54"

Light has always been important to my work. Early on, for the most part, I worked with the light of the Southwest, which is harsh and flattening. Shadows are crisp and hard and the light pervasive. It is a light that holds nothing back. Over the years I have become interested in a different kind of light, one with more depth and subtler opacities and transparencies.

Light and water in combination has been both a painting condition and a spiritual condition. A body in water changes shape: it's distorted, it wavers, its edges become less clear. It is a metaphor for transformation. The same is true with light that obliterates edges or reinforces them by creating a fracture with its shadows. It represents the transitional and the transitory.

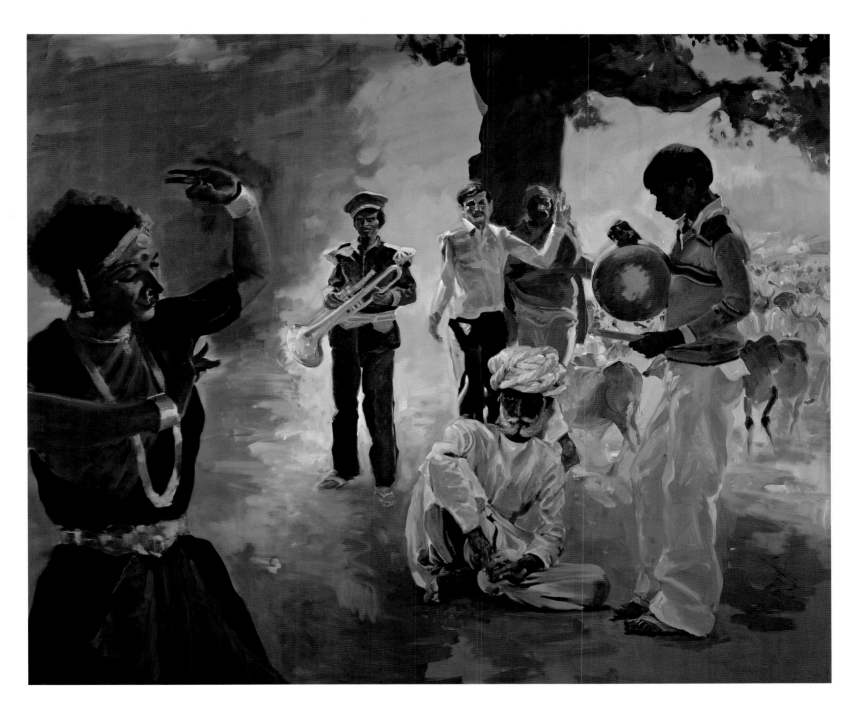

Cattle Auction, 1990
oil on linen
98" x 114"

On Scale

April has been making interesting observations about scale. She thinks people tend to interpret scale as size. So the heroic gesture becomes simply big, or intimacy is reduced to small. None of these things addresses what scale is really about. In the case of art it's about very physically perceived relationships that change your relationship to your own body. It literally changes your perception of something by making you in some way self-conscious about your place and your size.

Certain artists, like Degas, made relatively small-scale work but created within them an even more intimate universe just by having you look at scenes through a crooked arm, or over someone's ear, or around the side of someone's body. It narrates you through to a desired object that stands farther away. I do that also by obliging you to look beyond an object or person in the foreground, reversing what you would normally think of as hierarchy. You see that a lot in film. One of my favorite openings to a movie was in Fassbinder's film *Despair*. You're in an indeterminate space; you're hearing a noise you don't recognize. You don't know what it is because there aren't any similar objects or relationships that you can figure out. Then the camera starts to spiral out of it. You can feel it moving out, and as it pulls back you realize that you were just inside a cracked egg, sitting in a cup on a plate in a sink in a kitchen. The camera just keeps spiraling out and out and out until finally it's moved out of the room altogether and into the movie. That he starts the movie from the perspective of a broken eggshell is incredible.

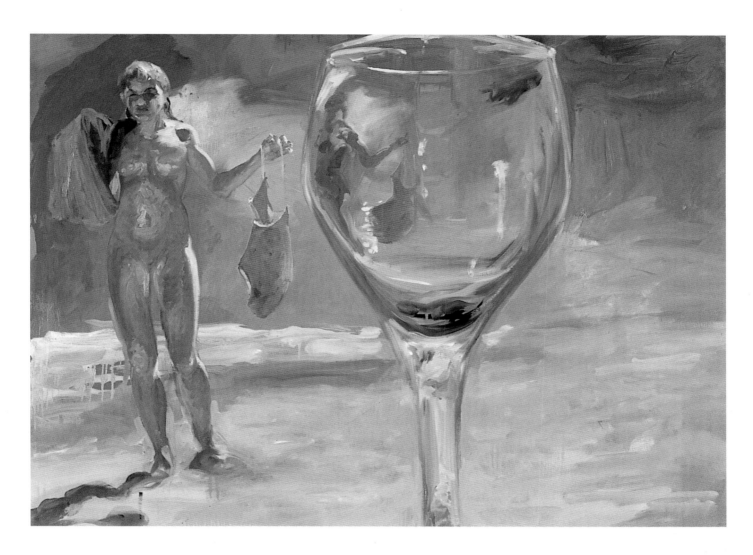

Untitled, 1987
oil on linen
48" x 35"

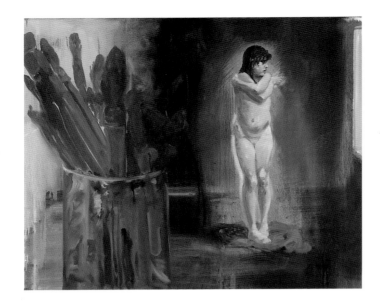

Untitled, 1988
oil on linen
30" x 36"

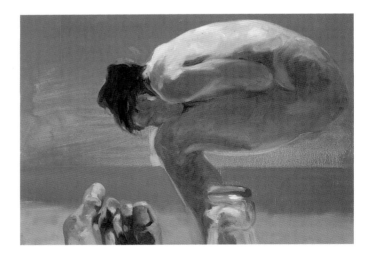

Untitled, 1988
oil on linen
30" x 36"

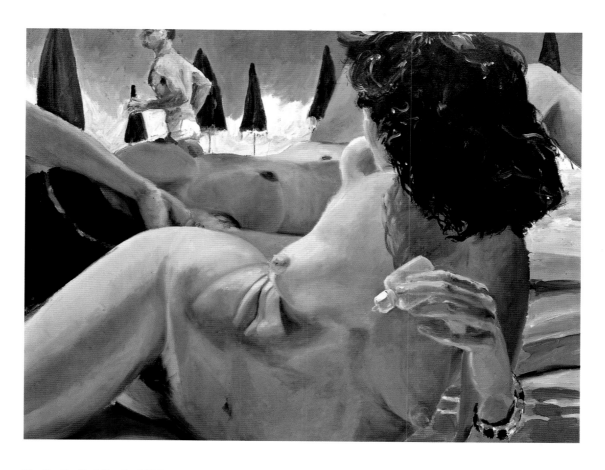

The Day the Shah Ran By, 1982
oil on canvas
36" x 48"

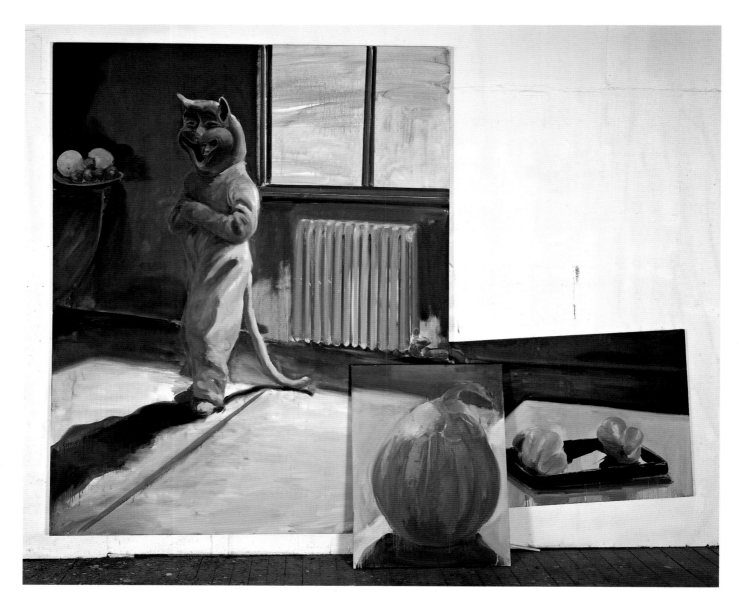

Catboy, 1986
oil on linen, three panels
105" x 127"

Humor and Irony

I think everything boils down to a humorous response. I also think that irony is a profound part of my generation, something that we've used in all forms of media. An ironic response to the world is common currency. The apparent lack of irony among the younger generation interests me. There's a kind of literalness to everything, which baffles me. Younger artists use images of sex not as a metaphor for something else, but literally as sex. Violence is just more imagery without connotations.

Duck, 1987
oil on linen
70" x 60"

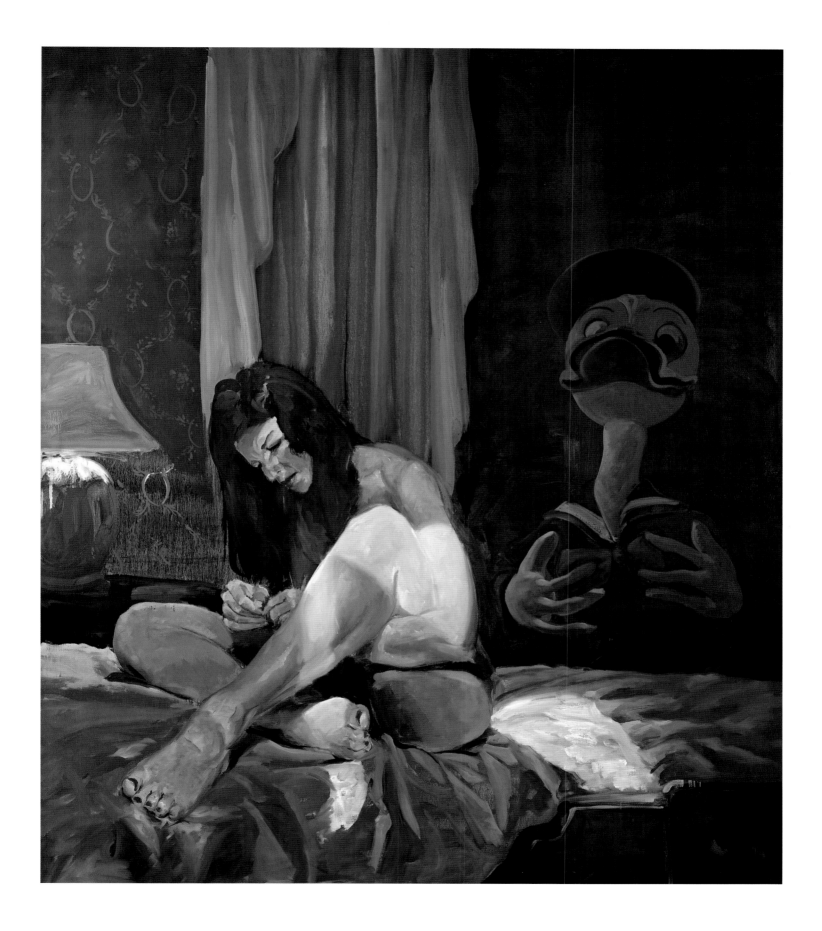

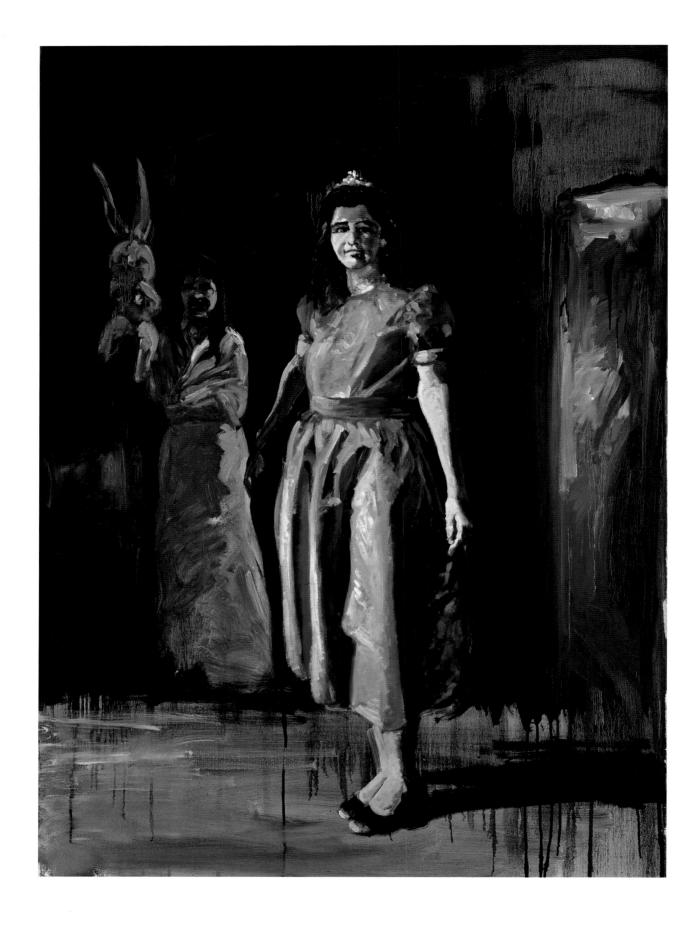

Study #2 for Girl with Green Dress, 1987
oil on linen

Study #2 for *Girl with Green Dress*

The girl in the green dress was the girl who was left out of Velázquez's painting *Las Meninas*. She would not get invited to the prom. She seems Spanish to me, although I didn't started out thinking Velázquez, and how I could comment on him. I simply found her and was fascinated. There's something wonderful and sweet and open and tragic or pathetic about her. About her being pudgy: I was thinking more about Walt Disney's *Fantasia* and "The Dance of the Hippos." I put her on tiptoes and made her very light.

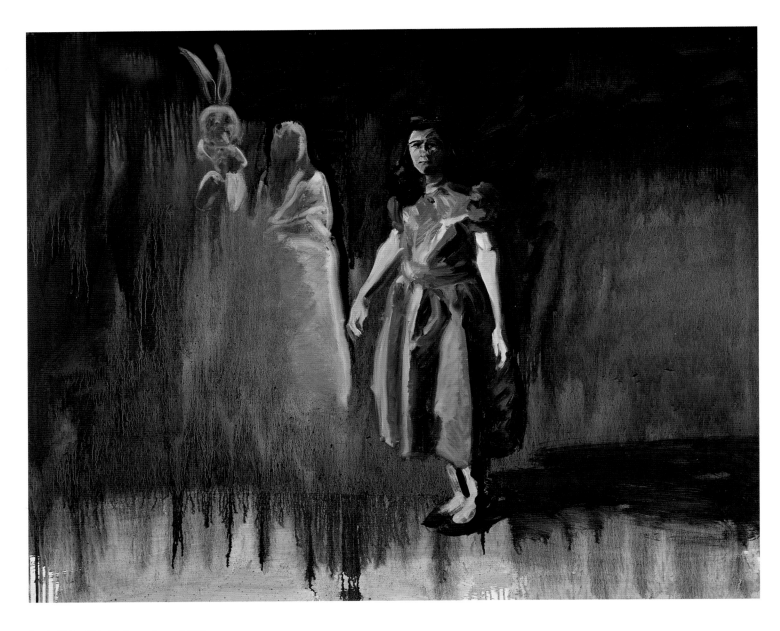

Study #1 for Girl with Green Dress, 1987
oil on linen
36" x 45"

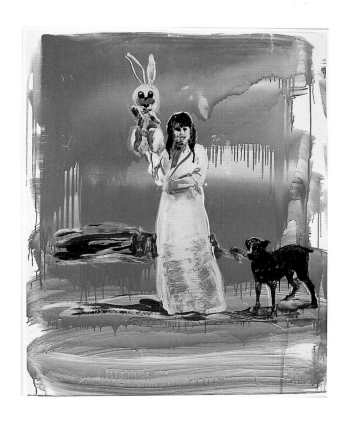

Study for Girl with the Green Dress, 1987
oil on paper
35" x 28"

Untitled, 1987
oil on linen
60" x 45"

Untitled (Wedding Picture)

A girl is holding up a bridal gown looking into a mirror. She is not dressed and you're seeing her, undressed, from behind. She's seeing herself the way she wants to be seen and the way she will soon be seen as a bride, and you're seeing her as the object of your desire. But you see past that or underneath that. The painting holds two different fantasies about the same moment.

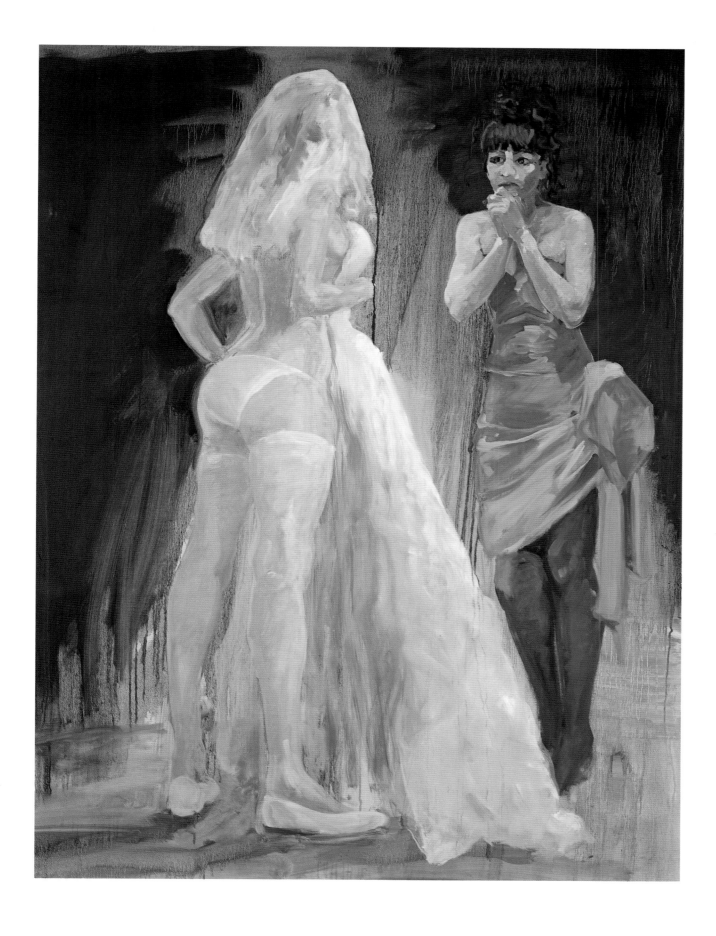

On Beckmann

What I like about Beckmann is that there really is a narrative to what he does. If you look at something of his long enough there are certain things with which you find yourself having free associations, or certain things you have to look at again to see how he's shifting your interpretation. *Olympia* is a good example. It was an enormous revelation for me. What you see is a voluptuous blond temptress in repose. In the foreground on a small table is a knife, maybe an open piece of fruit, an extinguished candle, and a bust, which I had first taken as a reference to some kind of classicism. It's like a studio scene and the bust is in shadow and painted charcoal gray. It's a man from midchest up with one arm raised and amputated. I found myself staring at this picture, and at some point I began to wonder what the gesture was about. I took the pose and I noticed that my arm went straight out. Then I looked at the date of the picture; it's 1945 and I realize this is about Nazi Germany. The gesture is an amputated *sieg heil*. The war's over, victory has become defeat, and this Nazi warrior is not only amputated and burnt to a crisp but he's caught in an eternal gesture toward this Aryan ideal of a woman. And the gesture has failed. The candle is extinguished. Then you look at the woman's face; she is Siren-like and she's not accepting the failure. She remains desirable, she's still petulant, she's still waiting. It scary because it's as if it could start all over again. It's a really compelling painting because she's also the artist's muse, who properly embodies ideas about beauty and idealism. You're looking at a painting that can be taken as a traditional artist/model studio scene as well. That is what is so magnificent about Beckmann: He infuses mythical content on a quotidian level and makes it ironic.

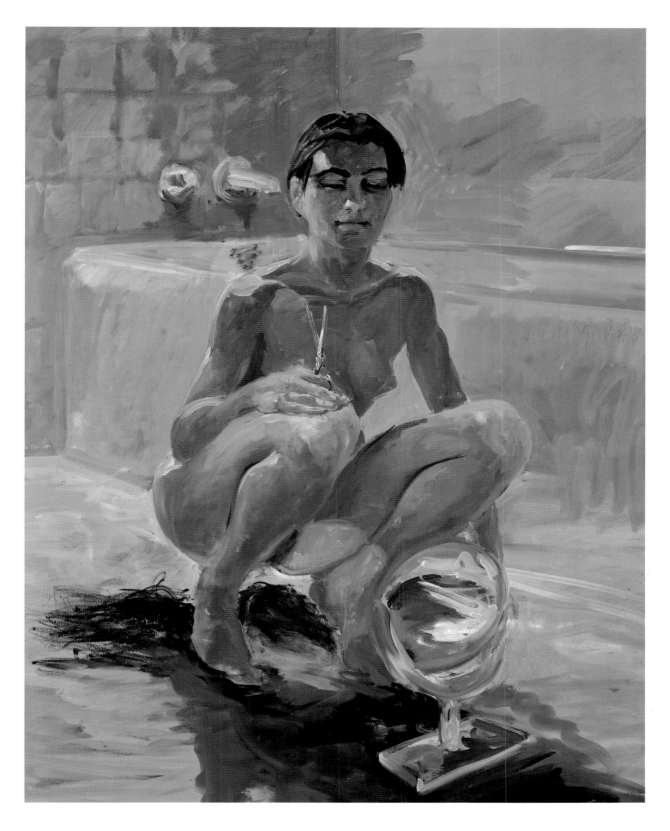

Haircut I, 1985
oil on canvas
54" x 42"

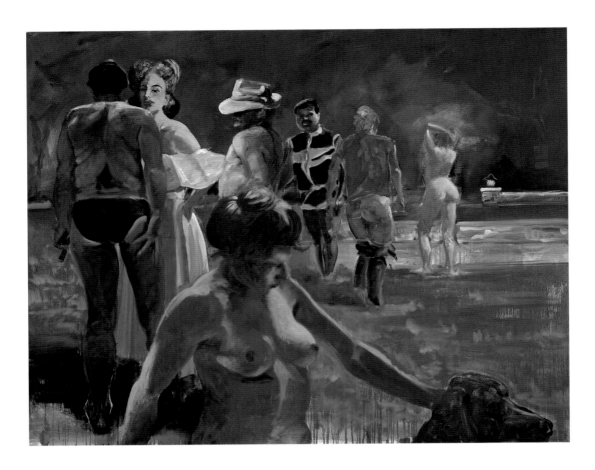

Truman Capote in Hollywood, 1987
oil on linen
46" x 58"

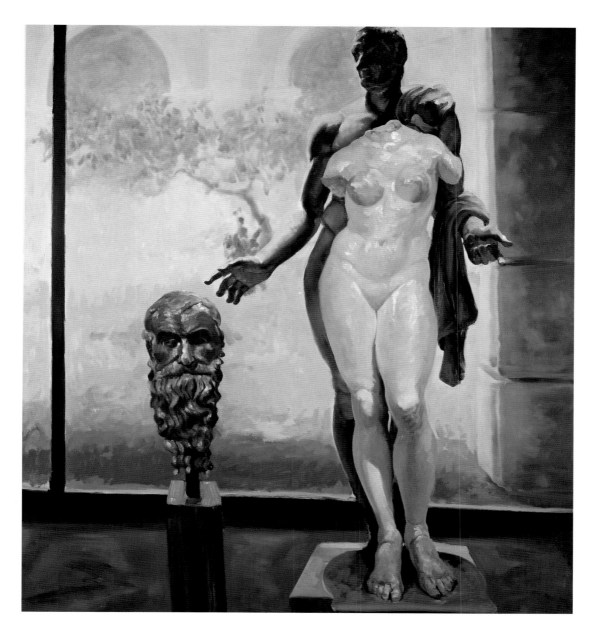

The "Ultimate Opera," 1998
oil on linen
65" x 58"

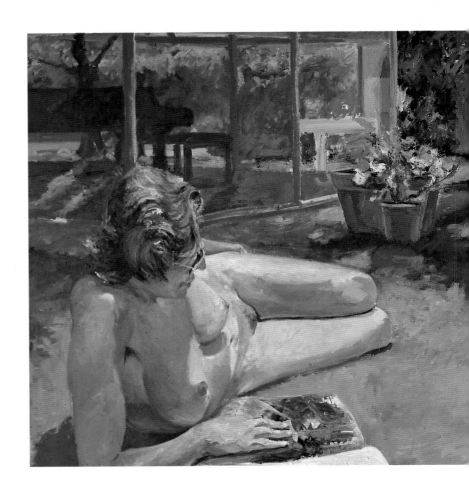

On Audience

I was asked if I wanted to write about a Beckmann painting, *The Departure*, which I had meditated on for years and from which I had gotten tremendous inspiration. I said no because it's my painting and I know what it means. I've gotten from it what I want. It would be interesting to hear what Beckmann was thinking about, but it's not important to the experience I have of the painting because it's not his painting.

I think that's something an audience needs to understand about a work of art: the experience of it really is an act of possession. A painter wants the viewer to internalize that painting, wants him to possess it, if not to physically live it. That's where the union between artist and audience occurs. It's something that you especially have to do with modern and contemporary art because every artist is forced to create his own context, his own language, and his own mythologies—basically his own content.

So how do you decipher all these individual things in a general way? How does communication work? You have to assume that there are some things that are common to all of us because of biology, because of social and historical events. And you have to assume that there are some things that are

common to us because of the nature of the mind. So when you look at a work of modern art, you have to be aware of your first associations and how the painting doesn't jive with them. You have to find where the reinterpretation of meaning is going to occur. You look at a Bonnard painting of his wife having breakfast in a little room, set against a fabulous spectrum of early-morning light. Then you look at her and she's as gray and sullen as could be. You realize that what you first thought was a wonderful domestic genre picture with beautiful impressionistic light is set against something that creates friction so that it's not as enjoyable, it's not a Monet painting of rocks or haystacks. And that's exactly what Bonnard is dealing with: that shift between the desire to live with beauty, the reality of a tormented wife, and the struggle to have both. I think that's the nature of modern artists.

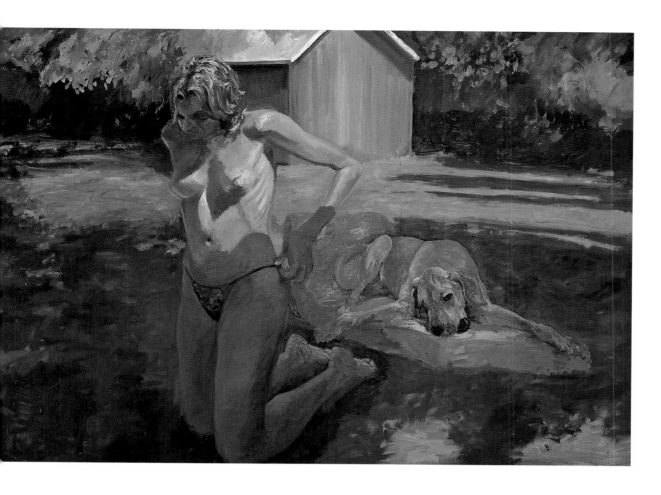

Mother and Daughter, 1984
oil on canvas, two panels
84" x 204"

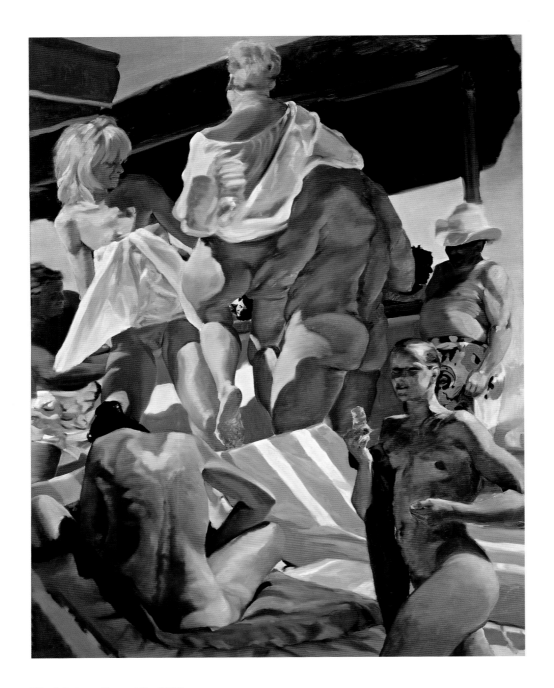

What's Between You and Me, 1992
oil on linen
98" x 74"

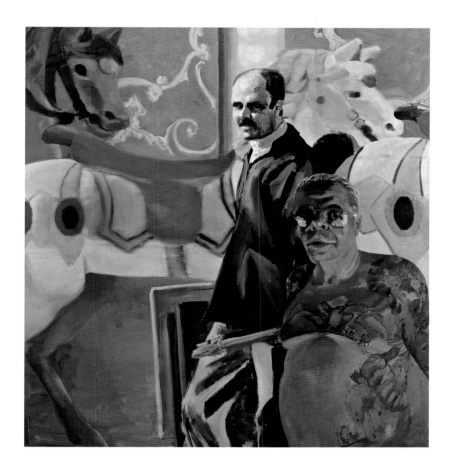

The Sunday Painter, 1992
oil on linen
58 ¼" x 54"

On Critics

For me the thing comes first. It's mute, it's real, it's experiential and so it makes you be there. It's interesting to see the process art has gone through, especially in late modernism, where words became a dominant part of the meaning as well as the making of the work. It changed the role of artist and critic, where the critic/philosopher became overly important. A lot of critics wanted to become artists—in fact thought they had, both in shaping interpretation and presentation. The work became minor. I can't stand the idea that my work would be a minor example of somebody else's major theory.

On Collectors

In *The Collector* you don't really know whether you're looking
at the scene from inside the storage room of the artist's studio,
whether you're looking at what the collector is looking at, or
whether you're seeing what's inside the artist's head when he's
sitting there. Basically what you've got is this: a guy who is
blind and bound (it's actually an image taken from a photo-
graph by Eakins), and a porno fantasy—a princess being
defiled by a slave or a savage. In one way or another all the
characters represent the artist's feelings and the relationship
of the artist to his collectors. He is either blinded and
enslaved or raped and humiliated. It is not a pretty picture.

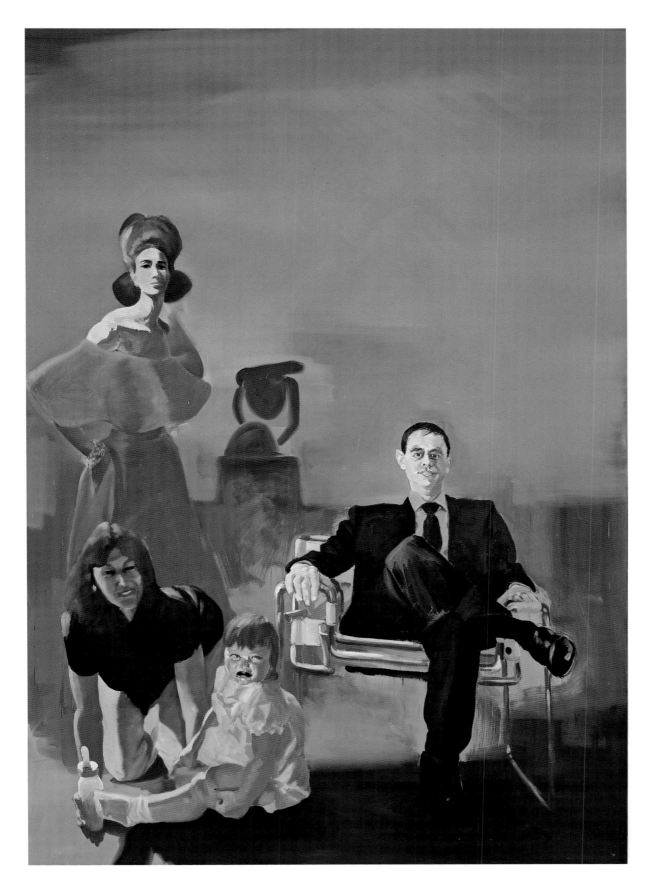

The Collector and Her Family, 1991
oil on linen
108" x 75"

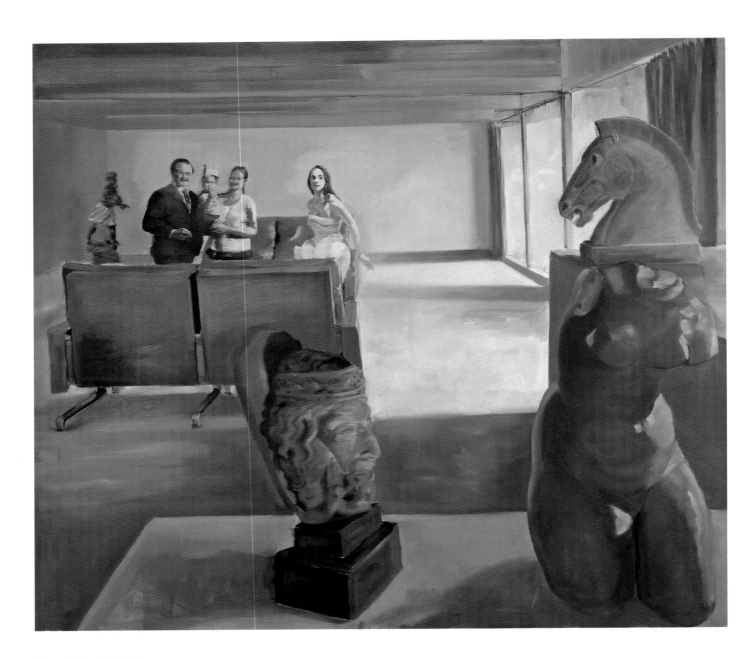

Chester's Gambit, 1991
oil on linen
86" x 98"

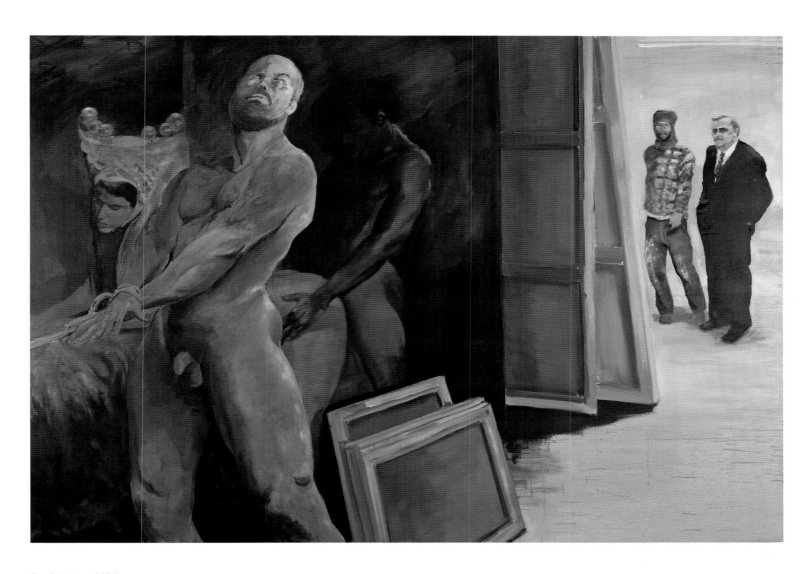

The Collector, 1991
oil on linen
75" x 108"

**Study for Sleepwalker,
1979**
oil on glassine, three
pieces
72" x 78"

Taboo

For me, the paintings that make up *Questionable Pleasure* are
investigations into whether there are legitimate taboos or not.
Certainly with a painting like *Sleepwalker* I exploded what I
thought was a taboo by showing a normal behavior that is part
of the universal growth pattern of a male. The three paintings
called *Questionable Pleasure* are definitely postfeminist medi-
tations. When feminists began questioning male desire and
male power it forced males—it certainly forced me—to re-
examine what those things meant, and whether you can adjust
yourself to something that, on some level, is genetic or biologi-
cal anyway.

Within the European tradition heroic painting was histori-
cal painting; it was also church and mythological painting with
great scenes of battle and rape. America has never had history
painting as a tradition; our heroic paintings have come through
landscape in the nineteenth century and through the existen-
tialism of abstract expressionism in the twentieth. Abstract
expressionism is about the individual freed of historical con-
straints, having broken free but nonetheless acting out against
one of the greatest symbols of history and culture—the blank
canvas. That's something that I greatly admire. Abstract
expressionism would look ridiculous if it were simply an ironic,
cynical gesture. I think, for example, that Lucio Fontana might
not have had the same resonance for us as he did for Euro-
peans, especially the French, when he started putting holes in
the canvas. But you have to believe that if nobody held the
canvas in such high regard, as an object of magical power, as
the embodiment of historical narrative, then the gesture
wouldn't have meant anything.

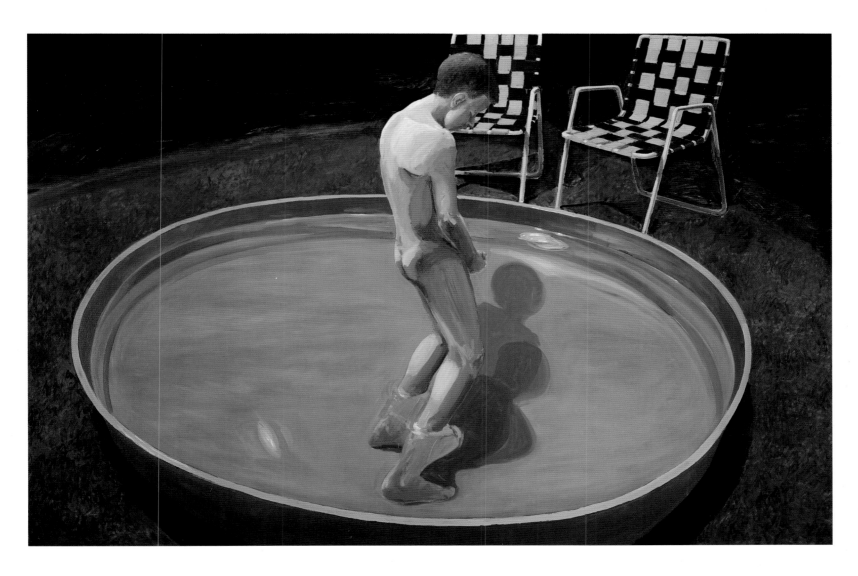

Sleepwalker, 1979
oil on canvas
69" x 105"

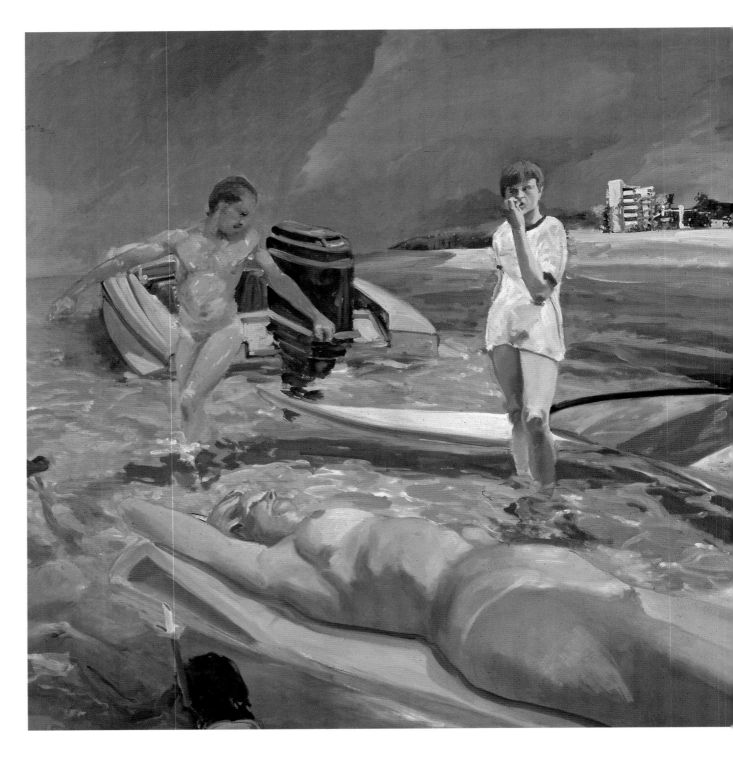

A Visit To / A Visit From / The Island, 1983
oil on canvas, two panels
84" x 168"

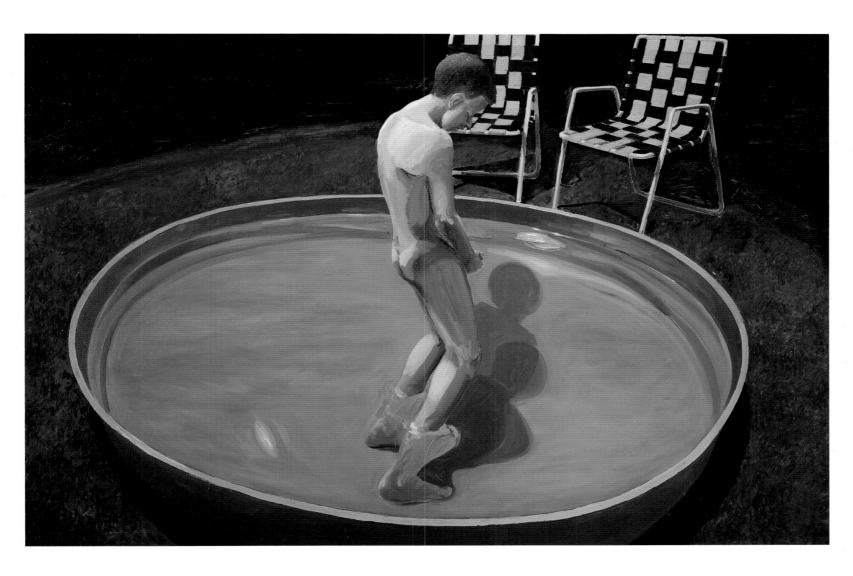

Sleepwalker, 1979
oil on canvas
69" x 105"

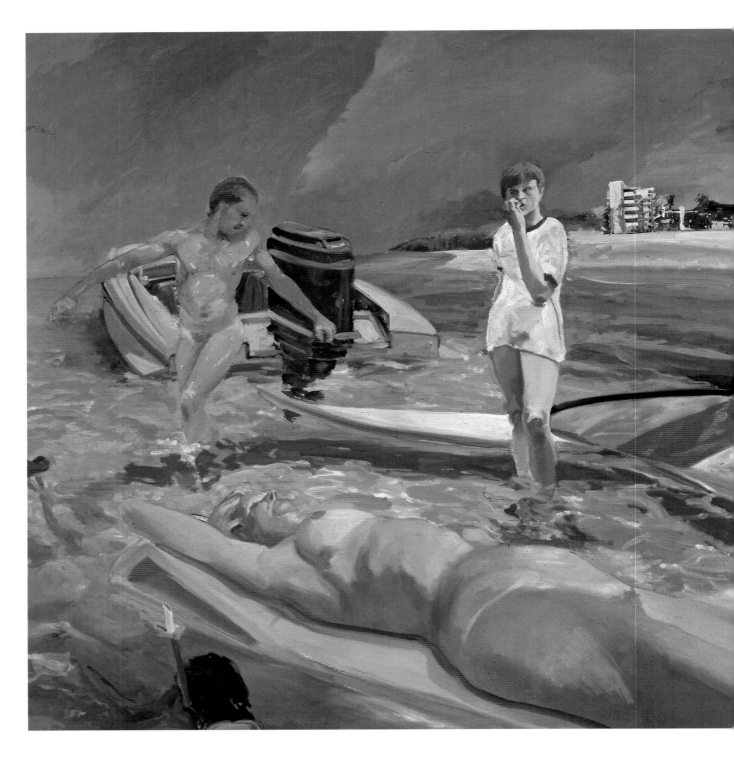

A Visit To/A Visit From/The Island, 1983
oil on canvas, two panels
84" x 168"

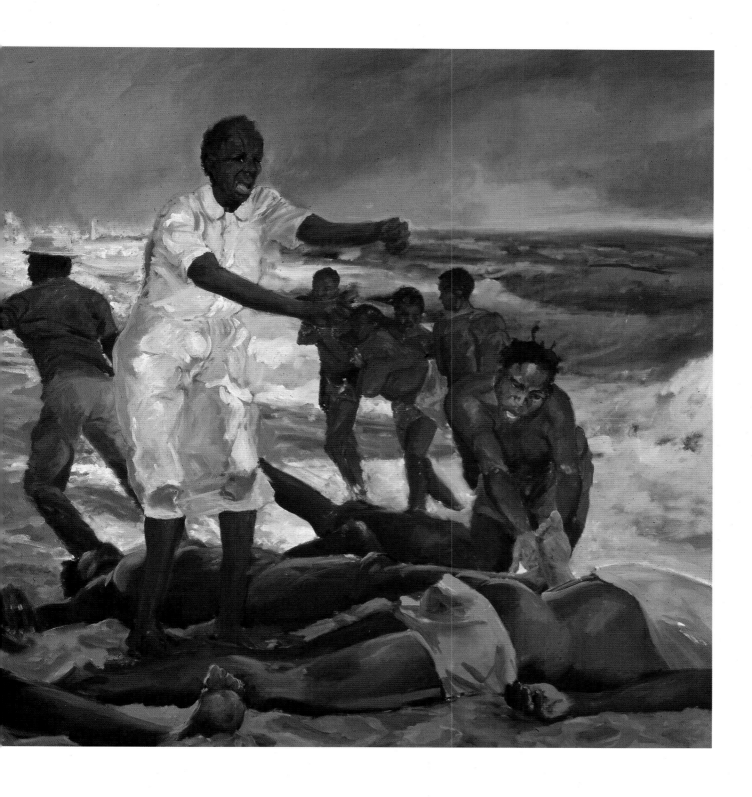

#15, 1990
oil on canvas
11" x 14"

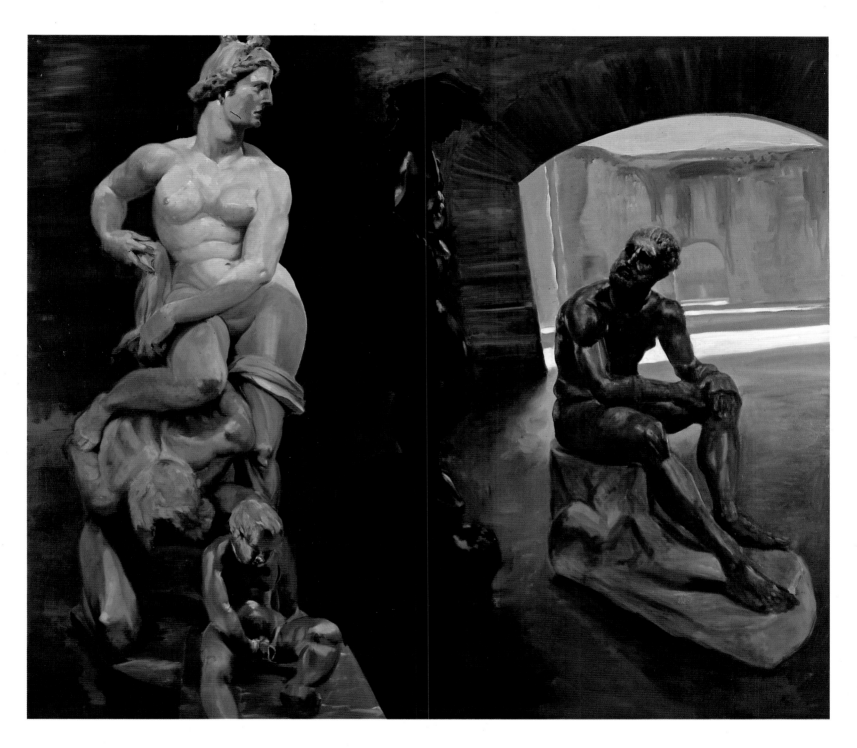

The Offspring of a Murderous Love, 1996
oil on linen
98" x 110"

Being an American in Europe, Part I

The experience of being on a beach in St. Tropez and seeing naked people interacting socially was both a revelation and an assault on my American puritanical background. I was in awe of it. I had so many mixed feelings about what I was witnessing: the confrontation with taboo, the absurdity of the taboo, and also the absurdity of the scene itself. Naked people behaving as though they were clothed has an undeniable element of comedy to it. Then there was the racial element. It's one thing to be naked, or to have your women naked; it's another thing to have a black man become part of that scene because of how we've mythologized the potency of black men. All of this was taking place and I was riveted by it. I naively thought that it was similar to being David Hockney in L.A. I thought I was naming something that was particularly French or particularly European the way Hockney named Los Angeles for Americans.

What it made me realize—and I've had this experience many times since—was that I'm an American wherever I go. India was the biggest confrontation I ever had with otherness, and there was no way I could penetrate the many layers of cultural meaning. When I look at the body of paintings I did from that trip I realize how I felt like such an outsider.

When I began the Italian paintings in Rome I was more aware. First of all, I'm part of a common culture so the language of its art, the mythologies and the Christian narratives, are familiar. At the same time, my cultural relationship to the church and to the history of Rome is very different because America, land of immigrants, has left that behind. I felt a greater loss in Rome, I think because it seemed a more spiritually unified culture. If you need to mourn—and I went there just after my father had died—Rome is the best place to do it. It's a city that is all about memory; it's all about the past and its connectedness to the present. The city that never forgets. It's also a city in which resurrection is part of everyday experience because workers knock over a stone in the road and a ruin appears underneath. The past just keeps rising back up. In Rome you live with great art, and great art talks to you about life and about death, about grief and about loss, and gives you permission to have all those feelings attached to them.

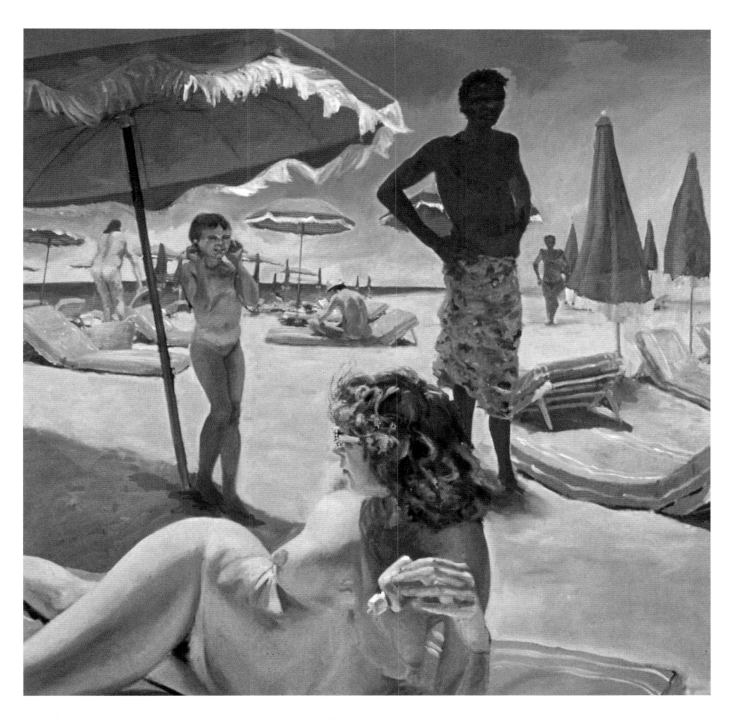

St. Tropez, 1982
oil on canvas
84" x 84"

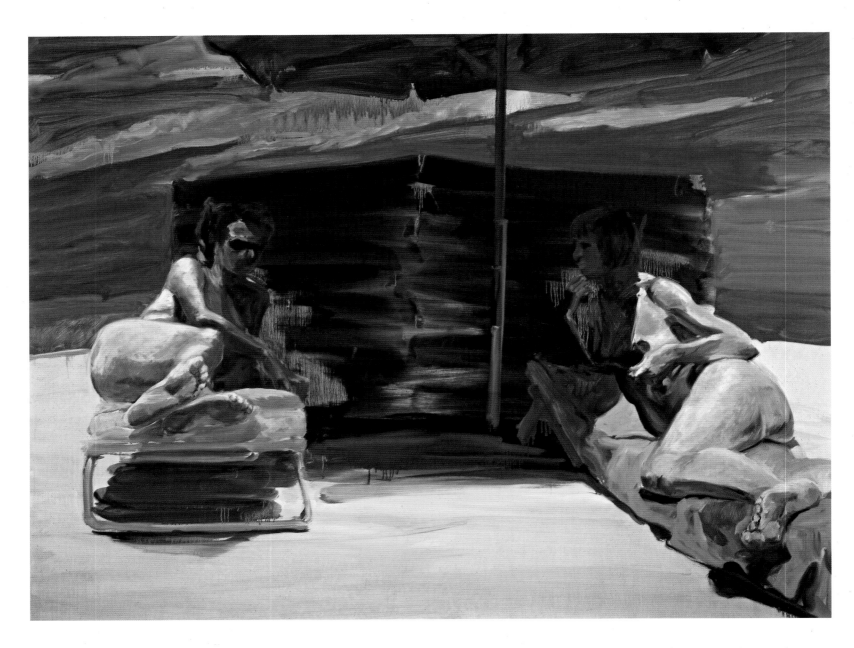

Couple In and Out of the Sun, 1986
oil on linen
60" x 80"

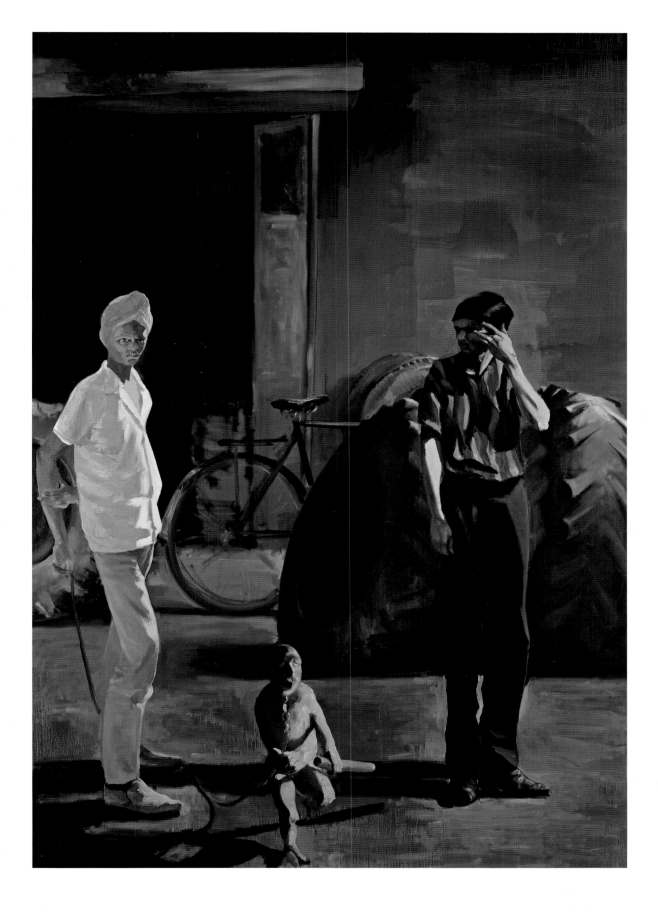

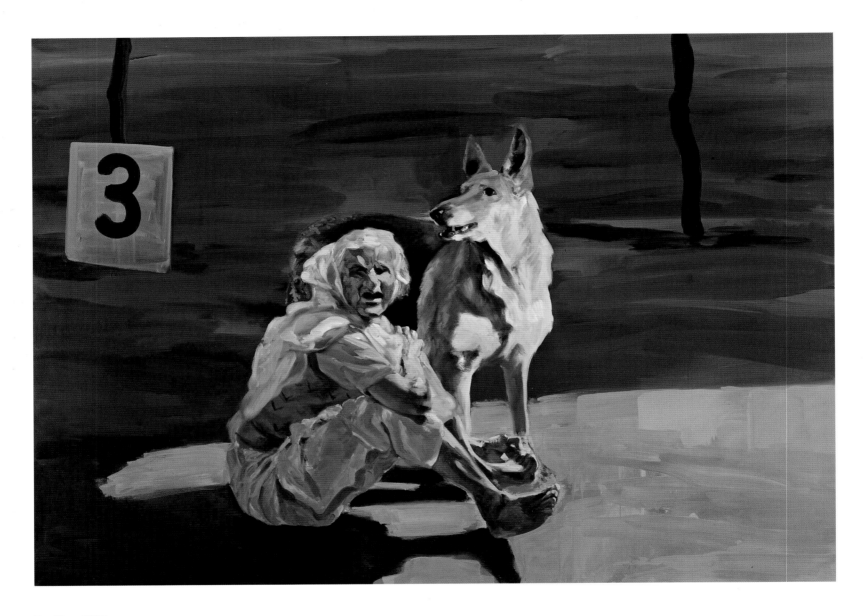

Dog Show, 1989
oil on linen
68" x 98"

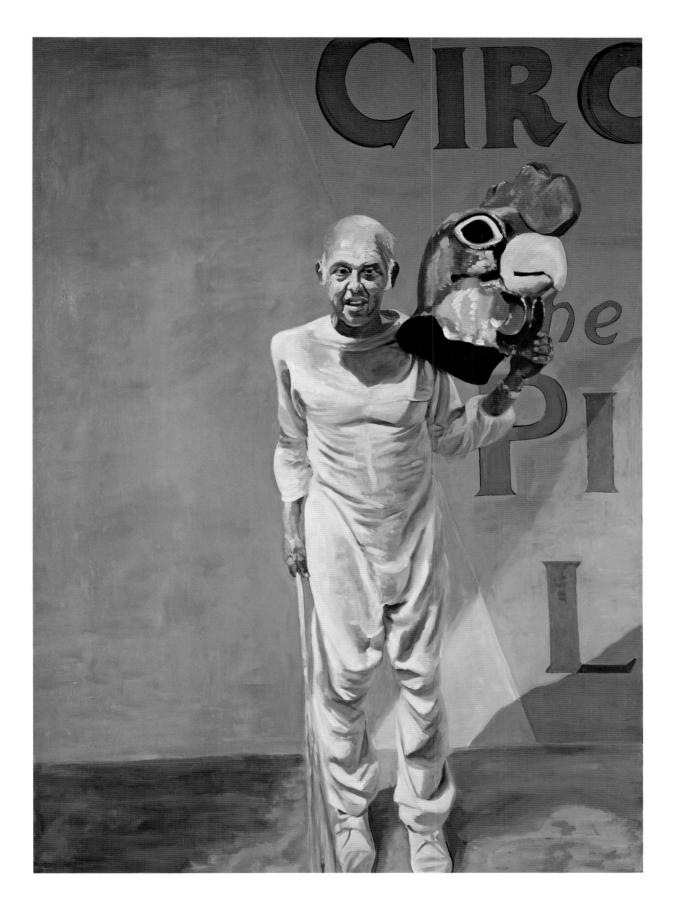

Chicken Man, 1991
oil on linen
108" x 75"

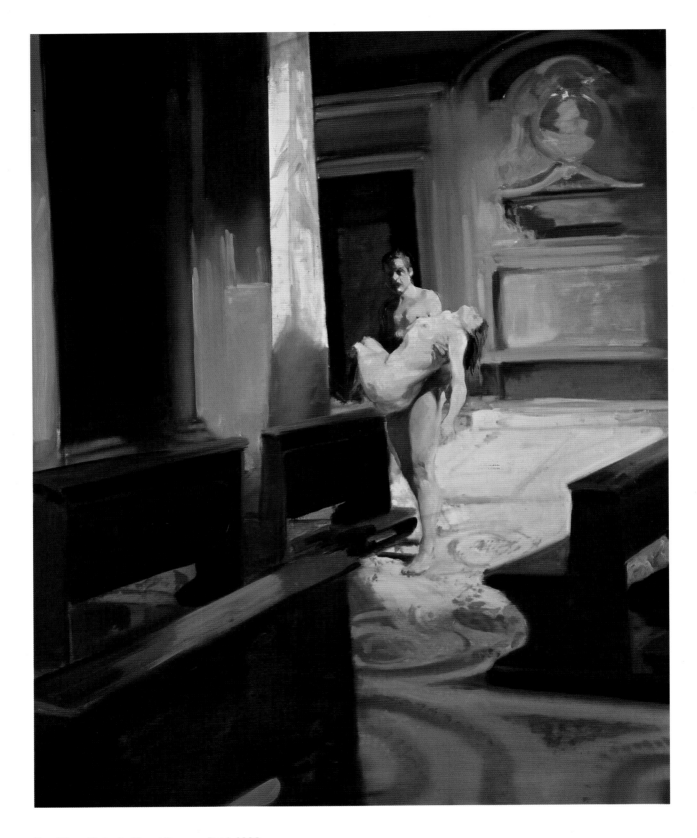

Once Where We Looked to put Down our Dead, 1996
oil on linen
98" x 80"

Untitled, 1995
oil on chromecoat
23" x 19"

Untitled, 1997
oil on chromecoat
27 ½" x 39 ¼"

A cathedral houses our smallness within its grandness. The iconography is so thoroughly integrated into the architecture that you understand it without knowing anything about it. There's an integration of architecture, art, theology, and sociology in European architecture. In America you walk into a building that you think is a bank but is actually a union hall, or a McDonald's. In Arizona you often can't tell the difference between a Burger King and a church. How architecture represents us is entirely different from our European past.

In the Rome paintings I used European architecture to express longing. It's also where I began to work with the chiaroscuro that I found so inspirational in Italian baroque painting. Those shadows and dark spaces create a profound atmosphere.

Untitled, 1995
oil on linen
36" x 42"

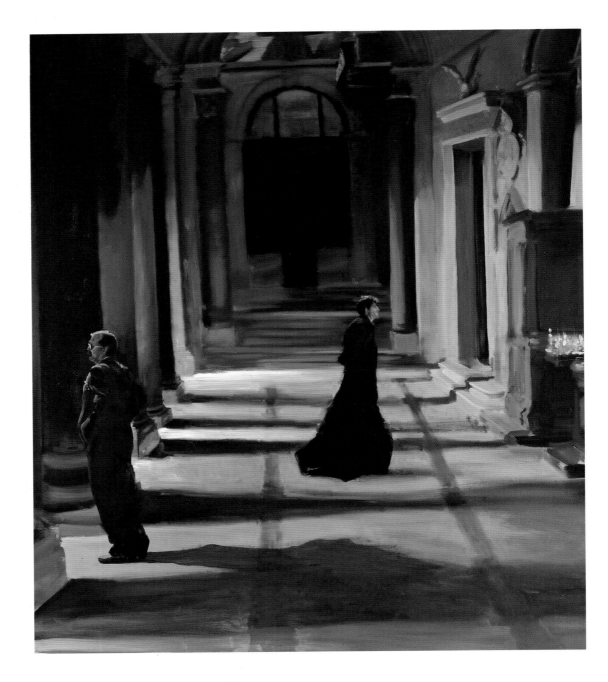

How Exciting would it be to Hear . . . (the Confessions of a Mafia Don), 1996
oil on linen
68" x 58"

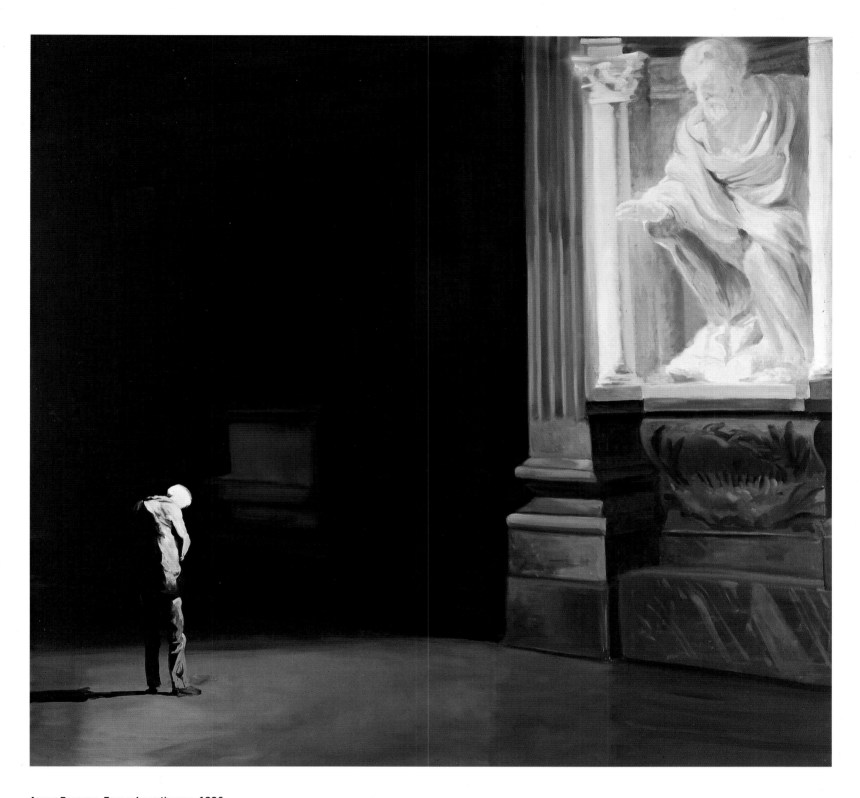

Anger, Remorse, Fear or Incontinence, 1996
oil on linen
98" x 103"

On *Why the French Fear Americans*

The painting is set against a carousel background, so there's a sense of both amusement and of life as a merry-go-round. The woman who's taking her clothes off is elderly and there's something self-assured about her. She's so confident that she must be senile. There's a Frenchman sitting on a bench passively watching. Maybe the whole thing is a projection, a fantasy on his part. But I was thinking that what makes the French uncomfortable is any break from bourgeois standards and mores, and Americans are especially capable of doing that. They're capable of gross behavior. Also, the French are appalled by the ugly body and here's a woman who clearly hasn't attempted in any way to keep herself up. I think that would be a source of embarrassment.

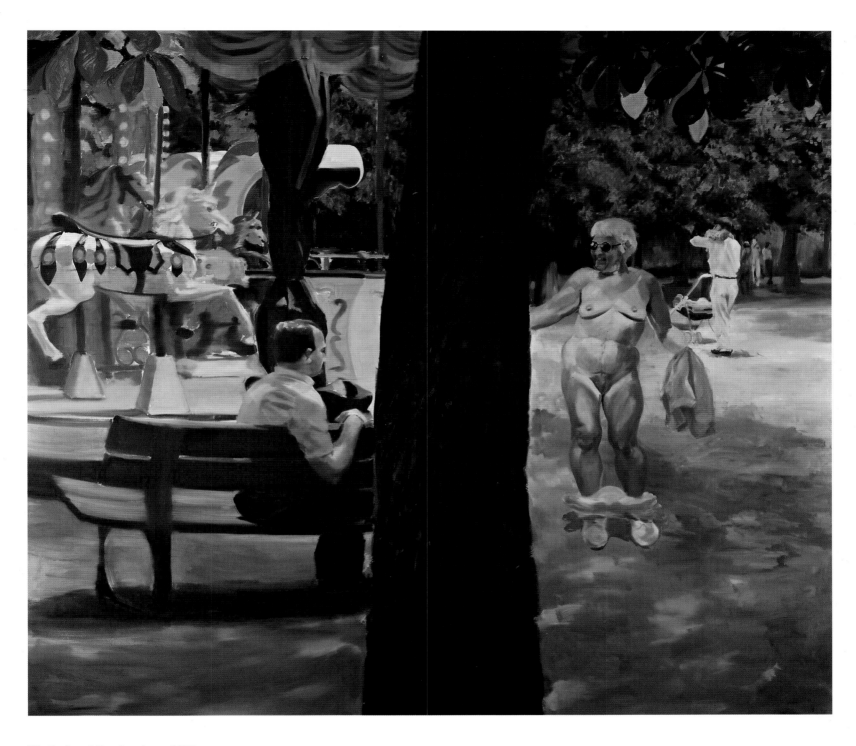

Why the French Fear Americans, 1992
oil on linen
86" x 98"

On the Indian Paintings

What was so interesting to me about India is that because the body is so hidden it becomes the same thing as nakedness. It's the opposite and therefore the same. And, of course, India is incredibly sensuous. It's so much about the senses—smell and taste and the visual. When I was there I was so happy to have an excuse and a justification for exploring other colors. You'd think I have this freedom already so I wouldn't need permission to go ahead and do whatever I want, but there is such accumulated logic to my painting strategy that it's very hard to break it. I actually needed something outside of it to say, "Well, now I'm not painting there, I'm painting here and I can go ahead and use what's around me."

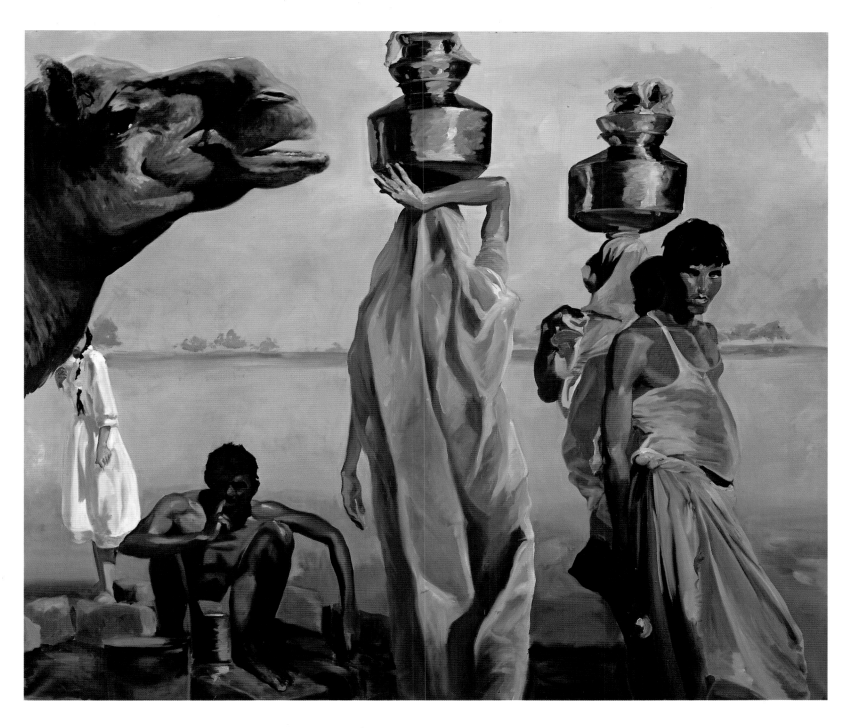

By the River, 1989
oil on linen
98" x 114"

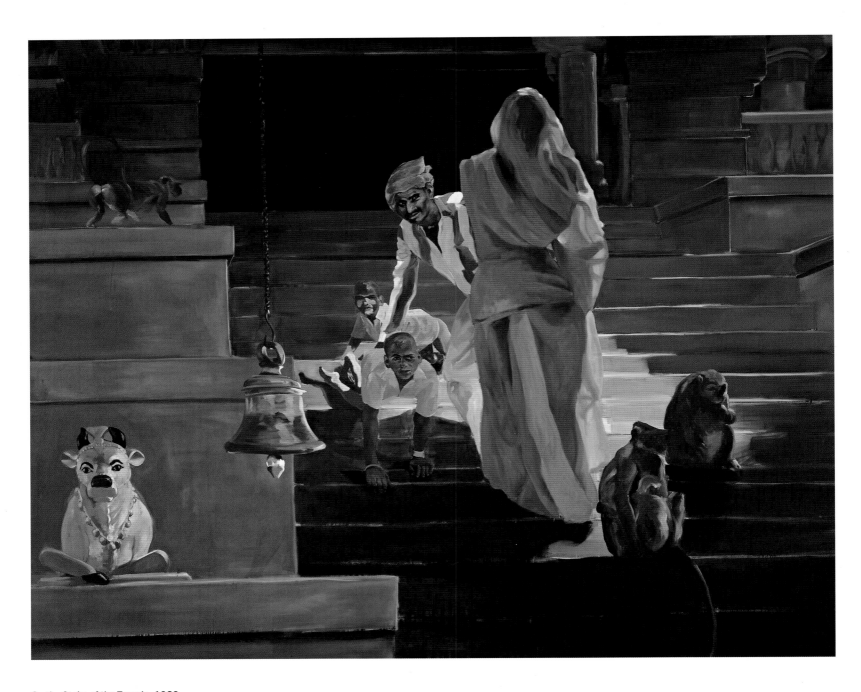

On the Stairs of the Temple, 1989
oil on linen
115" x 140"

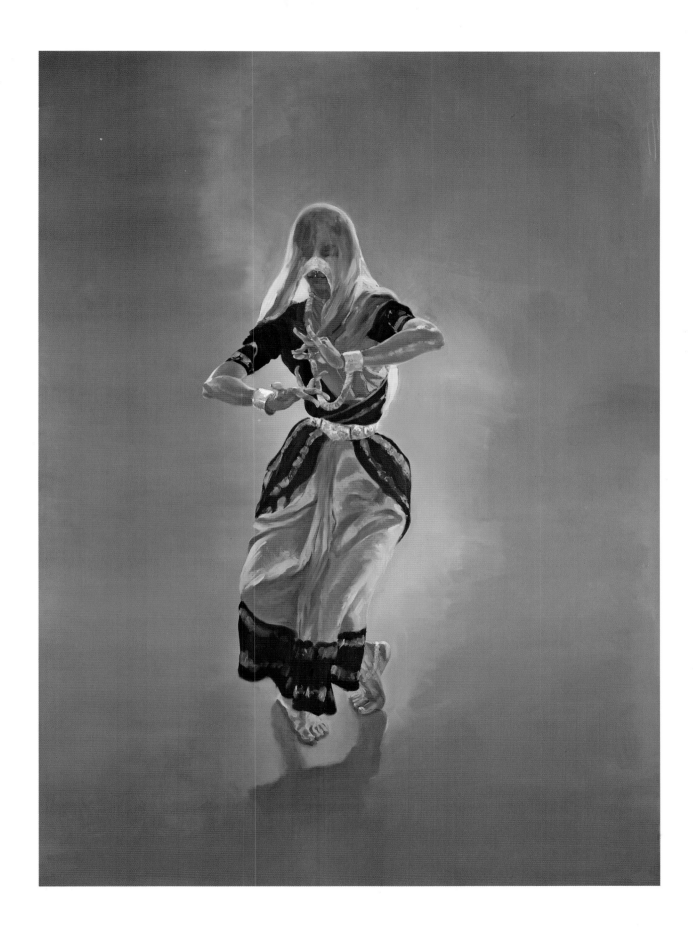

Dancer, 1990
oil on linen
108" x 75"

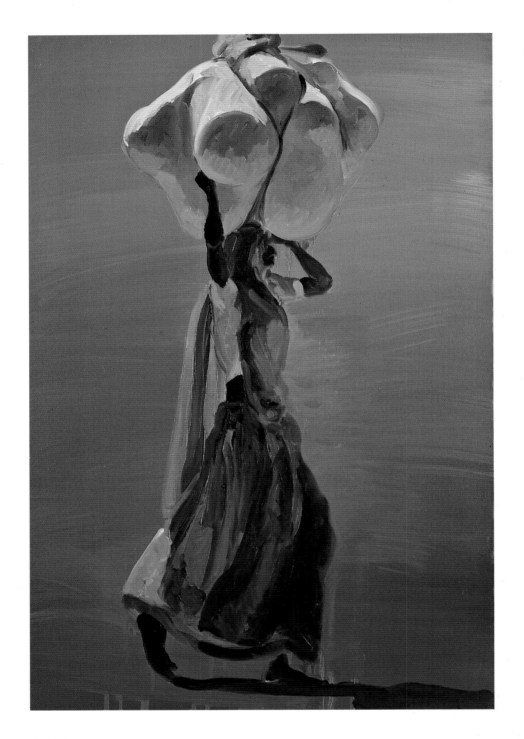

Untitled, 1990
oil on canvas
30" x 20"

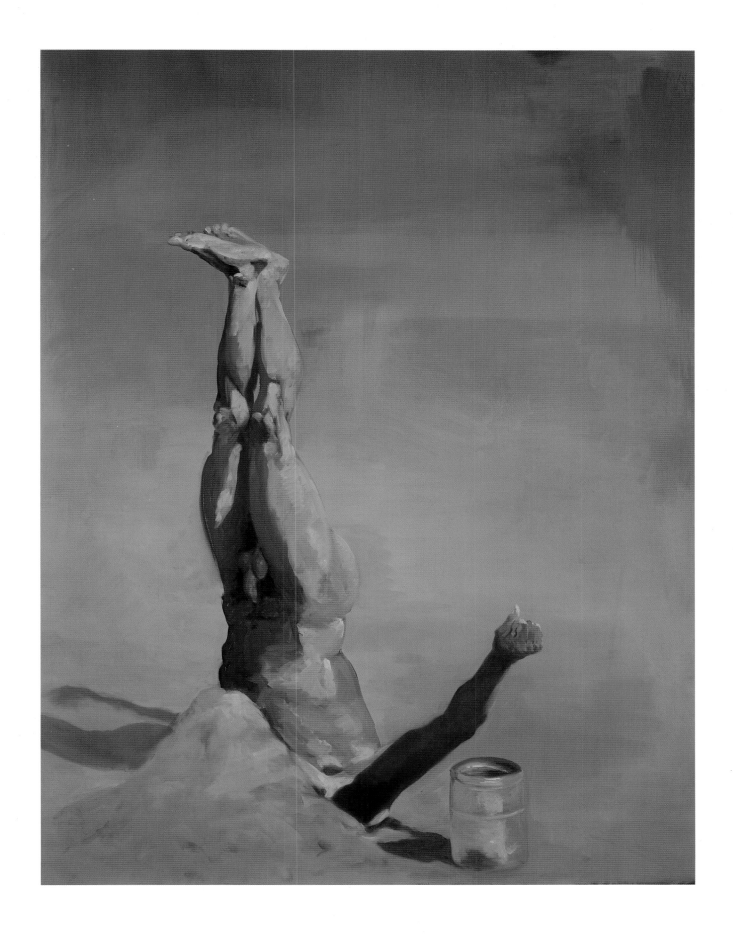

Holy Man, 1990
oil on linen
98" x 74"

On Mythology

I don't know whether it's possible to create a mythology that
would then become accepted by others, or whether it would
always remain a personal iconography. Certainly I have always
looked for the archetype so that the work has wider resonance,
but I don't think an artist can make that other leap in which it
becomes a new archetype. I can't elevate my characters to the
status of gods. The thing that I always liked about Greek,
Roman, or Buddhist mythology—and this aspect is the oppo-
site of Christian mythology—is that on a simplistic level the
human personality gets broken down into its parts and each
part becomes a god. Then they interact. And because the gods
are not that concerned with humans, sometimes they come in
and fuck us up, or worse, ignore us. But what's instructional is
that it gives humans a chance to observe behavior: when you
see a god who is obsessive or mischievous, you can also find
human equivalents. Whereas with Christianity, rather than get-
ting to observe the gods, it's one God observing us. It's a little
harder to live by.

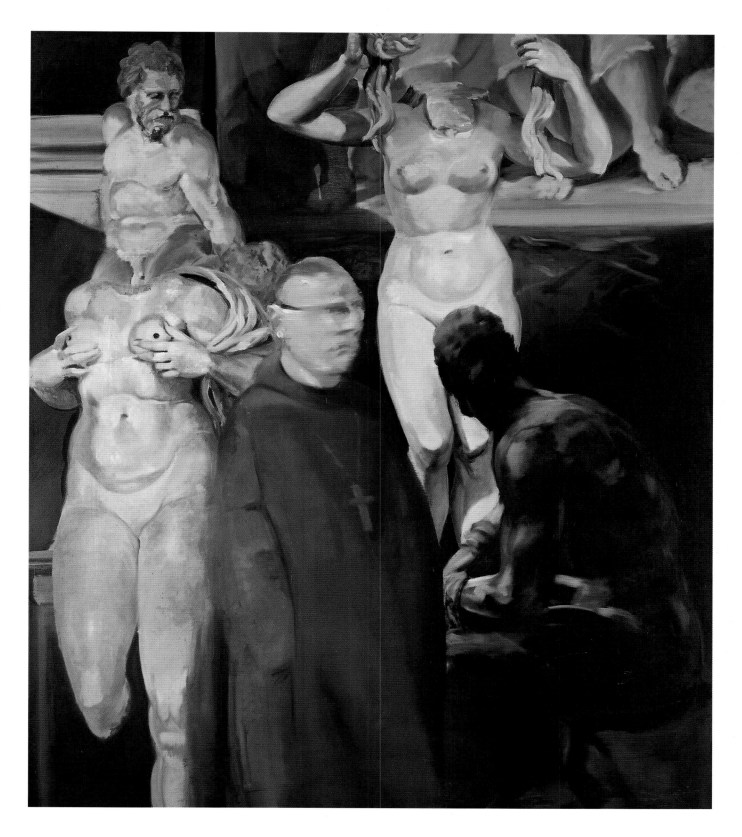

Cyclops Among the Eternally Dead, 1996
oil on linen
65" x 55"

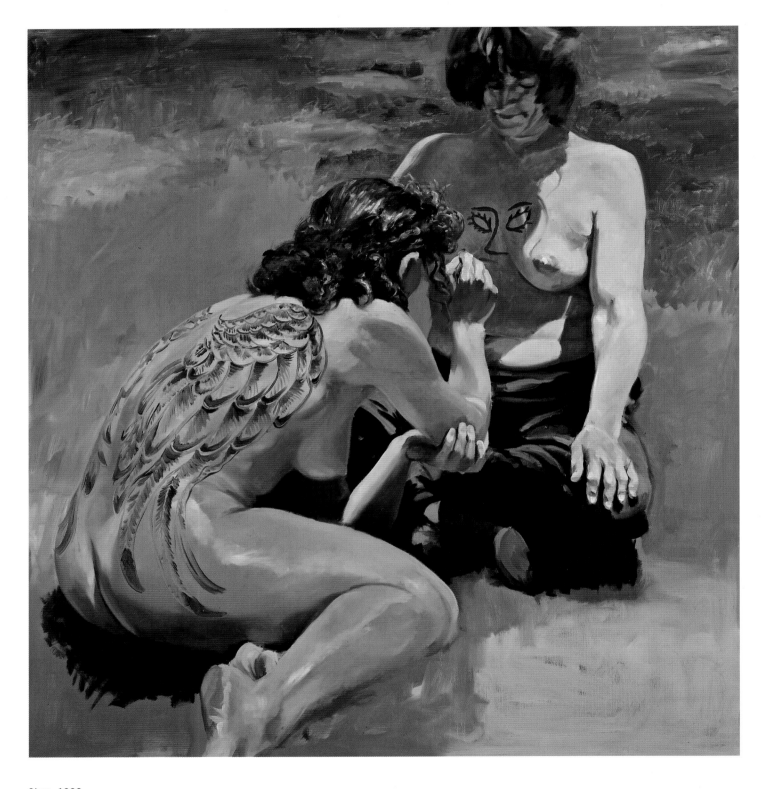

Slave, 1993
oil on linen
58" x 54"

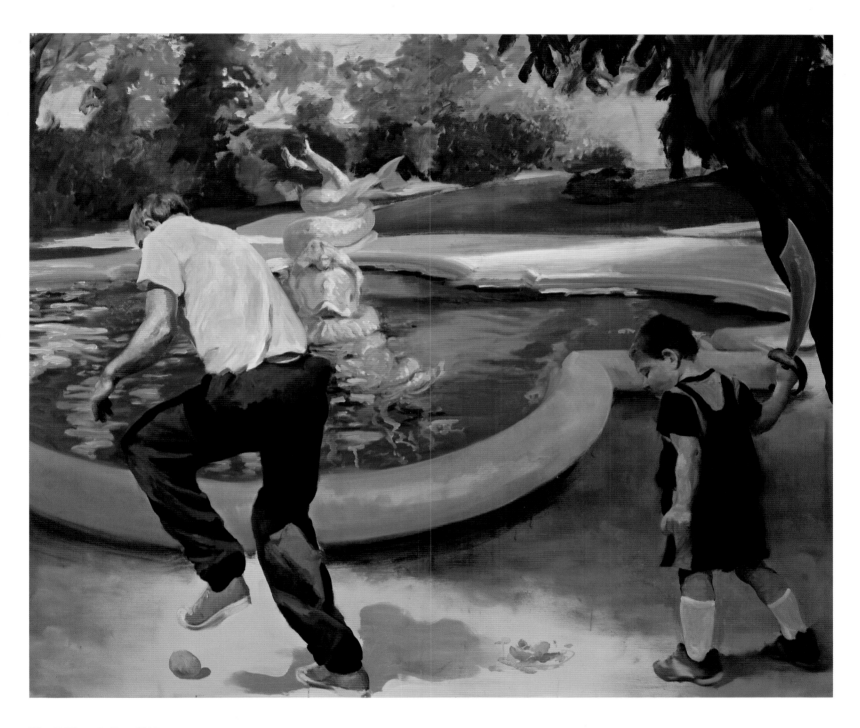

What Fell from the Tree, 1997
oil on linen
58" x 68"

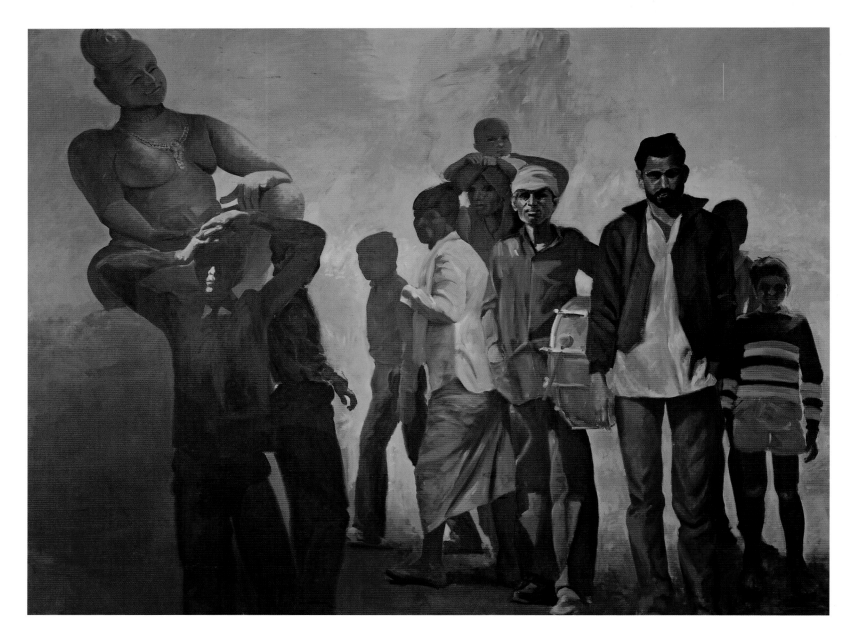

Kowdoolie, 1990
oil on linen
98" x 130"

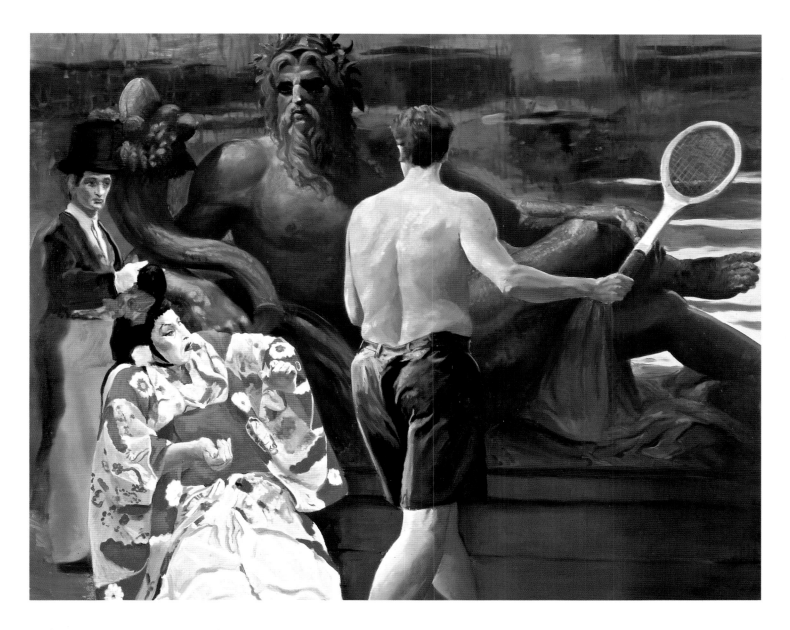

Busting Up the Raree: Homage to Fellini, 1994
oil on linen
80" x 98"

Busting Up the Raree is a painting that slips from narrative into a dreamlike allegory. It has a circus atmosphere and I never pinned down its meaning. What struck me was that the figures are all males, and they're all different kinds of males. There's the river-god sculpture, who's obviously a father figure. There's a maitre d' or ringmaster miming an introduction of sorts. There's the drag queen who's dressed as Madam Butterfly, acting out hara-kiri with a chopstick. Then there's the tennis player, who's not a professional but an amateur. They're all amateurs or stand-ins. They represent forms of identity and false identity.

Best Western Study, 1983
oil on canvas, three panels
80" x 84"

On Memory

From the mid-1970s to the early 1980s I wasn't using any photographic sources. I was painting from memory. Memory has a particular legitimacy in terms of experience. I was there, so it was first-hand. I insisted on working from memory, and that also meant memory of form as well as memory of event. How many times have you looked at somebody's arm? You should be able to remember what it looks like. Let's see if I can draw it; let's see if I can paint it. How well can I remember light hitting fingers; do I have enough information? I thought there would be a hierarchy of intention based on those things that were most vividly recalled, so that by the time I'd moved to the tree out-side the house it was barely indicated because it really wasn't something my memory was focusing on.

There are many different layers of memory. There's tech-nical memory—that is to say, the structure of an arm. There are gestures, which become psychological or emotional and take you into other kinds of memory. There are memories of light and color; the list is quite extensive. Max Beckmann was a memory painter. What's so fascinating about his work is that there are some things that he's absolutely obsessed

about getting right and they become overworked in relation to other things. So he might paint and scrape off and paint and scrape off and paint and build up a woman's arm, but when it comes to her other arm, it's just a silhouette. He's really only interested in this one arm and what it's holding. When you look at his paintings you start focusing on the same things he focused on. He sits at the opposite end of a spectrum that includes Degas, who realized hierarchies of focus through photography. Degas was more a rationalist in his painting, more a realist in that sense.

Best Western,
1983
oil on canvas
108" x 78"

. . . So She Moved into the Light, 1997
oil on linen
74" x 98"

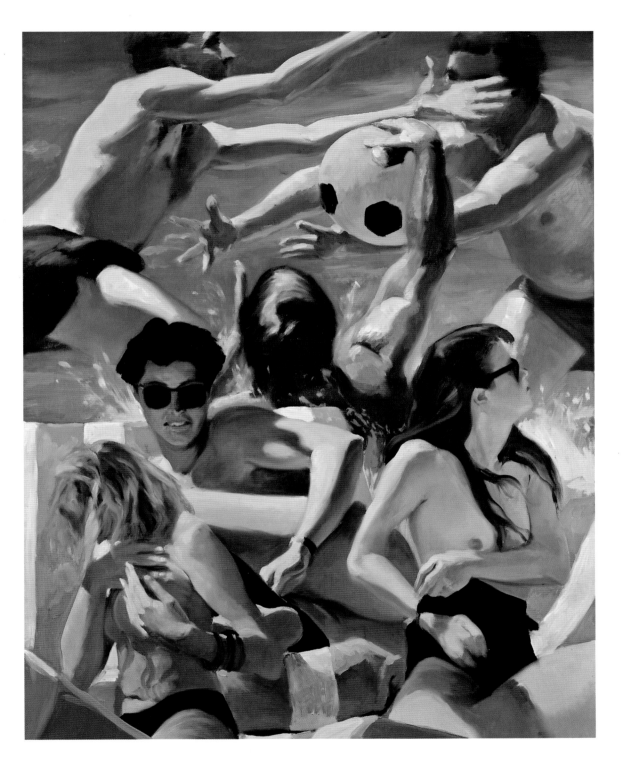

The Call of the Ball, 1993
oil on linen
65" x 50"

Untitled and *Dog in God House*

The balloon that turns up in some of the Roman paintings is a kind of punctuation, a kind of comic relief. I set it against a heavy spiritual, religious, and orthodox weight. One great thing I've discovered about Italians, especially Romans, is that they have such a natural way of being with their church. You go into a cathedral and there's a wedding going on but there are also busloads of tourists walking around and people taking photographs of the wedding in progress. Rather than anyone stopping and saying, "Hey, could you leave, this is serious, it's a wedding, and this is the House of God," the attitude is, "Of course there are people everywhere and everyone is doing something different." They don't have the same reverence we have about priests and nuns—they treat them like people. In Rome people even bring all their animals into church to be blessed.

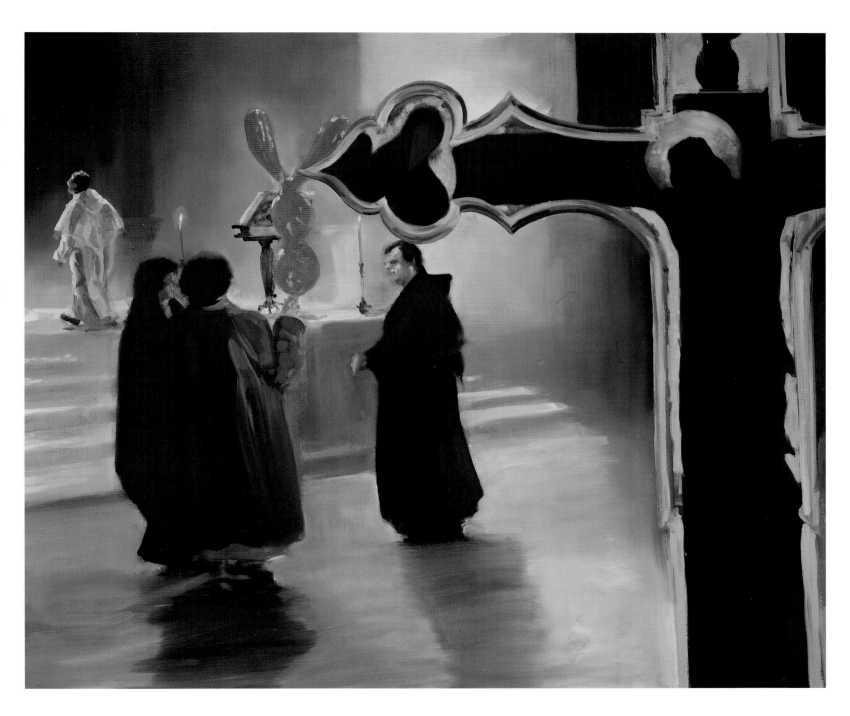

Untitled, 1998
oil on linen
55" x 65"

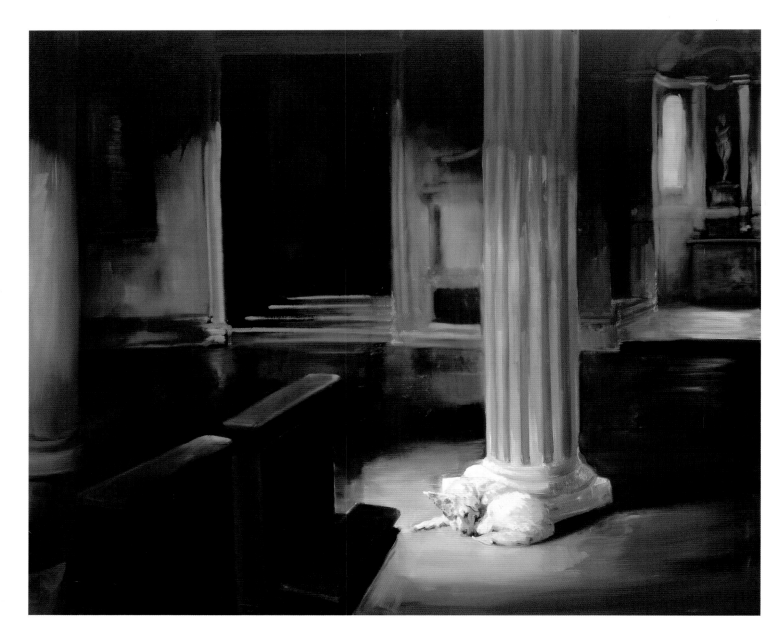

Dog in God House, 1997
oil on linen
55" x 65"

If the Dead had Ears, 1996
oil on linen
80" x 98 ¼"

Untitled, 1992
oil on linen
58" x 54"

Once I was walking through a show in Baltimore of the baroque painter Bernardo Strozzi. I was with a friend of mine, Jack Stephens, who's a writer, and I started talking about how the problem with contemporary art is that it has reduced the world to a shadowless environment. In doing that it got rid of that part of the mind that can be scary and sudden. I was lamenting it because it's a real part of our imaginative nature. Instead we've created an electric environment that tries hard to eradicate shadows because we're afraid of the evil that lurks within them. What we are left with is some mighty flat painting.

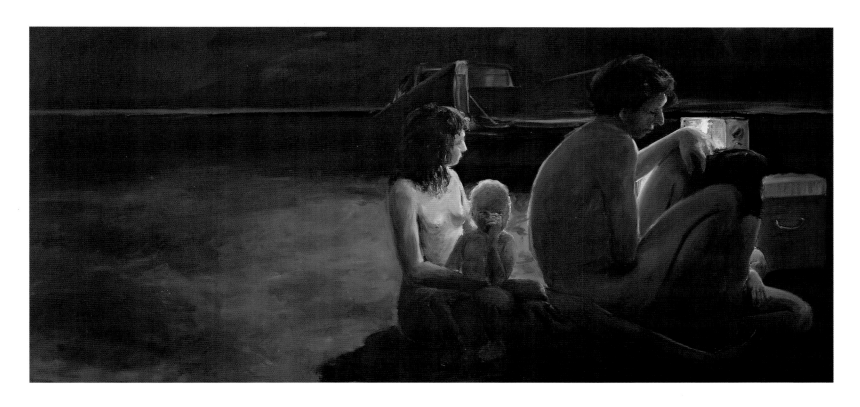

Overnight, 1981
oil on canvas
51" x 108"

I think my work has been getting better and better. For example, *The Travel of Romance* is one of the most poignant meditations I've ever done on desire. That sequence is a summary of adult life; it's something that I could only have understood in midlife. The paintings started out as one scene in which you see a crouching woman. I don't think I've ever made a more egglike figure. She has a look on her face of such distance. A black man is trying to rouse her out of it, trying to engage her in some way. He's so animated. I realized when I did the painting that I was looking at two people in the closest possible proximity and I couldn't look at both of them at the same time. They existed in such different realities and each one was so absorbing that the minute I looked at her I couldn't see him, and when I saw him and his animation, I lost her. I started thinking, where are these people and what is this a meditation on? There was a suitcase in the back of the painting so I thought about travel. Did they travel to this room or were they trying to leave it? Who are they in relation to each other? I thought I'd expand it because it seemed so strange to be so close and yet not be connected at all. I wanted to know more about the situation. I wondered whether one was a figment of the other's imagination. It turned out that in the next four paintings, while the black man physically disappeared, his presence was always represented by a tapestry, a mask, or in some other way. Although you never saw him again, her gaze was always in response to his presence. She went through this transition during which she moved around this small environment over the course of a day; she went from a fetal position to a woman crawling across the floor, to standing and then bending and finally back to a fetal position. She actually describes the course of a whole life.

The other element is the light, which became more and more obliterating as she approached the end of the drama. By the time she had shrunk back into her fetal position, the light was both annihilating and absorbing.

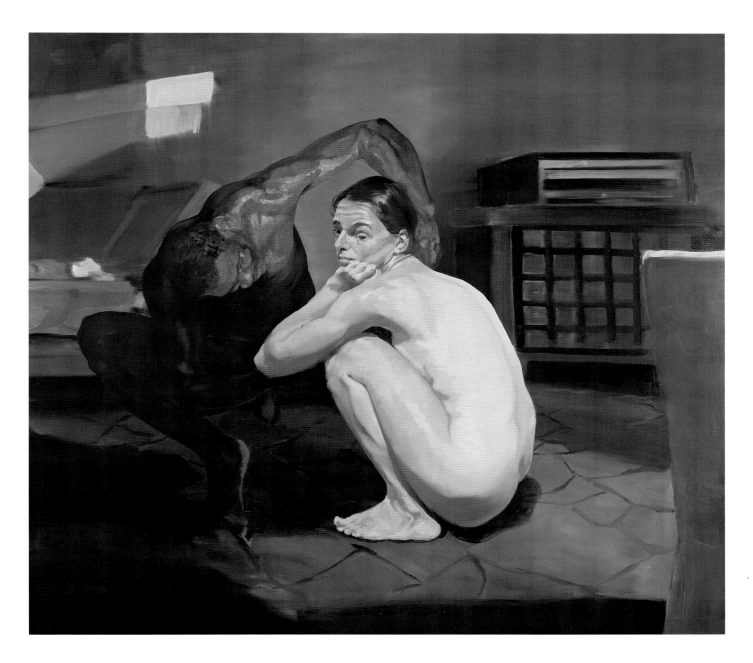

The Travel of Romance, Scene I, 1994
oil on linen
58" x 65"

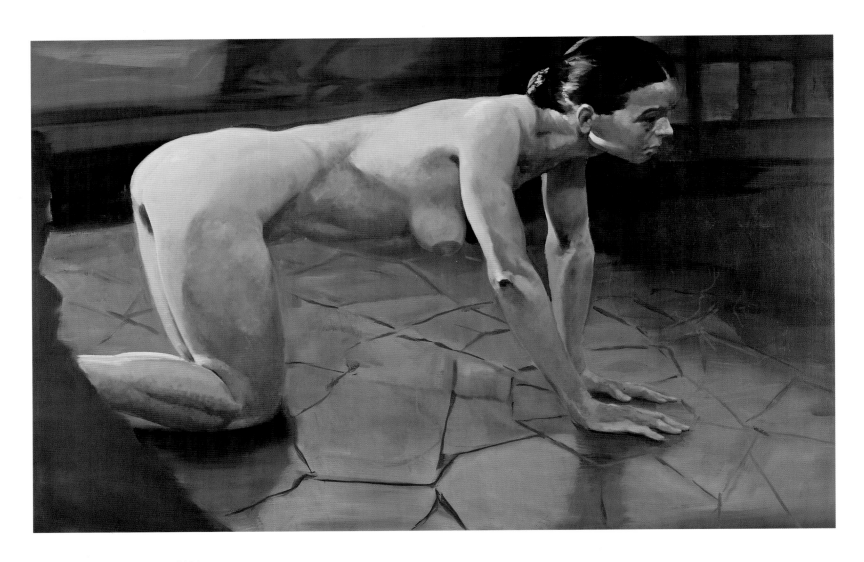

The Travel of Romance, Scene II, 1994
oil on linen
45" x 70"

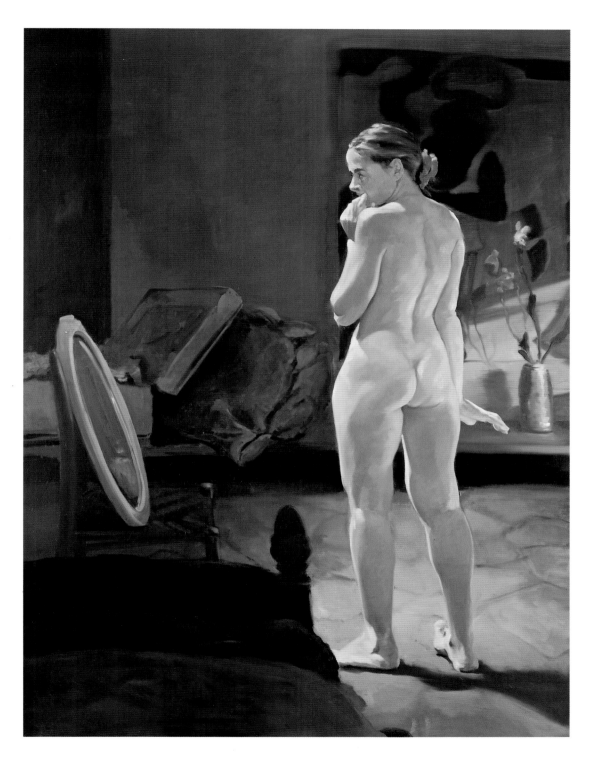

The Travel of Romance, Scene III, 1994
oil on linen
72" x 54"

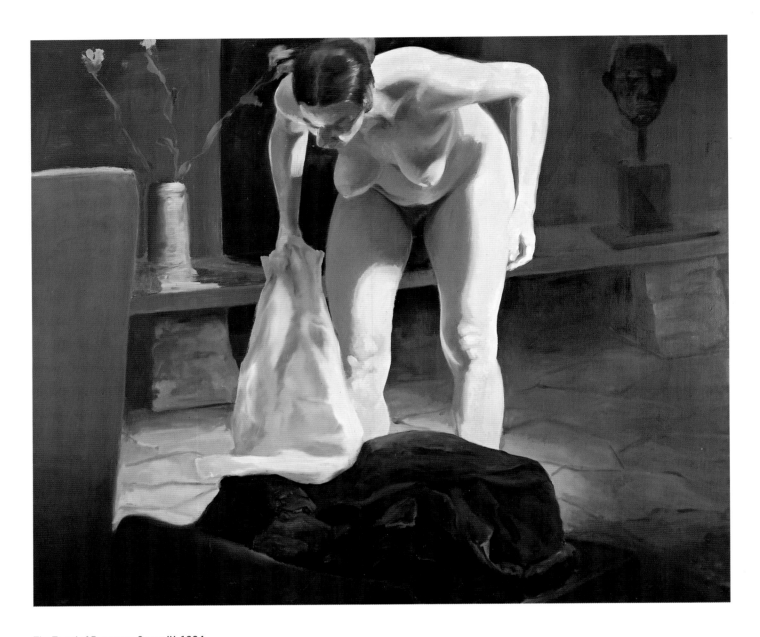

The Travel of Romance, Scene IV, 1994
oil on linen
55" x 65"

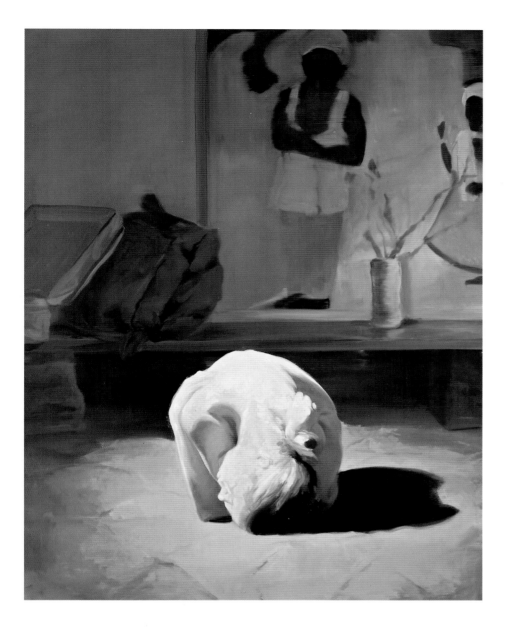

The Travel of Romance, Scene V, 1994
oil on linen
70" x 54"

On the Theater of Painting

As much as I think about film, my work feels more like theater. It's more a stage set; there's more artifice than there would be in film. The thing that separates film and theater is that theater puts the onus on the actor in a different way. Live performance, the need for actors to create an imaginatively real space out of something that isn't real and the pressure to sustain that imaginative space is incredible. Painting, and the act of painting, has that pressure too.

On *Questionable Pleasure*

Questionable Pleasure is an ironic and coy title I gave to a suite of three paintings having to do with aspects of male desire within a self-conscious, postfeminist world. Two of these paintings are of a woman posing or acting in a provocative way. She bends and twists as though you might have instructed her to do this. Or is she presenting herself to you in that way, or is she totally oblivious of your presence? Whether it's self-directed or ordered, it's still a question of pleasure. In the third painting she's frontal and absolutely exposed and I think extremely vulnerable, which in some way reframes the nature of the two other pictures. She is innocent, she even seems childlike, and that changes the nature and impact of your fantasy.

I think of posture and pose as different things. Pose is an abstraction of the body and is something that artists have used to deal with formalistic problems in painting. It's about aesthetics, beauty and proportion, about line and shapes expressed through the forms of the body. Posture is body language; posture is the shape the body takes based on the accumulation of experience. So it's through posture that you gain insight into the person. It is also the signal to tell you how to respond, because you can tell whether someone is aggressive, angry, frightened, hurt, vulnerable, or impenetrable by their body language. It's something that's so instinctual, so innate in us, that we perceive it very quickly. For me, the movement between pose and posture always involves a flip-flop. What I'm after is the point at which the body could read one way and then be quickly undermined to bring in a more complicated set of conditions. So in *The Philosopher's Chair* if she's undressing, then his questions are about what will be next: if she's dressing, then they're about what has been. One set of questions would be his because of how clearly introspective and not quite in the moment he is. If it's about what's going to happen, then it's filled with performance anxiety or some level of doubt. Do I really like her body, is this somebody I want, why did I invite her here, what's going to happen after? It becomes this thing where he projects a number of questions. In the painting his zipper is open. Again, is he already dressed and that's the last thing to do, or is it the first thing done? The other thing is that the shape of the open fly is vaginal, a pointed ovoid thing that could be part of his anxiety. Has impotence rendered him female? Is that also something that he's thinking about?

Questionable Pleasure, I, 1994
oil on linen
70" x 45"

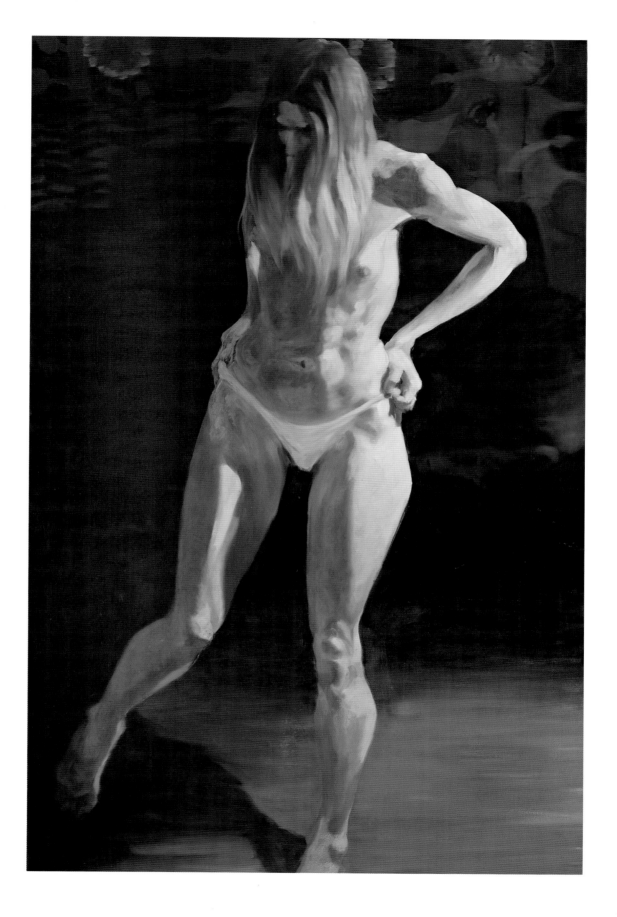

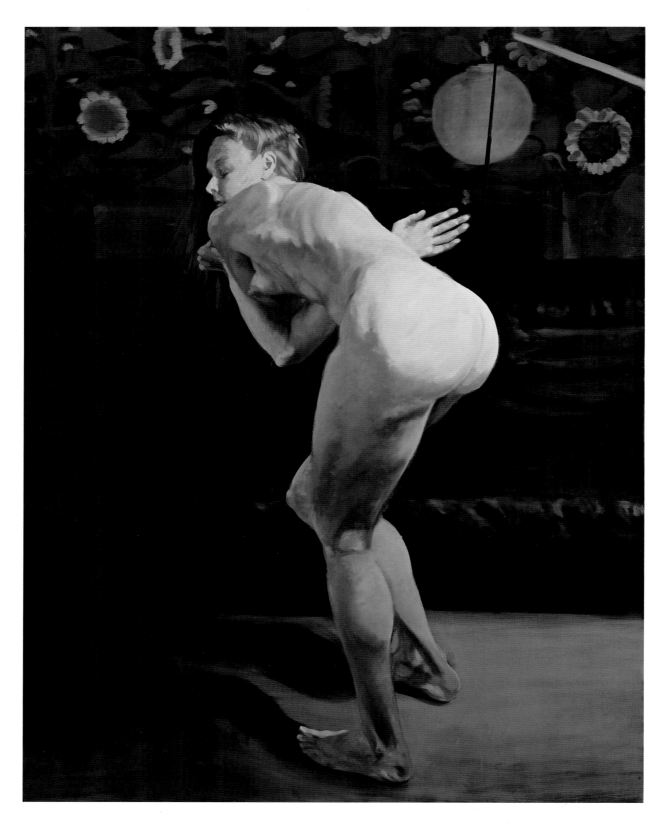

Questionable Pleasure, II, 1994
oil on linen
70" x 54"

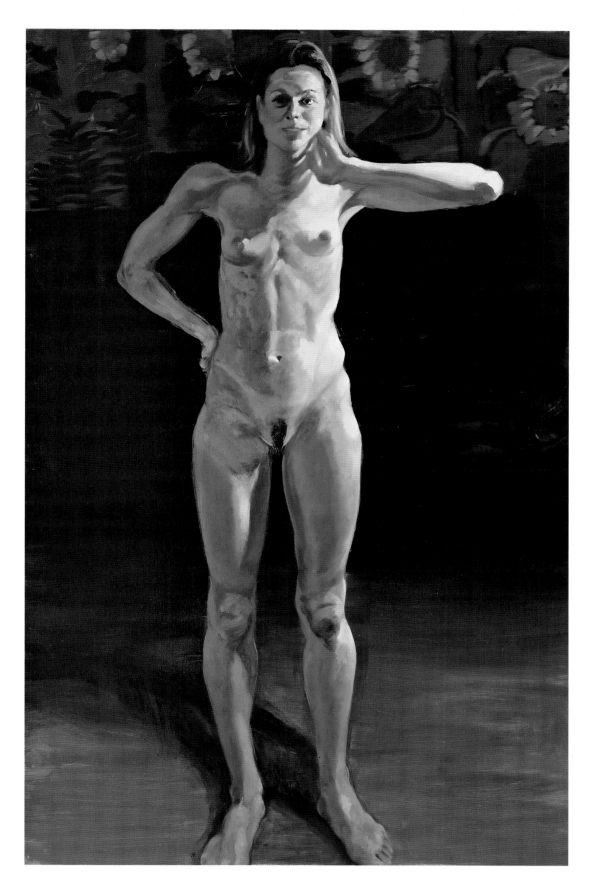

Questionable Pleasure, III, 1994
oil on linen
70" x 45"

On *Reflection II*

There is actually a series of five paintings on this theme. Three
survived in sequence and one was changed and taken out of
the sequence. I finally did not insist on them being together.
You see a woman sitting on the corner of a bed. It's dark inte-
rior space, and because there's light coming from some source
behind her that illuminates part of the bed, there's the impli-
cation that she may not be alone. In a few of the paintings
there actually is a pair of man's glasses on a bedside table.
The implication is that maybe they had finished having sex
and he went to clean himself off, or he went off to the bath-
room in the middle of the night and woke her up. Whatever it
is, she's in an introspective space as she sits on the edge of
this bed. In the first one she's leaning forward inspecting her
hands. They are actually quite large in the painting, and she is
looking at her wrists. It has a feeling of eerie, suicidal medita-
tion. In the next painting she sits back as though maybe the
thoughts she had been having jolted her into that position.
When she comes forward again in the third painting she's
grasping the bedclothes; and then in the fourth she's standing
on the bed holding the sheets up to her. The light is dawning
so the room keeps getting lighter and lighter. She holds up the
bedclothes almost like a wedding gown. In the fifth one she's
standing totally naked. In a way these paintings are this
woman's journey from darkness to light and from a death med-
itation to an affirmation of life.

Whether I'm working with a single painting or a series, the
search is always the same: I'm trying to find a summary way of
expressing these feelings. Sometimes within a single painting
I'll go through the sense of the narrative without being able to
actually feel enough detail to go from one particular moment
to the next. In other cases I find—as with this woman—that I
knew her in such detail I was able to paint the whole thing
without losing interest in it. Each painting led me to the next.
It was a way of amplifying the first picture, trying to see if it
would go in a different direction, trying to clarify the feelings I
already had. The reason I separated them and didn't insist on
the entire journey was that the more she moved into the light
the more projected and visual the whole thing became. The
last two have beautiful light and color, and in the last one the
flesh is particularly wonderful. So they took on a sensuous and
erotic quality independent of the narrative.

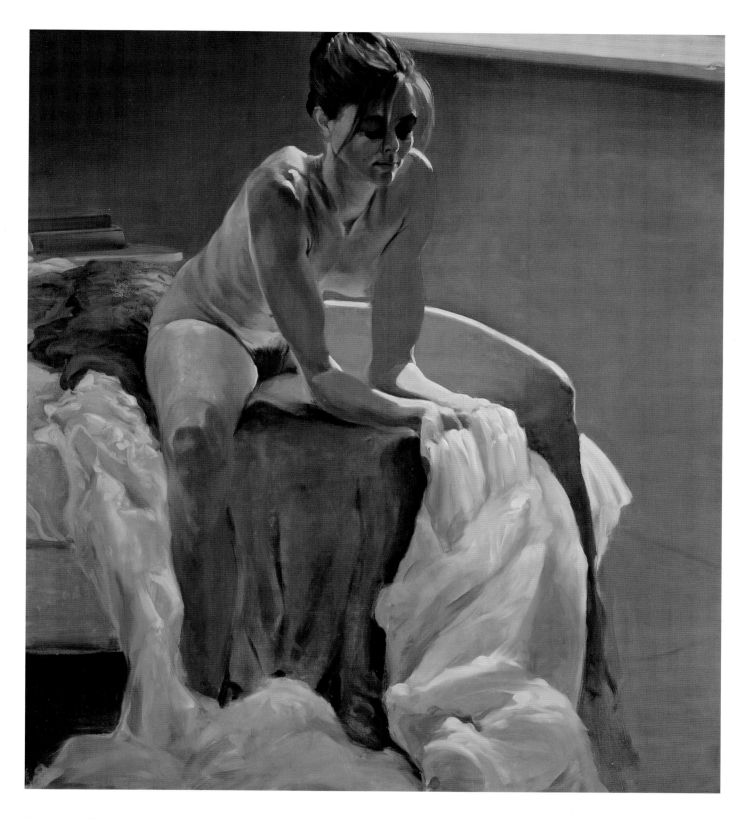

Reflection II, Who, 1995
oil on linen
65" x 58"

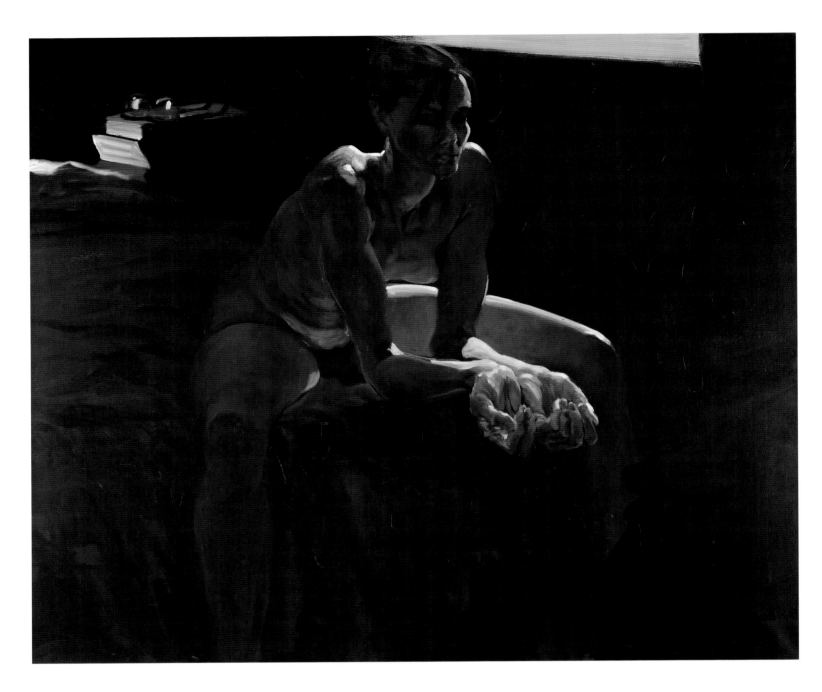

Reflection III, When, 1995
oil on linen
55" x 65"

Handwritten on drawing:
Let us suppose.

The fat man's the Groom
Watch him go around the room
zoom zoom

The Fatman's the Groom, 1988
charcoal on sketchpad paper
23" x 29"

On the Body

I just can't imagine a person one hundred percent comfortable in their body. Ever. There are moments when the body becomes awkward and difficult and betrays your internal life. I'm interested in things that look like one thing and then become something else; and flip back and forth. That has to be true of bodies as well. I've used gestures of the body as a way of expressing two kinds of realities; one is the motor response to an action, and the other is a psychological response that torques the body in a certain way. Somebody could simply be turning because they hear a voice off to the side, or they could be turning away because of an internal thought that caused their body to react reflexively. The same movement could be perceived as incidental and understood as poignant.

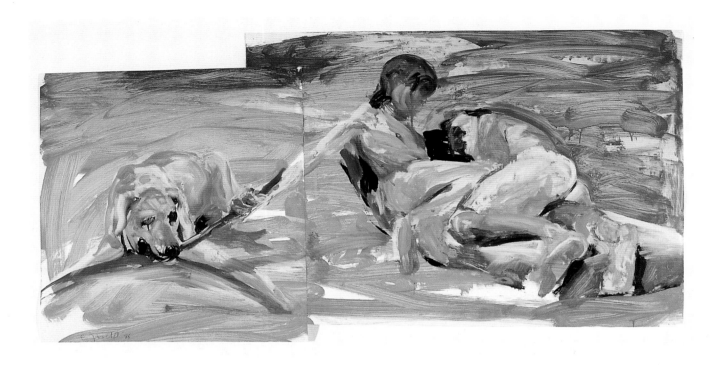

Untitled, 1985
oil on paper, two
pieces
26" x 54"

Untitled, 1985
oil on paper, two
pieces
24" x 17"

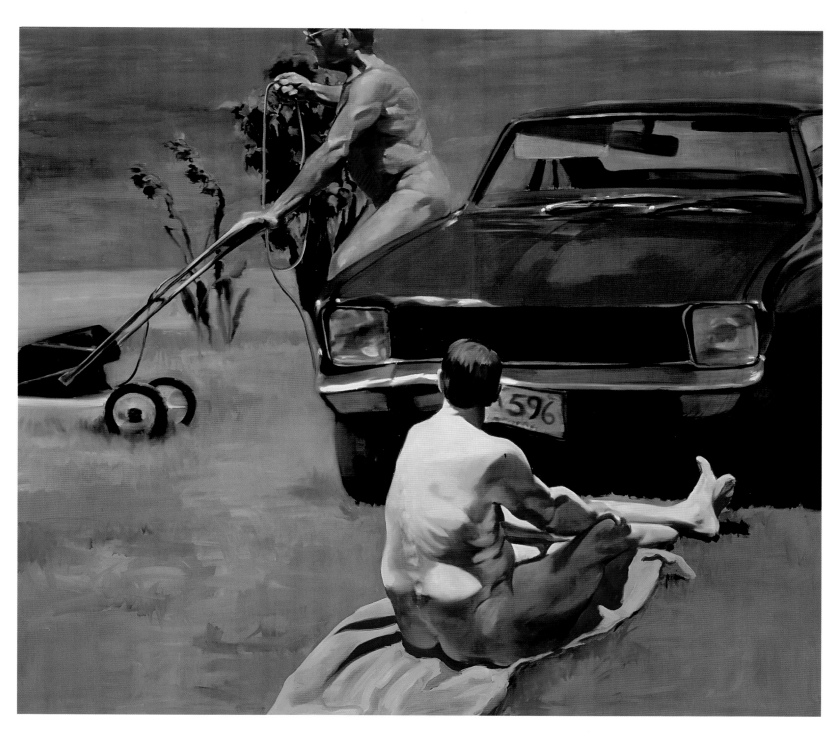

Strange Place to Park, 1992
oil on linen
86" x 98"

Untitled, 1997
watercolor on paper
60" x 40½"

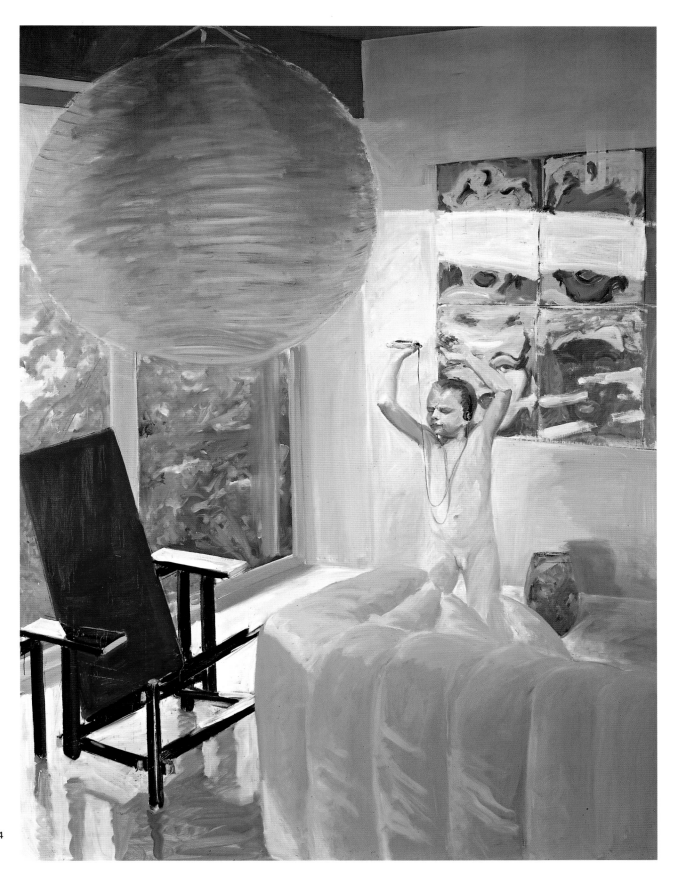

The Power of Rock and Roll, 1984
oil on linen
120" x 88"

On Sculpture

My theory about the evolution of the body in modern art is that Rodin represents the end of the body as flesh, as muscle, and as a sexual, physical being. The next great sculptor is Giacometti, who's work is about anorexia, anxiety, and the denial of the body.

For me, both in sculpture and painting, I've had to look back to the nineteenth century because I am interested in flesh, in musculature, and in the sex of the body. I went back to the nineteenth century to see what I could bring forward. The handmade feeling, the presence of Rodin's hand in the sculpture, is so satisfying and so powerful. His gestures are nonclassical and so expressive that they feel contemporary. When I started making paintings, references to Degas and Manet and Winslow Homer and Hopper in my work all came up, and rightfully so. Although it was said critically, it was always as if there were some possibility of bringing painting forward through these influences. But when I started making sculpture the criticism focused on Rodin and that was the end of the discussion. Period. It was as if there was no way you could bring Rodin forward. He was full and complete unto himself so that anything that came from that was simply derivative rather than a reinterpretation. I just know that I look at Rodin and Manet and Degas in the same way, as artists to have a dialogue with.

The sheer pleasure of using the hand with clay is irresistible. I also found that it informed my painting because I had to think about the object and the image in a different way.

I had to use a different part of the brain. In painting your hand follows your eye, and in sculpture your eye follows your hand. In sculpture and in modeling the hand has a lot of information you didn't know it had. The hand feels the form and then the eye looks to see if it looked the way it felt. The hand has such an intimate understanding of the shape of the body because it has touched the body so much that you start to unlock all kinds of memory from just simply touching. I think probably my most successful sculptures so far have been the ones that are at one-third human scale. It is very charged at that scale. They're meant to be caressed. It's really a shame that you can't touch all sculpture because it's certainly the pleasure the artist has. There's nothing more satisfying and powerful than creating a human form.

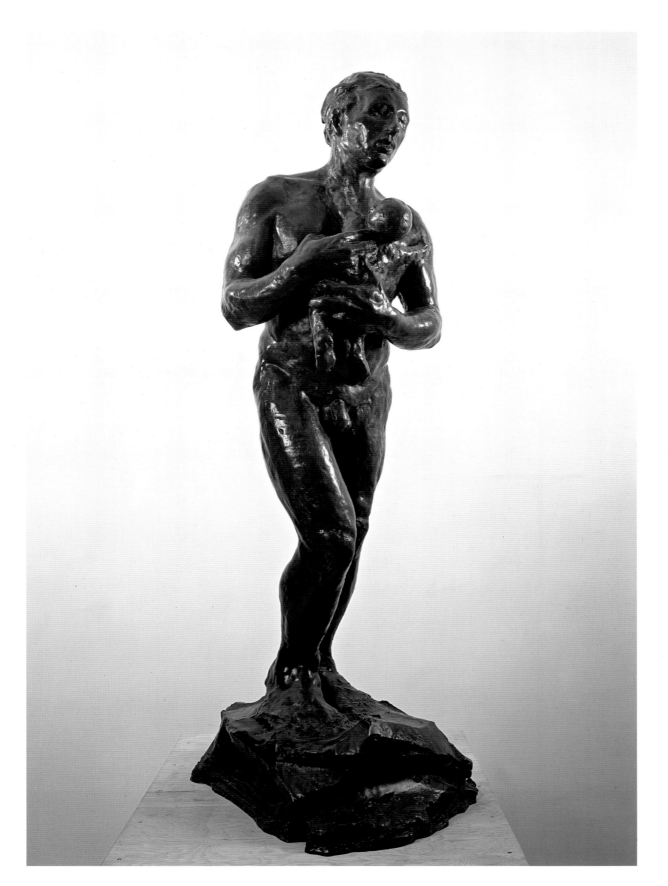

Untitled (Man and Child), 1992
bronze, edition of three, 1 AP
77" x 26 ½" x 38"

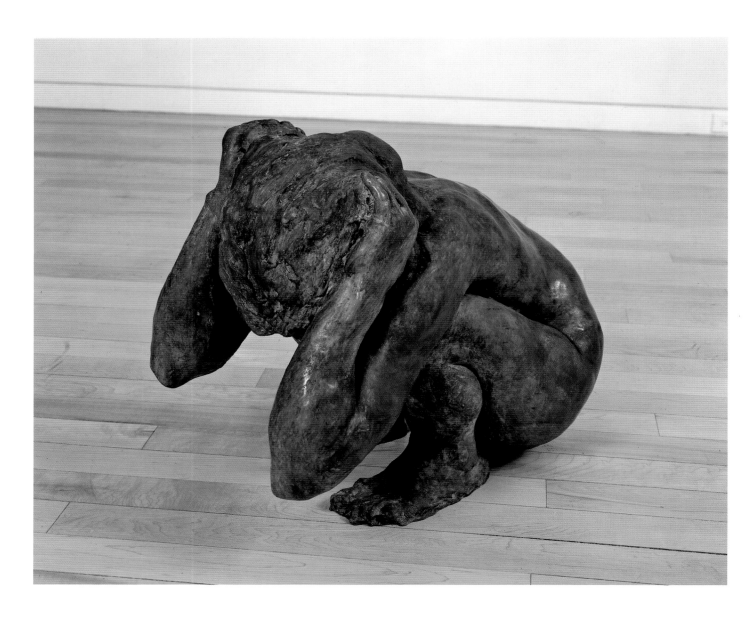

Message of God, 1997
bronze, edition of three, 1 AP
21" x 16 ½" x 25"

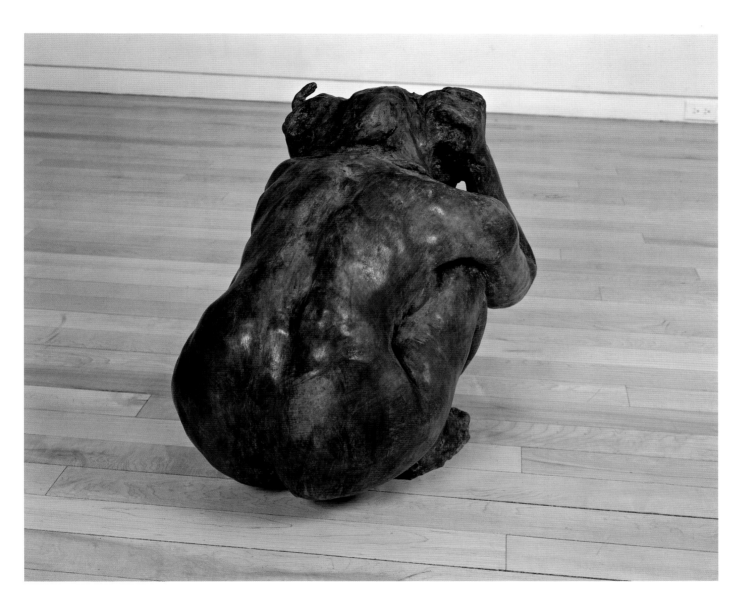

Message of God, 1997
bronze, edition of three, 1 AP
21" x 16 ½" x 25"

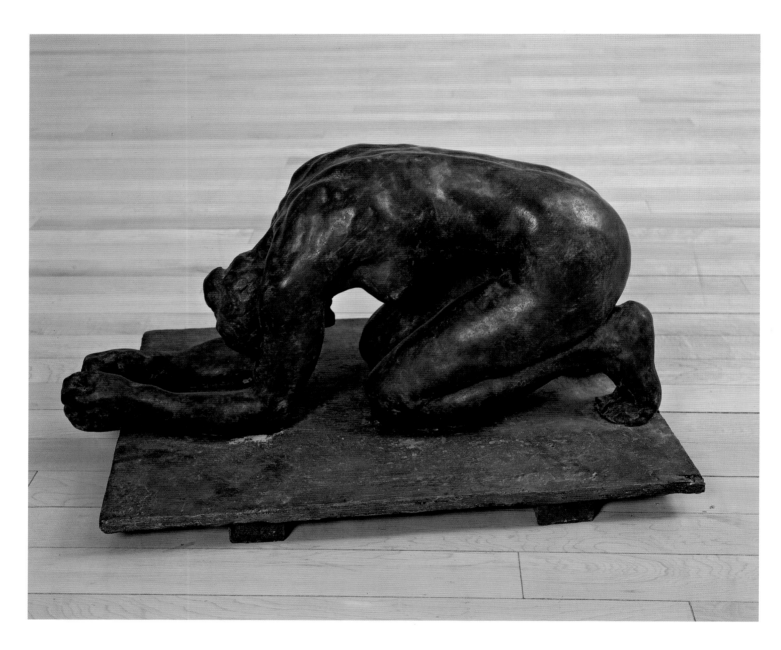

The Wait, 1997
bronze, edition of five, 1 AP
14 ½" x 29 ½" x 20"

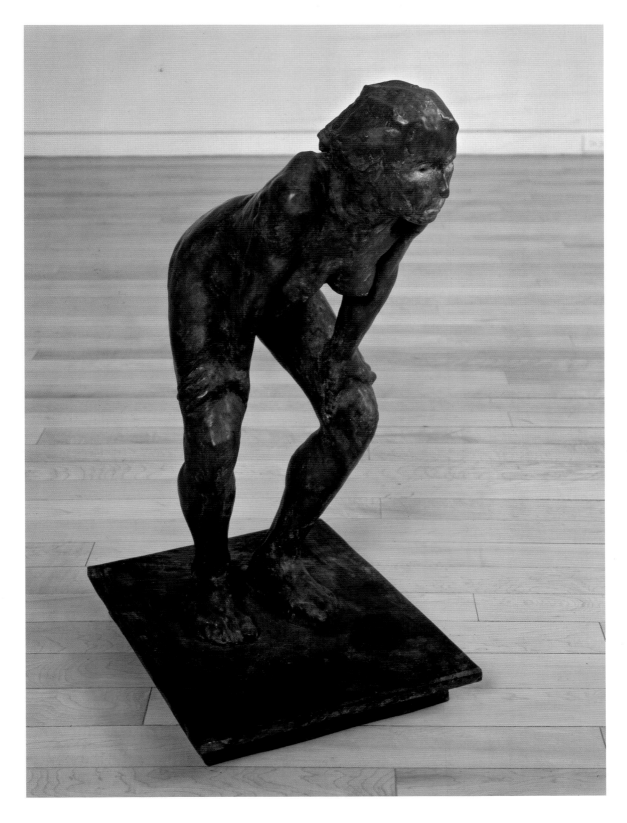

Watcher, 1997
bronze, edition of five, 1AP
32" x 19" x 14½"

On Rodin

Rodin amazes me with the loose continuous line of his drawings. For somebody who modeled his sculptures in such a thick and muscular way, it's surprising to see the soft balloon-like sensuality in his drawings. I'm inspired by the fact that an artist can use different languages and mediums that express the breadth of his incredible sensitivity and perception.

Then there are the shapes he makes, especially in the erotic work. Rodin keeps it hot and he keeps himself a part of it in a hot way. There's so much of erotic art where the artist gets so obsessed with the narrative, or with erotic detail, that it becomes cold. Or deeper anxieties about sex come out. But with Rodin's erotic work it looks like he's having sex, enjoying sex, and wants to have more sex. It seems wonderfully unselfconscious and uninhibited.

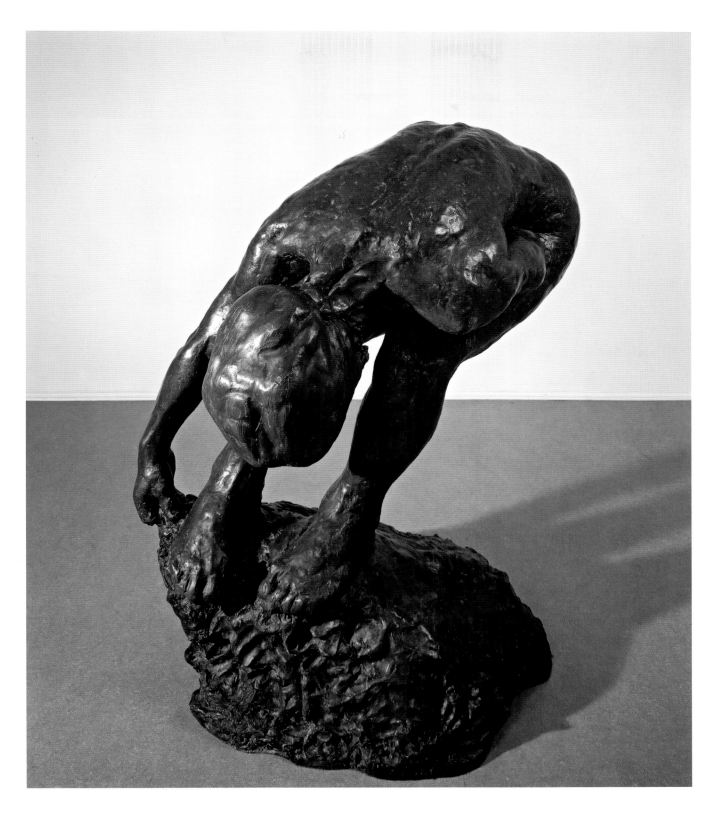

Untitled (Woman Bending), 1992
bronze
42" x 24" x 36"

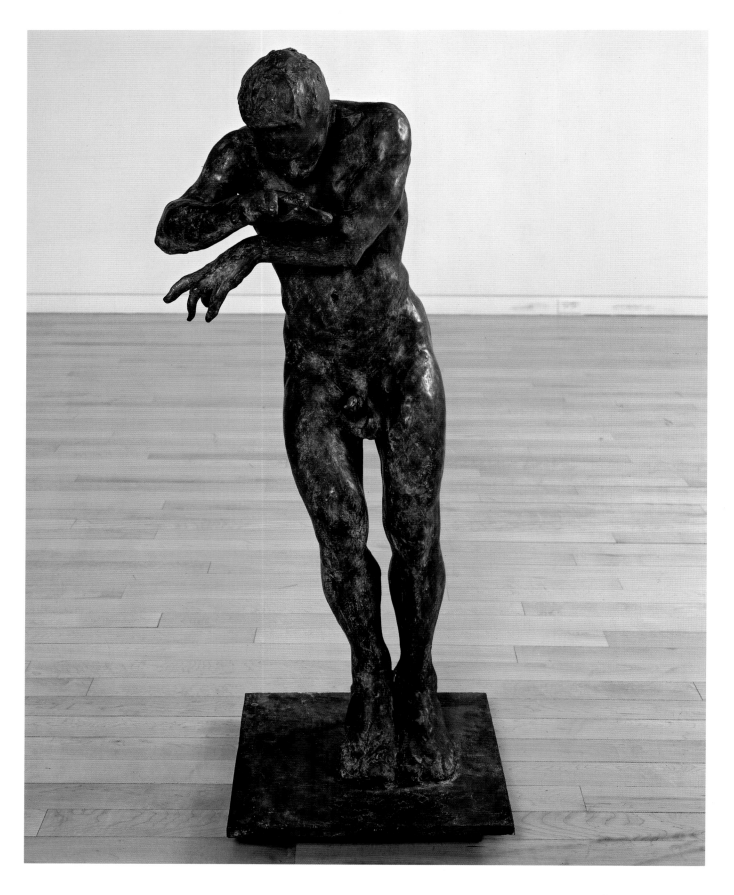

Puppeteer, 1997
bronze, edition of three, 1 AP
51 ½" x 18" x 18 ½"

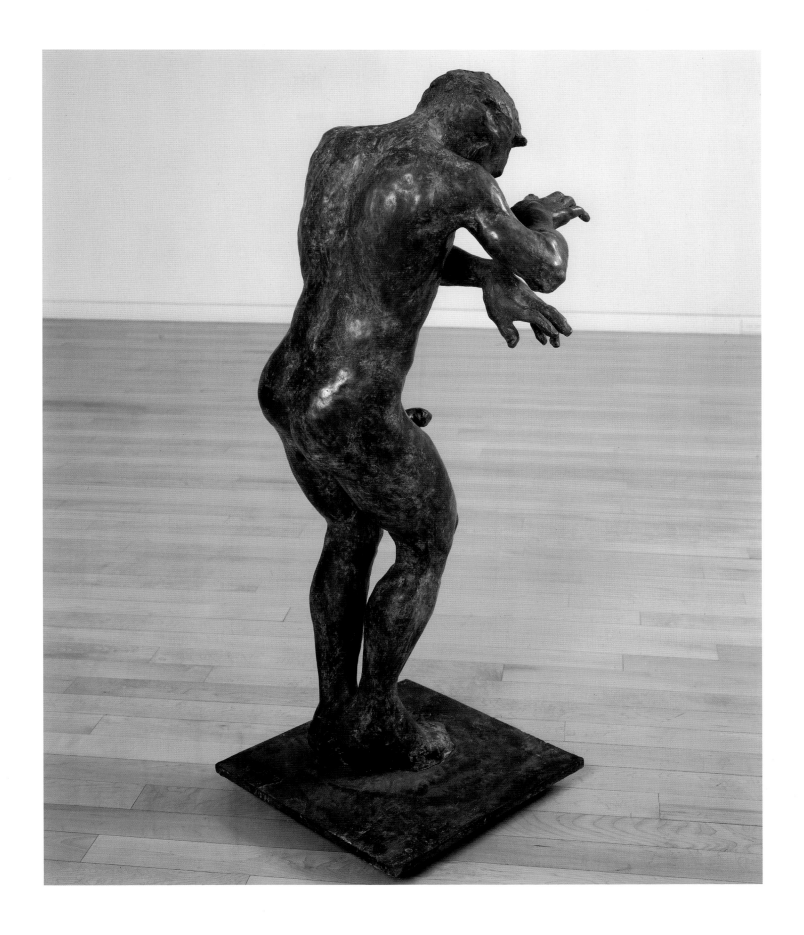

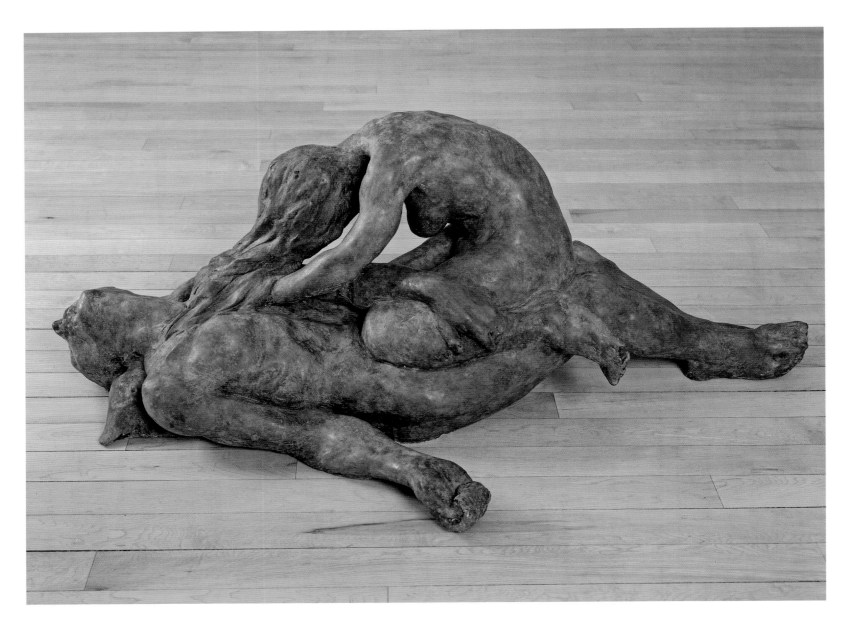

Hysterics of Love, 1997
bronze, edition of three, 1 AP
21" x 28" x 54"

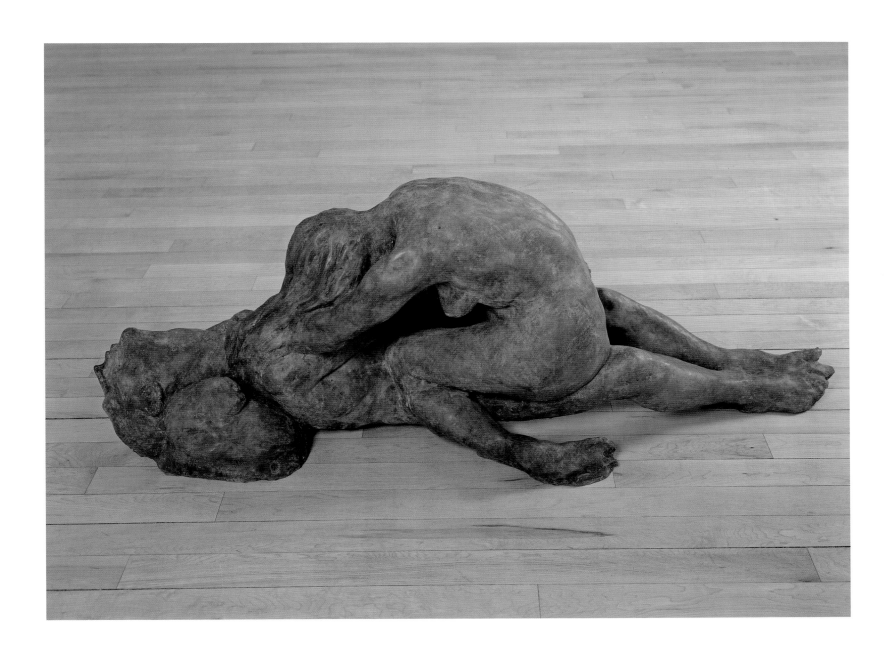

Untitled, 1996
oil on chromecoat
23" x 19"

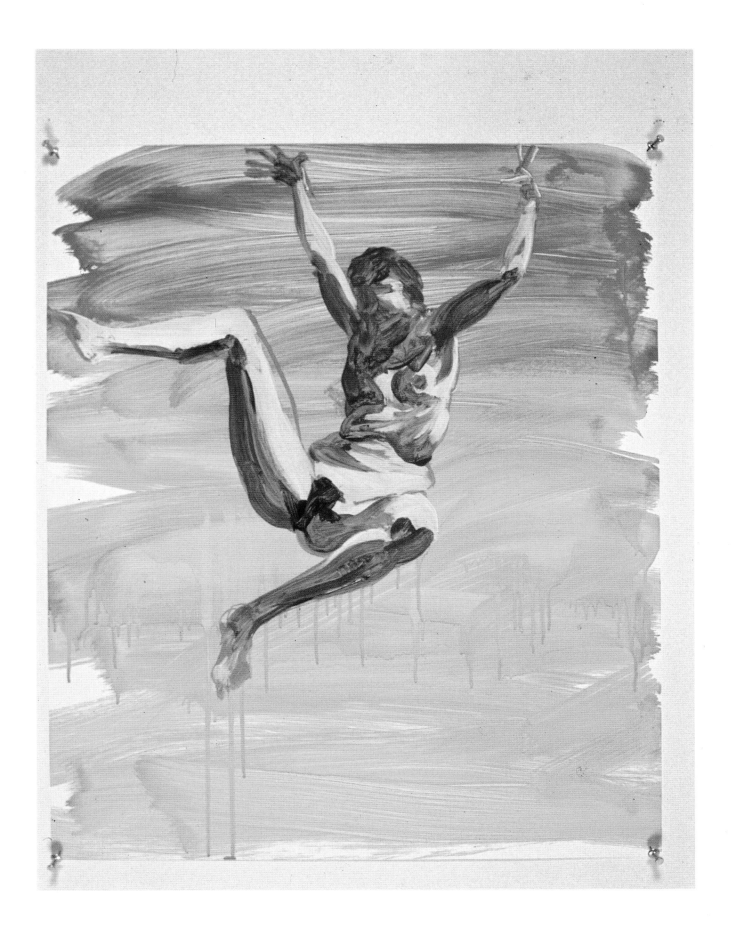

On Being a Painter

Painting starts in very personal ways. What is my relationship to being here, and to the ways I am trying to express something in a medium this old? It's a medium of limited forms so I have to work with that limitation. I take painting seriously because it's the way I am in the world. It's a language and it's a very primitive language. Primitive in the sense that it precedes language. When I first started painting I used words a lot because I'd had a longer relationship with language than I'd had with the medium of paint. It was better developed. By now, though, I've had a sufficiently long relationship with paint for it to be a primary language.

I paint to tell myself about myself. Painting is a way of saying what it is like to be me. It's also a way of saying what it is like to be me living with you. It's about the individual psyche and the individual formed by the Other.

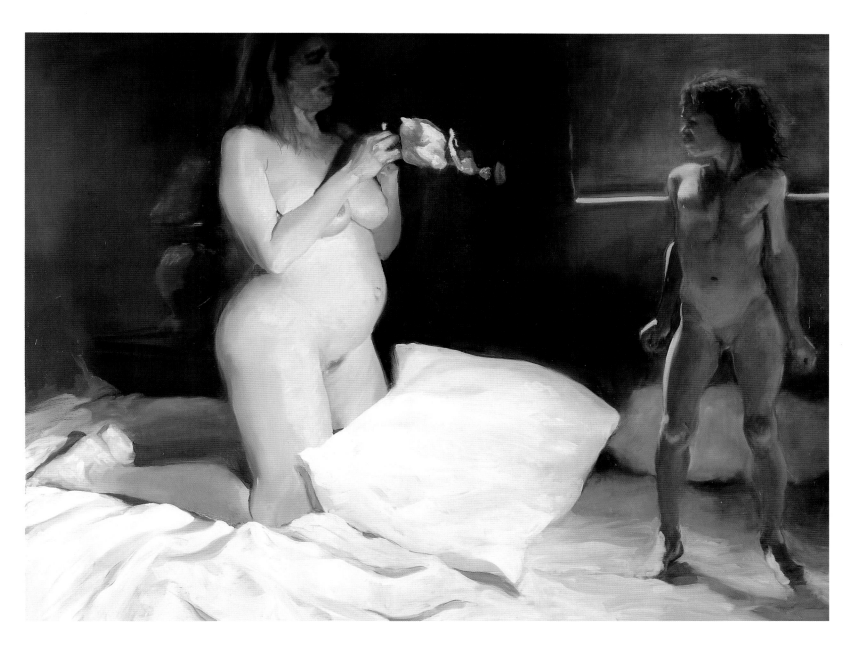

Lessons Learned, 1999
oil on linen
58" x 75"

Self-Portraiture

All my self-portraits are a response to Max Beckmann's *Self-Portrait in Tuxedo* (1927). There's a revelation in the way that he tried to normalize and to socialize himself rather than be the angst-ridden, mystical, introverted artist. He placed himself squarely in Berlin nightlife. He's got a cigarette in his hand, no brushes or easels. He had connected to a plain truth. In the first self-portrait I did in Halifax I'm dressed in a suit leaning next to my painter's table, on which there's a palette and a paintbrush. There's a bicycle in the background, which I used as a symbol of childhood. I'm not presenting myself as an artist in that self-portrait. I look more like a dealer.

I did a later self-portrait that was also set against the backdrop of an uncomplicated, bourgeois, middle-class world. There's a big speedboat roaring along in the background. It's a sunny, beautiful day, and April and I are sitting almost as if we were artists selling portraits to tourists. On an easel there's a portrait of a glamorous model. I thought it was very tongue-in-cheek.

I so overexpose myself in my work that the idea of exposing myself further in a self-portrait seems absurd. I don't think that looking the way I do carries any of the things I care about, feel about, or want to express. Other artists have done portraits of me, and I've liked their paintings but I've never felt that someone captured me because typically they make me out to be this good-looking guy who doesn't think very much. I always have this Clark Kent kind of look.

In *Portrait of an Artist* it was literally and figuratively self-effacing to put on a mask—Shriner's hat with eyes and eyebrows. What attracted me to it was that it integrated so beautifully with my face so that you almost couldn't tell which was which, except that it was so strange. April and I were just fooling around with it when she clicked the photo.

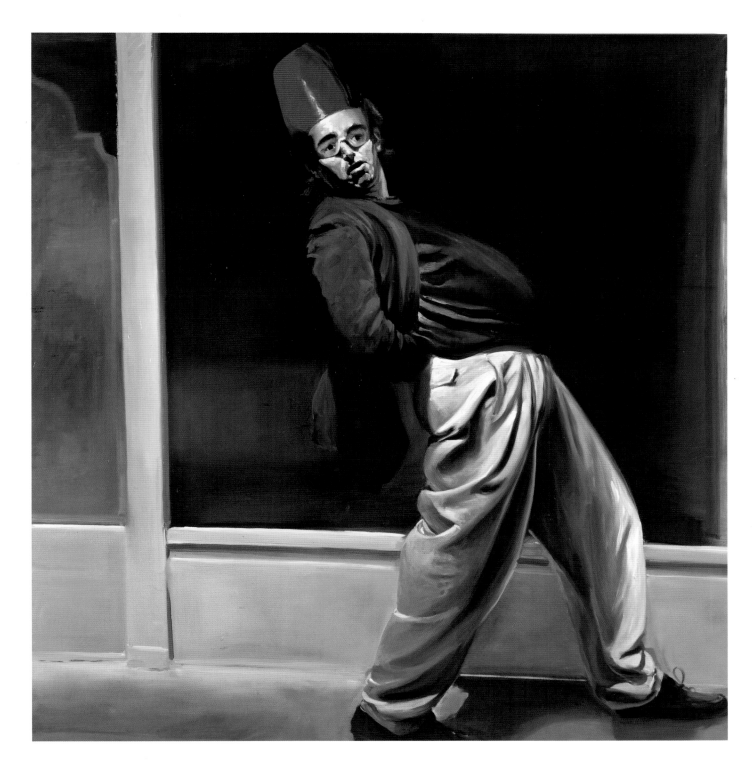

Portrait of the Artist, 1998
oil on linen
72" x 68"

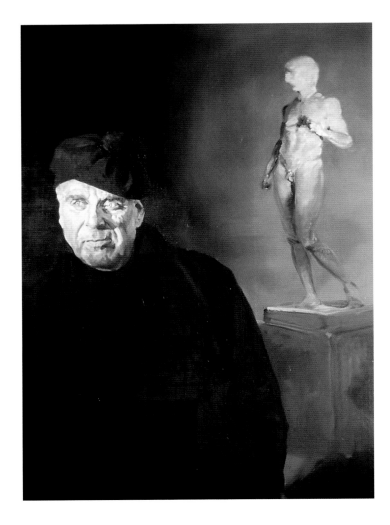

Ralph, 1997
oil on linen
48" x 35"

Portraiture

The genre of portraiture is one of the most difficult of the modern idioms because it's essentially nonverbal. With narrative painting there can be a pretext to generate the work and therefore a text to fall back on. Whereas with portraiture—and it's the same with landscape—you make a painting of a person and if you're successful the person is there. What more can be said? You can't defend it as an art strategy. You've simply created a person. With late modernism, where language is so much a part of the strategy and the rationale for artmaking, to move into a nonverbal realm is both enticing and scary. It happens that the people I know are all people who are themselves creative and are really good at what they do. So I think the portraits have been a way of acknowledging that they should be remembered. Part of a painter's job description would include recording history in some way. It's not the realm of painting per se; it's the realm of representational painting. And part of the job description of representational painting is that you look at and record life, its history, its people, and the objects that surround you.

Painting people you know is terrifying. If you have good friends the idea of not letting them see how you see them makes no sense. You naturally move into the realm of feeling. In a portrait you go through many likenesses because a person doesn't look one reducible way. These likenesses can be radically different, which you see when you take a lot of photographs of somebody; they move slightly, they animate themselves in a different way, and all of a sudden their face changes shape, their body changes size—it's amazing how mutable these things are. So which person do you arrive at? Which one sums up how you see them and feel toward them and how you see yourself in relation to them? With just the flick of a brush the mouth changes shape and somebody who was relaxed becomes tense, develops a snicker, or becomes startled. As the brush goes this way or that you have to ask which one is true.

I think about all the portraits Velázquez did of King Philip of Spain, which were so varied and which came out of the long-term, protracted intimacy he had with this person of power. The portraits range from very public to really intimate moments. I don't think any one is truer than

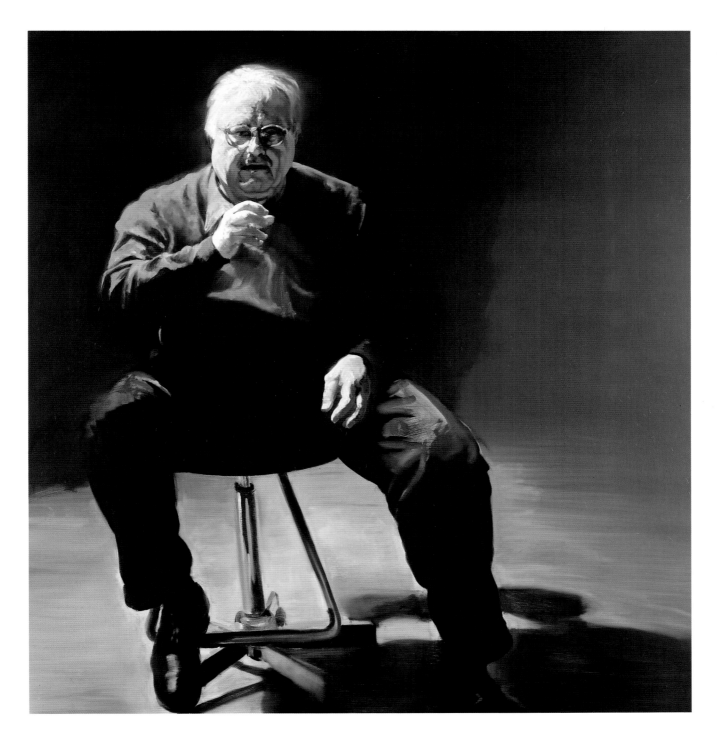

Fred, 1998
oil on linen
72" x 68"

the others and yet they're all incisive and defining in some way.

The power of a portrait has to do not just with the image and character of that person, but also with seeing how that person impacts the artist who renders them, which is what happens in a painting. It happens less in a photograph because there's a mechanical distance. But in a painting you actually see the synthesis between who that person is and the way the artist sees and feels toward that person, so it's a much more dimensionalized experience of witness. And witnessing is really the most profound verification of being.

I started with a portrait of Ralph Gibson. It was a whim. I'd taken pictures of him in Rome—it was at sunset and there was this fabulous light on his face. I was just fooling around in my studio, I may have been between things and figured it might be fun. Ralph's reaction was key because his reaction was to say to me—with enthusiasm—what it feels like to be seen. I thought, this is what I should do with all the people that I love: show them that I see them.

After Ralph I painted Steve Martin. We had been vacationing together in St. Bart's, where I had taken several pictures of him on the beach there. Being such a public figure he is always aware of the presence of cameras. It is nearly impossible to capture a candid moment of Steve on film especially with his hat and his sunglasses, which makes access that much more difficult.

I've known Mike Nichols for a few years. I invited him to talk to my class at the New York Academy of Art. I had designed a seminar class with the idea that there were five ways of thinking about narrative painting, one being from the point of view of direction. He's a brilliant man with tremendous experience, wit, and passion. One of the great storytellers that I know. I have painted him as though I was hanging on every word.

My relationship with Mary Boone goes back to 1982. The first thing that needs to be said about Mary is that she's an incredibly powerful and very complicated woman, which is why she's so interesting. As a businesswoman she is very passionate, aggressive, and clearheaded. She is also an attractive, sexual woman. So there are a lot of different ways for her to project and for people to perceive her projection.

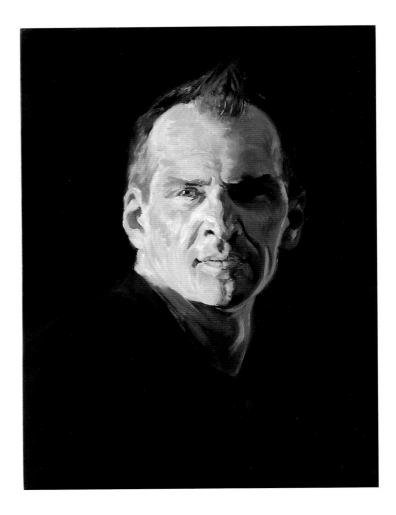

Jack, 1998
oil on linen
24" x 18"

It's complicated to paint women because they seem a little more confident in expressing vanity, whereas men are vain but less confident about expressing it. With women you can read immediately that they're not being seen the way they want to be seen. I don't tell any of the people I've painted to do anything; I don't tell them what to wear or how to stand or sit. I just invite them to be in front of the camera and they can do whatever they want. So although Mary set up that painting of herself I think she was surprised to see it.

Bruce's Ferguson's is the most magical of all the pictures. Spatially his is very different from the others in that you look up to his head and then down to his feet. He's actually compressed in the space, yet he still has this up-and-down thing. The scale is very strange. I think it contributes to the sense that he's some kind of magical being. When he came by to be photographed I reminded him that he does something that I've never seen anyone else do when trying on clothes. Everyone does something when they try on clothes—they put their hands in their pockets or they stand or look a certain way. Well, Bruce dances. It's really a very interesting way of seeing yourself. So he re-created that dance for me, which is where the gesture came from.

My work has always dealt with issues of privacy, so for me to paint April naked does not seem out of the ordinary. The painting takes place in a hotel room in Paris. The light that engulfs her is more than the light the window can offer. It illuminates her body while shadowing her face. Her eyes stare out at you from a darkness. She feels wary and vulnerable. It is not her naked body exposed to light, which feels vulnerable. It is in her face where the light can't reach.

It was interesting to see the portrait of April in the show at Mary Boone's because even though she's without clothes on, she seemed the most clothed. The others who are fully dressed are more bare. The artist behind his mask is totally hidden and comical.

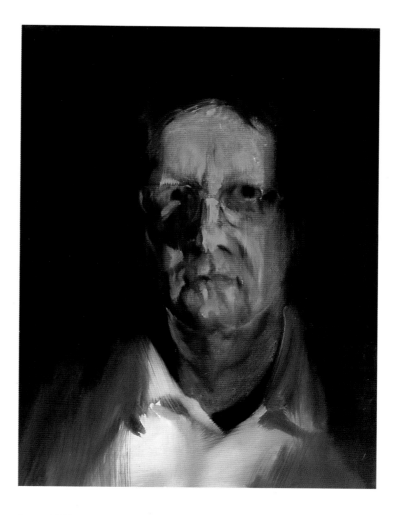

Bryan, 1998
oil on linen
24" x 18 ⅛"

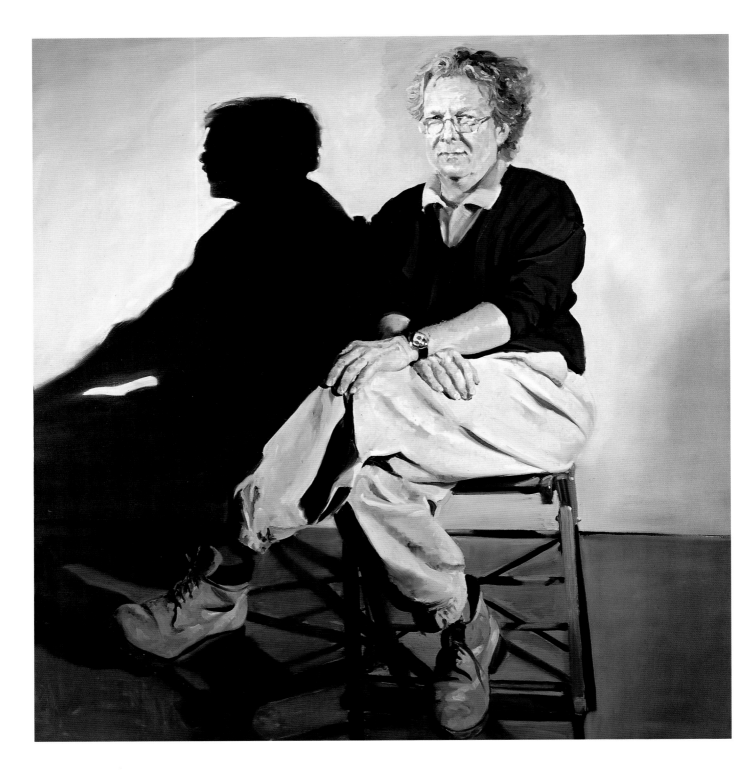

Bryan, 1998
oil on linen
24" x 18 ⅛"

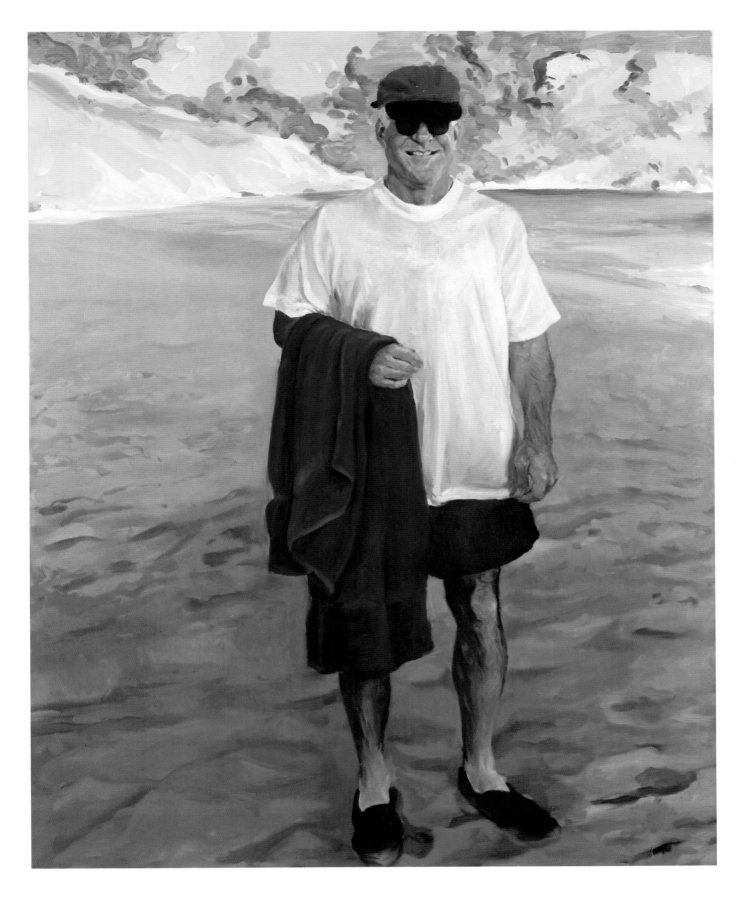

Steve, 1998
oil on linen
73" x 58"

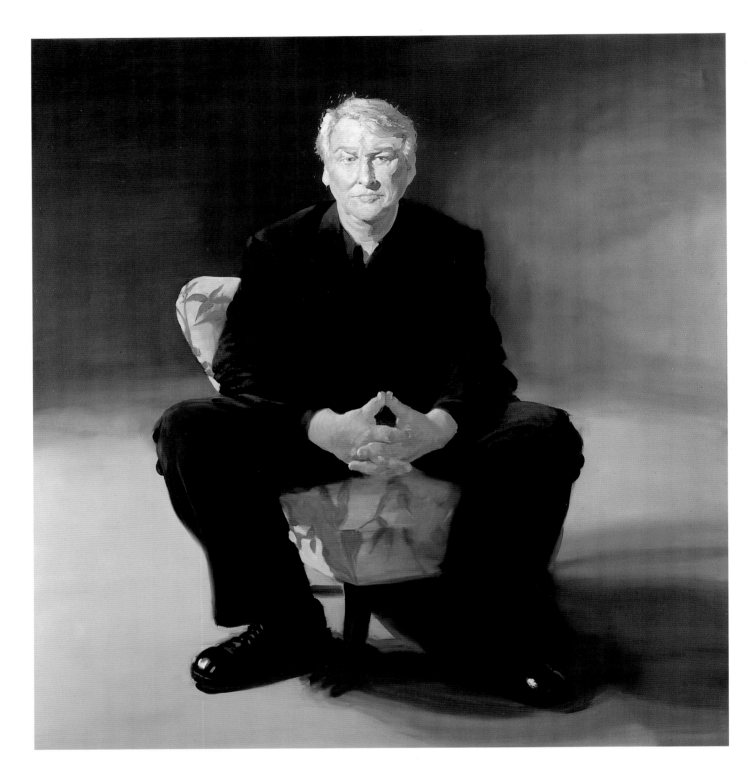

Mike, 1999
oil on linen
69" x 65"

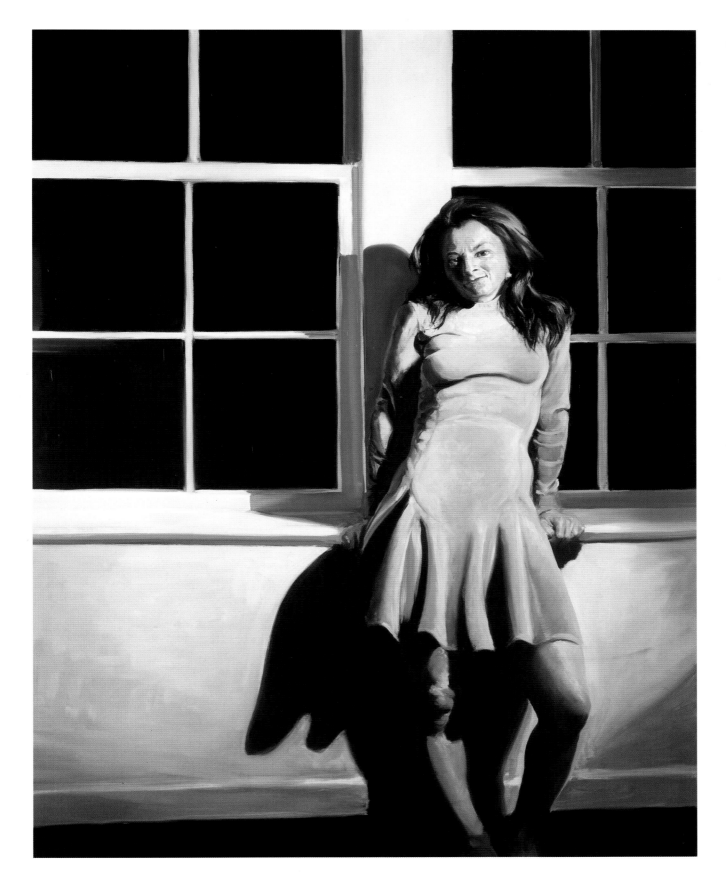

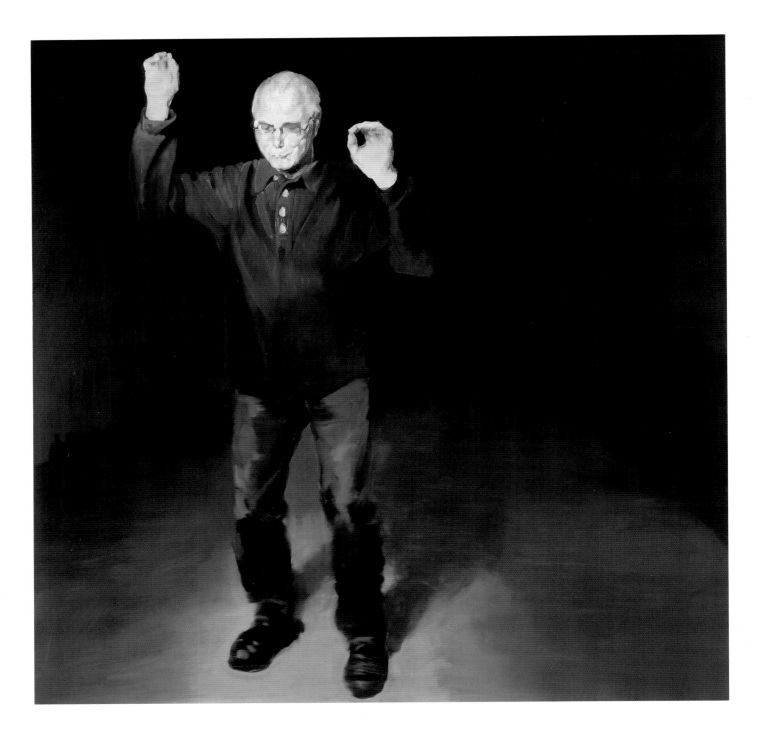

Bruce, 1998
oil on linen
72" x 68"

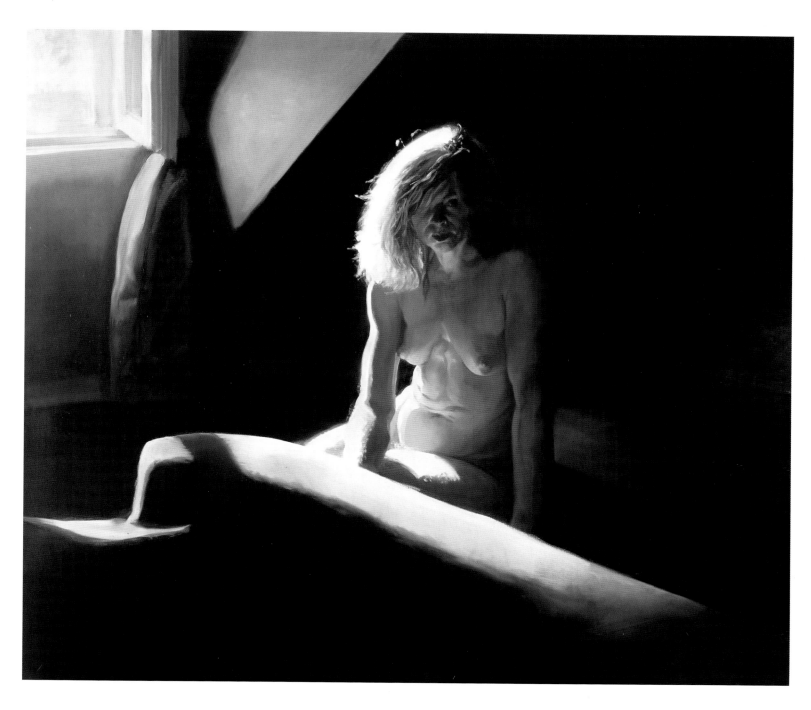

April in Paris, 1998
oil on linen
61" x 71"

On Rembrandt

I've tended to understand my work anecdotally. I paint a paint-
ing and then become the audience, so I can talk about it the
same way somebody else would talk about it, but with less of
a sense of possession. It stands apart from me and I'm
bemused by it. I look to someone like Rembrandt for inspira-
tion about aging. I would like to be as honest and unwavering
as he was. Every ten years he would take a hard look and
reveal himself unflinchingly. That inspires me a lot, because
ultimately what more could you want from art than for some-
one to honestly say, "This is what it's like to be alive" and to
make that a shared experience. As viewers we appreciate his
vulnerability. One of the great ironies is that such vulnerability
gives one strength. I gain encouragement looking at this wiz-
ened and sad man confronting you with the physical shift he's
gone through. This loss of power is something that we all know
or will know about.

Study for Portrait of the Artist as an Old Man, 1985
oil on chromecoat
16" x 11"

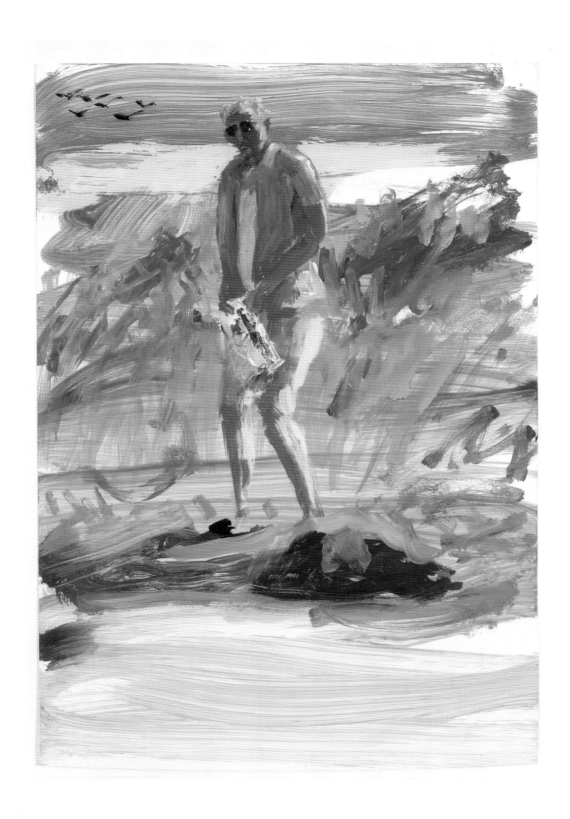

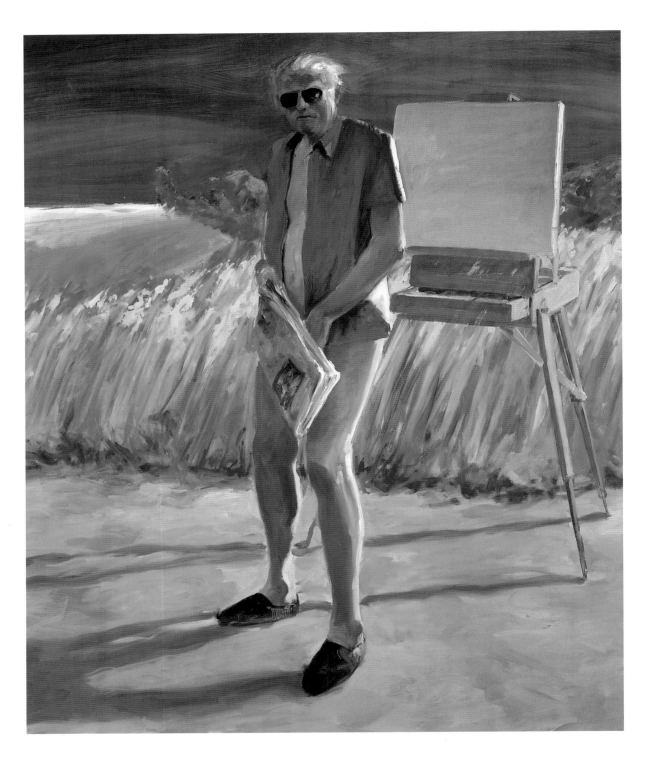

Portrait of the Artist as an Old Man, 1984
oil on canvas
85" x 70"

Frailty is a Moment of Self Reflection, 1996
oil on linen
68" x 58"

On Being Finished

The hardest thing for an artist, especially a contemporary artist, is knowing when something is finished. It's a dilemma because there are no rules, no checklist, and no external narratives that allow you to say, "Okay, I've told the story." So with every painting you're faced with the same question. The way I've answered it is that it's done when I become the audience, when I'm looking at something and don't have a need to fix it. I'm not there saying, "I can make this arm better" or "that guy really isn't working so I'll get rid of him." It's finished when I'm looking and asking, "What the hell's going on here?" and want to try to figure it out from the audience's point of view.

I think the painting does unfold to the viewer the way that it revealed itself to me, in the way that it accumulated as a process. I hope that what's there can be unraveled, that it resonates in a way that encourages you to wonder what it's about.

Painting is a process by which I return my thoughts to feelings. I go from my head back into memory, into feelings that were caused by events before they became words, before they became thoughts. And because painting is a nonverbal—and in process a preverbal—condition, it's about trying to get all the words out of the picture so the picture can just represent. When someone comes to it they can start putting words back in. And because the words they put in are their words, they possess the painting. The problem with a lot of narrative and allegorical work is that all the words are already there. At the present there's a whole movement to elevate Norman Rockwell out of the esteemed position of Great Illustrator to some kind of High Artist. There's nothing wrong with being an illustrator. But the difference is that you look at Norman Rockwell's work and the words are all there, and have been from the beginning. It's a narrative that everyone knows he's put an image to.

Brother and Sister, 1991
oil on linen
98" x 74"

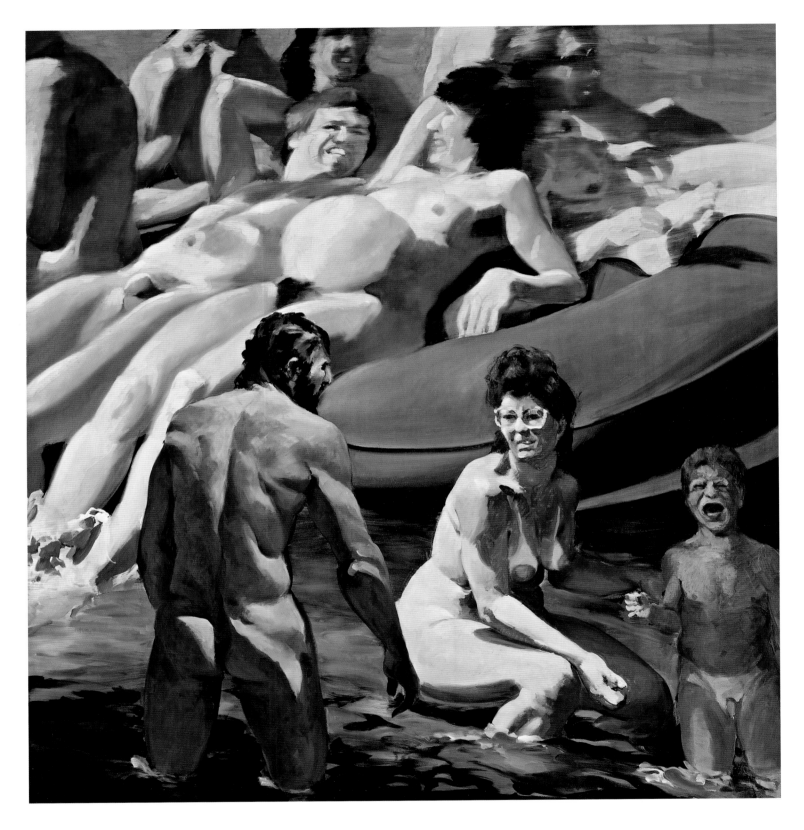

Untitled, 1992
oil on linen
58 ¼" x 54 ¼"

Untitled, 1983
charcoal on paper
75" x 60 ½"

Faith in Painting

There's an area that's deeply meaningful to me, but one that I've never really been able to talk about because of the degree of faith involved in painting: the belief that a canvas—this blank object—could have incredible power, that it could connect itself to such an enormous expanse of human history. On one hand painting has all that—and I think every painter understands that implicitly—and at the same time we're living in a culture that has devalued its significance to the point where you have to accept the argument that painting actually doesn't have the power it did. There are too many examples out there that indicate it doesn't. That's become a spiritual struggle and an ambivalence: that deep longing for and sacred attempt at creating any object of power and beauty and meaning, and at the same time a self-consciousness in recognizing the possible absurdity and waste of that attempt.

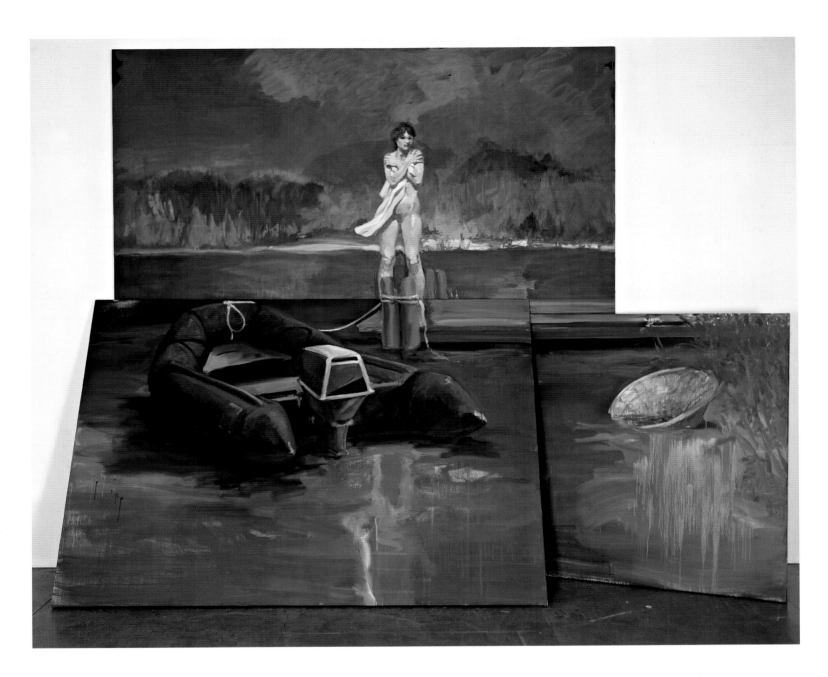

The Evacuation of Saigon, 1987
oil on linen, three panels
120" x 142"

On the Heaven, Hell, and Earth Theory

I have lots of theories about art, but this is the Heaven, Hell, and Earth theory.

When artists were working within the narrative of Christianity they had to be proficient in the language of Heaven, Hell, and the Garden. Those are three imaginative states of being that are interwoven but distinct. The Heaven part of the brain seeks order and homogeneity, a kind of democracy. It's about dissolution of the self, a longing to give up the self for the priority of the whole. Of course, Hell is the opposite; it's about chaos and a heightened awareness of isolation expressed through pain and torment. It's everything offensive to the senses because it is the senses *in extremis*: everything is the smelliest, the worst tasting, the ugliest. The Garden is the human stage that is temporal—it's a before and an after thing—and it represents innocence.

Throughout its history, Christian and Western art have become specialized like everything else. As art moved away from the church, artists began to specialize in certain things, became only Heaven painters, Hell painters, or Garden painters, which could be expressed in quotidian or historical or mythological terms. An artist might be a court painter, for example, and would paint the heavenly, orderly relationship of king and court to daily life. Another artist might paint the hellish, tormented side of that same life, depicted as battle scenes. Moving through history, the impressionists' heaven became the park, and Hell corresponded to the bar and the demimonde. Everything was expressed in the language of society. Things changed with modernism. The figure disappeared but the need for artists to connect to those different parts of the imagination was still there. Torment and the longing for harmony still exist; the nature of innocence and guilt still exist. Within the specialized language of modernism you could say, for example, that Agnes Martin is a Heaven painter and Jackson Pollock is a Hell painter. Of course, when I tell this cockamamie theory to people they say, "What are you?" and I say, "Not only am I a Garden painter, but I'm a post-Fall Garden painter." My early work was standing outside the gate looking to go back in. There is a real lament over the loss of innocence. Of course, the older I get the farther from the garden I am, but the longing for the time before is still very much a part of my work.

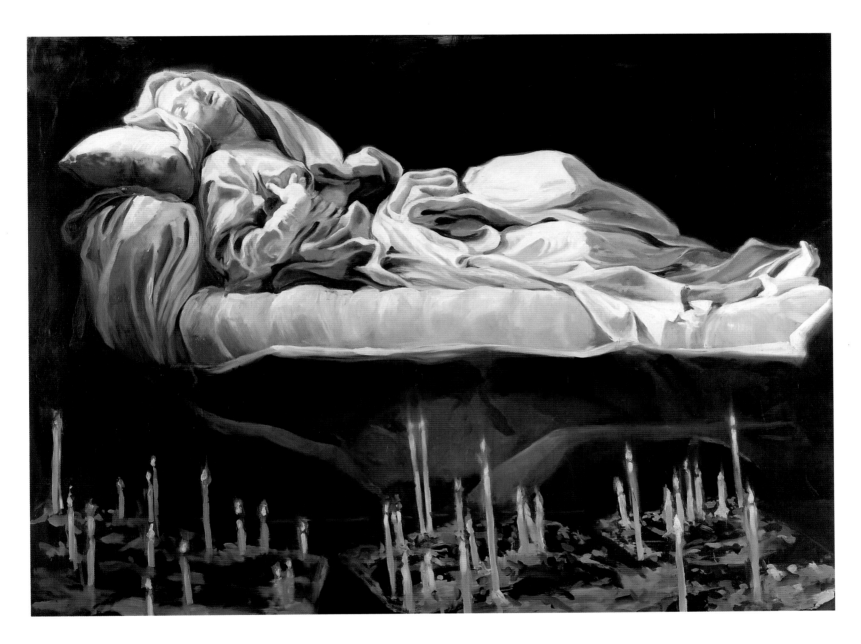

Beata Ludivica, 1996
oil on linen
74" x 98"

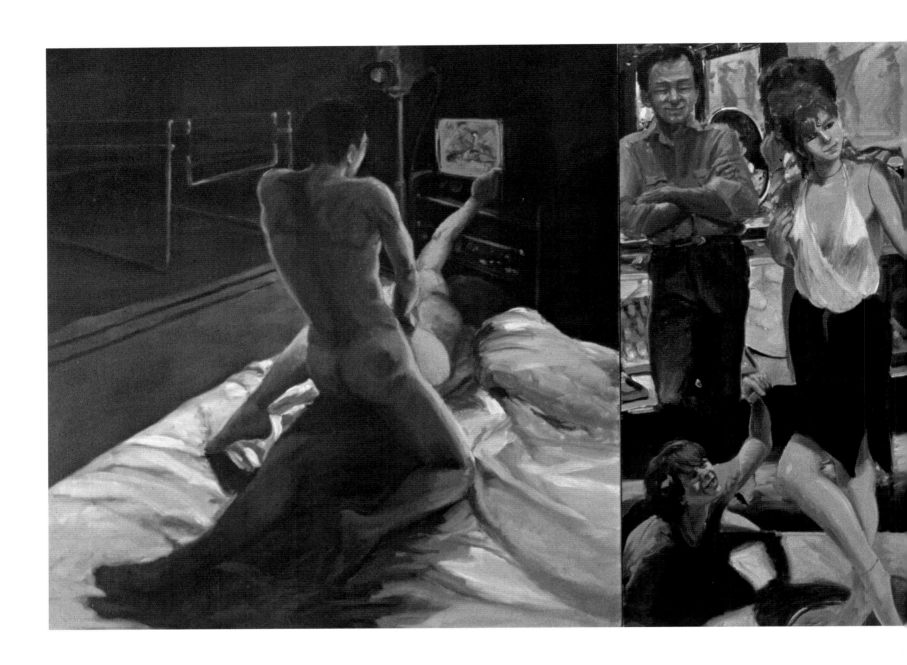

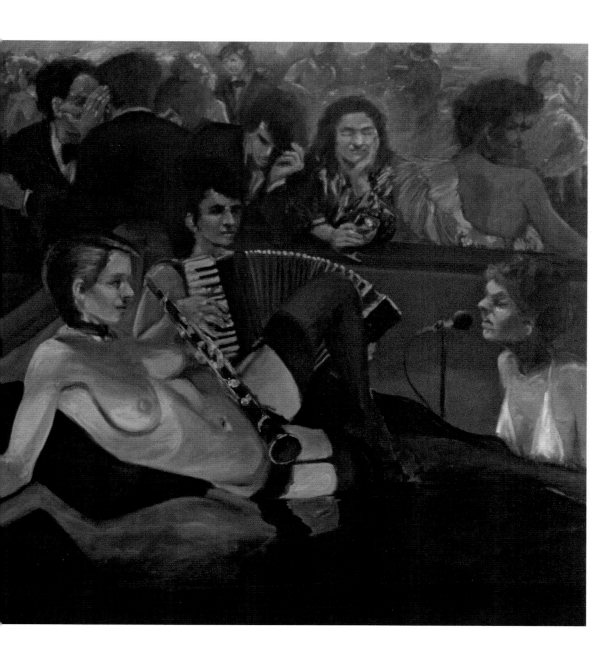

Inside Out, 1982
oil on canvas, three panels
72" x 178"

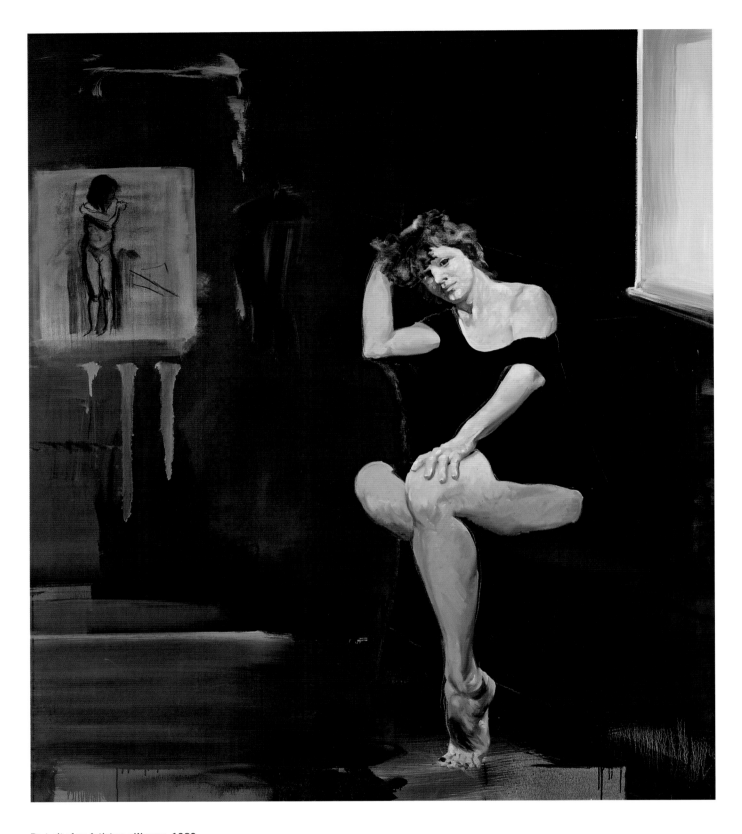

Portrait of an Artist as a Woman, 1989
oil on linen
68" x 58"

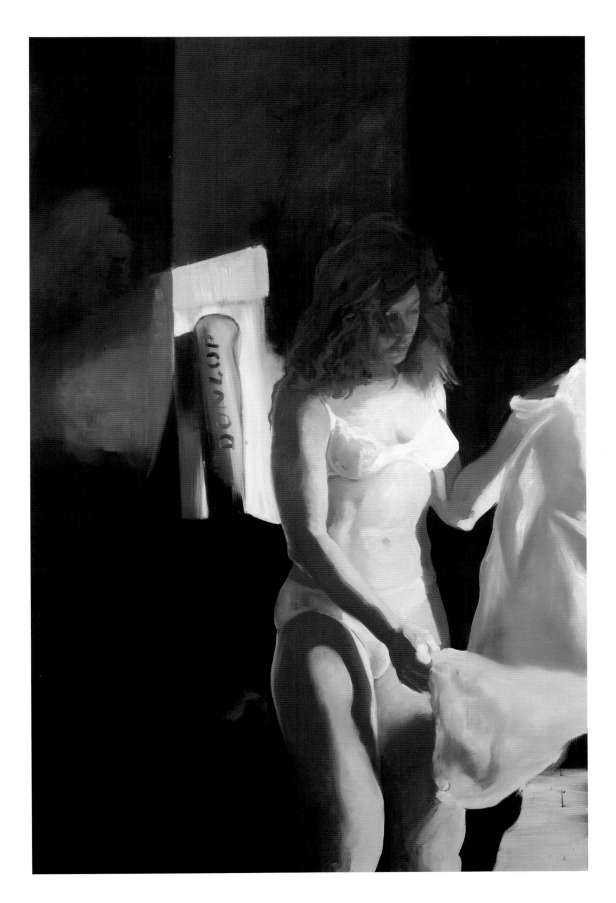

April Undressing, 1993
oil on linen
70" x 45"

BARBEQUE

by Steve Martin

In very thick books on art history, I have sometimes seen a triangle superimposed over a reproduction of Raphael's Madonna and child, with the top of the triangle placed at the Madonna's head and its base running across her torso. This is used to illustrate the solidity of the painting's construction. I have never understood, however, why a triangle is solid, or at least anymore solid than any other geometric shape. I suppose it is implied that the mind converts the subtly perceived triangle into subtly perceived strength. It also implies that Raphael opted for the triangle shape, but I can't help but think that a woman cradling a baby creates a triangle shape every time, unless she is wearing a big flat hat, which would create a square. But a square is also a solid shape. Therefore, Raphael's major decision, in my book, was not to put a big flat hat on the Madonna. If there is a painting of a triangle—I assume there is, and if not, someone better get busy—I wonder if a very thick art book would superimpose a triangle over it, to show the mysterious power of its structure. My problem is that I have seen paintings that have no observable triangle

structure in them, and they seem to be perfectly fine. So I'm not sure what we gain by painting out Raphael's triangle, except that it's fun to do so, and we get to discuss something other than what the picture is about. This is one of the joys of art; it is precise enough to discuss exactly and imprecise enough that we can muse about it as far away as three back flips off the mat.

There was a time, a recent time, when it was fashionable to note how wonderfully an artist has used *negative space*. Negative space was, I suppose, anything that was not the subject of the picture. The term was used so we didn't have to say things like, "notice how wonderfully the artist has painted the *wallpaper*." This term, and others like it, are often understood for the times they are used, then five, ten, or fifty years later, no one understands them anymore.

There are plenty of sophisticated versions of elementary terms, so that we can talk about art with appropriate language in all contexts:

Schoolyard: "She's naked"
Gallery: "Exquisite flesh tones"

Museum: "Notice how the artist is confronting us"
Academy: "The object has started a dialogue with us"
Art magazine: "Nudism"

Sometimes a term appears that is so dense it is untranslatable, and becomes tautological in that the only thing in the real world it refers to is itself. I can remember being baffled years ago when a dealer discussed a certain picture's psychological loading, then I would take the painting home and point it out to others. Then we would all carry the term in our heads and we would have a special language with which to understand the painting, and we would feel secure and proud. Hopefully, we initiates would not, in the quiet moments before sleep, ever ask ourselves, "who cares about psychological loading?"

The implication of triangles and "loading" and "dialogue" is that we should not judge an artwork by what is actually in it. Canova's near-kitsch but still incredibly beautiful sculpture of the Three Graces—and I am not the first writer to observe this—displays the three finest fantasy female asses in all art. However, I would not like to read this observation in a very thick art book. This fact is for me to think and never ever say, except to you right now for scholarly pur-poses. In fact, when I look at the Canova, it's important for me to set this observation aside and think in terms of psychological loading and triangles instead of wondering what the artist was thinking as he was chiseling out the three impossible *derrieres*. Because if I don't, there is only one other thing to think about when looking at the Canova, once I have circled it several times to show my interest in looking at it from all sides, once I have mulled inside my head every mundane thought such as I've got to work out more and wonder who the models were, and that is Canova's outstanding technical achievement in carving marble.

The value of obscuring writing, contrary to its intent, is that it keeps us from understanding a painting; for my experience is that once a work of art is understood, it becomes lifeless. Fortunately, after language attack upon language attack, the greatest paintings remain inexplicable at their hearts. Yet discussion of art at high levels and with esoteric language is necessary and perfectly viable, as long as both parties hold the key to

each other's usage. But most valued is the intelligent, lucid writer who makes us appreciate that which the artist has chosen to express without words.

I cannot write about Eric's painting *Barbeque* in any context except a personal one, because this painting holds in its mysterious narrative an evocative representation of my own past. As a boy growing up in Orange County, California, in the late 1950s and early 1960s, I felt, in retrospect, like a boy eating fire in the middle of a sanguine family barbeque.

The palm tree poking up behind the pink and, to me, very familiar tract house places the scene squarely in southern California. Through the house's vaulted window—high architectural style in the area where I grew up—is seen the 1950s modern lamp and the sofa which was already ugly in it's own era, even to my fifteen-year-old eyes that had seen nothing else. The high A-frame ceiling was an Orange County version of elegance (the tract house we lived in, with its postage-stamp-size plot of land, was part of "Brookside Estates"). The zigzag swimming pool was too modern to exist in my environ, but its spirit is exactly right. And in front of that is the happy cookout, swim party, and family gathering—not a triangle I'm afraid, but a wobbly parallelogram. But the sky tells me something that the structure can't. It is a greeny-gray soup, suggesting something awful has happened, but the awful thing is psychological. This eerie tone saturates not only this painting but much of Eric's work.

A teenage boy stands amid the family scene, blowing a fireball into the already nuclear sky. The father looks on and the mother and the daughter frolic innocently in the swimming pool. But the father's face is contorted satanically, and the mother and the daughter are both nude. These conditions are the dark projections of the boy. Thrust into the foreground, residing on a backyard table, is a bowl of fish. The fish bowl is out of time and out of context. Whole fish would never have been available in my Orange County town and they certainly wouldn't have been barbequed; that is the province of big beef patties. There was also no contact with slaughter of any kind. Those fish, were they being barbequed on one anomalous night, would have been filleted days before and far away.

The bowl of fish then, becomes a comment, an irony. To my mind, it is a religious reference and Christ related. I don't have a specific explanation, and don't want one, but the bowl's presence gives the painting a mystical tilt. The bowl sitting so large in the foreground is also funny, and when viewed in the right mood, can arouse a perplexed chuckle. So we're left with a mystical, funny object dead center that tells us this is simply a genre painting

The boy is Christ-like in his pose, flanked on either side by individual scenes, like a religious triptych. This suggestion elevates the drama in the scene to symbolic levels. I'm not sure if Eric intended this or if it was subconscious. I supposed I could ask him, but why bother him when I don't really need to know? The angular, rebellious, almost military salute of defiance, given by the boy as his arm extends outwards: the black power salute turned on its side for polite Orange County.

The boy's action is perfectly chosen. Eating fire, in this case blowing gasoline from the mouth over a flame, is carnival and cheap (I used to see tattooed and t-shirted fire-eaters in my youth at the sideshow of the now defunct Long Beach Pike), yet it is also explosive and daring. It is the externalization of his internal desire to be free, to breathe fire, yet the boy has chosen earthly means to express it: a rural, primitive kind of show business. It is

clear to me that the boy is not sprouting fire mystically because the mechanical action of creating the fire is fully illustrated. But the action transcends its theatrical roots and becomes a portrait of the artist as a young man, as if the miracle camera had clicked and revealed his insides. The family looks on as though nothing more extraordinary was going on than a fine trick with a yo-yo.

Painting, unlike theater, movies, and dance, can afford to be boring. We do not have to give a picture any more time than it asks us to. It is why minimalism can flourish along with extravaganzas. In fact, as much as I try to absorb a painting it is nearly impos-sible for me to gather it in by staring at it. Like being stumped on the daily crossword, the answers often reveal themselves when you set it down and stop thinking about them. I have been able to view *Barbeque* periodically and over time. In spite of its clarity of character and its clarity of narrative, it continues to give off mystery; it continues to keep secrets unrevealed.

Barbeque elevates itself into the surreal as if by magic. Its realistic narrative is skewed into the psychological by clues that Eric knows how to deliver. Image, tone, and paint surface combine and infuse the mundane scene with energy, desire, and sex. It is an example of what the best art does: imply meaning that is greater than the explicit message of the work itself.

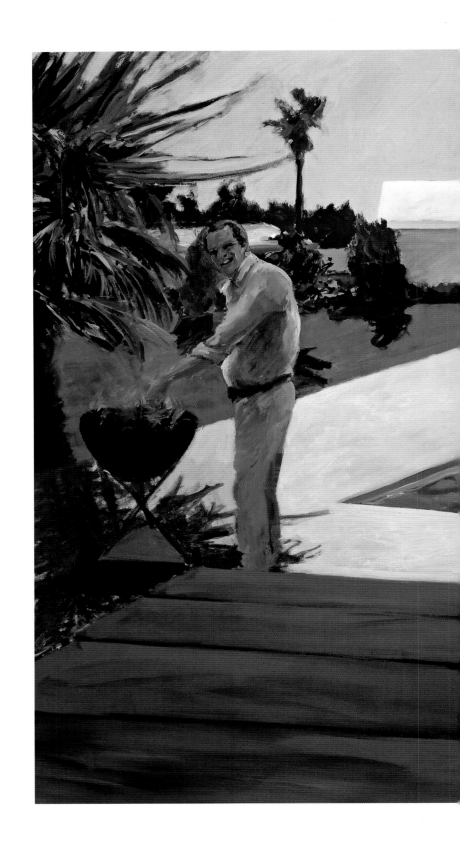

Barbeque, 1982
oil on canvas
65" x 100"

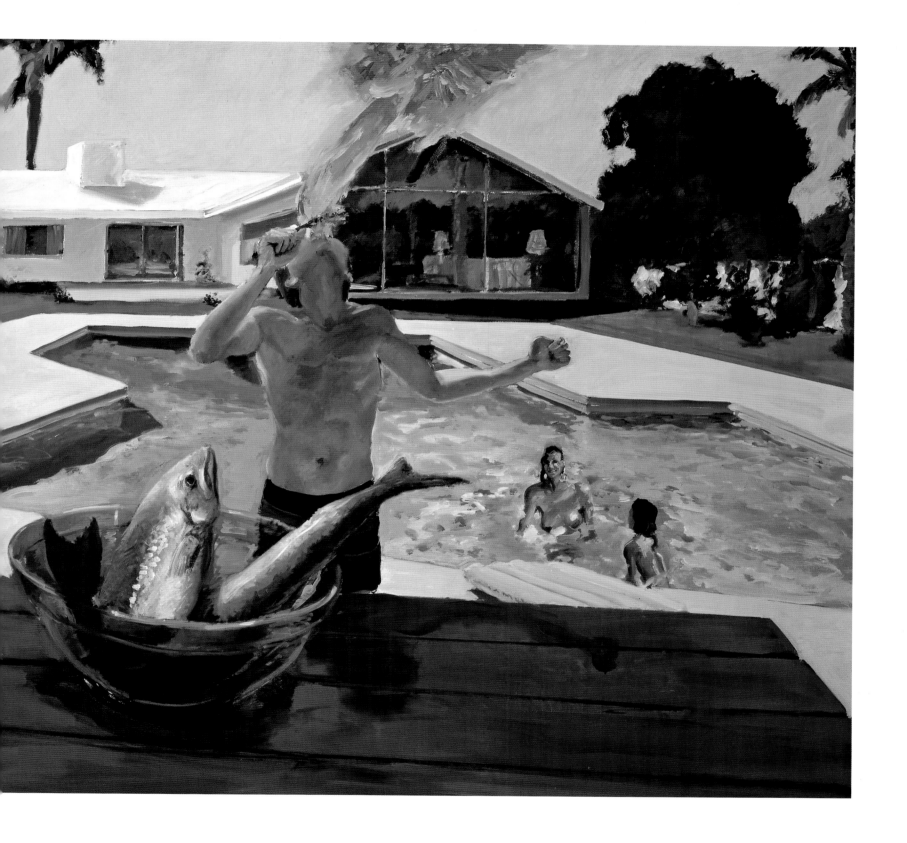

Born in New York City in 1948, Eric Fischl was raised on Long Island. He studied painting at California Institute for the Arts and was graduated with a bachelor of fine arts in 1972. In 1974 he moved to Halifax, Nova Scotia, where he taught painting at the Nova Scotia College of Art and Design. Fischl moved to New York City in 1978 and had his first solo exhibition in 1979 at the Edward Thorpe Gallery, which represented him until 1982.

Fischl's paintings, drawings, and prints have been the subject of a number of solo exhibitions, the largest of which has been "Fischl: Paintings," which originated at the Mendel Art Gallery in Saskatchewan, Canada, in 1984 and which traveled to the Stedelijk Van Abbemuseum in Eindhoven, the Kunsthalle Basel, the Institute of Contemporary Arts in London, the Art Gallery of Ontario, the Museum of Contemporary Art in Chicago, and the Whitney Museum of American Art; "Scenes Before the Eye," an exhibition of prints, which originated at California State University in Long Beach in 1986 and traveled to several locations; and

"Eric Fischl," an exhibition of paintings and drawings which was shown at the Aarhus Kunstmuseum, the Louisiana Museum of Modern Art in Denmark, the Akademie der Bilden Künste in Vienna, and the Musée Cantonal des Beaux-Arts in Lausanne, Switzerland, in 1990. His most recent solo exhibitions were in 2000 at Gagosian Gallery, London and in 1999 at Mary Boone Gallery, New York, Mary Ryan Gallery, New York, and Mario Diacono Gallery, Boston.

Among the major group exhibitions that have included Fischl's work are "An International Survey of Recent Painting and Sculpture" at the Museum of Modern Art in New York in 1984, "Paradise Lost/Paradise Regained: American Visions of the New Decade" at the Venice Bienalle in 1984, "Documenta 8" in Kassel in 1987, and the Whitney Museum of American Art Biennal Exhibitions in 1983, 1985, and 1991. Recent group exhibitions that have included Fischl's work include: "NowHere," at the Louisiana Museum of Modern Art in Humlebaek, Denmark, in 1996; "Singular Impressions: The Monotype in America," National

Museum of American Art, Smithsonian Institution, Washington, D.C., in 1997; "Change of Scene XVI," Museum für Moderne Kunst, Frankfurt, in 1999–2000; and "The American Century: Art and Culture, 1900–2000," Whitney Museum of American Art, New York, in 1999–2000. In 1988 a compendium of Fischl's work, edited by David Whitney and with an essay by Peter Schjeldahl, was published by Art in America and Stewart, Tabori and Chang.

Fischl has collaborated with several other artists and authors. With Allen Ginsberg, he created sets for *Kaddish*, performed in New York in 1988. With Jamaica Kincaid, he created the limited edition book *Annie, Gwen, Lilly, Pam and Tulip* (Whitney Museum of American Art, 1986). With Jerry Saltz he compiled *Sketchbook with Voices* (Alfred van der Marck Editions, 1986), a sketchbook with contributions by over sixty artists. E. L. Doctorow contributed poetry to *Scenes and Sequences*, which was produced in a limited edition and included an original monotype (Peter Blum Editions, 1989).

Fischl's work is represented in numerous private, museum and corporate collections, including the Whitney Museum of American Art, the Museum of Modern Art, Museum of Contemporary Art in Los Angeles, the St. Louis Museum of Art, the Louisiana Museum of Art in Denmark, and the PaineWebber Collection, among others.

Mary Boone Gallery and Gagosian Gallery in New York represent Fischl. He lives in New York City and Sag Harbor, New York.

Biography

Born: New York City, 1948
Lives: New York City and Sag Harbor, New York

Education

California Institute for the Arts, B.F.A. 1972

One Person Exhibitions

Gagosian Gallery, London, England, "Eric Fischl," 2000.
Mario Diacono Gallery, Boston, Massachusetts, "Eric Fischl," 1999–2000.
Mary Ryan Gallery, New York, New York, "Eric Fischl Unique Works," 1999.
Mary Boone Gallery, New York, New York, 1999.
Galerie Daniel Templon, Paris, France, 1999.
Galleria Lawrence Rubin, Milan, Italy, "Eric Fischl: Recent Paintings and Works on Paper," 1998.
Gagosian Gallery, New York, New York, "Eric Fischl: Sculpture," 1998.
Galerie Daniel Templon, Paris, France, "Eric Fischl: Saint-Tropez Photographies," 1997.
Baldwin Gallery, Aspen, Colorado, "Eric Fischl: New Works on Paper," 1997.
Mary Boone Gallery, New York, New York, "Eric Fischl," 1996.
Numark Gallery, Washington, D.C., "Eric Fischl: Prints and Monotypes," 1996.
Alexa Lee Gallery, Ann Arbor, Michigan, "Eric Fischl: Solar Intaglio Prints," 1995.
Michael Nagy Fine Art, Potts Point, Australia, "Eric Fischl," 1995.
Laura Carpenter Fine Art, Santa Fe, New Mexico, "Eric Fischl: The Travel of Romance," 1994.
Mary Boone Gallery, New York, New York, "Eric Fischl: The Travel of Romance" (cat.), 1994.
Off Shore Gallery, East Hampton, New York, "Eric Fischl: Watercolors," 1994.
Galerie Daniel Templon, Paris, France, "Eric Fischl: Oeuvres Récentes," 1994.
Daniel Weinberg Gallery, New York, New York, "Eric Fischl," 1994.
Galeria Soledad Lorenzo, Madrid, Spain, "Eric Fischl" (cat.), 1993.
Mary Ryan Gallery, New York, New York, "Eric Fischl—New Solar Plate Intaglio Prints," 1993.
Michael Kohn Gallery, Santa Monica, California, "Eric Fischl: St. Tropez, 1982–1988, Photographs," 1992.
Milwaukee Art Museum, Milwaukee, Wisconsin, "Eric Fischl: Drawings," 1991. Traveled to Montgomery Museum of Fine Arts, Montgomery, Alabama, 1992; Center for Fine Arts, Miami, Florida, 1992.
Guild Hall, Southampton, New York, "Eric Fischl: A Cinematic View," 1991.
Aarhus Kunstmuseum, Aarhus, Denmark, "Eric Fischl" (cat.), 1991. Traveled to Louisiana Museum, Humlebaek, Denmark, 1991.
Mary Boone Gallery, New York, New York, "Eric Fischl," 1990.
Walker Art Center, Minneapolis, Minnesota, "Eric Fischl: Works in Progress," 1990.
Musée Cantonal des Beaux-Arts, Lausanne, Switzerland, "Eric Fischl," 1990.
Grunwald Center for the Graphic Arts, University of California, Los Angeles, California, "Scenes and Sequences" (cat.), 1990. Traveled to Walker Art Center, Minneapolis, Minnesota, 1990; Yale University Art Gallery, New Haven, Connecticut, 1991; Hood Museum of Art, Dartmouth College, Hanover, New Hampshire, 1991.
Mary Ryan Gallery, New York, New York, "Eric Fischl–A Survey of Etchings, Woodcuts, and Monotypes from the Past Decade," 1990.
Gemaldegalerie der Akademie der Bildenden Kunste, Vienna, Austria, "Eric Fishl," 1990.
Koury-Wingate Gallery, New York, New York, "Eric Fischl," 1990.
Waddington Galleries, London, England, "Eric Fischl" (cat.), 1989.
Mary Boone Gallery, New York, New York, "Eric Fischl" (cat.), 1988.
Michael Werner Gallery, Cologne, Germany, "Eric Fischl: Bilder und Zeichnungen" (cat.), 1988.
Mary Boone Gallery, New York, New York, "Eric Fischl," 1987.
Sable-Castelli Gallery, Toronto, Ontario, "Eric Fischl," 1987.

University Art Museum, California State University, Long Beach, California, "Eric Fischl: Scenes Before the Eye" (cat.), 1986. Traveled to University Art Museum, University of California, Berkeley, California, 1986–87; Contemporary Arts Center, Honolulu, Hawaii, 1987; The Baltimore Museum of Art, Baltimore, Maryland, 1987; The St. Louis Art Museum, St. Louis, Missouri, 1987.

Mary Boone Gallery, New York, New York, "Eric Fischl," 1986.

Daniel Weinberg Gallery, Los Angeles, California, "Eric Fishl," 1986.

Larry Gagosian Gallery, Los Angeles, California, "Eric Fischl," 1986.

Mario Diacono Gallery, Boston, Massachusetts, "Eric Fischl: The Works on Glassine, 1979–80," 1985–86.

Mendel Art Gallery, Saskatoon, Saskatchewan, "Eric Fischl: Paintings" (cat.), 1985. Traveled to Stedelijk Van Abbemuseum, Eindhoven, Netherlands, 1985; Kunsthalle Basel, Basel, Switzerland, 1985; Institute of Contemporary Arts, London, England, 1985; Art Gallery of Ontario, Toronto, Ontario, 1985; Museum of Contemporary Art, Chicago, Illinois, 1985–86; Whitney Museum of American Art, New York, New York, 1986.

Sable-Castelli Gallery, Toronto, Ontario, "Eric Fischl," 1985.

Mary Boone/Michael Werner Gallery, New York, New York, "Eric Fischl" (cat.), 1984.

Institute of Contemporary Art, Boston, Massachusetts, "Currents," 1984.

Galleria Mario Diacono, Rome, Italy, "Birthday Boy," 1983.

Centre Saidye Bronfman, Montreal, Quebec, "Eric Fischl: Dessins" (cat.), 1983.

Sir George Williams Art Galleries, Concordia University, Montreal, Quebec, "Eric Fischl: Paintings" (cat.), 1983.

Multiples Inc./Marian Goodman Gallery, New York, New York, 1983.

Nigel Greenwood Gallery, London, England, "Eric Fischl," 1983.

Larry Gagosian Gallery, Los Angeles, California, "Eric Fischl," 1983.

Sable-Castelli Gallery, Toronto, Ontario, "Eric Fischl," 1982.

Edward Thorpe Gallery, New York, New York, "Eric Fischl," 1982.

University of Colorado Art Galleries, Boulder, Colorado, 1982.

Edward Thorpe Gallery, New York, New York, "Eric Fischl," 1981.

Sable-Castelli Gallery, Toronto, Ontario, "Eric Fischl," 1981.

Emily Davis Gallery, University of Akron, Akron, Ohio, "Eric Fischl: Paintings and Drawings" (cat.), 1980.

Edward Thorpe Gallery, New York, New York, 1980.

Galerie B., Montreal, Quebec, 1978.

Studio, Halifax, Nova Scotia, 1976.

Galerie B., Montreal, Quebec, 1976.

Dalhousie Art Gallery, Halifax, Nova Scotia, "Bridge Shield Shelter" (cat.), 1975.

Schick Art Gallery, Skidmore College, Saratoga Springs, New York, "A Plurality of Truths," 2000.

Museum für Moderne Kunst, Frankfurt, Germany, "Change of Scene XVII," 2000.

The Art Museum at Florida International University, Miami, Florida, "Modernism & Abstraction: Treasures from the Smithsonian American Art Museum," 2000. Traveling to Colby College Museum of Art, Waterville, Maine, 2000; Memorial Art Gallery of the University of Rochester, Rochester, New York, 2001; Allentown Art Museum, Allentown, Pennsylvania, 2001; First Center for the Visual Arts, Nashville, Tennessee, 2001; Worcester Art Museum, Worcester, Massachusetts, 2001–2; National Academy Museum, New York, New York, 2002; Des Moines Art Center, Des Moines, Iowa, 2002; Oakland Museum of California, Oakland, California, 2002.

The Equitable Gallery, New York, New York, "Dreams 1900–2000: Science, Art, and the Unconscious Mind," 1999–2000. Traveling to Historisches Museum der Stadt Wien, Vienna, Austria, 2000; Binghampton University Art Museum, Binghampton, New York, 2000; Passage de Retz, Paris, France, 2000–2001.

Gagosian Gallery, New York, New York, "David Salle, Francesco Clemente, Eric Fischl," 2000.

Whitney Museum of American Art, New York, New York, "The American Century: Art and Culture, 1900–2000," 1999–2000.

Aspen Art Museum, Aspen, Colorado, 1999.

Blickle Foundation, Kraichtal, Germany, "Figuration—Outsider or a New Trend?," 1999. Traveled to Rupertinum, Salzburg, Austria, 1999; Museion Bolzano, Bolzano, Italy, 1999–2000.

Museum für Moderne Kunst, Frankfurt, Germany, "Change of Scene XVI," 1999–2000.

Museum of Contemporary Art, Chicago, Illinois, "Decades in Dialogue: Perspectives on the MCA Collection," 1999.

The Cleveland Museum of Art, Cleveland, Ohio, "Cleveland Collects Contemporary Art" (cat.), 1998–99.

Rupertinum, Salzburg, Austria, "Ideal and Reality. The Image of the Body in 20th-Century Art. From Bonnard to Warhol. Works on Paper" (cat.), 1998.

Cultergest, Lisbon, Portugal, "The '80s," 1998.

The Parrish Art Museum, Southampton, New York, "The Centennial Open," 1998.

Carpenter Center for the Visual Arts, Harvard University, Cambridge, Massachusetts, "Five Artists: The Body/The Figure," 1998.

Whitney Museum of American Art, New York, New York, "Views from Abroad: European Perspectives on American Art 3" (cat.), 1997.

National Museum of American Art, Smithsonian Institution, Washington, D.C., "Singular Impressions: The Monotype in America" (cat.), 1997.

Nassau County Museum of Art, Roslyn Harbor, New York, "Feminine Image" (cat.), 1997.

California Center for the Arts Museum, Escondido, California, "Myths and Magical Fantasies," 1997.

American Academy in Rome, Rome, Italy, Annual Exhibition (cat.), 1996.

Louisiana Museum of Modern Art, Himlebaek, Denmark, "NowHere," 1996.

National Gallery of Art, Washington, D.C., "The Robert and Jane Meyerhoff Collection" (cat.), 1996.

Detroit Institute of Arts, Detroit, Michigan, "The PaineWebber Art Collection" (cat.), 1995. Traveled to Museum of Fine Arts, Boston, Massachusetts, 1996; Minneapolis Institute of Arts, Minneapolis, Minnesota, 1996; San Diego Museum of Art, San Diego, California, 1997; Center for the Fine Arts, Miami, Florida, 1997.

Musée d'art Contemporain de Montréal, Montreal, Quebec, "L'Effet Cinéma," 1995–96.

L'Orangerie du Jardin de Luxembourg, Paris, France, "23 Artistes pour

Médicins du Monde," 1994. Traveled to Galerie Enrico Navarra, Paris, France; Galerie Enrico Navarra, New York, New York; Galerie Enrico Navarra, Tokyo, Japan; Harcourts Gallery, San Francisco, California; Acpy la Métaierie, Bryere, Parly, France; Molinar Gallery, Scottsdale, Arizona; Jan Abrams Gallery, Los Angeles, California; Fondation Ebel, Villa Turque, La Chaux-de-Fonds, Switzerland.

Aarhus Kunstmuseum, Aarhus, Denmark, "Strange Hotel" (cat.), 1993.

National Gallery of Art, Washington, D.C., "Dürer to Diebenkorn: Recent Acquisitions of Art on Paper," 1992.

San Jose Museum of Art, San Jose, California, "Drawing Redux," 1992.

The Miyagi Museum of Art, Sendai, Miyagi, Japan, "American Realism and Figurative Art: 1952–1990" (cat.), 1991. Traveled to Sogo Museum of Art, Yokohama, Japan, 1992; Tokushima Modern Art Museum, Tokushima, Japan, 1992; Museum of Modern Art, Shiga, Japan, 1992; Kochi Prefectural Museum of Folk Art, Kochi, Japan, 1992.

Whitney Museum of American Art, New York, New York, Biennial Exhibition, 1991.

Institute of Contemporary Art, Philadelphia, Pennsylvania, "Interactions," 1991.

Parrish Art Museum, Southampton, New York, 1990.

Whitney Museum of American Art at Philip Morris, New York, New York, "Suburban Home Life: Tracking the American Dream" (cat.), 1989.

Rheinhalle, Cologne, Germany, "Bilderstreit," 1989.

Museum des 20. Jahrhunderts, Vienna, Austria, "Viennese Divan: Sigmund Freud Nowadays," 1989.

Art Gallery of Nova Scotia, Halifax, Nova Scotia, "Eight/Twenty" (cat.), 1988. Traveled to Kitchener-Waterloo Art Gallery, Kitchener, Ontario, 1989; Art Gallery of Windsor, Windsor, Ontario, 1989; Edmonton Art Gallery, Edmonton, Alberta, 1990.

Parrish Art Museum, Southampton, New York, "Drawing on the East End, 1940–1988," 1988.

Sara Hilden Art Museum, Suomi, Finland, "American Contemporary Art" (cat.), 1988. Traveled to Kunstnernes Hus, Norge, Norway, 1988.

Whitney Museum of American Art, New York, New York, "Figure as Subject: The Revival of Figuration Since 1975" (cat.), 1988. Traveled to Erwing A. Ulrich Museum of Art, Wichita State University, Wichita, Kansas, 1988; Arkansas Art Center, Little Rock, Arkansas, 1988; Amarillo Art Center, Amarillo, Texas, 1988; Utah Museum of Fine Arts, University of Utah, Salt Lake City, Utah, 1988–89; Madison Art Center, Madison, Wisconsin, 1989.

Independent curators, New York, New York, "Morality Tales: History . Painting in the 1980s" (cat.), Grey Art Gallery and Study Center, New York University, New York, New York, 1987; Laguna Art Museum, Laguna Beach, California, 1987; The Berkshire Museum, Pittsfield, Massachusetts, 1988; Wadsworth Atheneum, Hartford, Connecticut, 1988; The Lowe Art Museum, University of Miami, Coral Gables, Florida, 1988; Goldie Paley Gallery, Moore College of Art, Philadelphia, Pennsylvania, 1988; Duke University Museum of Art, Durham, North Carolina, 1989; Sheldon Memorial Art Gallery, University of Nebraska, Lincoln, Nebraska, 1989; Musée de Quebec, Quebec City, Quebec, 1986.

Montreal International Center for Contemporary Arts, Montreal, Quebec, "Stations," 1987.

Kassel, Germany, "Documenta 8" (cat.), 1987.

Whitney Museum of American Art at Philip Morris, "The Viewer as Voyeur" (cat.), 1987.

Los Angeles County Museum of Art, Los Angeles, California, "Avant Garde in the Eighties" (cat.), 1987.

Walker Art Center, Minneapolis, Minnesota, "Past/Imperfect: Eric Fischl, Vernon Fisher, Laurie Simmons" (cat.), 1987. Traveled to Knight Gallery/Spirit Square Center for the Arts, Charlotte, North Carolina, 1987; Contemporary Arts Center, Cincinnati, Ohio, 1988; Institute of Contemporary Art, University of Pennsylvania, Philadelphia, Pennsylvania, 1988.

Institute of Contemporary Arts, London, England, "State of the Art," 1987.

Museum of Art, Fort Lauderdale, Florida, "An American Renaissance: Painting and Sculpture Since 1940" (cat.), 1986.

Art Gallery of New South Wales, Sydney, Australia, "Origins, Originality, and Beyond," Biennial of Sydney, 1986.

Museum Ludwig, Cologne, Germany, "Europa/Amerika," 1986.

Museum of Contemporary Art, Los Angeles, California, "Individuals: A Selected History of Contemporary Art, 1945–1986," 1986.

Carnegie Institute of Modern Art, Pittsburgh, Pennsylvania, "Carnegie International" (cat.), 1985–86.

Grande Halle du Parc de la Villette, Paris, France, XIII Biennale de Paris, 1985.

Whitney Museum of American Art, New York, New York, Whitney Biennial, 1985.

ARCal., Marseilles, France, "New Art '85," 1985.

Hirshhorn Museum and Sculpture Garden, Washington, D.C., "Content" (cat.), 1984–85.

Venice Biennale, Venice, Italy, "Paradise Lost/Paradise Regained: American Visions of the New Decade" (cat.), 1984.

Aldrich Museum of Contemporary Art, Ridgefield, Connecticut, "American Neo-Expressionists" (cat.), 1984.

Museum of Modern Art, New York, New York, "An International Survey of Recent Painting and Sculpture" (cat.), 1984.

Musée d'Art Contemporain, Montreal, Quebec, "Via New York" (cat.), 1984.

Whitney Museum of American Art at Philip Morris, New York, New York, "Visions of Childhood: A Contemporary Iconography" (cat.), 1984.

San Francisco Museum of Modern Art, San Francisco, California, "The Human Condition: SFMOMA Biennial III," 1984.

Neue Galerie-Sammlung Ludwig, Aachen, Germany, "Apekte Americanischer Kunst der Gegenwart," 1984.

Palacio de Velazquez, Madrid, Spain, "Tendencias en Nueva York" (cat.), 1983.

Parrish Art Museum, Southampton, New York, "The Painterly Figure" (cat.), 1983.

Three Rivers Arts Festival, Pittsburgh, Pennsylvania, "New York Painting Today" (cat.), 1983.

Kunstmuseum, Lucerne, Switzerland, "Back to the USA" (cat.), 1983. Traveled to Rheinisches Landesmuseum, Bonn, Germany, 1983–84; Wurttembergischer Kunstverein, Stuttgart, Germany, 1984.

Whitney Museum of American Art, New York, New York, "1983 Biennial Exhibition" (cat.), 1983.

Seibu Museum of Art, Tokyo, Japan, "Mary Boone and Her Artists," 1983.

Kunstverein für die Rheinlande und Westfalen, Düsseldorf, Germany, "New York Now," 1983.

Whitney Museum of American Art, New York, New York, "Focus on the Figure: Twenty Years," 1982.

P.S. 1, Long Island City, New York, "Critical Perspectives," 1982.

Museum of Art, Rhode Island School of Design, Providence, Rhode Island, "Art for Your Collection," 1981.

Glenbow Museum, Calgary, Alberta, "Aspects of Canadian Painting in the Seventies" (cat.), 1980.

P.S. 1, Long Island City, New York, "The Great Big Drawing Show," 1979.

Basel Kunsthalle, Basel, Switzerland, "Neuen Kanadische Kunstler" (cat.), 1978.

Vancouver Art Gallery, Vancouver, British Columbia, "Seventeen Artists: A Protean View," 1976.

ACKNOWLEDGMENTS

I would like to thank my great good friend Bruce Ferguson for his initial input and efforts in largely selecting the works of this book. It is what gave its content content. I would like to thank Arthur Danto for his precise and lucid essay about my work and career. He has made me feel smart. I want to thank Steve Martin for his thoughtful and amusing meditation on my painting, *Barbeque*. (Actually, it is his painting.) I would like to thank Robert Enright (whom I personally believe to be the best interviewer on this planet) for his research and energy and insights while conducting the interview, which he largely edited himself out of to make it seem like I was the one who thought it. I want to especially thank and acknowledge Claudia Carson for her diligence in finding all the necessary material and making sure it got where it was supposed to go at the time it was supposed to get there. Sasha Cutter Nye deserves a big round of applause for her deft stewardship in editing and organizing this book and selecting designer Patrick Seymour, who made this book such a beautiful object. A special thank you to Gianfranco Monacelli and to his press for making me a part of his collection of excellent monographs. I want to express my love and admiration for my wife, April Gornik. It is her opinions and thoughts and love I value most. Thank you to Mary Boone and all the good people at Mary Boone Gallery who have been so helpful in supplying the necessary documentation for this book. I would also like to thank Larry Gagosian and his staff at the Gagosian Gallery for their assistance. Thank you also to the Mary Ryan Gallery for the images they have generously supplied. Lastly, I wish to acknowledge and thank all the patrons who have supported my work over the length of my career. I list them here.

List of Collectors

Public Collections

The Aldrich Museum of Contemporary Art,
 Ridgefield, Connecticut
Art Gallery of New South Wales, Sydney,
 Australia
Art Gallery of Ontario, Toronto, Ontario
Art Institute of Chicago, Chicago, Illinois
Art Museum, California State University, Long
 Beach, California
Baltimore Museum of Art, Baltimore, Maryland
Basel Kunsthalle, Basel, Switzerland
The Eli Broad Family Foundation, Santa Monica,
 California
Carnegie Museum of Art, Pittsburgh,
 Pennsylvania
Chase Manhattan Bank, New York, New York
Cincinnati Art Museum, Cincinnati, Ohio
Douglas S. Cramer Foundation, Los Angeles,
 California
Dallas Museum of Art, Dallas, Texas
Dannheiser Foundation, New York, New York
Des Moines Art Center, Des Moines, Iowa
Greenville County Museum of Art, Greenville,
 South Carolina
Guild Hall, East Hampton, New York
High Museum of Art, Atlanta, Georgia
Hirshhorn Museum and Sculpture Garden,
 Washington, D.C.
Ho-Am Art Museum, Seoul, South Korea
Louisiana Museum of Modern Art, Humlebaek,
 Denmark
Ludwig Museum of Contemporary Art,
 Budapest, Hungary
Mars Museum, Marstown, New Jersey
Menil Collection, Houston, Texas
Musée National d'Art Moderne, Centre Georges
 Pompidou, Paris, France
Museum of Contemporary Art, Chicago, Illinois
Museum of Contemporary Art, Los Angeles,
 California
Museum of Modern Art, New York, New York
National Academy of Arts and Letters, New York,
 New York
National Gallery of Art, Washington, D.C.
National Gallery of Canada, Ottowa, Ontario
National Museum of American Art, Smithsonian
 Institution, Washington, D.C.
Neue Gallery, Aachen, Germany
New York Academy of Art, New York, New York
Oklahoma City Art Museum, Oklahoma City,
 Oklahoma
PaineWebber Art Museum, New York, New York
Philadelphia Museum of Art, Philadelphia,
 Pennsylvania
The Rivendell Collection, Bard College,
 Annandale-on-Hudson, New York
Saatchi Gallery, London, England
St. Louis Art Museum, St. Louis, Missouri
San Francisco Art Institute, San Francisco,
 California
San Francisco Museum of Modern Art, San
 Francisco, California
Toledo Museum of Art, Toledo, Ohio
Whitney Museum of American Art, New York,
 New York

Private Collectors

Cesare and Paola Anticoli
Martha Baer
Jill Barad
Ramis Barquet

Bazinet
Harvey Bernstein
Joel Bernstein
Lawrence and Mickey Beyer
Carlo Bilotti
Richard Blumenthal
Mary Boone
Norman and Irma Braman
Peter Brant
Sandy Brant
Andrew and Elise Brownstein
Matthias Brunner
James Burrows
Shawn Byers
Paul Cantor
Arthur and Jeanne Cohen
Claudia Cohen
Eugene Corman
D. Antonio Cruz
H. Corbin Day
Roberto De Guardiola
Frits De Kneght
Beth De Woody
James Dorment
Edward Downe
Stefan Edlis and Gael Neeson
Mallory Factor
Howard and Suzanne Feldman
Robert Feldman
Bruce Ferguson
Anthony Fisher
Don and Doris Fisher
Shirlee Fonda
Hugh and Lee Freund
Richard and Kathy Fuld
Larry Gagosian
David Geffen
David and Susan Gersh
Phillip and Bea Gersh
Robert and Linda Gersh
Raynold Gideon
Arthur and Carol Goldberg
Noam and Gera Gottesman
Stanley and Barbara Grandon
Peter Greenwald
Gerald and Carolyn Grinstein
Agnes Gund
Charles Heilbronn
Samuel and Ronnie Heyman
Doris Hillman
David Hoberman
Paul and Camille Hoffmann
Bryan Hunt
Gregory and Deborah Hymowitz
Barbara Jakobson
Elton John
Jasper Johns
Philip Johnson
Bruce and Janet Karatz
Pauline Karpides
Aron Katz
Kenji Kawabata
Ellen Kern
Gilbert and Ann Kinney
Arnold and Anne Kopelson
Nathaniel and Georgia Kramer
Emily Fisher Landau
Morton Landowne
Bert and Lori Langer
Ray Learsy

Robert Lehrman
Dorothy Lichtenstein
Robert Littman
Peter Lund
Michael and Ninah Lynne
Lewis and Susan Manilow
Achille Maramotti
Martin Margulies
Leonidas Marinopoulos
D. Marcos Martin
Steve Martin
Dinos Martinos
Erich Marx
Larry Marx
Mark Maslan
Joseph Mazzaferro
Patrick McCarthy
Jean McCusker
John McEnroe
Joseph and Arlene McHugh
Stephen McMurray
Byron Meyer
Robert and Jane Meyerhoff
Buck Mickel
Nicole Miller
Edward Minskoff
Josef Mittelmann
Alan Mnuchin
Robert Mnuchin
Ricardo Mora
Thomas Newby
Donald Newhouse
S.I. Newhouse
Mike Nichols and Diane Sawyer
Leonard Nimoy
Richard Nye
Michael Ovitz
John and Mary Pappajohn
Ron Perelman
Ronald Pizzuti
Howard Rachofsky
Leslie Rankow
D. Antonio Recoder
Anita Reiner
James and Ida Mae Rich
Donald and Mera Rubell
Michael and Joan Salke
Arno and Danner Schefler
Barbara Schwartz
Terry Semel
Stanley Shopkorn
Sam Simon
Martin Sklar
Jerry and Lynn Speyer
Jerry and Emily Spiegel
Eugene Stevens
Edwin Stringer
Roselyn Swig
Al Trenk
Paul Walter
Max Werner
David Whitney
Virginia and Bagley Wright
Neda Young
Bette Ziegler
David Whitney
Virginia and Bagley Wright
Neda Young
Bette Ziegler

Cover:
Detail from The Bed, The Chair, The Sitter, 1999
oil on linen
78" x 93"

·Spine:
Detail from The Philosopher's Chair, 1999
oil on linen
75" x 86"

Back Cover:
Detail from Kowdoolie, 1990
oil on linen
98" x 130"

Page 2:
Detail from Portrait of the Artist as an Old Man, 1984
oil on canvas
85" x 70"

Page 4,5:
Detail from Bad Boy, 1981
oil on canvas
66" x 96"

Page 6:
Detail from Birth of Love, 2nd Version, 1987
oil on linen, four panels
119" x 142 ½"

Page 8:
Detail from Holy Man, 1990
oil on linen
98" x 74"

Page 9:
Detail from Imitating the Dog (Mother and Daughter II), 1984
oil on canvas
96" x 84"

First published in the United States of
America in 2000 by
The Monacelli Press, Inc.
10 East 92nd Street, New York,
New York 10128

Library of Congress Catalog Card
Number: 00-108773

ISBN: 1-58093-075-1

Printed and bound in Italy

Designed by Tsang Seymour Design, NYC